PRAISE FOR The Rescue A

"Dolnick raises good questions about museum responsibility, the complexities of criminal motivation and the sheer madness of the human drive to attach obscene price tags to objects that were created for loftier purposes." —John Loughery, *Washington Post*

"Art theft generates between four and six billion dollars a year in revenues, according to Interpol. That makes it number three in illicit commerce, behind drugs and illegal arms. An engaging tour of this little known world is found in Edward Dolnick's *Rescue Artist*."

-Monica Gagnier, Business Week

00404445

"Riveting. . . . Readers entering the little-known world of Hill with Dolnick as guide are unlikely to exit willingly."

-Steve Weinberg, Cleveland Plain Dealer

"A masterful portrait of the 'rescue artist.'"

-Karen Algeo Krizman, Rocky Mountain News

"The Rescue Artist is an action-packed investigation of the whole sordid history of art crime. . . . Dolnick, with his seasoned journalistic background, writes with a crisp, breezy style that runs with the speed of thieves purloining stolen canvases."

-Donald Harington, Atlanta Journal-Constitution

"[A] fascinating, stranger-than-fiction story. . . . The prose is quick, witty, wildly intriguing, and Dolnick's voice really shines through as he reports the story with a contagious excitement for the topic. . . . Dolnick pieces together an exceptional book of art thieves, art detectives, artists, and their works, and even after the first chapter it is hard to put the book down and not feel slightly more refined and sophisticated with all the acquired art knowledge."

-Ben Taylor, Albuquerque Journal

"A highly accessible and well-written book that often evokes a crime novel rather than a work of nonfiction.... *The Rescue Artist* will satisfy both the reader who would like a good mystery yarn to enliven his or her summer reading as well as someone who wants a crash course in art theft, art recovery, police undercover work, museum security (or the lack thereof), and even a primer on many of the world's great works of art and the lives of the artists who created them." —Lawrence M. Kaye and Howard N. Spiegler, *New York Law Journal*

"Edward Dolnick has given us much more than an outstanding detective story that happens to be taken from real life. He has provided us with an insider's view of the hidden world of art theft, where paintings by old masters are used to settle gambling debts and priceless canvases are rolled up carelessly in the trunk. This is a fascinating tale, expertly told with characters as crisply drawn as any Rembrandt and the sort of intrigue generally found only in a thriller." —Arthur Golden, author of *Memoirs of a Geisha*

"The Rescue Artist is a masterpiece. Engrossing, entertaining, often surreally hilarious. In all, a feat no less impressive than the heist of The Scream in under a minute using nothing but a ladder."

—Mary Roach, author of Stiff: The Curious Lives of Human Cadavers

"A lively and literate romp through the world of big-time art crime, led by Scotland Yard's rumpled undercover ace, Charley Hill. . . . A rollicking good ride." —Gerard O'Neill, co-author of *Black Mass: The Irish Mob. the FBI, and a Devil's Deal*

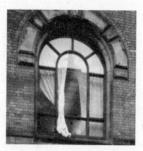

THE RESCUE ARTIST

ALSO BY EDWARD DOLNICK

Madness on the Couch

Down the Great Unknown

THE RESCUE ARTIST

A TRUE STORY OF ART,

THIEVES, AND THE HUNT

FOR A MISSING MASTERPIECE

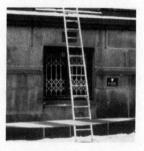

EDWARD DOLNICK

NEW YORK . LONDON . TORONTO . SYDNEY

HARPER C PERENNIAL

A hardcover edition of this book was published in 2005 by HarperCollins Publishers.

P.S.™ is a trademark of HarperCollins Publishers.

THE RESCUE ARTIST. Copyright © 2005 by Edward Dolnick. All rights reserved. Printed in the United States of America. No part of this book may be used or reproduced in any manner whatsoever without written permission except in the case of brief quotations embodied in critical articles and reviews. For information address HarperCollins Publishers, 10 East 53rd Street, New York, NY 10022.

HarperCollins books may be purchased for educational, business, or sales promotional use. For information please write: Special Markets Department, HarperCollins Publishers, 10 East 53rd Street, New York, NY 10022.

FIRST HARPER PERENNIAL EDITION PUBLISHED 2006.

Designed by Laura Lindgren

The Library of Congress has catalogued the hardcover edition as follows:

Dolnick, Edward.

The rescue artist : a true story of art, thieves, and the hunt for a missing masterpiece / Edward Dolnick.—1st ed.

```
p. cm.
```

Includes bibliographical references and index.

ISBN-10: 0-06-053117-7

ISBN-13: 978-0-06-053117-1

1. Art thefts—Investigation. 2. Art thefts—Investigation—Norway. 3. Theft from museums—Norway. 4. Munch, Edvard, 1863–1944. Scream (Nasjonalgalleriet [Norway]) I. Title.

N8795.D65 2005 364.16'2'09481—dc22

ISBN-10: 0-06-053118-5 (pbk.) ISBN-13: 978-0-06-053118-8 (pbk.)

06 07 08 09 10 \$/RRD 10 9 8 7 6 5 4 3 2 1

2004062060

For Sam and Ben

Being on the tightrope is living. Everything else is waiting. —KARL WALLENDA

CONTENTS

Prologue / 1

PART I Two Men and a Ladder

Break-in / 5
 Easy Pickings / 11
 Whodunit? / 17
 The Priests / 21
 The Art Squad / 25
 The Rescue Artist / 34

PART II

Vermeer and the Irish Gangster

7 Screenwriters / 45
8 The Man from the Getty / 50
9 The General / 56
10 Russborough House / 65
11 Encounter in Antwerp / 70
12 Munch / 78

PART III The Man from the Getty

13 "Watch the Papers!" / 91
14 The Art of Seduction / 97
15 First Encounter / 107
16 Fiasco at the Plaza / 113
17 Russborough House Redux / 121
18 Money Is Honey / 128
19 Dr. No / 133
20 "This Is Peter Brewgal" / 139
21 Mona Lisa Smile / 143
22 Gangsters / 152

PART IV The Undercover Game

23 Crook or Clown? / 159
24 Prop Trap / 163
25 First Time Undercover / 167
26 The Trick of It / 174
27 Front-Row Seat / 181
28 A Crook's Tale / 185
29 "Can I Interest You in a Rembrandt?" / 191
30 Traffic Stop / 197

PART V In the Basement

31 A Stranger / 203
32 On the Road / 207
33 "Hands Up!" / 210
34 The Thrill of the Hunt / 214

35 The Plan / 217
36 "Down Those Stairs" / 220
37 The End of the Trail / 225 Epilogue / 233

Afterword 241 Notes 245 Acknowledgments 251 Index 253

THE RESCUE ARTIST

PROLOGUE

JUNE 2004

The mismatched pictures stare down from the wall of the tiny office: Vermeer, Goya, Titian, Munch, Rembrandt. Ordinary reproductions worth only a few dollars, they are unframed and of different sizes. Several dangle slightly askew from tacks jammed in the wall. The originals hung in gilt frames in the grandest museums in the world, and tourists made pilgrimages to see them. Each was worth millions, or tens of millions.

And, at some point in the last several years, each was stolen. Some were recovered—the tall man who arranged this small display is the one who found them—and some are still missing. The "curator" of this odd collection dislikes anything that smacks of statistics, but he is haunted by a melancholy fact: nine out of ten stolen paintings disappear forever.

In the world of art crime, one detective has an unmatched résumé. His name is Charley Hill. The aim of this book is to explore the art underworld; Hill will serve as our guide. It is odd and unfamiliar territory, dangerous one moment, ludicrous the next, and sometimes both at once.

We will look at many tales of stolen paintings along the way in order to learn something of the territory in general, but the story of one worldfamous work—*The Scream*, by Edvard Munch—will serve as the thread we follow through the labyrinth. A decade ago, Hill had no more connection with that painting than did any of the millions who recognized it instantly from reproductions and cartoons.

On the morning of February 14, 1994, a phone call changed all that.

rrrrr . R Two Men and a Ladder

1

Break-in

OSLO, NORWAY FEBRUARY 12, 1994 6:29 A.M.

n the predawn gloom of a Norwegian winter morning, two men in a stolen car pulled to a halt in front of the National Gallery, Norway's preeminent art museum. They left the engine running and raced across the snow. Behind the bushes along the museum's front wall they found the ladder they had stashed away earlier that night. Silently, they leaned the ladder against the wall.

A guard inside the museum, his rounds finished, basked in the warmth of the basement security room. He had paperwork to take care of, which was a bore, but at least he was done patrolling the museum, inside and out, on a night when the temperature had fallen to fifteen degrees. He had taken the job only seven weeks before.

The guard took up his stack of memos grudgingly, like a student turning to his homework. In front of his desk stood a bank of eighteen closedcircuit television monitors. One screen suddenly flickered with life. The black-and-white picture was shadowy—the sun would not rise for another ninety minutes—but the essentials were clear enough. A man bundled in a parka stood at the foot of a ladder, holding it steady in his gloved hands. His companion had already begun to climb. The guard struggled through his paperwork, oblivious to the television monitors.

The top of the ladder rested on a sill just beneath a tall window on the second floor of the museum. Behind that window was an exhibit celebrating the work of Norway's greatest artist, Edvard Munch. Fifty-six of Munch's paintings lined the walls. Fifty-five of them would be unfamiliar to anyone but an art student. One was known around the world, an icon as instantly recognizable as the *Mona Lisa* or van Gogh's *Starry Night*. In poster form, it hung in countless dorm rooms and office cubicles; it featured endlessly in cartoons and on T-shirts and greeting cards. This was *The Scream*.

The man on the ladder made it to within a rung or two of the top, lost his balance, and crashed to the ground. He staggered to his feet and stumbled back toward the ladder. The guard sat in his basement bunker unaware of the commotion outside. This time the intruder made it up the ladder. He smashed the window with a hammer, knocked a few stubborn shards of glass out of the way, and climbed into the museum. An alarm sounded. In his bunker, the guard cursed the false alarm. He walked past the array of television screens without noticing the lone monitor that showed the thieves, stepped over to the control panel, and set the alarm back to zero.

The thief turned to *The Scream*—it hung only a yard from the window—and snipped the wire that held it to the wall. *The Scream*, at roughly two feet by three feet, was big and bulky. With an ornate frame and sheets of protective glass both front and back, it was heavy, too—a difficult load to carry out a window and down a slippery metal ladder. The thief leaned out the window as far as he could and placed the painting on the ladder. "Catch!" he whispered, and then, like a parent sending his toddler down a steep hill on a sled, he let go.

His companion on the ground, straining upward, caught the sliding painting. The two men ran to their car, tucked their precious cargo into the back seat, and roared off. Elapsed time inside the museum: fifty seconds. In less than a minute the thieves had gained possession of a painting valued at \$72 million.

It had been absurdly easy. "Organized crime, Norwegian style," a Scotland Yard detective would later marvel. "Two men and a ladder!" At 6:37 A.M. a gust of wind whipped into the dark museum and set the curtains at the broken window dancing. A motion detector triggered a second alarm. This time the guard, 24-year-old Geir Berntsen, decided that something *was* wrong. Panicky and befuddled, he thrashed about trying to sort out what to do. Check things out himself? Call the police? Berntsen still had not noticed the crucial television monitor, which now displayed a ladder standing unattended against the museum's front wall. Nor had he realized that the alarm had come from room 10, where *The Scream* hung.

Berntsen phoned his supervisor, who was at home in bed and halfasleep, and blurted out his incoherent story. In midtale, yet another alarm sounded. It was 6:46 A.M. Fully awake now, Berntsen's supervisor hollered at him to call the police and check the monitors. At almost precisely the same moment, a police car making a routine patrol through Oslo's empty streets happened to draw near the National Gallery. A glance told the tale: a dark night, a ladder, a shattered window.

The police car skidded to a stop. One cop radioed in the break-in, and two others ran toward the museum. The first man to the ladder scrambled his way to the top, and then, like his thief counterpart a few minutes before, slipped and fell off.

Back to the radio. The police needed another patrol car, to bring their colleague to the emergency room. Then they ran into the museum, this time by way of the stairs.

The policemen hurried to the room with the ladder on the sill. A frigid breeze flowed in through the broken window. The walls of the dark room were lined with paintings, but there was a blank spot next to the high window on University Street. The police ducked the billowing curtains and stepped over the broken glass. A pair of wire cutters lay on the floor. Someone had left a postcard.

The day of the crime was no ordinary winter Saturday. February 12 marked the first day of the 1994 Olympic Winter Games, held in the Norwegian city of Lillehammer. For Norway in general, and for its leading political and cultural figures in particular, this was a rare chance to bask in the world's admiring notice.

The opening ceremonies, a happy and controversy-free spectacle, were expected to draw 240 million television viewers. To most of that multitude, the word "Norway" called up only the vaguest associations. Snow. Fjords. Pine trees. Reindeer, maybe. Blondes, perhaps, or was that just Sweden? Asked to name a famous Norwegian, most people would draw a blank.

In the minds of the Norwegian establishment, the Olympics were a chance to begin to dispel that ignorance. When viewers around the world turned on their TV sets, they would see a national coming-out party. They would see Norway at its best.

Instead, they saw a celebration marred by shock and outrage. "In this beautiful scenery," lamented the minister of culture, "it is hard to imagine that such evil things could take place."

The thieves had no such somber thoughts. When they snatched *The Scream*, they had left a postcard for the authorities to find. It showed a painting by the popular Norwegian artist Marit Walle, who specializes in cheerful, cartoon-like scenes of everyday life. Walle's *Raging Hormones*, for instance, depicts two gray-haired matrons at the beach, binoculars to their eyes, ogling young hunks. The thieves had made their choice as carefully as shoppers in search of the perfect birthday card. They had settled on a Walle painting called *A Good Story*. It shows three men laughing uproariously, red-faced, pounding the table, gasping for breath. On the back of the card one of the thieves had scribbled, "Thanks for the poor security."

The security was worse than poor. "All the windows were locked," the National Gallery's director, Knut Berg, told reporters. "We didn't figure that thieves would climb through broken glass. There was a *lot* of glass. I wouldn't have dared to go through all that glass."

National Gallery officials, it soon became clear, had made a string of bad decisions. *The Scream* had been moved from its customary setting on the National Gallery's third floor to the second floor. That was more convenient for visitors, since it was closer to the street, but more tempting to thieves as

well, for the same reason. Knut Berg had been museum director for twenty years, and for twenty years he had done battle with the politicians who controlled his budget. Now, on the brink of retirement, he had orchestrated a can't-miss crowd-pleaser. As he watched his installers put the show together, Berg had bustled about happily, beaming with anticipation.

His security chief was more wary. "From January through May 1994," he had instructed the museum guards in a memo, "Edvard Munch paintings will be exhibited on the first floor [the second floor, in American usage] in rooms 9, 10, and 12. Cameras . . . should be monitored throughout the night. The night guard should vary his routine and should keep a special eye on the outside walls of the exhibition area. This is a unique exhibition, on the first floor, and we expect it to draw extra attention."

Bringing *The Scream* nearer to ground level was a blunder, and installing the painting next to a window that opened on the street compounded it. Making matters worse still, the windows of the old brick museum had no protective bars and were made of ordinary, rather than reinforced, glass. *The Scream* was not bolted to the wall but hung from a wire, just like an ordinary painting in an ordinary home, without any connection to the alarm system.

The thieves had prepared carefully. Some of their scouting was surreptitious. They had found, for example, that the night guard finished his rounds at about six in the morning and then retreated to his desk. But they carried out much of their research at leisure and in the open, joining the stream of visitors enjoying the "Festival of Norwegian Culture." The museum's cameras were out-of-date, they saw, and left some vital areas uncovered. In room 10, there were no cameras at all.

Like most good planners, the thieves kept things simple. They focused exclusively on *The Scream*, resisting the temptation to pick up other baubles along the way. Nor did they bother with cutting phone lines or disarming burglar alarms or any such electronic skullduggery. Speed was the key; if the thieves could get in and out quickly enough, the best alarms would provide little more than background noise.

For several nights before the theft, workmen at a construction site near the National Gallery had left a ladder lying in plain view. In the dark of night a few hours before the museum break-in, the thieves walked off with it. (The building site happened to be at Norway's largest newspaper, *Verdens Gang.* For crooks with a taste for publicity, it was a sweet touch that a newspaper whose job would be to shout out the story had itself played a bit part in the break-in.)

The day before the heist, the thieves stole two cars, a Mazda and an Audi. Both were in good condition and roomy, well-suited to fast driving and awkward cargo. The Mazda was the getaway car. The thieves drove a few blocks to where they had parked the Audi and transferred *The Scream* to the second car, in case anyone at the museum had seen them flee. Then they split up and drove off in different directions.

Within hours, everyone with a television set, in every country in the world, knew about the theft. In Norway, while excited reporters chattered for the cameras, chagrined officials at the National Gallery picked out a gift-shop poster of their lost masterpiece. The day before, *The Scream* had reigned in glory. Now a cheap poster in a flimsy frame hung in its place. Beneath the poster, a hand-lettered sign read simply: STOLEN! 2

Easy Pickings

orway's museum officials had made two far-reaching mistakes. The first was a failure to focus on details. Buoyed by lofty thoughts about the glories of great art, the National Gallery had paid too little heed to mundane questions of security. The second mistake was a failure of imagination. No one would be audacious enough, museum higher-ups had assured one another, to steal a painting that any buyer would immediately know was stolen.

It's not that anyone in the art world denies the existence of thieves. Even the smallest museum hires security guards. But the subject is so unseemly, and the yoking together of the words "art" and "crime" so much a joining of the sublime and the grimy, that the art community tends to avert its eyes and hope that the whole nasty subject will go away.

Which is fine with the thieves.

For art crime is a huge and thriving industry. Crime statistics are always dodgy, but Interpol, the international police agency, reckons that the amount of money changing hands in the art underworld comes to between \$4 billion and \$6 billion a year. On the roster of international illicit trade, art crime is number three, trailing only drugs and illegal arms. In Italy alone, where it is common for a tiny village to boast a church with a fifteenthcentury altarpiece, police say that thieves make off with a museum's worth of art each year.

The bulk of what is stolen is good but not great (since that is easiest to

resell), but cherished masterpieces disappear, too, and at an alarming rate. In all the world there are only 36 Vermeers. Of that tiny number, three— *The Concert, The Guitar Player,* and *Lady Writing a Letter with Her Maid* have been stolen in recent years.*

Lady Writing a Letter with Her Maid was snatched off the wall of a sprawling Irish mansion, found a week later in a cottage 200 miles away and returned to its owner, then stolen from the same owner a second time a dozen years later. In London, thieves have stolen the same Rembrandt portrait four times.

Within the span of a few months in the spring and summer of 2003, thieves stole two sixteenth-century masterpieces, each one worth \$50 million or more. In May, thieves clambered up scaffolding outside Vienna's Kunsthistorisches Museum and made off with an elaborate gold and ebony saltcellar by Benvenuto Cellini—"the Mona Lisa of sculptures," according to the museum's distraught director.[†] In August, two well-dressed, wellspoken thieves in Scotland bought £6 tickets and joined a tour of Drumlanrig Castle, which houses a renowned art collection. A few minutes later they put a knife to the throat of the guide, pulled Leonardo da Vinci's *Madonna of the Yarnwinder* off the wall, and strolled away with it. A pair of tourists from New Zealand happened to be visiting the castle, video camera in hand. They heard an alarm and then nearly collided with a man climbing over the castle wall. "Don't worry, love," one thief said. "We're the police. This is just practice."

"When the second man came over the wall," the couple later told police, "we felt something was going on." Then came a third man over the wall, "carrying something under his arm." The thieves ran past the pair of

^{*}Yet another Vermeer, *The Astronomer*, was confiscated by the Nazis for the personal collection of Adolf Hitler. The painting had belonged to a member of the Rothschild family. Today it hangs in the Louvre.

^tCellini made the saltcellar for King Francis I of France, in 1543. In his swashbuckling autobiography, the Florentine goldsmith tells of the king's reaction to a wax model of the proposed sculpture (and to Cellini himself). "This is a hundred times more divine a thing than I had ever dreamed of," the monarch stammers. "What a miracle of a man!"

The king asks Cellini to name his price, Cellini does so (1000 gold crowns), and the royal treasurer hands over the money. Four robbers brandishing swords attack Cellini on his way home, but he holds them off singlehandedly, displaying such "skill in using the sword," he tells us, that the cowed thieves take him for a soldier.

gawking tourists (who filmed the entire encounter), climbed into a VW Golf in the visitors parking lot, and disappeared.

The value of the stolen *Madonna*, one of only a dozen oil paintings by Leonardo, is almost incalculable. The experts' guesses range from a low of \$50 million to a high of \$235 million, a figure that more than doubles the current record for the highest price ever paid for a painting.

A museum of stolen masterpieces would rival any of the world's great treasure houses of art. The Museum of the Missing would fill endless galleries; the collection of paintings and drawings would include 551 Picassos, 43 van Goghs, 174 Rembrandts, and 209 Renoirs. Vermeer would be there, and Caravaggio and van Eyck and Cézanne and Titian and El Greco.

The assaults on art come from every direction. In Paraguay, in July 2002, thieves tunneled for 25 yards beneath the street, surfaced in the National Fine Arts Museum, and disappeared with five old masters with a combined value of well over \$1 million. In Oxford, in December 1999, a cat burglar smashed a skylight in the Ashmolean Museum, slithered down a rope, and ran off with a Cézanne worth \$4.8 million. In Rome, in May 1998, thieves opted for a "stay-behind," one of the simplest and most widely employed tactics. Late in the day, three men entered the National Gallery of Modern Art and hid behind an exhibition curtain until after closing time. When the visitors had gone home, the thieves emerged from hiding. Brandishing guns, they grabbed three guards, forced them to shut off the alarms, and tied them up. Fifteen minutes later, the thieves walked out the front door. They carried with them two van Goghs and a Cézanne, with a combined worth of \$34 million, as well as \$860 in cash, from ticket receipts.

If a stolen painting does reappear, it tends to surface in an incongruously humble setting, like a bewitched princess in a Brothers Grimm story who wakes up in a woodcutter's cottage. In 1989, for instance, the superintendent of an apartment co-op in Queens found a stolen Manet still life called *Bouquet of Peonies*, valued at up to \$5 million, hidden in the basement behind a washing machine.

But most stolen art is gone forever: the overall recovery rate is about

ten percent. The lone bit of good news is that the better the painting, the better the odds it will someday be found. For the greatest paintings of all—which are the hardest for thieves to unload, since they can never find legitimate buyers—there is the most reason to hope.

Ж

Most often, thieves leave the pizzazz to Hollywood. The pros go more for brute efficiency than for style. The biggest art theft of modern times could hardly have been simpler. On March 18, 1990, in Boston, two armed men in police uniforms and dime-store black mustaches showed up at the Isabella Stewart Gardner Museum at 1:20 in the morning. The museum is small and elegant, and maintained today almost precisely as it was a century ago. The thieves pounded on a side door and shouted to the guards that they were investigating reports of a disturbance inside the museum grounds.

The guards opened the door, and the two "policemen" rushed in and overpowered them. It took only a minute. The guards were art school students with scarcely any security training, earning \$6.85 an hour. (In the excitement of the moment, they forgot the central lesson they had been taught: "In the middle of the night you don't open that door for God himself.") The thieves left the guards handcuffed and gagged in the museum basement. The guards calmed down quickly, so much so that investigators later suspected they were high at the time of the break-in. One guard fell asleep while bound in the basement.

With the guards out of the way, the thieves disabled the alarm system—which was not much of a safeguard in any case, since it sounded only inside the museum itself—and wandered through the galleries for eighty minutes on a private shopping spree. They helped themselves to a dozen paintings and drawings, among them Vermeer's *Concert*; three Rembrandts, including his only seascape and an exquisite, stamp-sized self-portrait; Manet's *Chez Tortoni*; and five charcoal sketches and watercolors by Degas. (They stopped a moment to take the video cassette from the security camera, as well.) The choices were eccentric, or ignorant the thieves snatched a bronze eagle from atop a Napoleonic flagstaff but left Titian's immensely valuable *Rape of Europa* untouched. Even so, they fled with treasures worth \$300 million. "Tell them you'll be hearing from us," the thieves called to the guards as they left, but no one ever has. In the world of art crime, the Gardner paintings are the holy grail.

*

Thieves are opportunists, always on the lookout for goods lying around unprotected. Museums, churches, art galleries, and isolated country houses make tempting targets, and not only because art connoisseurs respond to art crime with the fluttery dismay of a Victorian hostess whose guests have unaccountably spoken of sex.

The point of museums, the reason they exist, is to display their treasures to as many people as possible. Banks, which safeguard literal treasure, have it far easier. They can hide their money in underground vaults with foot-thick doors and protect it with armed guards and fortress-like security, and no one will complain. In comparison with even middling banks in midsized cities, the world's best museums are as open as street fairs.

Security is neglected, too, because even the greatest museums face chronic money shortages. In the autumn of 2003, at the Tate Modern, the most popular art museum in Britain, restroom cubicles displayed a notice thanking an anonymous benefactor for the funds to buy toilet paper. Britain's National Gallery is scarcely better off. "We do not get from government even the basic operating costs of this place, what it costs to open the doors, turn the lights on, and look after the collection," the director laments. Museums can always choose to invest in more guards and better alarms, but money spent on security is money not available for the museum's true mission.

In the United States especially, museum guards are poorly paid and poorly trained. One large security company looks at how much McDonald's pays its employees in a given region and then offers its museum guards fifty cents an hour less than that. "The people protecting our art," says security specialist Steven Keller, "are the ones who couldn't get jobs flipping burgers."

Some museums *have* swallowed hard and installed costly state-of-theart alarm systems and motion detectors and taken on more guards. But as security has grown more robust, thieves have grown more brazen. If museums are locked and monitored by electronic alarms at night, thieves don't give up; they simply walk through the front doors during the day. Or, depending on the setting, they smash their way through ground-floor doors in SUVs. They may well carry guns, and horrified visitors and shocked (and unarmed) guards scarcely slow them down.

From a criminal's point of view, a world-renowned painting is a multimilliondollar bill framed and mounted on a poorly guarded wall. On a blustery spring day in May 1998, at about lunchtime, a visitor to the Louvre entered room 67 and approached a small oil painting by Corot, a landscape called *Le Chemin de Sèvres* that depicts a quiet country road. Working quickly but calmly in the seldom-visited room, the thief removed the painting from its frame, left the frame and its glass intact on the wall, and hurried off. (For a thief, the size of a painting is crucial. The great majority of stolen paintings are small, because they are easy to hide and to carry.)

About an hour later, a tourist noticed the empty frame and informed a guard. Security ordered all the doors of the sprawling museum shut. Springing that slow-motion trap took ten minutes. Then, with the thief long gone, museum guards searched each of the museum's thousands of visitors. The thief has never been found.

The daylight theft of the \$1.3 million painting spurred an official investigation and the firing of the Louvre's chief of security. (Two years later, as the bureaucratic battle dragged on, he was still living rent-free in an apartment in the Louvre.)

The investigators' findings would have made Pollyanna despair. The Louvre had only an approximate idea of how many artworks it owned and how many people it employed. Built 800 years ago as a palace and converted to a museum two centuries ago, the immense complex is an endless and hard-to-patrol maze. Closed-circuit cameras did not cover the entire museum (room 67 was not monitored), and the camera systems in different wings of the museum worked independently and could not be scanned from a central location. Security at the Louvre was so poor, the report noted, that "it would be easier for a thief to steal one of its 32,000 exhibits than it would be to take an item from a department store."

Why bother with banks?

Whodunit?

FEBRUARY 12, 1994

n Norway, it seemed as if every police officer in the nation was searching for the thieves who had taken *The Scream*. Exactly how the crooks planned to cash in on the masterpiece was unclear, but one of their motives was unmistakable: the theft was a jeering insult, a raised middle finger directed at Norway's cultural and political elite. No mere economic crime, this was personal, a what-are-you-going-to-do-about-it taunt from criminals flaunting their cleverness.

That was the point, police assumed, of timing the crime for the Olympics, when 2,000 reporters were jostling for a story. It explained the choice of *The Scream*, one of the modern world's most recognizable images. It accounted for the mocking note and the ladder—a gleaming, twelve-foot-long calling card—left defiantly in place.

For the thieves this was multimillion-dollar fun. Just forty minutes after the break-in, the phone rang at *Dagbladet*, one of Norway's major newspapers. It was 7:10 A.M. The caller asked for the news desk. "You have to get to the National Gallery," she said. "Something amazing has happened somebody stole *The Scream* and they left a postcard that said 'Thanks for the poor security.'"

"Who is this?" No reply. "Who's calling?" The tipster hung up.

At 7:30, the National Gallery's security chief made a melancholy phone call to Knut Berg, the museum's director. "There's been a burglary. They took *The Scream*." Neither man needed to spell out for the other just how bad the news was.

At the same moment, many of Norway's highest government officials were together on a private bus headed to Lillehammer to participate in the opening ceremonies of the Olympic Games. The mood was cheery and, bearing in mind how early it was, almost festive. Then came the crackle of a news bulletin on the radio. When the bus pulled in to Lillehammer, it was besieged by reporters shouting questions about *The Scream*.

Answers were scarce. Back in Oslo, television reporters flocked to the National Gallery to film their stories. "All we know for certain," a stunned Knut Berg admitted, "is that, to our sorrow, what could not happen has happened."

It had happened before, although never to *The Scream*. In 1980, only a few years into Berg's tenure, a drug addict had walked into Norway's National Gallery in the middle of the day and walked out with a Rembrandt. He found a buyer for the drawing, a small study of a man's head, and pocketed about \$10,000, some five percent of the work's true value. French police recovered the drawing in Paris six weeks later.

In 1982 thieves once again entered the National Gallery during the day. This time they hid in a storeroom and emerged in the middle of the night when the guards were in another part of the museum. They grabbed a Gauguin, a Rembrandt (not the one stolen in 1980), a Goya, and five other works, passed them out a window to colleagues, and escaped. The theft led National Gallery officials to install additional alarms and outside cameras and to build the basement alarm station where the guard would later sit, unmindful of the television monitors, as *The Scream* was passed out the window.

In 1988, thieves broke into the Munch Museum in Oslo, only a mile or two from the National Gallery. There they stole *The Vampire*, perhaps Munch's second best-known painting. Women in Munch's work are sometimes desirable, often dangerous, and usually both at once. *The Vampire* depicts a red-haired woman biting, or perhaps kissing, the neck of a darkhaired man sprawled face-down before her.

The thief had none of the artist's subtlety. He simply broke a window, grabbed the painting, and ran. The alarm sounded, but by the time the guard had hurried from the far side of the building, he found only broken glass and a blank spot on the wall.

In 1993, the National Gallery was hit again. With the Olympics less than a year off and plans for the blockbuster exhibition already underway, this was a hard-to-miss warning. The thieves struck on August 23, in daylight. While one shift of guards replaced another, and while a television crew filmed in another room, someone walked off with Munch's *Study for a Portrait*, which depicts a sad-eyed young woman looking abstractedly into the middle distance.

The work, valued at \$300,000, was not protected by an alarm, nor was it in a room watched by security cameras. In response, the National Gallery beefed up its security yet again. This time the museum was safe, Knut Berg declared. During the day, the guards would spot any thief trying to make off with a painting, and at night the museum was as secure as a fortress.

Ж

With *The Scream* gone and the world watching, the Norwegian police faced enormous pressure. They searched for fingerprints but came up empty: the thieves had worn gloves. There were no footprints inside the museum and no identifiable prints or other marks near the ladder. For a brief moment, it seemed that a tiny, dark stain on a piece of broken glass might be blood. Nope.

Police technicians scanned the museum's surveillance tapes over and over again, frame by frame. The quality was frustratingly poor. The thieves did not seem to be wearing masks, but even blown-up pictures of their faces were too fuzzy to be of any use. A security camera trained on the front of the museum had filmed the thieves' car, but the vague shape could not even be identified as a particular make.

The police did crack the tiny mystery of where the ladder had come from, but no one at the building site had seen anything. The postcard was scarcely more help. The scribbled message on the back was in colloquial Norwegian, so the police guessed that the thieves were from Norway, but that was hardly conclusive. Maybe some overseas Mr. Big had planned the job and hired local talent for the actual break-in.

Police appeals for help did not yield a single eyewitness. No one had seen two men carrying a twelve-foot ladder down the street or driving a car with a ladder lashed to the roof. Hope surged momentarily when police found a taxi driver who had been parked near the museum while the thieves came and went, but he insisted that he had been busy counting his take for the night. If anyone had come running from the museum carrying a painting, he had missed it.

He had looked up long enough to notice and describe in considerable detail a fair-haired woman, about 25, who had been walking down the street in front of the museum. Was this the mystery woman who had phoned *Dagbladet*? The police issued an urgent plea for help. Would the young woman in the red coat and red slacks, with a long braid, please come forward?

Silence.

While the police raced in frantic circles and National Gallery officials wrung their hands, the Norwegian public looked on with glee. A nation that placed a higher value on dignity and propriety might have reacted with outrage, but Norwegians treated the episode as slapstick. Even the figure skating farce at the Olympics—this was the year of Tonya and Nancy and the Great Kneecapping—was less entertaining.

Video footage of the thieves and their pratfalls on the ladder played endlessly on the news, like a scene from a silent comedy. The film looked all the sillier because the security cameras somehow made moving figures look as if they were racing at double speed and in herky-jerky lurches.

In living rooms and pubs across the nation, Norwegians stared delightedly at the tiny, black-and-white figures propping their ladder up against the wall. They watched the blurry figures slip and slide with their newly acquired treasure, and they guffawed with delight.

Score Round One for the bad guys.

The Priests

FEBRUARY 1994

A police headquarters, at the National Gallery, at Oslo's newspapers and television and radio stations, phones rang day and night. Someone waiting for a bus had seen a man carrying a large plastic bag with a heavy wooden frame peeking out of the top. A man in a bar had overheard a suspicious conversation between two men sitting nearby. An ex-con had crucial information that he would happily share with the police in return for a small consideration.

Norway's tabloids bayed for blood. What had the National Gallery been thinking? What were the police doing? Who was to blame for this fiasco? Journalists from around the world posed similar questions in a dozen languages.

The minister of culture and the leaders of the National Gallery disappeared to plot strategy, only to reemerge desperate and forlorn. What were their options? The state could not pay to get the painting back, even if someone knew whom to deal with, because Parliament would never agree to pay millions of dollars of taxpayers' money to thieves. And if somehow such a deal *could* be justified politically, it would set a terrible precedent that would mean open season on every art treasure in a national collection.

With public money ruled off-limits, the chance of a big money reward

seemed lost. Reasoning that even a small reward might be more enticing than none at all, the National Gallery decided to reach into its own threadbare pocket. For information leading to *The Scream*'s recovery, the museum announced, it would offer a reward of KR 200,000, about \$25,000. The painting, the newspapers repeated incessantly, was valued at over \$70 million.

Nobody bit.

The Norwegian police, in the meantime, had tapped their network of informants but had come up with nothing but false leads. If someone in Oslo's underworld had stashed *The Scream* away, no one seemed to know it. This was bad news, and even worse than it appeared at first. The police desperately wanted a breakthrough, to silence their critics and show up the smirking thieves. But it was not simply a matter of self-respect. *The Scream* was delicate—the blue of the water in the middle distance, for instance, is chalk that could vanish with the touch of a careless sleeve and every day of exposure was a risk. Thieves who would happily slide a masterpiece down a ladder might well cut it from its frame, for easier transport, or hide it in a moldy basement or an attic with a leaky roof.

Then, after five days of rumor and confusion but nary a lead, came the first possibility of a break. Two of Norway's most controversial figures, priests who had been booted out of the state church for organizing anti-abortion protests, thrust their way into the middle of *The Scream* free-for-all.

Before the Olympics began, Ludvig Nessa and Børre Knudsen had promised to pull off a "spectacular" protest to publicize their cause. The police knew the ex-priests well, from run-ins over the course of a decade. Typically Nessa and Knudsen would show up at a hospital and demand that the doctors stop performing abortions. If all went well, the hospital would call the police, and the priests in their black robes and white-ruffed collars would have a chance to make their case in front of the television cameras.

Arrests were all to the good, and so was anything else that drew the public eye to Action New Life. Protests and demonstrations drew the most attention, but mass mailings were useful, too. Nessa and Knudsen favored one drawing in particular. A crude cartoon, it showed a woman's hand crushing a tiny, helpless figure. Even a glance revealed that the central figure, howling in anguish, was lifted straight from *The Scream*.

Within a day or two of the theft, a journalist phoned Ludvig Nessa with a "crazy idea." Were the two blurry figures on the National Gallery tape in fact Ludvig Nessa and Børre Knudsen? Nessa gulped and stammered. The reporter explained his reasoning and asked his question again. "No comment," said Nessa.

On the morning of February 17, fax machines in every international media outlet in Norway and at every radio and television station in Oslo began spitting out the priests' drawing. This time it carried a new message, in large black letters. "Which is worth more," the headline shouted, "a painting or a child?"

Thrilled that the stalled hunt was on again, the media descended on Nessa and Knudsen. CNN carried the story, and so did the BBC and the *New York Times.* Neither priest answered direct questions about the theft. "We cannot be too open about this," Knudsen told reporters. "We have sent a signal, and we want this signal to be understood, but we have to be a bit cryptic."

Knudsen hinted at a deal. If Norway's national television station agreed to show an anti-abortion film called *The Silent Scream*, then perhaps the National Gallery might find itself back in possession of its missing masterpiece.

The reporters pleaded for solid information. Did Knudsen know the whereabouts of *The Scream*?

"No comment."

Would he have been willing to steal the painting to promote his views? "Yes, absolutely."

The media loved the story, but the police scoffed at it. The priests were publicity hounds, said Leif Lier, the Norwegian detective in charge of the investigation, but they weren't thieves. "We knew them very well, from protests over the years. It was a good newspaper story, but it was no story for the police at all."

*

Far from Norway, a small group of men followed the case intently. They were Scotland Yard detectives, members of an elite group called the Art and Antiques Unit, better known simply as the Art Squad. The story broke over the weekend. Monday morning, February 14, 1994, first thing, the head of the Art Squad phoned his best undercover man.

"Charley, did you hear about The Scream?"

"I watched it on the news last night."

"Do you think we can help?"

Officially, another country's stolen painting had nothing to do with Scotland Yard. The hunt for *The Scream* was certain to be tricky and expensive and likely to be dangerous. "Tell me again," the police higher-ups were sure to demand, "why is this *our* problem?"

It wasn't a bad question. The honest answer, in Detective Charley Hill's words, was that the case had "sweet fuck-all to do with policing London. But it's too good to miss." 5

The Art Squad

n the world of art crime, London is one of the great crossroads. (The United States, with the single colossal exception of the Gardner theft, is a backwater in comparison.) Every criminal knows that police in pursuit of thieves tend to lose interest (or authority) when the crooks leave their jurisdiction. Art, on the other hand, knows no borders; a van Gogh stolen from a gallery in Geneva and smuggled into Rome retains every dollar of its value.

The law varies from country to country, too, in ways that keep art on the move. In Italy, for example, if a person buys a painting in good faith from a legitimate dealer, the new owner immediately becomes the rightful owner whether or not the painting was stolen. Japan is nearly as permissive: after two years, all sales are final. Steal a painting, hide it for two years, sell it in Japan, and the buyer can freely hang it for the world to see. In the United States, in contrast, the rule is that "no one can sell what he does not own," and the corollary is "buyer beware." If an American buys stolen art, even unknowingly, the original owner is entitled to reclaim it.

The result is that stolen paintings and sculptures travel a long and circuitous route through the underworld. The transactions all take place out of sight because no reputable dealer would sell a stolen work. Years ago, even well-intentioned dealers might have done so unknowingly. Today, the advent of computerized databases of stolen art has made it nearly impossible, at least in the case of masterpieces, for dealers to plead ignorance. So purloined objects pass from hand to hand and eventually link a cast of characters who, in ordinary circumstances, would barely recognize one another's existence. Museum directors perched on the loftiest branches of the art world find themselves fielding phone calls demanding ransoms from thugs who have never ventured into a museum except to rob one. Paintings swiped from titled aristocrats who preside over centuries-old country houses end up in the hands of down-market drug dealers who hide them in plastic supermarket bags and cram them inside train station lockers.

It was the job of the Art Squad to know that dubious traffic in all its twists and convolutions.

The squad was tiny, and honored more in speeches than in practice. A small group within the much larger Serious and Organised Crime Unit, the Art Squad never numbered more than half a dozen, often fell as low as two or three, and occasionally was disbanded altogether. Within Scotland Yard, politics was a rough and complicated game. For a group whose toehold on power was as precarious as the Art Squad, the risk of being defined out of existence as part of an "internal reorganization" always loomed large.

Part of the problem was simply that "art" had to do with "culture," and in the macho world of policing, anything so effete was suspect. The art detectives themselves hurried to deny any hoity-toity ways. "People often say to me, 'You must know so much about art,' " says Dick Ellis, one of the top men at the Art Squad for ten years. "The truth is, I know buggerall about art."

"The police won't say so," remarks Charley Hill, "but what they think is, 'What's so important about pictures, anyway?' The attitude is, 'You've seen one, you've seen 'em all.'

"Which is a difficult argument to counter," Hill continues, "when you're dealing with complete ignoramuses. You can take the high road all you want, and all they'll do is write you off as some sort of aesthete who thinks that pictures are what it's all about."

Ordinarily, the police are quick to sympathize with crime victims. But a little old lady who has been knocked on the head is an entirely different creature from Lord Pifflepuffle, whose estate has a hundred rooms and whose grounds stretch a thousand acres, and who has lost a painting purchased by his great-grandfather a century ago. When the loss is a painting and there are dozens more still on the walls, the well of sympathy can run pretty dry.

In so grand a setting, the police are often ill at ease and primed to take offense. Lord P.'s posh accent may be enough to trigger their resentment, or perhaps his aides will make the fatal mistake of treating the police like servants. It doesn't take much.

In rare circumstances—if the stolen painting was a national treasure, say, or if the thieves shot someone—the hunt for the missing artwork may become a priority. More likely, the police will reason (silently) that Lord P. was a toff who should be glad he got off so lightly. He was rich, the painting was probably insured, and, in any event, there are bigger fish to fry.

On the question of insurance, the commonsense assumption of the police and of the thieves, too—is quite likely wrong. Hard as it is to believe, a great many paintings worth millions of dollars are not insured. In Britain, for example, the works of art in the permanent collections of the great public museums, including, notably, the National Gallery and the Tate, are not insured against theft. The rationale is that "You do not spend Treasury money twice." In other words, the public, having provided the funds for the purchase itself, should not be further burdened with buying insurance.

When great paintings travel from one museum to another for an exhibit, they *are* insured, but the insurance is "nail to nail." It applies only from the moment the works are taken off the wall of their home institution to the moment they are set back in place. At home the paintings are insured against damage but not theft. Fire, because it could destroy paintings wholesale, is the nightmare fear for museums. Theft, which rarely involves more than a painting or two at a time, is seen as a matter for guards and cameras rather than insurers. *The Scream* was not insured.

American policy is different from European, and American museums do buy insurance against theft. A small museum might have a policy that covers \$5 million or \$10 million worth of art; a world-renowned museum might have \$500 million worth of coverage. Here, too, there are exceptions, and the Gardner was the exception of exceptions. The museum and the mock-Italian palace that houses it were the legacy of Isabella Stewart Gardner, the eccentric Boston socialite and patron of the arts. "Mrs. Jack" died in 1924, but she lives on in the famous portrait by her friend John Singer Sargent, in countless appealing but dubious anecdotes—she supposedly took a lion cub on a leash for a walk down Tremont Street—and, above all, in her museum. For years the museum also served as Mrs. Jack's home; she lived on the fourth floor, above three floors of carefully gathered treasures. Gardner's will stipulated that her paintings be displayed just as she had arranged them. None was to be sold or even moved. No new works were to elbow their way into the collection.

One consequence was that, though Boston grew ever more bustling as the decades passed, 2 Palace Road remained an oasis of tranquility. Another was that the museum trustees decided to forego theft insurance. The customary rationale for insuring art, after all, is to make it possible to replace objects that have been stolen or damaged. But if any such replacement is forbidden, why pay insurance year after year? Insuring the collection might even *draw* thieves who believed they could steal paintings and hold them for ransom. (So the trustees reasoned. A contrary view—that, in the event of a theft, the museum would be better off with a check from an insurance company than with a dead loss—lost out.)

So when thieves broke into the Gardner in the winter of 1990 and walked away with \$300 million worth of art, not a single penny of the loss was covered by insurance.

Private owners are often just as reckless. Some are shortsighted. Others, especially those who have inherited paintings worth a fortune, may lie low in fear they will draw the notice of the taxman. Still others are oncegrand aristocrats, nowadays rich in land and property but poor in cash, who choose to put their money into replacing a two-acre slate roof or modernizing centuries-old plumbing rather than into insuring dozens of dusty canvases passed down through the generations.

Surprisingly, in light of how many people choose to do without it, insurance for art is a bargain. The going rate is a few tenths of a percent, roughly on a par with homeowner's insurance; the premium on a million-dollar painting is a few thousand dollars a year. But the rates are low because the risk of theft is low, and many owners take a chance. The Duke of Buccleuch, for example, owns an art collection worth some £400 million. One painting alone, Leonardo da Vinci's *Madonna of the Yarnwinder*, stolen in the summer of 2003, was worth perhaps £50 million. The duke had insured his entire collection for £3.2 million.

Ж

The disdain for art crime on the part of the police is not simply philistinism. The police, always strapped for money and facing crises on every front, have to choose which crimes to pursue. They confront a real-life counterpart of the dilemma from freshman philosophy class: Do you rescue the man crying for help in the window of the burning house, or do you save the Rembrandt hanging above the mantel?

The public, too, prefers that the police focus on "real" crime rather than on stolen art. Unsolved assaults are scandals; missing paintings are mysteries. The police have little choice but to show they are fighting allout to control the crimes that dominate the television news and the tabloid headlines. "If we should find a drug dealer who's also a pedophile and who's involved in arts and antiques, maybe we'd get something done," complains one detective who has been chasing art crooks for thirty years. "But if a villain is involved in arts and antiques on their own, the police don't care."

Ж

On the same morning that John Butler, the head of the Art Squad, phoned Charley Hill to talk about *The Scream*, the *Times* of London ran an editorial on the theft. "Who could sell such a painting?" the newspaper asked, bewildered. "Where could it be hidden? Who would dare receive such stolen property, unless it was an obsessive millionaire admirer of Munch, ready to risk all for a furtive midnight peep into his darkened cellar where the icon might be hidden?"

Legitimate questions all, but art detectives snarl at anyone who dares ask them. One reason is impatience; they have work to do, and outsiders posing questions are a nuisance, like toddlers endlessly demanding, "Why, Daddy? Tell me why." An honest answer, moreover, would necessarily be long and involved. An art thief's motives are a toxic brew, and psychology is as important as economics. To reduce a thief's motives to money is as mistaken as to say that a connoisseur's sole reason for spending a million dollars on a painting is beauty.

Yes, for a start, thieves steal because they believe the risks are so low and the potential rewards so high. Just where they will find a buyer, they leave as a problem for another day. Perhaps a dishonest collector, or the distraught owner, or the owner's insurance company. (Often, when a masterpiece is stolen, notices appear promising a reward for information leading to its return. The iron belief in the underworld, based on the size of those rewards, is that the black-market value of a painting is ten percent of its legitimate value.)

Judged purely on its business merits, stealing top-flight paintings is a game for suckers only. The temptation is plain: like heroin and cocaine, masterpieces represent millions of dollars of value squeezed into a tiny volume. And though smuggling drugs is dangerous, transporting art is easy. Any shipper would happily carry a painting halfway around the world. If a crook wanted to bypass UPS or Federal Express, that would be easy, too. He could quite likely saunter through customs with a Rembrandt in his luggage. On the off chance that an inspector betrayed the slightest interest, the thief could pass it off as a copy he'd bought for his living room from a struggling student.

But the seeming advantages dissolve like mirages. Other items that combine colossal value and small size—such as drugs, diamonds, jewelry, and gold and silver artifacts—are either "faceless" or readily disguised. Rubies and pearls can be plucked from a stolen necklace and thereby rendered unidentifiable. Diamonds can be recut. Antiquities looted from archeological digs—and therefore not yet known to scholars or the police can be sold without fear that an aggrieved owner will demand the return of his property.

Not so for art. A great painting shouts out its identity (not to sleepy customs agents, perhaps, but certainly to would-be buyers), and to disguise a masterpiece would quite likely be to destroy it. A painting's identity, moreover, extends beyond the canvas. Every important painting trails behind it a written record, in effect a pedigree, that traces the history of its passage from one owner to the next. No legitimate buyer would believe for a moment that an undocumented work could be the real thing, any more than he would believe the tale of a fast-talking stranger who claimed to be the rightful king of France.

If thieves reasoned like ordinary people, these drawbacks would push them away from art. As the theft of *The Scream* and countless other paintings demonstrates, though, thieves carry on undaunted. Beyond the financial motive, the Art Squad has learned over the years, thieves steal art to show their peers how nervy they are, and to gain trophies they can flaunt, and to see their crimes splashed across the headlines, and to stick it to those in power. Thieves steal, too, because they use paintings as black-market currency for deals with their fellow crooks. For the police, it becomes a game of Follow the Bouncing Ball: a Picasso stolen from a weekend house in the Dordogne passes through the hands of a French gang, which sells it to one based in Amsterdam, which in turn sells it to drug dealers in Turkey, where it serves as a down payment for a shipment of heroin that ends up on the streets of London.

Especially when it comes to the most famous paintings, thieves' motives often have as much to do with bragging rights as with anything tangible. Stealing an old master wins the thief kudos: he gains the envy and admiration of his set. The painting as a work of art is beside the point; crooks are seldom, if ever, art connoisseurs. A Rembrandt with a £5 million price tag is desirable because it is the ultimate trophy. In other circles, a man might achieve the same goal by buying a Rolls Royce or climbing Everest or shooting a lion and mounting its head on the wall.

The longer the odds, the greater the coup. In 1997, for instance, a thief in London strode into the posh Lefevre Gallery and asked if a particular portrait was by Picasso. Told that it was, he took out a shotgun, grabbed the painting, and hurried into a waiting taxi. The risk and the pizzazz were the point—an armed robbery, in midday, in midtown, with the ultimate brand-name as the prize. What ambitious young thief could resist the challenge?

Questions about why thieves do what they do grate on detectives' nerves because they imply, as the detectives see it, that criminals are complex, misunderstood, intriguing figures. Why do thieves steal art? Detectives bark out a short answer, which is more a warning to back off than an explanation: "Because they do." Why do bullies beat up weaklings? Why do gangsters shoot their rivals?

Come back to it again. Why do thieves steal masterpieces?

"Because they want to and they can."

Ж

When *The Scream* disappeared, the Norwegian police asked themselves the usual questions about who might have done it. As the days went by, they added one more: Why haven't we heard from the thieves?

From the start, the Norwegians had assumed that the thieves who had taken *The Scream* intended to hold it for ransom. "Artnapping," after all, offers the advantages of kidnapping without all the fuss. No one needs to feed a stolen painting or keep it quiet or watch over it day and night; a painting cannot put up a fight or scream for help or testify in court. And if everything goes wrong and the police begin closing in, a painting can always be flung into a trashcan or tossed onto a bonfire.

But first days passed, and then weeks, and still the thieves kept silent.

*

Scotland Yard had begun mulling over the case as soon as the story broke, before it had any official role to play. The first challenge, the detectives on the Art Squad reckoned, would be to devise a way to lure the thieves out from hiding.

"What can we use as a plan?" John Butler asked Charley Hill.

"Give me a quarter of an hour, and I'll think of something."

It was a Monday morning in February 1994, a cold, bleak day. Butler was in London. Hill happened to be on assignment to Europol, the European counterpart of the international police organization Interpol. He was based in The Hague, Holland, in a dank slab of a building by a busy road and a frozen canal. In World War II, it had served as a regional Gestapo headquarters.

For a restless, moody man like Hill, life tethered to a desk was purgatory. On the other hand, few pleasures matched the thrill of dueling with a crew of cunning, malevolent thieves. Hill put down the phone and leaned back contentedly in his chair. He stretched his long legs, closed his eyes, and tried to put himself inside the mind of a crook who had snatched one of the most famous works of the twentieth century.

How to coax a thief like that into the open? Hill reviewed some of his undercover roles. Typically he played a shady American or Canadian businessman, a wheeler-dealer who traveled in expensive but flashy circles, an outgoing man who liked to talk and drink late into the night and who might reveal, as the hours slipped by, that he could snarl as well as smile.

The tone of these intimate performances—and the audience—varied from job to job. One week, Hill might find himself playing a swindler looking to buy counterfeit bills, and the next, he might be passing himself off as a crooked collector in the market for a stolen painting. As a swindler, Hill would likely curse and carry on. Playing a connoisseur, he would turn down the bluster and threats and instead conjure up a bit of what he calls "art chat." A soliloquy on Turner's use of light and shade might do nicely.

Perhaps Hill's allotted quarter-hour had gone by, but not by much. He smiled to himself and picked up the phone to tell Butler his plan. The Rescue Artist

harley Hill is a tall, round-faced man with curly brown hair and thick glasses. He is half-English and half-American, and his biography sounds as if a careless clerk had stapled together pages from several different résumés. Born in England but raised mostly in the United States (with a couple of stints in Germany thrown in), Hill is an ex-soldier and ex-Fulbright scholar who flirted with academia, and then the church, and eventually landed a job as a cop walking a beat in some of London's diciest neighborhoods.

A stranger seeing Hill on the street might take him for an academic (though one less rumpled than most) or a businessman whose daydreams turned on balance sheets and bottom lines. A closer look would spur second thoughts. Hill swaggers when he walks, as if the sidewalk were his private property. He can be charming and engaging—especially if the conversation has turned to one of his pet topics, like naval history—but he is restless and impatient, with a bad temper that flashes unpredictably. A sudden glare or a slammed telephone serve as hints that perhaps this would not be a good man to cross.

His speech tends toward the formal, but the scholar and the cop often collide head-on in his conversation. A sentence that begins with Charley quoting Edmund Burke on liberty may well end up with a reference to some "lying sack of shit."

Hill's accent, too, is an odd mix. To Americans, he sounds almost, but

not quite, familiar—Canadian, perhaps, or Australian? The English find him similarly hard to place. *Is* he English? Perhaps there's a bit of Ireland in his speech?

In time, Hill came to specialize in undercover work. At home in all the worlds he had passed through in his zigzag life—or in none of them—he found he could effortlessly win the confidence of a gang of thugs drinking in a dive or a party of art lovers strolling through a gallery. Unlike a character actor, who fits in so well with his surroundings that he can scarcely be recalled later, Hill does not disappear into his roles. He prefers, instead, to pose as an exotic stranger, an outsider but one worth doing business with.

In the small world of art crooks and art cops, Hill stands nearly alone. On both sides of the law, the prudent strategy is to focus on art below the highest rank. From a thief's point of view, the best paintings to steal are ones good enough to command high prices but not so stellar that they shout trouble; from an investigator's vantage point, where the focus is on closing cases, stolen paintings are worth chasing only if the odds of success are high. A long shot, even if it might yield the painting of a lifetime, is too risky. Quantity trumps quality. "We fish with nets," explains the head of a private firm in the art recovery business. "For us, it's an industrial process. Charley Hill is like a man fishing with a rod. He's looking for the biggest fish."

More often than anyone else, he's landed them. Vermeer, Goya, and Titian are among the prizes. In twenty years Hill has recovered masterpieces worth well over \$100 million.

Ж

Families have their own cultures, just as countries do. In Charley Hill's family—his father an American soldier, his mother an embodiment of glamour and English elegance—the favorite stories all sounded the same notes: war, heroes, romance, tragedy. Charley Hill drank deep from those heady waters. The catch is that he came to believe fervently in two utterly opposed ideas. On the one hand, Hill is a true-blue believer in heroes and villains and fighting for the good cause, no matter how hopeless the odds. He is, simultaneously, a deep-dyed cynic and skeptic who believes in his bones that the race is not to the swift but to the con man who paid off the official timer.

In many ways, Hill is the world's oldest Boy Scout. He would be *thrilled* to find a little old lady who needed help crossing the street. If he is walking in a park, he picks up discarded bags of potato chips and chuckedout beer cans, to throw away later. When any of his friends flies in to Heathrow, Hill will be waiting eagerly to greet them, no matter how ghastly the hour and how miserable the traffic he has fought through. He will be near the front of the crowd with a big grin plastered on his face and a bottle of water in his hands, in case the flight has left the new arrival a bit dry.

It is perfectly possible, though, that come two o'clock the next morning, the same pampered friends will find themselves careening down the highway in Hill's car at 100 miles an hour. Hill will be at the wheel, ignoring his friends' pleas to slow down. If they grow truly frightened, so much the better.

Such abrupt shifts are all the more striking because no one places a higher value on friendship than Hill. Photos of old pals hold places of honor on his refrigerator at home; he phones and visits and frets about chums from as far back as grade school. On the not-so-rare occasions when a college-age child of American friends washes up forlorn and homesick in London, Hill drops everything to swoop to the rescue. He doesn't go in for long, soulful conversations—it is impossible to picture the words "Tell me all about it" passing his lips—but he has a knack for cobbling together outings and adventures that vaporize gloom and melancholy by their sheer intensity.

A drawing that depicted Hill's talents would reveal a strange and uneven landscape, with silvery skyscrapers next to vacant lots and abandoned warehouses. Though he is a gifted mimic, for example, he is hopeless at languages. His greatest asset is a daunting, and dauntingly haphazard, memory. Nearly anything can trigger a cascade of recollections, most likely with names and dates and a word-for-word quotation or two.

Hill does not drone on, like some cocktail party bore. On the contrary, the mark of his conversation is that he dips in and out as the mood strikes him. Few others see the connections he does. Someone's remark about present-day politics might move Hill to comment on George Washington's record in the French and Indian Wars. An allusion to the latest celebrity trial might spur a recitation of a bit of doggerel on Oscar Wilde's arrest ("Mr. Woilde, we've come for tew take yew / Where felons and criminals dwell / We must ask yew tew leave with us quietly / For this is the Cadogan Hotel").

Hill's aversions are as fervent as his obsessions. Order and precision are off-putting, history and art and geography enticing. Logic is a straitjacket, and numbers are the friends of his sworn enemies, the bureaucrats. Hill is as unlikely to use a word like "percentage" or "average" as a minister would be to curse at the dinner table.

Even the numbers that his fellow detectives use to gauge the scale of art crime rouse his wrath. "It's all bullshit," he complains. "People talk about these incredible figures, but all the figures you see are completely made up. Police statistics do not distinguish between something of artistic quality and a sodding ornament somebody won shooting in a fairground."

Hill can shut down without warning. One moment he might be happily rattling on about his hero Sir John Hawkwood, the English mercenary who fought in Italy in the 1300s and managed to get his portrait painted (posthumously) by Uccello. Then, suddenly, he will switch off. If he is driving, he will interrupt himself in midstream, grab the wheel in a stranglehold, and carry on in a silence broken only by the whine of the engine and a few snarled remarks about the prats who are blocking his way. If he is with friends at dinner, he will withdraw from the conversation, yawn mightily—it might be only nine o'clock at night—announce that he is knackered, and head home to bed.

When he is in a good mood, Hill's natural bent is exuberantly over the top. Not content with remarking that one of his acquaintances has more admirers than another, for example, he delights in fashioning an elaborate comparison: "When Frank dies he'll have a burning longboat pushed out to sea with his body on it and salutes from the warriors standing along the headland, with weeping women and children alongside them. But poor George will be interred and his body will eventually yield one loud fart in his cold coffin that no one will hear."

In less boisterous moods, he favors a kind of wry understatement. Many of his fellow soldiers, Hill recalls, had taken "a career opportunity offered by the judiciary," by which he means that a judge had given them a choice of the army or prison. His boyishness is unmistakable. Thunder is good, lightning is better, a jaunt to town is much improved if some reason can be found to run after a moving bus and jump aboard the platform. A dusting of an inch of snow is more than enough excuse to bundle up in coat and scarf and gloves and boots, as if for an assault on Antarctica, and then to set out across the wilds of Kew Gardens.

Even a make-believe adventure like a dash into the snow is better than no adventure at all, but Hill is no Walter Mitty. His work routinely involves dealing with "vindictive, cunning, violent thieves," and the danger is not a cost but a bonus. "I think the real reason Charley volunteered for Vietnam," remarks one friend who has known him since they were both teenagers, "is that he finally figured out that nobody gets killed playing football."

If Prince Valiant and Raymond Chandler's Philip Marlowe shared custody of a single body, the amalgam might resemble Charley Hill.

Hill's father was a farmboy from the American Southwest, his mother a high-spirited Englishwoman who trained as a ballerina but then joined Bluebell Kelly's troupe of high-kicking dancers. (In an old Gene Kelly movie called *Les Girls*, the Kay Kendall character was based on Hill's mother.) Hill's parents met during World War II, and few couples could have had less in common. Landon Hill grew up in hardscrabble Oklahoma and made it out to the wider world by way of Oklahoma A&M and the military; Zita Widdrington, daughter of the Reverend Canon Percy Elborough Tinling Widdrington, was raised near Cambridge, in the kind of setting that Americans picture when they dream of England. This part of East Anglia is thatched roofs and timber-framed houses and cheery pubs and a medieval church with a spire that soars 180 feet into the sky. The village names are out of *Harry Potter:* Little Dunmow, Great Dunmow, Thaxted, Tilty.

Zita grew up in a great, sprawling house that overflowed with visitors. (Her husband-to-be was one of them, a young Army Air Force officer whom she first saw playing chess with her father.) P. E. T. Widdrington was a rector in the Church of England and a Fabian socialist, "a showman and a show-off," in his daughter's words. G. K. Chesterton was a frequent visitor, George Bernard Shaw an occasional houseguest and the cause of much giggling among the children because of his scraggly beard and his preference for sleeping on the floor rather than in a bed.

It was a charmed and glittery life. One day at H. G. Wells's house, when she was six, Zita was told to prepare for a special treat.

"Zita, I'd like you to meet Charlie Chaplin."

A small, nondescript man drew near. Zita burst into fits of weeping. "He's *not* Charlie Chaplin." The stranger retreated. And then, a few minutes later, this time wearing a bowler hat and twirling a cane, around the corner came the great man himself.

Even today, at eighty-seven, Zita retains the manner of a precocious child blurting out naughty and "forbidden" remarks, secure in the knowledge that she is too adorable to be rebuked. She is a formidable storyteller who basks in the spotlight. She tells of swimming in the Mediterranean sixty years ago with Didi Dumas, a handsome young Frenchman who was testing an underwater breathing device that he was working on with another young man, named Cousteau. She tells war stories—about her arrest (on trumped-up charges) for running guns to Greece, the jail cell she was thrown in, her escape on foot across France. She tells of a beau's death in the war in a plane crash (this was before Charley's father), "the great tragedy of my life."

Charley Hill was raised on such gripping and harrowing tales, though his own childhood was more prosaic. His father, Landon Hill, was an Air Force officer who later switched over to the National Security Agency. Zita spent her married life dragging her family from one dreary assignment to another. "Dayton, Ohio," she sighs theatrically. "Oh, it was absolutely dreadful."

Charley, perpetually the new kid in town, attended perhaps a dozen schools in all, in Texas and London and Colorado and Frankfurt, Germany, and Washington, D.C. (Decades later, he still recalls the name of the bully who beat him up when he showed up in San Antonio, age seven, fresh from England, chirping away in a funny accent and decked out in wool hat, long socks, and short pants.) Growing up became one long exercise in sizing up new acquaintances and learning how to fit in with the locals. Charley is proud of his mismatched ancestry, "log cabin on one side and knight of the realm on the other." He prizes a collection of ancient family photos that show his American forebears standing proudly in front of a rude cabin in Oklahoma's Indian Territory. Better yet, in Hill's eyes, a great-great-grandmother on his father's side was a full-blooded Cherokee, so he can claim *both* cowboy and Indian ancestors. The connection always sets Hill to computing just what fraction Indian he is himself, but he is deeply non-numeric and the answer never comes out the same way twice in a row.

Landon Hill's story was markedly less cheery. He emerged from World War II physically unharmed but psychically scarred. He had been one of the first American soldiers at Dachau, for instance, and the scenes he witnessed there—Landon supervised the unloading of railroad cars crammed with dead bodies—haunted him for the rest of his life. "One of those really bright people who couldn't cope with life," in Charley's view, the war hero became an alcoholic. On a December day in 1966, drunk, he stepped out of a taxicab in Washington's Dupont Circle and slammed the door on his coat. The taxi sped off and dragged him to his death.

Half a year later, Charley Hill volunteered to fight in Vietnam. He likes to boast that he comes from a long line of soldiers, and it doesn't take much coaxing to start him reciting the roll. The list begins with his father, and, if he includes ancestors on both sides of his family, stretches back through the War of 1812 and the French and Indian Wars. Earlier than that, the trail is murky, but the first of Hill's soldier forebears fought in a border skirmish in Scotland around 1400 and even made a cameo in "The Ballad of Chevy Chase." Charley quotes the lines with glee: "and good Squire Widdrington, though in woeful dumps, for when his legs were smitten off, he fought upon his stumps."

Hill is forever screeching his car to a halt to read aloud a plaque to fallen heroes or to enjoy a melancholy stroll through a military cemetery. He opposed the Vietnam War, but he craved the adventure and the danger. And since the fighting was going on in any case, it seemed unfair to leave it all to the poor and the poorly connected. In a burst of "sophomoric idealism," Hill dropped out of college and went off to war. "Anyway, I was a sophomore," he notes happily.

Hill found himself the lone college boy in a platoon of poor blacks and rural whites. Twelve of the fifteen men in his squad were killed or wounded. Hill survived his tour in the jungle unhurt, and he learned what it was like to come under fire and hunt an enemy who melted away into the night.

He learned, as well, something about himself that he very much wanted to know. The journalist Michael Kelly, who was killed while covering the war in Iraq, once remarked that many men "go to great lengths in life to not find out the answer to the question, How brave am I? War presents you with specific opportunities to find out the answer to that question.... The question is asked for you and answered for you, in front of you and in front of other people. It's interesting, because you see it in all the people around you and you see it in yourself. And that's knowledge you have for the rest of your life."

Kelly may have been right that most men do not want to know how brave they are, but Hill craved that knowledge. Curiously, though, he passed his self-imposed test but found he drew little comfort from that success. Physical bravery turned out to be just a fact, like being six feet tall or having brown hair. Moral courage—the strength to obey one's conscience in the face of opposition—was rarer and more admirable. Kelly, it turned out, had asked the wrong question.

Vietnam abounded in moral choices. After one raid on an enemy camp, Hill and two fellow soldiers found the camp abandoned but for a wounded old man, a Montagnard who had presumably led North Vietnamese soldiers through the mountain passes. Hill's two companions wanted to shoot the man, but Hill stepped in, sparing the prisoner's life. Eventually a captain turned up and ordered the wounded man evacuated by helicopter. The next time there was a firefight, one of the thwarted soldiers warned Hill, he'd get even with him.

When his tour of duty ended, Hill left November Platoon and returned home to Washington, D.C. At loose ends, and sobered and dismayed by what he had seen, he was without a plan for what he would do next. It would not be too much to say that art saved him.

"They were showing that wonderful series put together by Kenneth

Clark, *Civilization*, at the National Gallery on Sunday mornings," Hill recalls. "I was working nights as a security guard, but I woke up early, stood in a goddamned line, watched on the big screen, and sat there mesmerized. I loved it. It just opened my eyes. I'd already seen a lot of things—my mother had dragged my sisters and me to Florence and the National Gallery in D.C. and the National Gallery in London, and I'd taken Art 101—but I'd never had a coherent idea about art.

"I'd just come from a year in the jungle and this was my reintroduction to civilized life."

TATA Vermeer and the Irish Gangster

7

Screenwriters

t would be years before Hill thought of somehow turning his love of art into a career. In the meantime, he tried on and quickly rejected an entire wardrobe of possible lives. After Vietnam, he moved on from his security guard job and studied history at George Washington University. Then he won a Fulbright scholarship to Trinity College in Dublin, taught high school in Belfast, studied theology in London, and eventually landed a job on the metropolitan police force in London. The police work led eventually to undercover work in general and to art cases in particular.

Hill made a most unconventional cop. The British bobby in the 1970s still looked like a character out of Gilbert and Sullivan, in his tall helmet and with an inch-long brass whistle clipped to his chest. One grizzled old cop from Norfolk—in gruffness and taciturnity the rough equivalent of a Vermont farmer—never quite got over his first encounters with his new colleague. "Picture a portly fellow with big, tortoise-shell glasses and curly hair patrolling his beat"—here he squared his shoulders, puffed out his chest, and took a few swift strides—"and all the time talking in that American/Canadian/English accent about medieval history and wearing a coal scuttle on his head. That was Charley Hill."

Hill's friends—he has a large and loyal circle, on both sides of the Atlantic—saw the same quirks, but saw them in a far darker light. The question they debated endlessly with one another was whether Charley would ever find a way to turn his contradictions to his advantage, or if the

strain would eventually tear him apart. "We never stopped worrying about if he could hold it together," said a friend who had stayed close to Hill since they were both sixteen. "He wanted to be a priest, and at the same time he was prepared to beat people up and shoot them and kill them. That's not about conflicting goals, that's about the *Three Faces of Eve.*"

Ж

Now it was Hill's job to dream up a way to return *The Scream* to its rightful owners. But before any scheme could be put into play, the Art Squad detectives would have to convince their superiors at Scotland Yard that the case was worth the effort. For Hill that was self-evident, a challenge scarcely worth dignifying with a response. What mission could be cleaner than recovering the loftiest creations of mankind from ignorant, violent louts? The brass were sure to plead poverty, but cost wasn't the issue; the real problem was that the boys at the top pissed away money like water.

That wasn't a view that won Hill many friends in high places, which only served to strengthen his conviction that he was in the right. Hill took a willful, sometimes adolescent, pride in offending anyone in a position to derail his career.

Edgar Allan Poe wrote a short story called "The Imp of the Perverse," about a compulsion that moves us to act precisely against what we recognize to be our own self-interest. We roll our eyes when the boss presents his pet idea; we snicker when we should praise; we blurt out the truth when a white lie would be just as easy and infinitely preferable. "With certain minds, under certain conditions," wrote Poe, "it becomes absolutely irresistible." The imp of the perverse has a permanent perch atop Charley Hill's shoulder.

Bureaucrats, above all others, moved him to indignation. "Whingeing, plodding, paint-by-numbers dullards," their only pleasures were kissing ass and getting in the way. Of course they'd want to leave The Scream to someone else.

It fell to John Butler, head of the Art Squad, to sell the mission to his bosses. He could argue sincerely that art crime was international and therefore called for an international response, but this was a tricky assignment even so. The international argument would have been easier to sell if somewhere along the line one of the nations involved was Britain. "What Butler had to do," says Art Squad detective Dick Ellis, "was convince the hierarchy at the Met[ropolitan Police] to pay for an undercover operation to recover *somebody else's property*"—here Ellis's voice rises in admiration and incredulity, as if he were a sports commentator describing a skater's triple axel—"even though it hadn't come from London, and wasn't in London, and wasn't likely to come to London."

Over the years, the men (and, rarely, women) in charge of the Art Squad had learned not to burden their superiors with too much information. "We liked to give them something of a fait accompli," says Ellis, who ran the squad for most of the decade between 1989 and 1999. "Usually we'd already decided to go ahead and we'd had the first couple of meetings before we told anyone what we were up to. That was by and large how we got things off the ground. Then, once you're flying, their only choice is to force a crash."

Ellis spelled out the sales pitch he favored. The first approach to the higher-ups was easy. "If this works—if we can get *The Scream* back—the Art Squad will look golden, and *you'll* look golden." Smiles all around. Then came the twist. "We've already committed to this. If we pull out now we're going to look bloody ridiculous. Or not *we—you*, in management, are going to look bloody ridiculous." Too late now.

Ж

And then, unexpectedly, an English criminal came along and made everyone's life easier. His name was Billy Harwood, and he had served seven years in prison in Norway for trafficking in heroin. The Norwegians had sent Harwood back to England to serve the remaining five years of his prison term, and the English had released him on parole.

Now Harwood contacted the Norwegian embassy in London with an intriguing story. From contacts he'd made in prison in Norway, Harwood said, he knew who'd taken *The Scream*. He knew the thieves and they trusted him. These were hard and wary men. No outsider could lure them into the open; at the first hint that something was up, they would protect themselves by destroying the painting.

But the crooks *would* deal with their old friend Harwood. He offered to oversee *The Scream*'s return to the National Gallery. In return, he wanted £5 million. The Norwegians quickly contacted Scotland Yard to tell them about Harwood's proposal. The English police didn't put any stock in Harwood's story—they figured him (correctly, it turned out) for an opportunist looking to spin some fast talk and big promises into a bonanza—but this was good news nonetheless. With Harwood inadvertently serving as a bridge between the English police and the Norwegians, Scotland Yard finally had a legitimate entrée into the case.

Ж

For Hill and all the other Art Squad detectives, planning stings was one of the best parts of the job. Recovering stolen art was different in crucial ways from most other police work. Finding a painting and hanging it back on the wall where it belonged was the main goal; throwing a crook in jail was secondary. (By the time the police found the trail, in any case, the original thieves might well be long gone.) The hope was to find a way to tempt a criminal who had stashed a painting in an abandoned warehouse or a locker at a train station to bring it into the open, where the police could grab it. That required, first of all, cultivating informants to pick up news and rumors. Many times a direct approach was futile: Kicking down a door and shouting "Police!" was all very well, but where was the painting?

For the Art Squad, making up stories was as much a part of the job as making arrests. In the 1980s and early 1990s, for example, when mysterious Japanese buyers paid record-setting prices for brand-name artists— \$54 million for van Gogh's *Irises*, \$78 million for Renoir's *Ball at the Moulin de la Galette*, \$82.5 million for van Gogh's *Portrait of Dr. Gachet* the Art Squad kicked around schemes for taking advantage of those headlines. Could they find a Japanese-speaking detective to play a gangster or a tycoon who wanted a masterpiece to hang above his fireplace?

"You're a bit like a scriptwriter," says Dick Ellis. "It's a challenge to come up with something that has a genuine feel to it. You bounce it around and ask, 'Is this actually going to stand up? Are people going to believe this? Is it too outlandish?' "

A good plan for a sting needs to combine several elements that don't fit together easily. The best cover stories are simple because they have to work first time out. There is no dress rehearsal—just opening night. Since things inevitably go wrong, the trick is to find undercover cops who can ad lib. (Compounding all the hazards that come with too little practice time is a difficulty that real scriptwriters never face: the detectives only write the dialogue for half the performers.)

At the same time, the plot line has to be complex enough to be plausible. Crooks are jumpy, always on the watch for set-ups and double-crosses. If a come-on is too blatant, they'll walk away. Game over.

"First of all," says Ellis, "you sit down and look at the theft, and you try to figure the type of criminals you're dealing with. You need to put yourself in their shoes and come up with a scenario that they'll feel comfortable with. That means they have to feel in control of the situation, when in fact what you've done is feed them into a scenario where they've actually *lost* control to the police who are running the operation."

This makes for a high-stakes game of "he thinks that I think that he thinks...." Lose your bearings, and you lose everything.

The Man from the Getty

FEBRUARY 14, 1994

harley Hill's first thought was that the thieves who had *The* Scream knew that it would be impossible to sell it openly. Unless they had stolen the picture in order to destroy it, they had some other purpose in mind. What purpose? Ransom, most likely.

Could the Norwegian government pay for the return of a national treasure? No, that would just encourage the scumbags. What was a variation on that theme? Somebody else could pay on the government's behalf. "Blatant casuistry, of course," Hill thought, "but there you are."

Now, who in the hell would do that?

The way to lure the thieves into the open, Hill figured, was to dangle money. Who could come up with millions to retrieve someone else's painting? In the art world, one name in particular means money. Even crooks know the Getty Museum, the sprawling southern California museum named for its founder, J. Paul Getty, the oil billionaire. Getty, at one time the richest man in the world, had endowed the richest museum in the world.

Getty himself had been a sour, pinched, bad-tempered cuss, a Dickensian villain who looked a bit like Homer Simpson's boss, Mr. Burns. He lived outside London on an estate that was surrounded by barbed wire and guarded by twenty attack dogs. A pathological cheapskate despite his riches, Getty kept a pay phone in his mansion for his guests and squirreled away bits of old string to reuse later. In 1973, Getty made news across the world when he refused to pay ransom to an Italian gang that had kidnapped his grandson and demanded \$17 million for his release. Only after the gang cut off the boy's right ear and mailed it to a newspaper in Rome did Getty relent a bit. He negotiated his grandson's release for \$2.7 million, which was, he said, as much money as he could put his hands on.

The Getty Museum, in contrast, spent money like a lottery winner on a binge. U.S. tax laws require that foundations spend five percent of their endowment each year, and for the Getty that meant a mandatory \$250 million a year. Older, poorer museums cringed with envy as they watched their nouveau riche rival gobble up treasure after treasure. Today the Getty's seeit-and-buy-it frenzy has eased—the museum opened a new, six-building, dollar-devouring "campus" in 1997—but after years of conspicuous consumption, mention of the Getty produces a response that is almost Pavlovian in everyone who hears it.

It was the one institution a villain would know about, Hill figured. No other museum conjured up images of money spilling out of pockets. Beyond that, the Getty could do what it wanted without fretting about the rules and red tape that slowed down tax-supported dinosaurs. Above all else the name had cachet. You couldn't tell the crooks, "Uncle Fred's going to pay your ransom." It wouldn't carry any weight. But a mention of "the Getty" would catch their attention.

The rest of Hill's story almost wrote itself: He would claim to be a representative of the Getty Museum, negotiating sotto voce on behalf of his colleagues at Oslo's National Gallery. The Getty would ransom *The Scream* and in return for their hush-hush rescue work, Norway would loan it the painting.

Hill would play a big, fast-talking American, a wheeler-dealer accustomed to getting what he wanted and not too fussy about how he got it. For an undercover cop with a hammy streak, it was the role of a lifetime. "It's perfect," Hill thought. "I'll be the Man from the Getty."

Hill phoned John Butler, his Art Squad colleague, and spelled out his plan. "Nice idea," said Butler. "Let's try it." Butler phoned back a few minutes later. "I've spoken to the Norwegians. They like it. What do you picture as our next step?"

"First," said Hill, "I guess we'd better talk to the Getty."

This would take some delicacy, since it was a bit late to ask the Getty for permission to invoke its name. And though the Getty wasn't actually putting any money at risk, it was unlikely to welcome even the suggestion that it was a kind of ATM to the art world. Hill insisted that there was no problem. Most people were glad to do Scotland Yard a favor, and everyone in the art world wanted to help the Norwegians out of a jam. The people at the Getty might huff and puff, but they'd get over it.

By good fortune, the Art Squad's Dick Ellis had worked on several cases with the Getty over the previous half-dozen years. By happenstance, too, Hill had visited the Getty on his honeymoon twenty years before. He didn't know any more about the museum than any other tourist might, but he figured he had seen enough to avoid any egregious faux pas. That was astonishingly nervy, or foolish, and completely typical of Hill. Since his long-ago visit to California, the Getty had begun building a lavish new museum that was located a dozen miles from the one Hill had seen and bore no resemblance to it. Hill waved all that aside.

Ellis had a good relationship with the Getty's director and with its head of security. When the time came for the Art Squad to make its pitch, Ellis would be the man to fly to Los Angeles and make nice with the California museum.

Ellis, Charley Hill, and the head of the Art Squad, John Butler, met to fine-tune their strategy. It was early evening; the three men were at Scotland Yard. Butler called Ellis into his office. He had just opened a bottle of Bushmill's Irish whiskey, which happened to be Ellis's favorite. Hill was already there. The three detectives sat down and went over the whole scenario.

All three were large, forceful, outspoken men, with big egos and little inclination to defer to one another. They knew each other well, as friends, colleagues, and occasional rivals. When they told war stories about old cases, the talk tended to veer off-course into long disputes over who had originally thought of what, amid much eye-rolling and muttering and indignant cries of "Bollocks!" On this night, though, the three policemen were in high good humor, delighted with what they were about to put in motion. The Getty! Christ, why hadn't anyone thought of it before? This was going to be good.

Soon after, Ellis flew to California to make his pitch. He is an impressive figure, an inch or two under six feet but as solid and sturdy as a battering ram. Even his fingers are thick and strong; he pounds two-fingered on his laptop keyboard as if he were thrusting his fingers into the chest of an adversary in an angry argument.

In contrast with Hill, who had been odd man out in every group he'd ever joined, Ellis was the very image of a cop. He had joined the police at age nineteen and never risen to great rank, despite considerable talent, in good measure because he preferred a life of action to one behind a desk. His fellow cops, who had the foot soldiers' suspicion of their commanding officers, trusted Ellis as one of their own.

A veteran of countless briefings, Ellis is clear and well-organized. He speaks in numbered points, as if reading from an outline, and he likes to sort out logistical tangles. Ellis explained *The Scream* plan. The Getty gulped hard but heard him out.

In Hill's view, it was all a fine joke. "They were a bit tight-arsed at first," Ellis reported. "They made clear that they wouldn't do this for just anybody. They didn't want the Des Moines, Iowa, sheriff's department ringing them up to say, 'Can you give us a hand here?' But in the end they cooperated brilliantly."

Ellis had brought a photo of Charley Hill to California with him, along with Charley's birth date and other background information. If the Getty was going to lend its cover to this operation, Hill would need a new identity.

In short order, Charley Hill had vanished, and one Christopher Charles Roberts had arisen to take his place.* Most of the trappings were routine. Hill was provided with an American Express card in Roberts's name, a Getty Museum employee ID with his photo, and, for flashing at

^{*}For clarity's sake, I will refer to Hill by his real name throughout. The alternative—switching back and forth between "Hill" and "Roberts" depending on whether the speaker knows Hill's true identity—is appealing in theory but unpalatable in print.

the appropriate moments, business cards and personalized stationery. A second layer of preparation was more defensive in nature. The Getty's internal records—notably the payroll files for the past several years—had to be doctored in case anyone began snooping into Christopher Roberts's bona fides.

The risk wasn't so much that a suspicious crook might phone the Getty and learn anything useful. Even in ordinary circumstances, most institutions clam up when strangers ask questions about their employees. "But criminals will always check out the people they're dealing with," says Ellis, "and you have to be prepared for them to pay somebody within the institution to get them the information they want."

That possibility raised another danger. What if someone on the crooks' payroll began looking for Getty employees who knew Roberts? How to explain that no one did? To ward off such trouble down the road, the Getty concocted in-house records that listed Roberts as a roving scout permanently assigned to Europe, and working directly (and exclusively) for the director.

Unless you were in the very top tier of management at the Getty, Hill saw delightedly, you couldn't counter the argument that he was anything other than a proper employee. It was that good. Hill gave his new credentials an enthusiastic thumbs-up. "Everything looks perfectly pukka... kosher."

The translation of English slang into American was almost instantaneous, unusual only in that Hill spoke both idioms aloud. Usually Hill shifted on the fly, seamlessly denouncing some hapless twit as an "asshole" or an "arsehole" depending on whether his listeners were Americans or Brits. (Bilingual cursing was especially demanding, since so often it came in the heat of the moment. Hill's time in the Army, when he had worked on sounding "like a redneck from Fayetteville, North Carolina," had given him good practice.)

Hill is bilingual only in American English and British English, but within those narrow confines he is masterful. (On rare occasions he will venture as far afield as Canada. For an undercover job in the Czech Republic, Hill spent hours practicing broad vowel sounds so that he would sound authentically Canadian. Almost certainly this detail would be lost on the mobsters he was dealing with, but it reflected craftsmanship and professional pride, akin to a carpenter's taking pains to align all the slots in his screwheads in parallel.)

Hill chose the name "Christopher Charles Roberts" as a mnemonic the r sounds served as a reminder to himself to enunciate r's whenever he came to them, as Americans do, rather than to swallow them English-style. The use of his own name as a middle name was a precaution; with some fast talking, Hill might be able to wriggle out of trouble if by bad fortune someone he knew happened to call out to him on the street.

"Hi there," he'd say aloud to himself, like a singer practicing scales, "I'm Chris Roberts." There were key sounds and phrases and mannerisms that you had to get right. Do it wrong or overdo it, like Dick Van Dyke playing an Englishman, and you'd be caught the minute you opened your mouth.

The role of Chris Roberts, Getty sleazebag, would soon put Hill's skills to the test. The grading, it is worth bearing in mind, would be done by professional criminals.

The General

ill was the natural choice to star in the *Scream* story because he had just scored a giant triumph. In 1986, seven years before the theft of *The Scream*, a brutal Irish gangster named Martin Cahill had pulled off what was then the biggest art theft in history. Among the eighteen world-class paintings that Cahill grabbed from a mansion outside Dublin, Vermeer's *Lady Writing a Letter with her Maid* was the gem of gems. Its value on the open market can only be guessed at; \$50 million would not be a surprise, and \$100 million would not be out of the question. In 1993, Hill went undercover and brought it back, undamaged. The coup catapulted him to the top of his field and made him a star.

Six months later, *The Scream* vanished. For the Art Squad, the timing was ideal. If it could rack up a second huge success in a case sure to be splashed across the world's front pages, the Art Squad would be safe (at least for a while) from the in-house attacks that always came its way. For Charley Hill, too, the timing was fortunate, and not only because he was at the top of his game. Hill had decided that his undercover work in the Cahill case could serve as a model he could apply to going after *The Scream*.

Short, bald, chubby, unkempt, Martin Cahill looked like a down-market bartender or the night clerk at a fleabag hotel. In the 1970s and 1980s, he was, in fact, the top man in Dublin's underworld.

Decades ago, many art thefts were stylish, the province of smoothtalking villains with dubious morals and elegant manners. In recent years, the advent of big money has transformed a gentleman's sport into a serious, and dangerous, business. Raffles, the "gentleman thief" of Victorian England, has been shoved aside by thugs and criminal gangs whose expertise is in drug peddling and money laundering. Cahill, an armed robber, a kidnapper, and a car bomber, was typical of the new breed. Thomas Crown would have run away screaming.

Before Cahill, crime in Dublin had been largely a helter-skelter affair. Martin Cahill, who had more organizational skills and fewer scruples than any of his predecessors, changed the rules. "The General," as he was known, instituted weekly meetings to plan future robberies. He kept a sharp eye on the money that came in and how it was paid out. He took on giant jobs that had been deemed impossible; he headed, for instance, a 10-man team that pulled off what was then the biggest robbery in Irish history, a £2 million theft of gold and jewels from a closely guarded and fortress-like factory. In Dublin under Cahill, the term "organized crime" took on real meaning.

Just as important in consolidating his hold on power, Cahill took over terror tactics from the IRA and turned them on the police. This had nothing to do with politics-Cahill had no political views except that anyone in his way was a blood enemy-but it brought violence into territory that had always been off-limits. When prosecutors found evidence that placed Cahill at the scene of an armed robbery, for example, Cahill planted a homemade bomb under the car of James Donovan, the state's chief forensic expert, who was slated to testify in court. For weeks before the attack, Donovan had been under siege. His phone rang at all hours with criminals mouthing threats or simply waiting, silently, on the line. As Donovan drove home from his forensics lab one night, with a policeman sitting in the car next to him for protection, he saw he was being followed. Donovan considered driving to police headquarters but decided that, no matter where he went, Cahill's men would simply shoot him and flee to safety. "So I decided to drive home because I'd like to die at home, and it would be easier for my wife to have to identify the body in our own house."

Donovan pulled into his driveway. Cahill's man drove up behind him and waited. And eventually drove off. But three weeks later, at 8:30 on a January morning, Donovan pulled onto the highway on his way to work and the heat of his car's engine detonated a crude bomb. "I suddenly saw a mushroom cloud in front of my eyes, and at the center a great big tongue of flame," Donovan recalled. "I saw the smoke first, then the fire, and then I went blind. My eyes had been scored by the pieces of metal and then I heard a massive explosion. I tried to move my right hand and I couldn't. It was paralyzed. I put my left hand down and just past my knee found bits of squelchy material—tissue."

Astonishingly, Donovan lived. He returned to work after enduring a series of operations, maimed and partly blinded. Cahill was never charged in the attack.

Ж

Cahill had started out as just another thug. He had been convicted for the first time at age twelve, of larceny. A few years later, in the hope that it would straighten out his wayward boy, Cahill's father sent the young man to a Royal Navy recruiter. Cahill and the other applicants were asked to scan a brochure that listed various posts they might train for. Cahill's eyes lit on "bugler," an unfamiliar word. He hadn't known the Navy needed burglars, Cahill told his interviewer, but he had plenty of experience.

In years to come, the stories that swirled around Cahill's name would be decidedly darker. Cahill was hugely feared, a Dublin legend discussed mostly in nervous whispers. "People remember pain," he once said. "A bullet through the head is too easy. You think of the pain before you do wrong again."

Cahill delighted in handing out punishments that fed the rumors. He once crucified a member of his own gang he suspected of treachery: while henchmen held his victim down, Cahill nailed the man's hands to the floor. When he was not terrorizing friends and rivals, Cahill lived a life of twisted domesticity, in a happy ménage à trois with his wife and her sister. The household spilled over with nine young children, all fathered by Cahill, five with his wife and four with his sister-in-law.

In Cahill's professional life, contempt for authority played as large a role as lust for money. His aim was never merely to outdo his enemies but to humiliate them, to proclaim his "fuck you" disdain to the world. In 1987, for example, thieves broke into the public prosecutor's office in Dublin and stole hundreds of the state's files on pending criminal cases. No one doubted whose handiwork it was. Cahill savored even the pettiest triumphs over the powers that be. Through his years atop the criminal underworld, he took time each week to queue up for his weekly unemployment check, so he could thumb his nose at the state that denounced him as a public enemy but had no choice but to keep him on its payroll. The £92 checks were beside the point— Cahill owned two homes, five cars, and six motorcycles—but he thrived on the game-playing.

All the gangster's pranks proclaimed the same message: "I'm smarter than you are, and you can't touch me." He formed a group called Concerned Criminals, which advocated the right to "earn a dishonest living." A favorite Cahill ploy, on nights when his gang was engaged in a theft or a kidnapping, was to barge into a busy police station and make a scene, so that the police themselves would become his alibi.

On one occasion, when tax authorities sent an inspector to go over Cahill's accounts, the gangster played the genial host. At one point he excused himself to make a phone call, then returned to his guest and made a few remarks about vandalism and other dispiriting aspects of the modern world. Cahill gestured out the window to the street. "Now, d'ya see what I mean, just look out that window and look what those bloody vandals have done now." The tax inspector's car was in flames, burning like a bonfire.

Ж

Cahill's assault on Russborough House, a palatial mansion outside Dublin that housed one of the world's greatest private art collections, was his first venture into art crime. The robbery was doubly tempting, for it allowed Cahill to indulge both his greed and his hatred of the upper crust. The house, with a façade stretching 700 feet, was, by some accounts, the handsomest in Ireland. Built in the eighteenth century for a prosperous Dublin brewer (later the first Earl of Milltown), Russborough House had since 1952 belonged to an English couple, Sir Alfred and Lady Beit.

Sir Alfred had inherited a fortune—and a dazzling art collection—from an uncle who was one of the founders of the De Beers diamond company in South Africa. Lady Beit—Clementine Freeman-Mitford—occupied a high rank in the English pecking order and was a first cousin of the Mitford sisters, glamorous, aristocratic siblings (six altogether) notorious for their personal and political misadventures. The Beits had lived in South Africa for several years but had decided, in the early 1950s, to return to Britain. While flipping through the pages of *Country Life* magazine, Sir Alfred saw a photograph of Russborough House. He purchased the 100-room house without ever having seen it in person.

In 1986 Sir Alfred announced a plan to donate 17 of the masterpieces of his collection to the National Gallery of Ireland. Cahill pricked up his ears. The opportunity to make a fortune for himself *and* to deprive the state of a gift it coveted set him to planning in earnest. Sir Alfred's gift included Vermeer's *Lady Writing a Letter with Her Maid*, a stunning painting that was by far the best, and the best-known, in the Beit collection. "Everything of Vermeer is in the Beit *Letter*," one enraptured scholar had written.

Lady Writing a Letter was one of only two Vermeers in private hands; the other belonged to Queen Elizabeth. The painting was valued at £20 million. (After Vermeer's death, his widow had given it and a second of her husband's works, Lady Playing a Guitar, to a baker in Delft to settle a debt. The Vermeers owed the baker 617 florins, just under \$80 in today's currency.)

Ж

Vermeer, like Shakespeare, is a genius whose biography is almost completely unknown to us. (Tracy Chevalier's novel *Girl with a Pearl Earring* is a triumph of imagination that succeeds because of Chevalier's artistry in building up a plausible world from a handful of scattered facts.) The little information we do have only deepens the mystery. The artist who created paintings that embody quiet and calm lived and worked in a house with 11 children (four others died in infancy). The house belonged to his motherin-law, who lived there, too, and at first had opposed her daughter's marriage. Amid the noise and bustle, Vermeer devised masterpieces that the historian E. H. Gombrich aptly described as "still lifes with human beings."

Vermeer's professional life seemed no more likely than his domestic arrangements to promote serenity. At his peak Vermeer was one of Delft's more successful artists, but painting never provided nearly enough to live on. Though many of his peers painted perhaps fifty works in the course of a year, Vermeer turned out only two or three. His work brought in about 200 guilders a year, about as much as a sailor's pay. Throughout his life, he worked a second job, as an art dealer, and selling other people's work proved far more profitable than selling his own.

Late in life, Vermeer sank into debt. For the last three years of his life, he sold no paintings at all. He fell into "decay and decadence," his wife later recalled, in a statement that was a mandatory part of the process of declaring bankruptcy, and then "in a day and a half he had gone from being healthy to being dead." He was forty-three.

The rest of the story is scraps and gaps. Vermeer's grandfather, one scholar has learned, was a watchmaker who strayed into coin-forging. He managed to leave town a step ahead of the police, but two of his accomplices were convicted and beheaded. Of Vermeer's career, almost nothing is known beyond what the paintings themselves reveal. He seems to have painted mainly for individual patrons rather than for the market at large: a printer named Jacob Dissius owned nineteen Vermeers. (They were auctioned off, for an average price of about \$500 in today's money, after the printer's death.)

Vermeer left no diaries or letters. His personality, his motivation, his judgment of his own achievement—mysteries all. Perhaps we know what he looked like as a young man: some scholars believe that a figure in an early work called *The Procuress* is a self-portrait. Vermeer served a six-year apprenticeship to an older artist—this was a requirement for membership in Delft's art guild, which he joined in 1653, at age twenty-one—so we know that someone taught him. No one knows who. Vermeer himself took no pupils. No one knows who posed for him, though some historians speculate that his wife may have modeled for *Girl Reading a Letter at an Open Window* or several other works, or that one or another of his grown daughters may have modeled for *Girl with a Pearl Earring* or *Girl with a Red Hat*, among others.

"The greatest mystery of all," in the words of the historian Paul Johnson, "is how his works fell into a black hole of taste for nearly two hundred years. He is now more generally, and unreservedly, admired than any other painter."

Vermeer's obscurity lasted from his death, in 1675, until 1866, when a French critic named Théophile Thoré wrote three articles hailing the work of the painter he dubbed "the Sphinx of Delft." (Thoré went on to purchase, for prices in the range of a few thousand dollars in today's terms, Woman with a Pearl Necklace, now in the Staatliche Museum in Berlin; The Concert, stolen from the Gardner in 1990; and Young Woman Seated at a Virginal and Young Woman Standing at a Virginal, today both at the National Gallery in London.) Fascinated by Vermeer's use of light, the impressionists took up the cause, celebrating Vermeer as an ally two centuries ahead of his time. But not even the most fervent of those early admirers could have imagined that Vermeer would someday draw crowds who would wait in line for hours to see blockbuster shows devoted to his work.

By 1813 Vermeer had fallen so far out of favor that the exquisite *Lace-maker*, now in the Louvre, sold for $\pounds7$, roughly \$400 in today's terms. In 1816 his *Head of a Girl*, which depicts a different girl with a pearl earring, brought a mere three florins, about fifteen dollars in present-day terms. Today the painting hangs in the Met. A poster would cost more than the painting itself once fetched.

In the years of Vermeer's obscurity, no one quite knew which of several almost identically named Dutch painters was which. Was Johannes Vermeer, who painted women reading letters and suchlike, the same man as the portrait painter Johannes van der Meer? Which of the two Jan van der Meers was which, and was either of them Vermeer? Few knew and fewer cared.

That confusion both contributed to Vermeer's obscurity and reflected it. A bigger factor working against Vermeer was his tiny output. No one knows why Vermeer painted so little. The technical perfection of his canvases—his achievement in capturing the varied textures of cloth and bread and tile and skin, for instance—reduces even the coolest critics to invoking "miracles" and "mysteries" that lie beyond technique. In the face of such seemingly effortless mastery, it seems natural to assume that each canvas took countless hours. But scholars who have studied Vermeer's brushstrokes, sometimes with the aid of X rays, believe that he did not work especially slowly; he often applied fresh paint on top of paint that had not yet dried. The biographer Anthony Bailey suggests that for long periods Vermeer did not paint at all. (He notes, too, that Vermeer was a painter obsessed with the play of sunlight, and gray and rainy Holland may often have left him waiting in frustration.)

In the days before museums and mass reproductions, a painter who

produced only a handful of works, and therefore almost never turned up at auction or in any other public venue, might disappear from view. The only consolation was that, if fashion ever shifted, the rarity that had once undermined an artist would suddenly work in his favor. The fewer the paintings, the more valuable was each one.

So it has proved with Vermeer. Martin Cahill didn't know much about art. He knew that much.

Ж

Scouting Russborough House was no challenge, for the grand house had been open to the public since 1976. Nonetheless, Sir Alfred's astonishing collection was grievously underinsured. The coverage totaled \$2.4 million, less than a fraction of the worth of the Vermeer alone, to say nothing of the works by Goya, Rubens, Velázquez, Gainsborough, and Hals, among others. "They do not represent money to me," Sir Alfred explained, "and no amount of money could compensate me for the loss of such beautiful objects."

For £1, visitors could buy a ticket and examine Vermeer's Lady and Goya's Portrait of Doña Antonia Zarate and the collection's other prizes at their leisure. The ticket came with a brochure that served as a guide and instruction booklet for the curious visitor. For eight weeks in the spring of 1986, Martin Cahill spent his Sunday afternoons at Russborough House mingling with the tourists and studying the masterpieces.

On the night of May 21, 1986, Cahill and a gang of a dozen accomplices pounced. Sir Alfred and Lady Beit were away in London. Cahill had devised an elegantly simple plan. Just after midnight, he and two accomplices would sneak across the enormous grounds and approach Russborough House from the back. They would jimmy a window. Cahill would deliberately step in front of a motion sensor, tripping an alarm connected to the police station in the nearest village. Once the alarm had summoned the police, one of the thieves would disable it so that it could not sound again. Then, before the police could arrive, the thieves would retreat, empty-handed, to a hiding spot nearby.

On the night of May 21, Cahill set the plan in motion. Moments after the break-in, Cahill and his companions left the house and hid. The police raced the nineteen miles to the isolated country house. Together, the police and Sir Alfred's overseer surveyed the premises. Cahill and his men looked on from the darkness. The paintings were all in place. The furniture was untouched, and so were the clocks and the vases and the silver. No sign of a break-in. Evidently the alarm had malfunctioned.

The police drove off. Cahill waited a bit, and at about two o'clock in the morning, he signaled the rest of his crew. Up they drove, across the fields, to the dark and unprotected house. With Cahill clutching his £1 brochure as a guide, the gang raced from room to room grabbing paintings off the walls. Six minutes later, they roared off.

Ж

Martin Cahill, a brute who had once nailed an underling's hands to the floor, now had possession of eighteen of the world's cultural treasures. The Vermeer was chief among them. Vermeer's letter-writing lady, bathed in sunlight and utterly absorbed in her note, and her dutiful, timid-seeming maid, were both, of course, mere dabs of paint on canvas. Even so, it was hard to think of them in a gangster's hands without flinching.

On the day after the break-in, a group of schoolboys went fishing four miles from Russborough House. They saw something odd in a ditch, scrambled over for a close look, and found seven paintings flung in a heap. The seven, which included two Guardis, a van Ruysdael landscape, and a Joshua Reynolds portrait, were the least valuable of those Cahill had stolen. Tossed aside as too much trouble when the thieves changed cars, the paintings were nearly undamaged.

That left eleven paintings missing. According to rumor, they lay hidden in a plastic-lined pit a bit bigger than a grave somewhere in the mountains south of Dublin. This was lonely territory, remote from prying eyes, and an area Cahill had long favored for burying stolen property or shooting his enemies. 10

Russborough House

harley Hill had been involved in the Russborough House theft not merely from the beginning but from before the beginning. In the fall of 1985, before the break-in, rumors had begun circulating in the London underworld that someone with a load of stolen industrial diamonds was looking for a buyer. An informant brought the story to Scotland Yard, and a detective contacted Charley Hill. Would Hill be willing to play the role of a crooked American and see what he could find out?

Hill grabbed his chance and contacted the would-be seller at once. His name, he said, was Charley Berman ("a good American name," Hill figured, "and it has the r's"), and his work often brought him to London. Over the course of the next several months, the undercover cop and the diamond dealer sized each other up—Hill conveying his willingness to do business, the seller talking up his wares—and the two men struck up a friendship of sorts. More or less idly, in the course of one rambling conversation, Hill told his new acquaintance that his main business was dealing in art.

The man trying to peddle the diamonds was a crook named Tommy Coyle, based in Dublin. Over the course of the next several years he would go on to compile a record that would lead police to call him the biggest fence in Irish history. In 1990, he nearly scored a colossal coup. Shortly before, thieves had stolen £290 million pounds of treasury bonds from a courier in London. Coyle was arrested as he and two other men boarded a flight from Heathrow to Dublin. Police found £77 million of bonds in the men's luggage. Put on trial but acquitted, Coyle celebrated his triumph by buying a racehorse and naming it 77 Mill.

Now, with Hill, Coyle went out of his way to emphasize what a big player he was. He had access to a *lot* of diamonds. "We're talking about Aladdin's cave here," he boasted.

And then, out of the blue, something new. "I've got a picture you might be interested in," Coyle said. Hill half-expected a pornographic photo. He took a look. Picasso, not porno. Or perhaps, as Hill suspected, a fake in Picasso's style, though it wasn't easy to tell from a color photo.

A bit of research confirmed his suspicions. At their next meeting, Hill delivered the news.

"Look, I'm not interested in that picture; I don't think it's real," he said. "There are a lot more Picassos than Picasso ever painted."

Surprisingly, Hill's stock seemed to rise after his demurral. Soon after, in April of 1986, Coyle worked the conversation round to art once again.

"There's going to be a big art job," Coyle told Hill, in an urgent whisper. "Would you have any interest in looking at the pictures from it?"

"Yeah, of course I would. How big?"

"Really big. You'll read about it in the papers."

In Coyle's Irish accent, "papers" was partway to "pipers."

"It'll be the big one," Coyle said.

"Yeah, okay," said Hill.

Then, bang! Russborough House was hit and off they went, the Vermeer, the Goya, the two Metsus, the Gainsborough, two Rubens, the works.

The next day Coyle phoned Hill.

"Gee," Hill said, "that was a big one."

Hill and Coyle arranged to meet in London to discuss the Russborough House bounty. Coyle flew in from Dublin, Hill (supposedly) from the States, and they rendezvoused at the Post House Hotel, near Heathrow Airport.

Coyle came up to Hill's room. Hill had been told to offer drinks, and the two men filled their glasses and sat down to chat. "Yeah, I'd be interested in buying the paintings when the heat dies down," Hill said. "Some of them, not all of them."

They talked about the paintings and sipped their drinks. Coyle, pleased with his prospects, finished his drink and prepared to leave. Hill and Coyle shook hands. Someone knocked on the door. A waiter, with four glasses on a tray, room service stuff. "Afternoon, gentlemen. Everything all right?"

"Yeah, we're good."

The waiter took away the glasses Hill and Coyle had used and replaced them with clean ones.

The room service waiter was a cop, and he hurried the crook's glass to a fingerprint lab. Within a day Scotland Yard had a positive ID on the man trying to peddle the Beit paintings. From there, the trail led straight to Martin Cahill.

The industrial diamonds, it turned out, came from a General Electric plant outside Dublin. Martin Cahill and his gang had been stealing them and selling them in Antwerp, and now they were looking for new business opportunities. Stolen art was a venture into a new market.

Cahill's own taste in art ran to cheery scenes like the dime-store print in his living room of swans on a river, but he believed that Sir Alfred's stolen paintings would bring him a fortune. "He'd been reading how there were all these really eccentric art lovers around the world who were prepared to pay millions of pounds for art and stash them in their basements," said Paul Williams, Cahill's biographer. "He reckoned he would get millions, countless millions, of pounds for them on the black market."

With his new money, Cahill intended to make a major move into the drug importing and distributing business in Britain. The elaborate scheme involved setting up a "brass plate" bank in Antigua, a bank in name only, to launder the drug money that would soon be pouring in.

For a year, all attempts to recover the stolen paintings fizzled. Then came a break, or so it seemed, though in the end it nearly proved fatal. It was February 1987. The Dublin detective in charge of the Russborough House case, Gerry McGarrick, had a contact in the FBI named Tom Bishop.* McGarrick was an old pro. Weathered, able, reserved, he reminded Charley Hill of John Wayne. Bishop was a much-admired undercover agent. He had scored his greatest coup in the Abscam sting in the late 1970s, playing an aide of a supposed Arab sheik and handing out bribes on the sheik's behalf. The sting netted four congressmen and a senator, most memorably Florida representative Richard Kelly, caught on film stuffing \$25,000 into his pockets and then asking an FBI agent, "Does it show?"

McGarrick's plan was for Bishop to play a big-shot American gangster who wanted some trophy paintings to hang on his wall. Hill, in his role as Charley Berman, served as go-between and vouched for Bishop to Cahill's gang.

Bishop flew to Dublin to meet Cahill's men. He took with him a folder of photos showing him with Joe Bonanno and other Mafia big shots. The pictures had been snapped secretly by the FBI, but they looked like photos a crook might display on his desk.

Included in Bishop's show-and-tell pack were some pictures of stolen paintings he'd recovered, by Georgia O'Keefe and some others. Bishop planned to pass them off as things that belonged to him. Hill and Bishop went through the packet one last time. Impressive, they both agreed. Both men overlooked one crucial item.

Bishop met Cahill's crew. He handed over his photos. One of Cahill's men flipped through it. The others looked on. Suddenly the crook stopped his flipping, pulled out a piece of stationery from the stack, and waved it in the air. The top of the page bore the FBI logo. Underneath was a handwritten note: "Tom, don't forget these."

Cahill's men stood up and left the room. The gangsters walked out without pausing to shoot Bishop, which was some consolation. (If the meeting had been held in the gang's own territory rather than in Bishop's hotel room, the outcome might have been different.)

"The Tom Bishop screwup put an end to Charley Berman," Hill recalled years later, "because if Tom Bishop is a Fed, then Charley Berman, who brought him in, is a no-good son of a bitch, no matter where they think he's from, okay? End of Charley Berman."

*A pseudonym

Three years went by. Then, in May 1990, Turkish police in Istanbul arrested a Scottish criminal from Dundee who was trying to buy a shipment of heroin to sell in Britain. His down payment for the attempted purchase: Metsu's Woman Reading a Letter, stolen from Russborough House. Over the next few years, more of the stolen paintings surfaced. In April 1992, detectives in London working on a drug case happened on Gainsborough's Madame Baccelli, in the back of a truck. In March 1993, police chasing drug leads found a painting by the Dutch artist Anthonie Palamedesz in a locker at London's Euston train station. In the same month, British police acting on a tip raided a nondescript house in Hertfordshire and discovered, behind the sofa, Rubens's Portrait of a Monk. (The story of the last recovery had a bizarre twist. Before it made its way to Hertfordshire, the Rubens had been hidden in a house in London. By coincidence, a runof-the-mill thief, not connected in any way with the thieves who had hit Russborough House, happened to break into that very house. Finding the Rubens but not knowing what it was except that it looked posh, he grabbed it and ran off.)

The London recoveries left four paintings still missing, including the Goya and, most valuable of all, Vermeer's Lady Writing a Letter with her Maid.

Ж

In the meantime, Charley Hill had kept in touch with Gerry McGarrick, the Dublin detective heading up the Russborough House case. At some point in the early 1990s, Hill was in Dublin, and the two detectives met over a drink. By now some of the Beit paintings, though not the best, had begun turning up in London. McGarrick told Hill that he'd heard from informants that all the paintings had left Ireland and that the ones that had already been recovered in London were the only ones still in Britain. He'd heard rumors that the rest were somewhere in Belgium.

"At the time he said it to me," Hill recalled in 2002, "it was as good as saying, 'Kiss 'em goodbye.' "

11

Encounter in Antwerp

As time passed, other informants picked up rumors of a Belgian connection. The story emerged piecemeal but the pieces seemed to fit together: Cahill's gang, which had been selling stolen diamonds to a dealer in Antwerp for nearly a decade, had now handed that same dealer some of the missing paintings—no one was certain which ones. With the paintings as collateral, the dealer had loaned Cahill \$1 million. Cahill planned to turn his newfound money into heroin and then back into more money.

A million dollars was nowhere near the paintings' true value, but, after all, the thieves hadn't paid a penny for them. Outsiders who ponder art thefts always get it wrong: they focus on the gulf between a number like Cahill's \$1 million and the \$20 million that a masterpiece might fetch on the open market, and conclude that the thieves have blundered. Thieves sneer at reasoning like that. The proper comparison, as they see it, is not between \$1 million and \$20 million but between \$1 million and zero, which is what the paintings had cost them.

The diamond merchant had locked the paintings in a bank vault in Luxembourg, knowing they would keep their value. (Unlike stolen cars or computers, which lose value by the week, stolen paintings by top-flight artists can safely be laid down as investments, like fine wines.) Presumably he intended to sell them someday, or to barter them for drugs or arms or counterfeit bills or some other black market commodity. The problem for the police was finding a way to get those paintings out of the vault. On a tip, Charley Hill made contact with "a real crook of a lawyer" in Norway. Once again, Hill played a variant of his favorite role. This time he was an American art dealer working on behalf of a Middle Eastern tycoon bent on assembling, for his own delectation, a collection of world-class masterpieces.

His name was Christopher Charles Roberts, the identical pseudonym he would use in *The Scream* case. In this aspect of his life, as in every other, Hill was maddeningly inconsistent. In working undercover, he veered between obsessive attention to detail and carefree, well-then-fuck-'em casualness. Rebecca West once described someone as "every other inch a gentleman," and Hill was every other inch a master of minutiae. On the one hand, he might lavish hours on creating false papers perfect in every detail. On the other, he was more than capable of launching into spur-of-the-moment descriptions of buildings and even cities he had never seen.

But if Hill's improvisations sometimes landed him in predicaments that the rawest rookie would have avoided, he was equally capable of improvising saves that no one else could have come up with. The question was always, Which will it be this time?

In private life, too, Hill careened from extreme to extreme. He was cautious enough to have removed the street number from his front door after a spate of phone calls threatening him and his family, for instance, but so heedless of danger that on hot days he left that same front door standing wide open to all comers.

Hill's story of a Middle Eastern mystery man was ludicrous on its face, but he had found that greed worked wonders in covering over the holes in a plot. His usual strategy was not to concoct elaborate tales but merely to drop a few broad hints. He figured that this latest gangster audience would do the bulk of the storytelling work themselves, in a dollar-fueled daze that combined ignorance of the art market, prejudice (visions of oilrich sheiks), and Hollywood clichés (Mr. Big, in shadows, putting his feet up on the battleship-sized desk in his palatial office, lighting a cigar, and gazing fondly at the newest gilt-framed stolen treasure in his collection). "You've got to find the weakness in their beliefs and then exploit it," Hill says, "and crooks keep looking for goddamned Dr. No. That's their fantasy—somewhere out there is Mr. Big or Dr. No or Captain Nemo, in his hideaway with all his treasures. It's complete bullshit, of course, but criminals would much rather live in a fantasy world. They could easily learn how things really work, but they don't want to listen to anything other than the sound of their own voices."

Ж

The crooked lawyer told Chris Roberts, supposed Middle Eastern middleman, that he could help him buy the Russborough House paintings. Through the lawyer, Hill soon met a mysterious figure named Niall Mulvihill. The Antwerp diamond dealer and Mulvihill, it seemed, were partners of some sort.

Irish newspapers usually referred to Mulvihill as a "South Dublin businessman." The nature of that business was never spelled out, but Mulvihill had evidently done well for himself. He collected antique cars and lived in a big, rambling house near Dublin and owned another home in Marbella, on Spain's Costa del Sol. He was tall and flashy, resplendent in blazer, golf slacks, and tasseled loafers.

Hill liked nothing better than to play the same type. "I matched him tassel for tassel," Hill crowed in an interview years later. "I turned on this bogus bonhomie bullshit, hail-fellow-well-met and all that." The two men hit it off.

Hill's first problem was to get the paintings out of Luxembourg, where undercover police operations were forbidden. The law wasn't directed at Scotland Yard—it was a legacy of World War II, intended to insure that no Gestapo-style secret police could ever arise—but it made life more difficult for the Art Squad.

Hill spun a story that he hoped would take care of the Luxembourg hurdle. The Antwerp airport, he told Mulvihill, would make a convenient but slightly-off-the-beaten-track meeting spot. He would pay Mulvihill for the pictures and then fly out in a small plane, through France, on to Italy, and then to Lebanon. Though he didn't say so outright, Hill hinted that that was where the people he was buying the pictures for lived, and that's where they'd want to lay them down. Mulvihill, impatient to see some money, quickly agreed. Antwerp was fine. What about the money that Hill kept talking about?

Hill told Mulvihill not to worry. The money would be there. What about the paintings?

All illicit exchanges proceed warily because the two sides distrust one another and, at the same time, need one another. The question for both sides is, in effect, this: when a hand disappears inside a jacket, will it reemerge holding a check or a pistol?

On an August night in 1993, in Antwerp, over dinner at the DeKeyser Hotel, Mulvihill told Hill he had something to show him. Seven years had passed since the break-in at Russborough House. The two men walked to a parking garage nearby and rode the elevator to the third floor. The garage was full, and Mulvihill and Hill took several minutes to walk up and down, making sure they were alone. No one was around.

Mulvihill led the way to a parked Mercedes sedan, gestured Hill close, and opened the trunk. Inside was a black plastic trashbag. Hill gingerly rolled back the top of the bag. There, unharmed, still on its stretcher rather than rolled up, was Vermeer's *Lady Writing a Letter with her Maid*. Hill picked up the priceless painting.

"It's an astonishing thing to hold in your hands," he recalled a decade later. "No question it was the Vermeer. An amazing thing about a painting like that is you don't have to think, 'Is this a masterpiece or isn't it?' It just leaps out at you, bang!"

Mulvihill was "very matter-of-fact. He could have been selling me a truckful of sheepskin coats. This was just a straight business thing for him."

Hill clucked and fussed over the Vermeer, as befit an art buyer face-toface with a treasure. The main thing was to look as if he knew what he was doing and to make the right noises. Hill talked about the history of the painting and what good shape it was in, and he made a big point of holding it with handkerchiefs on either side, to protect it. When Mulvihill wasn't paying attention, Hill made sure to leave his fingerprints on the back.

That was a precaution. Hill's underworld acquaintances were happy to drink with him, but he knew perfectly well that if it suited them, they would shoot him just as happily. When Hill talked about "stolen masterpieces in barbarian hands," as he sometimes did, his listeners tended to assume he was talking about thieves who lacked any appreciation of what they had stolen. And so he was, but that was only part of his point. Gangsters like Cahill were not only as uncouth as barbarians, but also as violent. Now he pressed his fingers against the back of the painting. If Hill were to vanish but the police eventually recovered the Vermeer in any case, the fingerprints might at least provide a lead to his disappearance.

Hill handed the painting back to Mulvihill.

A week later, it was Hill's turn to play show-and-tell. With the cooperation of CitiBank, Scotland Yard had arranged to have two cashier's checks prepared in Mulvihill's name. One check was for \$1 million, the other for \$250,000. Just how Mulvihill intended to spread that money around, or why he wanted two checks, no one asked.

Hill and Mulvihill drove to a CitiBank branch in Brussels. Hill led the way. The bank manager, who had been briefed by headquarters, scurried out.

"Hello, Mr. Roberts. Delighted to see you."

The bank manager did his unctuous best, and Hill acted as if the fawning was merely his due. When the glad-handing had gone on long enough, it was time to brandish the checks. The bank manager produced them with a flourish, like a headwaiter presenting a rack of lamb on a silver tray. Mulvihill took the two checks in his hands, examined them closely and lovingly ("one million dollars and no cents"), and reluctantly turned them back to the bank manager.

With the preliminaries completed, Hill and Mulvihill both figured that the next meeting would be for real. Next time, Mulvihill would drive away with his money, and Hill would fly off with his paintings.

Hill and Mulvihill happily drove back to Antwerp. On the way, Hill, not paying attention, nearly missed the Antwerp exit. At the last instant, he swerved across the highway and careened across the merge lane, cutting off an eighteen-wheeler hauling a load of tomatoes. With the trucker's air horn still blaring, Mulvihill looked approvingly at Hill.

"Good work," he said. "There'll be no one following us now."

The two men, now fast friends, made final arrangements for the swap. The deal would go down at the Antwerp airport on September 1. On the appointed day, Hill drove to the rendezvous. A Belgian undercover cop called Antoine played the role of his bodyguard. Hill knew Antoine and liked him. More important, he looked like a bodyguard. Antoine was "a hairy-arsed, super-fit gendarme," Hill would say later. "Doesn't drink, lives on orange juice and yogurt"—Hill's tone made plain that *he* would as soon live on goat urine and locusts—"and he was tooled up, not ostentatiously but obviously, so you'd be sure to know he was armed. He had real presence; he looked the part of a serious minder. And he had a briefcase with the cashier's checks in it."

Antoine, a classic-car buff, drove a vintage, lovingly maintained Mercedes. As he and Hill made their way through Antwerp and out to the airport, an elderly woman on a bicycle rattled her way across a set of tram tracks. The bell fell off her handlebars and onto the street. It was midmorning, and traffic was heavy.

"Stop the car!" Hill barked, and then he hopped out of the Mercedes, halted traffic, retrieved the bell, and presented it to the woman on the bicycle.

"She gave me this wonderful smile of thanks," Hill recalled long afterward, "and when I got back in the car, Antoine had this 'what the fuck was *that*?' look on his face."

For Hill, who is in many ways akin to the small boy who imagines himself the star of the big game ("bases loaded, bottom of the ninth, all eyes on Hill as he strides to the plate"), this tiny scene was a not-to-bemissed chance to play the hero. "It was a pure Walter Raleigh moment," he recalled long afterward, basking in the memory. "That's all it was. And poor Antoine sitting there thinking, 'You ought to be concentrating on the job, not fooling about playing the gallant knight to some old biddy whose bicycle has gone bust.'"

At the airport, Hill and Antoine parked the car and walked into the small restaurant. It was noon. Hill ordered a coffee and cognac. In waltzed a dozen flight attendants, and, just behind them, Mulvihill and a crony.

"You got everything?" Mulvihill asked.

"Yup," said Hill.

The trickiest, most dangerous part of any deal is the exchange itself, when money and goods finally change hands. Hill and Mulvihill had each brought an ally, for muscle and backup. While Hill sat in the restaurant with Mulvihill's man, Mulvihill and Antoine walked outside toward Antoine's car. Both men were car buffs, and the Mercedes served as an ice-breaker. Mulvihill studied the cashier's checks and assured himself that they were the ones he had seen in the bank in Brussels.

Satisfied, Mulvihill returned to the restaurant. He turned to Hill.

"Want to see the pictures?"

Hill walked out to the parking lot with Mulvihill's partner, to a rented Peugeot. The bodyguard opened the trunk. Hill saw a sports bag, about big enough to hold a tennis racquet and a pair of sneakers. Next to it sat a black plastic bag wrapped around something rectangular and several large objects hidden inside layers of wrapping paper. The plastic bag was the same size and shape as the one Hill had seen in Antwerp, when Mulvihill had shown him the Vermeer. Hill put it to one side for a moment. He unzipped the sports bag. Inside, he saw a rolled-up canvas that he recognized as Goya's *Portrait of Doña Antonia Zarate*. Glad as he was to see the painting—the thieves wouldn't have brought it if they were running a scam—it was horrifying to see a two-hundred-year-old oil painting rolled up like a ten-dollar poster. Hill set the sports bag down gently. Turning to the bag that he hoped contained the Vermeer, he brushed a hand across his shirtfront, as if he were sweeping away a piece of lint.

Silently, two large BMWs alerted by Hill's signal sped into place, one in front of the Peugeot, one behind. Each car was "four up," with a driver and three men. This was the Belgian SWAT squad, big guys with Dirty Harry specials. They shouted commands in Flemish, presumably to drop everything and lie down. In case they had been misunderstood, the cops helped Hill and Mulvihill's bodyguard to the ground.

Shoved facedown onto the asphalt, Hill and his companion were handcuffed and searched and then hustled into a car and whisked off to a local police station. Mulvihill was taken into custody, too, and so was Antoine. To Charley Hill's great delight, the commotion had drawn the attention of everyone in the coffee shop, and the whole scene played out to a satisfying chorus of shrieks from the gawking flight attendants.

Once arrived at the police station, Hill and Antoine, the gendarme-cumbodyguard, were freed from their handcuffs, congratulated, and left to celebrate. Mulvihill was charged with handling stolen goods, but, as the *Irish Examiner* later reported, "he miraculously managed to escape prosecution."

The miracle was, in fact, mundane enough, though it did demonstrate that no one took art crime too seriously. A Belgian court dropped the charges against Mulvihill on the grounds that the robbery had taken place in Ireland, outside Belgian jurisdiction.

The trash bag did indeed contain the Vermeer. In all, the Belgian police recovered four of the Russborough House paintings (as well as three fake Picassos): the Vermeer, the Goya, an Antoine Vestier portrait, and Gabriel Metsu's *Man Writing a Letter*. The Metsu was a companion piece to the same artist's *Woman Reading a Letter*, the painting that police had found in Istanbul, where thieves were trying to barter it for heroin. The two works are considered Metsu's masterpieces.

Today, all but two of the eighteen paintings stolen from Russborough House in 1986 have been recovered. The missing works are Venetian scenes painted by Francesco Guardi, which some rumors have placed in Florida.

Vermeer's *Lady Writing a Letter with Her Maid* hangs safely in Dublin's National Gallery, serene still, despite all she has seen.

Ж

Martin Cahill, the engineer of the Russborough House theft, was killed in August 1994, shot through the driver's window of his car by a gunman dressed as a Dublin city worker. Cahill had slowed to a halt at a stop sign; a man with a clipboard approached the driver's window to ask a few questions about traffic.

In January 2003 Niall Mulvihill was shot in a gangland attack in Dublin. Mulvihill took four bullets but managed to drive two miles toward the nearest hospital. He crashed just short of the hospital, causing a four-car pileup. No one was charged with his murder.

Munch

MARCH 1994

or five months after the Russborough House recovery, Christopher Charles Roberts did not exist. Then, with *The Scream* stolen, Roberts was back, reincarnated this time as the Man from the Getty.

Charley Hill's first task in preparing for this new role was to learn about Edvard Munch. Studying up on artists was one of his favorite parts of the job. Hill's love of art ran deep, though he was a buff rather than a scholar. In his spare time, in whatever city he found himself, he visited museums and looked in on old friends in the collection. In Prague, it was a Dürer self-portrait; at the Hermitage in St. Petersburg, Rembrandt's *Sacrifice of Isaac* ("the angel arresting Abraham's hand is extraordinary, even though it doesn't quite work"); at the National Gallery in London a long list, perhaps headed by Leonardo's *Madonna of the Rocks*.

In Washington, D.C., Hill always made time for a particular favorite, Gilbert Stuart's *Skater (Portrait of William Grant)*. The striking work, an action painting in what was typically a stiff and earnest genre, thrust Stuart to fame. It depicts a tall figure in an elegant black coat and hat, carving a graceful turn on the ice on the Serpentine, in London's Hyde Park. (The story has it that Grant told Stuart that "the day was better suited for skating than sitting for one's portrait.") For Hill, the skating Scot embodies an idealized self-image, "the way I would have liked to have seen myself in that time."

For *The Scream* case in particular, where Hill's role was not that of an art-loving (though crooked) amateur but of a bigwig at a world-class art museum, his research would have to be particularly thorough. There were no shortcuts. Learning about Munch was a matter of assembling a giant stack of art books and diving in. The only catch was money. Though he was preparing to play a free-spending honcho at a money-is-no-object institution—and though he supposedly intended to ransom a \$72 million painting—Hill could not afford to buy the books he needed to study. Instead, he haunted the library and a bookstore near his home, where a patient manager made allowances for the tall man in the art section who read and read but never seemed to buy.

At the start, Hill knew no more about Munch than most people do. Temperamentally too conservative to care much for the modern world, he preferred paintings from the seventeenth and eighteenth centuries, though he made exceptions for a few works as close to the present day as the nineteenth century. The Goya portrait he had looked at in a car trunk, painted in 1805, reduced him to sputtering admiration. "Anyone with even half an eye or half a wit," he says, "standing there, holding it, you can't be anything but awestruck."

He had never seen *The Scream* in the flesh, so to speak, and, if he failed to get it back, he might never have the chance.

Two men more different than Charley Hill and Edvard Munch would be difficult to find. Still, the gruff ex-paratrooper found himself sympathizing with the melancholy, high-strung artist. As haunted and unstable as his near-contemporary van Gogh, Edvard Munch had endured an upbringing that would have blighted the sunniest nature. When Munch was five, his mother died of tuberculosis, with her young son at her bedside. Nine years later, his older sister died of the same disease. His brother, too, fell ill with tuberculosis, but survived.

Insanity was another family curse. Munch's sister Laura went mad and was eventually institutionalized. Munch's grandfather had died, mad, in an asylum, and Munch himself suffered a devastating breakdown in 1908, at age 45, that left him hospitalized for eight months. His treatment included electroshock, but he emerged more or less recovered and returned to his work.

Even at his healthiest, Munch was far from robust. Sickly throughout his childhood, he had survived tuberculosis and suffered through long bouts of bronchitis. Throughout his life he suffered from panic attacks. At the time he was working on *The Scream*, it took all his nerve to force himself to cross a street or look down from even the slightest height. He lived in fear of inhaling dust or germs; he shrank from drafts; he was so afraid of open spaces that when he ventured outdoors he clung to the nearest wall.

"Disease, insanity and death were the angels which attended my cradle, and since then have followed me throughout my life," Munch wrote in his journal. "I learned early about the misery and dangers of life, and about the afterlife, about the eternal punishment which awaited the children of sin in Hell."

He learned many of those lessons from his father, a doctor who treated Oslo's poorest residents for free but who adhered to fire-and-brimstone religious views. "When anxiety did not possess him, he would joke and play with us like a child," Munch recalled. "When he punished us . . . he could be almost insane in his violence. In my childhood I always felt that I was treated unjustly, without a mother, sick, and with the threat of punishment in Hell hanging over my head."

Munch grew to be a shy, lonely, hypersensitive young man, tall, thin, and good-looking (reputedly "the handsomest man in Norway"). In his twenties he fled puritanical Oslo for the guilty pleasures of Paris and the Black Piglet Café in Berlin. Here he drank too much, chased women and fled from them, and painted obsessively, late at night, in a shabby rented room cluttered with his own unfinished pictures.

The titles of some paintings from the 1890s, when Munch was in his early thirties and at his most productive, give some idea of his state of mind. He painted *Despair* and *By the Deathbed* in 1892, *The Scream* in 1893, *Anxiety* in 1894, *Death Struggle* in 1895.

The paintings are as bleak as the titles suggest. In comparison with Munch's portraits of isolation and woe, Edward Hopper's depictions of near-empty diners seem cheerful. *The Sick Child*, for example, shows Munch's sister Sophie, in bed and dying, attended by her despairing mother.

MUNCH

Sophie is wan and weak, but—and this is characteristic of Munch—the dying girl seems less anguished than the mother she will leave behind. The mother's pain is more than she can bear; she holds her daughter's hand, but she is past the point where she could offer any spoken consolation.

Even paintings with seemingly inviting subjects, like the 1892 street scene called *Spring Evening on Karl Johan Street*, are heavy-laden with grief. In Munch's version of a spring evening, a stream of men in black top hats and women in dark dresses advance zombie-like toward the viewer, their eyes wide and staring and their heads barely more than skulls. A lone figure, depicting Munch himself, walks unnoticed in the opposite direction.

Munch's aim in such paintings, he wrote, was to find a way to represent human "suffering and emotion, rather than to paint external nature." The painter's task was "to depict his deepest emotions, his soul, his sorrows and joys." An artist was a psychologist with a paintbrush.

Freud and Munch were almost exact contemporaries. Though neither man ever mentioned the other in print, the two were engaged in the same quest. In the age of anxiety, if Freud was the great explorer, Munch was his mapmaker. Far more directly than most artists, Munch served up a kind of autobiography on canvas. His paintings put his private torments on public view.

His relations with women, for example, could scarcely have been more fraught. "His father had prayed late at night to save his son from the sinful attractions of women, flesh, and free love," one art historian writes, "but the diabolic allures of alcohol and a bohemian life overpowered his prayers." In 1889, when Munch was twenty-six, his father died. One of the father's last acts was to mail his well-thumbed Bible to Munch, in Paris, in the hope that the directionless young man could yet be saved.

Women were temptresses intent on destroying men, and Munch had trouble resisting temptation. He fell in love for the first time at age twenty-two, with a married woman two years older than he was. "Was it because she took my first kiss that she took the sweetness of life from me?" he wrote later. "Was it because she lied, deceived, that one day she took the scales from my eyes so that I saw Medusa's head, saw life as a great horror?" Later relationships proved even more disastrous. For three years, the penniless artist carried on a tumultuous affair with a beautiful and vain woman named Tulla Larsen, a wealthy member of one of Copenhagen's leading families. After their breakup, she lured Munch to her room by enlisting friends to tell him that she had fallen deathly ill and yearned for one final conversation. Munch arrived, and Tulla sat up in her deathbed flourishing a gun. She was not sick, she admitted, but she would kill herself if Munch refused to take her back. Munch reached for the gun, Tulla grabbed it back, and it fired. The bullet took off the top joint of the middle finger of Munch's left hand. (Munch painted with his right hand.)

Munch later included Tulla Larsen in several works, notably in a portrait called *Hatred* and in another entitled *Still Life (The Murderess).* "I have painted a still life as good as any Cézanne," he wrote, describing the latter work, "except that in the background I have painted a murderess and her victim."

Ж

In between stints with Munch, Hill pored over the Getty Museum catalogue. One of the prizes in the collection, he learned, is a strange work by James Ensor called *Christ's Entry into Brussels in 1889*. The huge painting, about eight feet by fourteen feet, is an angry satire depicting the chaos that would greet Christ if he returned to the modern world. Jesus (who is depicted with Ensor's features) is nearly swallowed up in a tumultuous crowd; political banners and advertising slogans ("Coleman's mustard") wave overhead; the mayor preens as if the parade were in *his* honor. Ensor's masterpiece, Hill read, was one of the great forerunners of expressionism and a key step on the path that led Munch to *The Scream*.

Hill lit up. The Ensor painting, he figured, would be the key to his patter. The reason the Getty would pay the ransom, he'd say, is that the curators wanted to put *The Scream* on exhibition with Ensor's painting. For Hill, seeing Ensor was the Aha! moment when his Getty story fell into place.

No one else would have thought so. Even without Ensor, the Getty scheme was far from simple. If Hill was prepared to play a rich American, why go to the trouble of involving a museum? Why not simply pose as a tycoon bent on assembling an art collection no one else could match? Hill

MUNCH

contemptuously brushed aside any such objections as exactly the kind of "conventional and narrow-minded" thinking he despised.

Ж

"My art," Munch wrote, "is rooted in a single reflection: Why am I not as others are? Why was there a curse on my cradle?" Painting was not merely a career, or even a calling, but a cry from the abyss. "There should be no more paintings of interiors and people reading and women knitting," Munch declared. "There should be images of living people who breathe and feel and suffer and love—I shall paint a number of such pictures people will understand the holiness of it, and they will take off their hats as if they were in a church."

Instead, they took out rotten fruit and hurled it as if they were in a burlesque hall. It was Munch's raw, unfinished technique, not his subject matter, that inspired such scorn. The contempt directed at Munch echoed the critics' mockery when, two decades before, the impressionists had mounted their first shows.

"There is not even any proper underpainting in the picture," one Norwegian critic scolded, when he saw Munch's *Portrait of the Painter Jensen-Hjell.* "The colors have been crudely daubed on the canvas; indeed it looks as if it has been painted with the blotches of paint left over on the palette after another picture." One newspaper reported that visitors emerged from a Munch exhibition asking whether he held the paintbrush with his hands or his feet.

The abuse poured down even on paintings that would later be hailed as among Munch's greatest. At one show, Munch reported with horror, he approached *The Sick Child* and found a rowdy crowd "laughing and shouting" in front of the depiction of his sister's deathbed. Munch rushed outside, where one of his fellow artists, a then acclaimed and now forgotten figure, ran over and shouted in his face: "Humbug painter!" The critics were nearly as contemptuous. "The kindest service one can do for the painter E. Munch," one wrote, "is to pass over his pictures in silence."

From the beginning, though, a few viewers *did* understand what Munch was up to. In 1892, a group called the Association of Berlin Artists put on

an exhibition of Munch's work. The paintings were so controversial that they inspired a virtual civil war between an avant-garde faction of artists, who supported Munch, and a group of more conventional painters, who despised him. After only six days, the artists' association voted to close the show down. A riot broke out. Munch's reputation as an emblem of modernity was made.

The Scream appeared the following year. Most viewers hated it. The impression it gave, according to one French newspaper, was that Munch had dipped a finger in excrement and smeared it around.

The painting grew out of an actual experience, though scholars quarreled over its date. Munch had set out for an evening stroll along the water, near Oslo. "I was walking along the road with two friends," he recalled years afterward. "The sun set. I felt a tinge of melancholy. Suddenly the sky became a bloody red."

For years, Munch grappled with the memory of that sunset and labored to capture it in paint. The date of his evening walk has lately stirred a debate-1883 and 1886 and 1891 all have their partisansbecause it now seems likely that poor Munch, his nerves already aflame, happened to witness one of the astonishing meteorological sights of all time. At 10:02 in the morning on August 27, 1883, half a world away from Norway, the volcano on the island of Krakatoa erupted. The island vanished from the earth, blasting itself apart into the heavens. Six cubic miles of rock, rendered into pumice and dust, rained down; smaller particles wafted high into the atmosphere. In the months to come, those floating particles drifted around the world and created sunsets that blazed and glowed with colors of an intensity and splendor no one had ever seen. The New York Times reported, on November 28, 1883, that "soon after five o'clock the western horizon suddenly flamed into a brilliant scarlet, which crimsoned sky and clouds. People in the streets were startled at the unwonted sight and gathered in little groups on all the corners to gaze into the west. . . . The clouds gradually deepened to a bloody red hue, and a sanguinary flush was on the sea."

More stolid observers than Munch lost their bearings. In Poughkeepsie, New York, a team of firemen harnessed their horses to their pump wagon and raced toward the setting sun to fight the inferno on the horizon. In Oslo, on November 30, 1883, a newspaper reported that "a strong light was seen yesterday and today to the west of the city. People believed it was a fire: but it was actually a red refraction in the hazy atmosphere after sunset."

Was this the sunset that Munch witnessed? Art historians have always attributed the appearance of the sky in *The Scream* to the combination of Norway's vivid sunsets and Munch's jangled nerves. (Some downplay Munch's recollection and dismiss the question of literal sunsets altogether.) Now it seems that the detective work of two physicists and a professor of English may change that conventional wisdom.*

The scene impressed Munch so profoundly that he wrote several descriptions of his evening walk. "I stopped, leaned against the railing, dead-tired," he recalled in 1892. "And I looked at the flaming clouds that hung like blood and a sword over the blue-black fjord and city. My friends walked on. I stood there, trembling with fright. And I felt a loud, unending scream piercing nature."

That scream was destined to echo around the world. For Munch, it marked a personal, private terror. "For several years, I was almost mad at that time the terrifying face of insanity reared up its twisted head," he wrote later. "You know my picture *The Scream*. I was being stretched to the limit—nature was screaming in my blood—I was at breaking point."

Decades later, *The Scream* would achieve universal fame. No longer seen as an expression of one man's torment, it was taken instead as a shriek of despair that might have come from almost anyone. Munch had felt panicky and overwhelmed. Half a century later, after the deaths of millions in two world wars and the threatened death, from atomic bombs, of everyone else, those feelings resonated across the globe. Pop trends—the rise of coffee-house existentialism, a taste for European gloom à la Bergman,

^{*}The story linking Krakatoa and Munch's evening stroll appeared in an article called "When the Sky Ran Red" in *Sky & Telescope* magazine in February 2004. The authors were physicists Don Olson and Russell Doescher and English professor Marilynn Olson, who also found the exact spot where Munch stood trembling against the rail. The newspaper stories cited in the text above were quoted in their essay.

rumors of the death of God—had made angst and alienation fashionable. In March of 1961, *Time* magazine hailed the new mood with a cover story entitled "Guilt and Anxiety." The cover illustration? *The Scream*.

The Scream was everywhere, reproduced endlessly in posters and also in such austere settings as psychology textbooks. This first round of fame was more or less straightforward, a kind of homage. But paintings and sculptures can become celebrities of a sort, famous for being famous, and when they do, we subject them to the same indignities that we inflict on other stars who have had the presumption to fly too high. We daub a mustache on the *Mona Lisa*, dress Michelangelo's *David* in boxer shorts, transform the heartland figures of Grant Woods's *American Gothic* into pitchmen for breakfast cereal.

For Edvard Munch, who was not a wry fellow, the fate of *The Scream* would have been a joke cruel beyond imagining. He had begun painting in the hope that his audiences would "understand the holiness" of his images. In time, the most famous of those images would adorn key rings and Halloween masks and, in Macaulay Culkin's version, serve as the emblem for one of Hollywood's biggest hits. The central figure of *The Scream*, one art historian proclaims, is now "the counterpart to the familiar smiley face."

The Scream was intended as one in a sequence of some two dozen paintings called The Frieze of Life. (The count is not exact because Munch worked on the project for more than three decades, and dropped, added, and revised various paintings along the way.) All the paintings dealt in some way with Munch's favorite topics—sex, death, and alienation—but The Scream stands out from its fellows. In both emotion and technique, it is Munch's rawest work.

All the other paintings that make up *The Frieze of Life* are painted in oil on canvas. *The Scream* combines tempera, in essence poster paint, with pastel and chalk, and is painted not on canvas but on a sheet of ordinary, untreated cardboard. Munch worked and reworked the themes he took up in *The Scream*—the harrowing red-and-yellow sky and the other land-scape features are nearly identical in his 1892 oil painting *Despair*, for

example—but *The Scream* has an urgency that is almost painful. The famous central figure was sketched so hastily that we can see the cardboard peeking through the face.

For Charley Hill, such details were crucial. Recovering *The Scream*, if he could manage it, would be another tremendous coup, a triumph to savor for a lifetime. On the other hand, faked masterpieces were everywhere, and falling for one would be a career-killing blunder. Hill's very first undercover case had turned on a fake old master, and he feared fraudsters more than thieves—fraudsters were smart and greedy, he believed, while thieves were merely greedy.

Hill needed to be familiar with all the standard questions that art historians mull over because he might find himself dealing with nasty characters, or with experts in their pay, who would not react well if they found that the Getty's man seemed curiously ill-informed about art. This was detective work of a sort, and Hill enjoyed sifting through the expert opinions: is the central figure screaming, as it appears, or *hearing* a scream, as Munch's description seems to indicate? Was he (she? it?) indeed modeled on an Incan mummy that Munch saw displayed in a natural history museum in Paris? What is the significance of the vertical red stripe at the painting's right edge?

But more important than such hard-to-resolve issues were nuts-andbolts questions about the condition of the painting that would help Hill determine whether he was dealing with the real thing. In one of the red bands along the sky, for instance, someone had taken a pencil and written, "This must have been painted by a madman." The handwriting is not Munch's. Perhaps a visitor at some early exhibition scribbled the comment. No one knows, but the message is a crucial test of authenticity.

Munch seems to have had second thoughts about the red vertical stripe, to cite another example. Midway along the painting's right edge, he took a sharp knife to the stripe as if to cut it out, but then changed his mind and covered over the knife slit with a band of dark green paint.

Many of these identifying marks derived from Munch's working habits, which were as strange as every other aspect of his life. (Terrified by a scream that he heard piercing nature, he was equally terrified by silence. He always kept the radio on while he painted, though he often left it between stations, hissing static.) If a painting wasn't going well, Munch sometimes took a whip and beat it. He called the punishment "horse treatment" and believed that it improved the painting's character.

In other ways, too, Munch treated his paintings as living creatures. He was not jealous of other painters, Munch maintained, but his paintings were jealous of other paintings and could not be exhibited near the work of other artists. He called his paintings his children and could hardly bear to sell them. But he was a capricious parent who was sometimes astonishingly careless with his own work. He built an open-air studio so that he could paint outdoors, summer and winter, and he left his paintings hanging exposed to the elements for years. "He would casually throw [his paintings] on the floor and trample all over them," one art historian marvels, "or lay them like lids on a boiling pot of soup."

Endlessly experimental, Munch painted on canvas and wood and cardboard, using brushes and palette knives and, occasionally, his fingers. He painted furiously, racing to capture the images in his head and working to exhaustion. At the end of one late-night session of working and reworking *The Scream*, he finally wearied and blew out the candle near his easel. The wax spattered onto the painting, and the white drips can be seen toward the bottom right corner to this day.

Munch blew out that candle in 1893. More than a century later, in the winter of 1994, Charley Hill read about that wax and beamed with delight. What was the name of the Italian scientist who had proved you can't blow out a candle the same way twice? It was "forensic science stuff," the same with wax as with blood or paint, and there was no way on God's green earth to fake it. No con man could palm off a fake *Scream*—assuming he knew about the wax at all—because the splashes of wax would serve as an impossible-to-forge signature.

At a desk in his local library piled high with art books, Hill flipped to a close-up of *The Scream*. Then he set out to memorize the exact arrangement of the waxy drips.

The Man from the Getty

13

"Watch the Papers!"

APRIL 1994

harley Hill was now steeped in the details of Edvard Munch's life. With the Getty's cooperation lined up, Hill was eager to bring Chris Roberts on stage. The problem was that no one had heard from the thieves.

It was mid-April, and *The Scream* had been gone two months. It was time, Scotland Yard decided, to coax the crooks out from hiding. Dick Ellis knew a dubious art dealer in Paris and prevailed on him to spread the word that the Getty was eager to work a deal for *The Scream*. There was nothing special about Paris in this case, except that it wasn't London, so there would be no reason to suspect that Scotland Yard was involved.

In order to clear the way for the real thieves, Hill had to get rid of the pretenders. The first order of business was to dismiss Billy Harwood, the English criminal who had served time in a Norwegian prison and claimed to know the thieves who had *The Scream*. Harwood, the British cops had decided, was a scam artist.

Hill phoned Harwood. He was Chris Roberts, he said, the man from the Getty, working with Norway's National Gallery to recover *The Scream*. For this conversation, all Hill's newly acquired opinions on such matters as Munch's use of bold colors to convey emotional turmoil were beside the point. Hayward was a waste of time, and Hill was a man in a hurry.

One appealing aspect of undercover work, Hill liked to say, was that it gave him a chance "to call on certain of my less attractive character traits—arrogance, bullying, self-importance—it's a long list, but you get the idea." He spoke lightly, as if he were joking, but, fittingly for an undercover man, Hill liked to hide in plain sight. Many of his jokes were simply unpalatable truths.

For undercover cops, who operate more or less on their own, bullying and self-importance *are* perennial temptations. Grandiosity is an occupational hazard. "The undercover stuff can get to you," Hill once remarked. "You start believing your own bullshit, thinking you're completely immune to having to address anything that smacks of the difference between right and wrong."

Despite his scholarly tastes, Hill had a menacing, domineering way about him, and he used it to his advantage. Skinny when he was young, he had grown into a burly man. In a good mood, Hill had a teddy bear look, but the softness was deceptive. Like anyone with a bad temper, he felt a certain pleasure in giving way to his anger. During his days as a beat cop, Hill had pounded more than one mugger to the ground, and the memory of blows delivered (and caught) still pleased him years later. There was a code involved, and Hill would never pick on a little guy. But he believed in frontier justice, and he liked to quote a passage from *Elmer Gantry.* "He was," Sinclair Lewis wrote of his title character, who had started a brawl, "in that most blissful condition to which a powerful young man can attain—unrighteous violence in a righteous cause."

Hill was that rare creature, a bully with a taste for literature, and it was typical of him not only to see bliss in a beating but also to quote an author in support of his view. Now, as Chris Roberts, he shoved Billy Harwood out of his way.

The message wasn't subtle. In almost so many words, Hill told Harwood to go to hell. He was asking too much, he was an asshole, and nobody was going to have any dealings with him. Harwood stammered in dismay and repeated his eagerness to help the authorities. "Mr. Helpful Citizen," Hill scoffed, once Harwood was out of the way. "And all he asked in exchange was £5 million." The National Gallery, following Scotland Yard's instructions, made a great fuss of announcing that anyone who had any information about *The Scream* should contact Jens Kristian Thune, the museum's chairman of the board. Thune was a prominent and prosperous lawyer, but he had been chosen as mission control for the recovery of *The Scream* essentially by default. More worldly than the rest of the crew at the National Gallery, the portly and red-faced lawyer seemed better suited than any of the other museum officials to serve as the intermediary between the National Gallery and the public.

But all this—the theft of a masterpiece, the clamor from the world's press, the presence of Scotland Yard, the hatching of undercover schemes was new and astonishing to Thune, who found himself living inside one of the thrillers he liked to read. When *The Scream* was stolen, he had been National Gallery chairman for less than a week. The position, as it had been explained to him, was largely honorary. He would be expected to attend a few board meetings a year and to help choose a new director when Knut Berg retired the following year. No heavy lifting, except for the occasional glass of wine at a fundraiser.

On Friday, February 10, the day before the theft, Berg had taken his new chairman on an attic-to-basement tour of the National Gallery. Thune met all the museum's employees, visited the guard's security station, and marveled at the Munch exhibit. The next morning, Saturday, he drove with his family to the main train station in Oslo, headed for Lillehammer and the opening ceremonies of the Olympic games. At 6:25 in the morning, the taxi passed in front of the National Gallery. Thune chattered excitedly to his family about the museum and his new job and the tour he had taken the day before.

Had the taxi been four minutes later, he might have seen a ladder standing curiously out of place.

Ж

Thrilled that the job of art museum chairman had magically given him entrée to a world of hard-boiled detectives and shady informants, Thune performed his new duties zealously. He was especially pleased with the tape recorder that the police had rigged up in his office. Each time the phone rang, he eagerly pressed the "record" button.

The calls poured in, the tapes rolled, and the red herrings piled up. Many tips seemed so transparently dubious—"Buy me dinner and a drink and I'll make it worth your while"—that the police could reject them at once. Some leads took time and trouble to investigate. In early April, a police source told Leif Lier, the detective in charge of the investigation, that Munch's painting was in Stockholm in a locker at the train station. *The Scream* had been taken from its frame—Lier groaned—and stuffed inside a hockey bag. The Norwegians prevailed on their colleagues in Stockholm to check out each of the thousands of lockers in the train station. The search began on April 3, Easter Sunday, interrupting the Swedish cops' holiday. It took three days. Nothing.

The breakthrough finally came on Sunday, April 24. Thune had a cousin by marriage named Einar-Tore Ulving, who happened to be an art dealer. Small and high-strung, with a large, bald head that made him look a bit like Elmer Fudd, Ulving didn't cut much of a figure. He had a sharp eye for a deal, though, and his business had prospered. Ulving owned a summer house and a part-interest in a hotel (both properties only a short distance from Munch's summer house, in the town of Åsgårdstrand), and he liked to swoop low over the Norwegian countryside in his helicopter.

One of Ulving's clients stood out. His name was Tor Johnsen,* and he and Ulving made a strange pair. Ulving was soft and nervous, with the scrubbed-pink look of a ten-year-old buffed and honed for a piano recital; Johnsen was big and disheveled and, if not quite handsome, at least somewhere in the vicinity. Above all, he was menacing. Johnsen was, in Norwegian parlance, a "torpedo"—an enforcer, or leg-breaker, whose job was to convince people who owed money to Johnsen's employers that it would be prudent to pay up. He had spent a dozen years in prison for setting fire to a house and killing several people inside. Between stints in solitary— Johnsen repeatedly attacked the prison guards—he had taken up Thai

*A pseudonym

kick-boxing. Strong, agile, and bad-tempered, he became a jailhouse star and later a Scandinavian champion.

In the early 1990s, Johnsen developed an unexpected interest. He began showing up at art galleries and auctions, both buying and selling paintings. Ulving had noticed the "well-dressed, good-looking" newcomer but had not caught on immediately to his true character, perhaps because at their first meeting Johnsen was accompanied by a well-known and wealthy shipowner (the two had met at the racetrack). Soon enough, Ulving learned enough to fill in a little of Johnsen's biography. Still, he was an art dealer, not a social worker. Johnsen became a valued customer.

Toward the end of April 1994 Johnsen phoned Ulving. He knew some people, the ex-con said, who could arrange for *The Scream* to be returned to the National Gallery. He remembered, too, that Ulving and Thune were cousins of some sort. Maybe Ulving could give Thune a call.

On April 24, Ulving phoned Thune. Ordinarily, Ulving would have highlighted the good points of someone he was vouching for. Here, in an attempt to boost Johnsen's credibility as a thief and a friend of thieves, he stood the usual formula on its head. "I told him that Mr. Johnsen's reputation was not very good," Ulving recalled years later. "I told him he was a violent man. I told him he had been sentenced to jail for twelve years. So Mr. Thune knew all about him. And he asked me, 'Do you think this is substantial?' And I said, 'Based on what I know about Mr. Tor Johnsen, I think this is really substantial, and should be followed up.'"

When Ulving reported back to Johnsen, he admitted that he didn't know how seriously Thune had taken his message. For the next few days, Johnsen replied, it might be a good idea to keep an eye on the newspaper.

The next day, April 25, the top crime reporter at *Dagbladet* picked up his phone and heard a familiar voice. The caller had passed along useful tips in the past, and now he claimed to have information about *The Scream*. He couldn't say more than that on the phone.

The reporter, Gunnar Hultgreen, arranged to meet his informant faceto-face. Hultgreen rattled off questions, but the informant ducked them, on the grounds that he was only delivering a message. He mumbled something vague about "evidence" that would support his story, rattled off a few place names, and told Hultgreen to find a photographer. Hultgreen scribbled names and crude directions in his notebook—Nittedal, just east of Oslo; signs for Skedsmokorset; the village of Slattum; a right turn; a bus stop.

Hultgreen nabbed one of the newspaper's photographers. Then he phoned Lief Plahter, the chief restorer at the National Gallery, and told him he would pick him up in a few minutes. Plahter had worked on *The Scream* and knew it well.

Nittedal was about a dozen miles east of town, but the informant's directions were frustratingly sketchy. Eventually the reporter, the photographer, and the art restorer found a likely bus stop and inched along the road nearby, scanning the ground, though they weren't quite sure what they were looking for. Finding nothing on their first sweep, they turned around and crept back toward the bus stop.

It was the photographer who shouted first. "Could that be it?"

He had spotted a piece of carved wood a few inches long in the grass by the side of the road. The three men scrambled out of the car, the white-haired art restorer trailing his younger colleagues.

"Oh, my God," Plahter cried, as soon as he caught up with the others. "This is the frame."

It was, more precisely, a short section of the frame, lying upside down. No one touched it, in case the thieves had left fingerprints, but Plahter bent down for a closer look. He had recognized the frame at once because of its color and design, and now he saw indisputable proof that this small piece of wood was what it purported to be. Plahter pointed at the neat lettering on the back of the frame and read off the National Gallery's identification number.

The next day's tabloid headline screamed out, WE FOUND THE FRAME.

14

The Art of Seduction

The discovery of the frame was a good news-bad news joke on a giant scale. On the plus side, the police were finally dealing with actual thieves rather than hoaxsters and con men. Almost as important, it seemed likely that *The Scream* had not been smuggled out of Norway to some more remote hideaway. But the minuses were plain, too. If Munch's masterpiece had been removed from its frame, the painting was as vulnerable as a turtle taken from its shell. And the thieves were still at large.

Ulving, the art dealer, assured the Norwegian authorities that he was merely a good citizen caught up in a story that had nothing to do with him, and doing his best to cooperate with the authorities. This was not the first time, he said, that he had helped the police recover stolen paintings.

In 1988, thieves had stolen a number of Munch paintings and lithographs from private homes around Oslo. Out of the blue, someone phoned Ulving, trying to sell him a Munch lithograph. Ulving knew by the work's description that it had been stolen and called the police. They told Ulving to go ahead with the deal, but the thief caught sight of the police lurking near the designated rendezvous and fled.

Several days later Ulving's contact phoned him again, offering more Munch works. Ulving told the police again. They proposed another trap. This time Ulving was to say he wanted to buy several of the prints and paintings, rather than just one, for a client in Germany. Since the art was stolen, Ulving would offer only KR 1 million, about \$125,000. The art dealer and the thief agreed on a deal. The police rented an apartment above the thief's, so they could keep watch uninterrupted. On a Saturday morning shortly before the assigned meeting time, a detective phoned Ulving. The thief had left home, and they had a car tailing him and a plane overhead tracking him. He was headed *away* from Ulving; if he arrived at all, it wouldn't be for a long time.

Two minutes later, Ulving heard a knock on the door.

The thief burst in. "Everything ready?"

The police, Ulving later learned, had followed the wrong car. The thief hadn't been in Oslo for two days. While the surveillance cops monitored an empty apartment in Oslo, the thief had checked into a hotel in the countryside, in the tiny town of Åsgårdstrand. Ulving did a double-take. *The hotel in Åsgårdstrand?*

Ulving stalled for time. It would take him a little while to get the money together, and they needed to set up a new rendezvous. Once he had pushed his guest out the door, Ulving phoned the police and launched into an astonishing tale.

The hotel the thief had chosen for himself, of all the hotels in Norway, happened to be the one that Ulving owned! The coincidence was, Ulving would agree in an interview years later, "so strange, really unbelievable." Ulving phoned his hotel manager and told him to check the register of the tiny establishment. Look for a room booked two nights before, by a male guest, traveling alone.

One name fit. The manager hotfooted it to the room. There, in the closet, he found seven stolen Munch paintings and lithographs. The police, in the meantime, nabbed the thief at the rendezvous.

Despite the happy ending, Ulving said the experience had left him gun-shy. One brush with thieves was more than enough. Who knew what might happen if he got mixed up with cops and crooks again?

To Charley Hill's suspicious mind, everything about Ulving rang false. What was this good Samaritan doing tangled up in another stolen art case? Ulving insisted that his relationship with Johnsen was aboveboard. He was an experienced and knowledgeable art dealer; Johnsen had only recently discovered art. What could be more natural than for an expert to help a novice develop his eye? Hill's working theory was far simpler: Johnsen brought Ulving art that he had stolen (or that someone he knew had stolen), and Ulving sold it. Ulving was a "typical art dealer, a mendacious son of a bitch, just patently and obviously weasely."

The dogmatic tone was characteristic. Hill knew and admired dozens of serious, thoughtful, dedicated art dealers, and yet, confronted with a single dealer he thought was shady, he could forget all that in an instant. "Art dealers are used car salesmen," he complained, thinking of Ulving but generalizing wildly, "except they have all the upmarket social graces."

In other aspects of his life, Hill was prone to spectacular pratfalls, but he took great pride in his ability to read people. He made judgments about people quickly and amended them slowly or not at all. Whether his instinctive dislike of Ulving reflected insight or only nasty-mindedness was hard to know. Cops spend their careers scanning the gutter, and it is not a vantage point that gives them a sunny view of human nature. On one idyllic spring day years before he had ever met Ulving, Hill happened to see a jogger pass by in Richmond Park, the biggest and greenest open space in London. "Probably a rapist," Hill muttered, "looking for some mum who's only thinking about her baby in his stroller."

The novelist and ex-prosecutor Scott Turow could have been thinking of Hill when he called cops "our paid paranoids." "A copper sees a conspiracy in a cloudy day," Turow wrote. "He suspects treachery when you say good morning."

Ж

Though Hill disliked and distrusted Ulving, he had no doubt that he could win him over. Over the years, he had learned how to befriend all sorts of crooks and liars. In his line of work it was an essential skill. "That's been my great strength," he once observed, "to be able to develop rapport with criminals who tell me things they wouldn't tell anybody else."

Oddly, Hill's gift for forging alliances seems to work at both ends of the social scale but to fail in the middle. Killers will happily drink with Hill, and lords and ladies, too, but good, solid, salt-of-the-earth citizens purse their lips in distaste and back away.

"Now, that's an example of a man who's a killer and a horrible scumbag in anybody's book," Hill said once, naming a gangster, "and yet he and I can talk as easily as you please." Not long ago the two men met for a drink, in a bleak pub long after midnight. The bartender recognized Hill's companion as soon as he walked in. His hands trembled as he served their drinks.

"That son of a bitch is a fucking Khyber Pass bandit, British-version," Hill said later. "But when he meets someone who isn't frightened of him, and it's someone who's not out to do him harm, he likes talking to him. That's the way these guys operate. It's like Kipling's poem: "There is neither East nor West, Border, nor Breed, nor Birth, / When two strong men stand face to face, tho' they come from the ends of the earth."

At the other end of the social spectrum, Hill noted proudly, he and the Duke of Beaufort can happily pass an afternoon talking about art and armagnac. And though Hill would gladly visit with either the gangster or the duke, the two men on their own could not possibly find even an inch of common ground. "Never," said Hill. "It couldn't happen. Not unless [the gangster] sneaked into Badminton, held a gun to the duke's head, and locked him up in a cupboard in the bedroom with the duchess while he ransacked the place. That's the only rapport they would ever have."

But nobles and thieves are easy for Hill. It's those in between he finds hard. His problem is not with shopkeepers and salesmen in stores and conductors on trains; he likes turning rote exchanges into small conversations. Things go astray when Hill decides that the person across from him has his nose glued to a rule book. "If I were dealing with a bureaucrat," Hill conceded in an interview in 2003, "the chances are it would go horribly wrong. As often it has. They write me off as a snake-oil salesman, the sort of person they hate to have any dealings with, because they want to deal with bureaucratic procedures and buzz words and jargon from managementspeak."

Hill paints his failure as proof of his virtue—better to be one of Kipling's strong men than a member of the herd of "little bureaucrats feeding the meter"—and perhaps he *could* win over his enemies if he would make an effort. But he seldom does. Instead, in his encounters with those drab creatures who occupy neither the lowest nor the loftiest margins of society, Hill indulges himself in private jokes and obscure allusions.

Occasionally Hill finds himself called on to talk to a group of museum officials or insurance agents. He tends to leave them bewildered. His stories begin in the middle and end without warning. He scatters endless names without explanation. Even comments that he intends as transparent leave many in his audience feeling they have wandered into the wrong lecture hall. At one talk, for instance, Hill wanted to make the point that collectors worried about art thieves must take steps to protect themselves, rather than rely entirely on the police. "In the early fifth century," Hill remarked, "the Roman emperor wrote to a group of complaining Roman Britons that they should look after themselves. In the same year, Alaric the Visigoth sacked Rome, so the emperor obviously had a point about what he could do for this part of his empire."

With crooks, in contrast, Hill labors diligently to establish a bond. Honor among thieves is a fiction, but Hill has found that criminals do have a code of self-respect and self-esteem, and he has learned to turn that code to his advantage.

His role-playing takes him far from his true character. In his personal life, Hill's moral code is strict. He makes fun of his own uprightness ("I'm a Yankee Puritan of the worst kind, a Brit one"), but he adamantly adheres to such old-fashioned beliefs as the sanctity of promises and the obligations of friendship. His penchant for truth-telling is so extreme perhaps this is part of its attraction—that often it verges on rudeness. At work, on the other hand, lying is a job skill as fundamental as driving. Chatting up criminals and spinning stories to thieves is all in a day's work. For crooks, too, lying is second nature. One of his favorite sources, Hill says fondly, has "a capacity to lie that makes your eyes water."

Whether he is working undercover or as himself, Hill relies less on tricks than on the standard repertoire of anyone bent on seduction. He is outgoing but low-key, far too reserved and English to go in for backslapping or joke-telling. But he is friendly and solicitous, good with names, attentive to even the longest and most rambling stories. Some of this is simply good manners, but it goes deeper than that. "Even a villain has some humanity," Hill remarks, "and the trick is finding a way to connect with it."

Well before the Munch theft, Hill had begun cultivating a network of criminals and near criminals with good sources in the art underworld. The meetings are clandestine, but Hill is not undercover. Watch him at work as recently as 2002, at dinner with an informant he has known for years. Tom Russell* is a fit, sixty-ish man who looks like Anthony Hopkins, or as Hopkins might if he had gone in for gold jewelry and shirts that revealed great tufts of chest hair. Despite the flash, Russell occupies a lowly, vulnerable spot in a dangerous business. In the ecosystem of the London underworld, he is a small, scurrying animal trying to live by his wits among a host of bigger creatures with short tempers and sharp teeth.

Hill and Russell make a curious pair. The two men look and sound nothing alike. Hill, resplendent in his blazer, looks like a weekend sailor who has popped into his club for a few drinks. Russell looks as if he has been up all night in Atlantic City, and losing. Hill sounds posh; Russell speaks in the London equivalent of a dese-and-dose accent, in short bursts that overflow with slang and underworld shorthand. "A million quid" becomes "a million squid." "Nothing" is "nuffink." A job that was supposed to be easy "were going to be a piece o' piss."

And yet the two seem like old friends. Rivers of drink lubricate the conversation. Hill is a self-described heavy drinker, and Russell is not far behind. Tonight Hill is drinking gin-and-tonics—he's on his third before the appetizers are cleared—and Russell is having scotch. Hill, as host, makes sure that his guest is not left even momentarily holding an empty glass. (For either man to say "enough" or just to skip a round would be as unexpected as asking the bartender to brew a pot of chamomile tea.)

Russell has a lot to say, but his voice is low and his manner furtive. His eyes flicker around the room as he talks. When a waiter approaches or a patron wanders by on his way to the bar, Russell goes silent and drags on his cigarette until the intruder departs.

The recurring theme in all Russell's stories is that, despite the risks he takes on their behalf, the police constantly double-cross him. He passes on information and, instead of paying him the reward money they have promised, the police shortchange him or stiff him outright. If he complains, they threaten to hand him over to his enemies. Sometimes the betrayal is so skilled that it is almost artful. "I've been shagged so beautiful I never even felt it," Russell laments.

*A pseudonym

To hear him tell it, Russell lives in an Alice in Wonderland world where those charged with upholding the law spend their days subverting it, and what little honor there is, is among thieves. "The decline in standards in this country is a disgrace," he moans. "The things that go on—it makes me ashamed. Except for three men I could name—you know who they are, Charley—I wouldn't trust the police to say an honest word."

Hill listens to all this with what seems like utter empathy. Often, as the two men talk, the tone veers from casual and light to dark and angry and back again. Russell takes the lead, and Hill adapts at once to every shift. When Russell mentions the name of one crooked cop, Hill's eyes narrow in disdain. "I really do hate that bastard," Hill snarls, and it is hard to detect the well-spoken art lover beneath the venomous mask.

"Well, then, you've got plenty of company," Russell says, "because I fucking hate him, too."

Both men turn to their drinks for a moment.

Russell does most of the talking, and when he pauses between tales of how he has been done wrong, Hill catches up on domestic news. He asks after Russell's wife and gets updates on his kids. The surgery went well? Is his son's football team off to a good start? Hill is impressed that Tom looks so fit. Is he working out? And where did he get that tan? Has he been on holiday?

This is standard banter, but Hill appears to hang on every answer. The two compare notes on old acquaintances and run through a roster of cops and robbers they have known. The rhythm of the conversation evokes sports fans at a bar, recalling the old days. "He were a right villain, weren't he?" Russell asks cheerily, when Hill throws out yet another name.

The reminiscences turn from past triumphs and follies generally to art cases in particular. Russell asks Hill if he recalls the affair of the two 'eads. Years before, a pair of thieves had set out to steal a monumental Henry Moore bronze from a garden. The statue, called *King and Queen*, proved too massive to move, so the thieves took a chainsaw to the figures and cut off their heads, figuring they could at least sell those.

Russell's usefulness to Hill is that, one way or another, he hears lots of gossip and rumors about stolen art. "I'd have no compunction about turning

him in if he was doing the crimes himself," Hill says later, "but he's not. He just lives in that world, and he knows what's going on."

Hill does not try to connect with Russell by minimizing his own knowledge of art, or his enthusiasm for it. When Russell struggles to come up with the name of a stolen painting that had once floated through London's seamier backwaters, Charley reminds him that the missing work was Bruegel's *Christ and the Woman Taken in Adultery*. Russell's interest in sixteenth-century religious art would have to multiply many times before it could qualify as negligible, but Hill rattles on happily about Bruegel for a few minutes. Hill, at least, is rapt. Pieter Bruegel, he notes, was known as Bruegel the Elder because his son, also an artist and also called Pieter, was Brueghel the Younger, but the son spelled his name with an "h," whereas ...

The fancy talk, which seems like pointless showing off, is actually showing off with a point very much in mind. Two points, in fact. One is flattery: treating Russell with respect rather than condescension costs nothing and might earn some goodwill. More important, the highfalutin talk cements the notion that, however peculiar such devotion might be, Hill really does care deeply about art. The aim is to insure that when a stolen painting makes the rounds, Russell will make sure that Charley Hill hears about it.

How much of his camaraderie with Russell and his ilk is sincere and how much put-on, Hill himself seems not to know. Certainly his disdain for dishonest cops is unfeigned, as is his belief that they are legion. "Without exception," Hill says, "in every single job I've been involved in, there's been a corrupt cop somewhere." But Hill's distrust of the good guys does not spill over into fondness for the bad guys. He is far too cynical to believe that thieves are unfortunate souls who might have been redeemed by a kind word and a helping hand at the right time. Hill is fond of invoking the great names of English history and legend, but the tales he likes best are of knights errant battling black-hearted villains. There are no Robin Hoods in Charley Hill's Britain.

Hill's wife is a smart, insightful woman (and, by profession, a psychologist) who has often rebuked him for taking too rosy a view of his "horrible" acquaintances. Charley, she says, makes the mistake of thinking that because his informants are trying to *do* something good—help him find stolen paint-

104

ings—they *are* good. The notion makes her indignant. "These are not good people," she insists, as she has a hundred times before. "These are bad people, and the only reason they'd help to get a painting back is so they can tell somebody—a parole officer or a judge or someone—that 'I helped Charley Hill.' They're manipulative, they've screwed a lot of people in the past, and now they're simply trying a new maneuver, entirely for their own benefit."

Hill mounts a halfhearted defense, to little avail. (His acknowledgment that many of the characters he mingles with are "pretty appalling human beings" is perhaps a shade too cheerful.) The problem, his wife goes on, is that Charley decides to think the best of his dubious acquaintances ahead of time, because otherwise he could never behave in the friendly way he must if he is to forge alliances, and then he performs so convincingly that he takes himself in with his own act.

It might seem a tough position for a professional cynic, to hear himself accused by the person who knows him best of holding a naively sunny view of human nature. Hill doesn't seem much fazed, in part because the charge of naiveté doesn't quite hit home. His tolerance has a different source. F. Scott Fitzgerald famously observed that "the test of a first-rate intelligence is the ability to hold two opposed ideas in the mind at the same time, and still retain the ability to function." First-rate or not, many of us display such abilities every day. We scan a story on page one about astronomy and the cosmos, and then we turn to the back pages and read our horoscope to see what the day has in store for us.

When it comes to judging friends and lovers, though, people tend not to be so tolerant of contradiction. A lover who betrays us reveals his *entire* character in a new and damning light. "I thought I knew you!" we cry, in a howl of anger and bewilderment. Hill has a rare talent for viewing character in a double light. He can look at one of his criminal cronies and say, "This is someone whose company I enjoy" *and* say, "This is a dangerous person who would sell me out without a second thought."

Hill is not merely tolerant of violent and dishonest men, though, but drawn to them. The fascination is not so much with the men themselves—often they are merely schoolyard bullies grown up—as with the opportunity they offer. Crooks mean action.

Hill's character is a mix of contrary pieces, and "restlessness" is one of the most important. In his case, restlessness is a near neighbor of recklessness. It takes a jolt of adrenaline to give life its savor. Years ago a friend dubbed him "Mr. Risk."

Hill is a man willing to put up with a great deal for a chance to experience something new: he insists that his motive for volunteering to jump from airplanes and to fight in Vietnam was "intellectual curiosity." Crooks and con men, whatever else they may be, are not boring. For a man as temperamentally allergic to blandness and routine as Hill, that is a virtue almost beyond price.

"I like dealing with these people and trying to work out how they think and what they're about," he once said, in a moment of uncharacteristic defensiveness. "I find it a hell of a lot more interesting"—his tone had darkened and his customary belligerence had returned—"than sitting in some office pondering mankind in the abstract, or counting beans about how the rate of one kind of crime compares with the rate of some other kind."

"The awful truth," Hill went on, "is that I tend to like everyone and dislike everyone, including myself. I prefer the company of robust people. I suppose it's a matter of taste. I prefer to drink a gutsy rioja to some godawful chardonnay."

"Robust" was coy. Hill's real preference is for people and situations that offer the enticing possibility that at any moment things could go disastrously, irretrievably wrong. 15

First Encounter

MAY 5, 1994

ith the discovery of *The Scream*'s frame, the police finally had the break they needed. The Norwegian police and Thune, the National Gallery's chairman of the board, contacted Charley Hill and caught him up on the players: Johnsen, an ex-con; Ulving, an art dealer playing the role of middle man.

Hill phoned Ulving at once. "This is Chris Roberts. I'm a representative of the Getty in Europe, and I hope we can meet." Hill gave a phone number in Belgium.

The Belgian number was a tiny ploy. To hide any connection with Scotland Yard, Hill told Ulving he was based in Brussels. The Belgian police had taken care of the phone setup as part of a thank-you for Scotland Yard's help in recovering the Russborough House Vermeer in Antwerp a few months before.

Hill suggested to Ulving that he fly to Oslo so they could meet and negotiate the painting's return. A good idea, Ulving said, and he suggested that Hill not come empty-handed. Half a million pounds sounded right. In cash.

The money came from Scotland Yard, which kept a cash account for undercover operations. It fell to Dick Ellis, an Art Squad detective, to sign for the money, £500,000 in used notes. Taking responsibility for so much money, even briefly, was not an assignment anyone would seek. It carried all the potential for calamity of, say, being drafted to baby-sit a prince of the realm. In a long career, Ellis had never been involved in a deal with so much cash. He stuffed the bills, bundled in slabs, into a sports bag, nearly filling it. The plan was to fly the money to Oslo first thing the next morning. It would be too early in the day to sign the money out then, so Ellis planned to leave it overnight in a Scotland Yard safe.

The bag proved too big for the safe. Ellis decided to lock it in his office. "The Yard's a pretty secure building," he says, "but I can tell you that was a long night." The next morning, Ellis says dryly, "I was there on time."

On the morning of May 5, Ellis handed the cash to a thick, burly detective, an armored car in human form, called Sid Walker.* Six feet tall and 230 pounds, with a deep voice and a gruff manner, Walker looked like someone best left alone. In a long undercover career, he had convinced countless criminals that he was one of them. When he was young—he was about fifteen years older than Hill or Ellis—he had gone in for wrestling and rugby, and he still came across as formidable. Sometimes too much so. "He's been hired for more contract killings than some contract killers," Ellis says admiringly.

Walker's fellow cops, who gave one another a hard time almost as a matter of reflex, spoke of his coups with something approaching awe. But a few roles—shady art connoisseur, for one—lay beyond his reach. "Drugs, guns, contract killings, anything like that, and Sid was perfect," Charley Hill remarked. "Because he looks like a gorilla, and he sounds like one."

Despite appearances, Walker was quick-thinking, as agile mentally as he was physically—so experienced that almost nothing took him by surprise. He was well-organized, too, and he had laid down the guidelines that governed all of Scotland Yard's undercover operations. Walker had been Hill's mentor when the younger man first ventured undercover, and he had come to the rescue more than once when Hill had managed to offend his superior officers and get himself banished to Siberia.

Hill revered him. "He was, quite simply, the finest undercover officer of his generation," Hill has said on more than one occasion, "and he also

*A pseudonym

happens to be a personal friend whom I trust implicitly." When the Art Squad put together its plan for retrieving *The Scream*, Hill made only one demand: Sid Walker had to be part of the team.

Ж

With the cash ready and a plan in hand, the *Scream* team set off from Scotland Yard to Oslo. There were three players: Charley Hill, playing Chris Roberts; Sid Walker, whose job was to guard Hill and head off trouble; and John Butler, the head of the Art Squad, who would stay in the background but would run the operation.

Hill arranged to meet Ulving in the lobby of the Oslo Plaza, the swankiest hotel in town, a brand-new, gleaming high-rise. Hill, Walker, and Butler had rooms on different floors. Walker would arrive first, on his own. With the help of the Norwegian police, Butler would transform his room into a command bunker for the operation. Hill would show up last, late in the evening.

On the morning of May 5, Walker strolled through security at Heathrow Airport with the £500,000 in his carry-on bag. Baggage inspections were rare in those pre-9/11 days, but airport security hadn't been let in on the story. If someone found Walker's money and wanted to know what he was up to, Sid would have to dream up an explanation.

Hill flew into Oslo, rented the most expensive car at the airport, a topof-the-line Mercedes, and sped into town. Always a bold figure, he dashed on stage at the Plaza with the bravura of a Broadway star emerging, already singing, from the wings. He wore a seersucker suit, a white shirt, and a blue bow tie with big green dots, and he piled out of his Mercedes, bills crumpled in his hand for tips, beckoning one bellman to see to the car and another to grab his bags. Then he strode through the lobby to the front desk.

"Hi there," in a loud and unmistakably American voice. "I'm Chris Roberts."

Ulving was waiting in the lobby with Johnsen. Ulving perked up when he heard Hill, and he and Johnsen came rushing over to introduce themselves.

Sid Walker was already in the lobby, keeping a surreptitious eye on things. Not surreptitious enough, it turned out. Johnsen, a savvy and professional criminal, spotted Walker—though, for the moment, he kept silent—and recognized at once that he didn't belong. Why was a roughneck like that hanging around the hotel?

It was ten o'clock at night. Hill told Ulving and Johnsen that after he went to his room and changed, they could meet for a drink. Soon after, the three men settled in at the Sky Bar in the hotel's rooftop lounge. Minutes later, Walker came into the bar. Johnsen turned accusingly to Hill.

"Is he with you?"

Hesitation could mean disaster.

"Of course he is," Hill barked at once. "He's the guy who's going to look after me. I'm not going to come into this town with a lot of money just to have you take it off of me." Johnsen seemed to buy it, so Hill beckoned to Walker to come over.

The danger was that Walker had no idea about the conversation he had missed. He could only guess what Hill had been saying, and if he guessed wrong they were both in serious trouble. With Johnsen already on edge, Hill knew that the least signal from him to Walker—a raised eyebrow, for instance, as if to say "Careful now!"—was impossible.

"I saw you downstairs," Johnsen challenged Walker.

Walker was dismissive. "Yeah. You did. What do you want me to do, sit in my room all day?"

Hill launched into the cover story he and Walker had cooked up ahead of time. Walker was an English criminal who lived in Holland and occasionally did bodyguard work for Hill.

Hill had planned to introduce Walker sooner or later. Maybe they'd gambled when they shouldn't have. The only reason to leave Walker roaming free was the vague hope that he might turn up something intriguing. Hill hadn't figured on Johnsen spotting the competition so quickly. Could he turn that to his advantage? Johnsen would be pleased with himself; maybe his pride in his own shrewdness would lead him to lower his guard a bit.

Hill figured the cover story rang pretty true. Walker wasn't the kind of guy you asked a lot of questions about, because one look at him seemed enough to resolve any mystery about the line of work he was in. And it made sense that the man from the Getty would have a bodyguard to watch out for

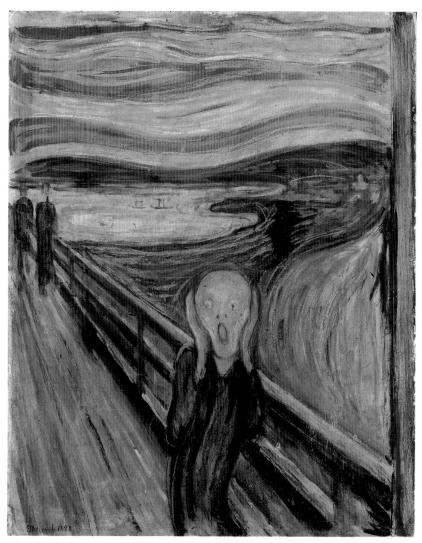

Edvard Munch, *The Scream*, 1893 tempera and oil pastel on cardboard, 73.5 × 91 cm PHOTO: J. Lathion; © National Gallery, Norway / ARS

Edvard Munch painted *The Scream* in 1893. It is his rawest, most emotional work and was inspired by an actual stroll at sunset. "I stopped, leaned against the railing, dead-tired," Munch recalled. "And I looked at the flaming clouds that hung like blood and a sword over the blue-black fjord and city.... I stood there, trembling with fright. And I felt a loud, unending scream piercing nature."

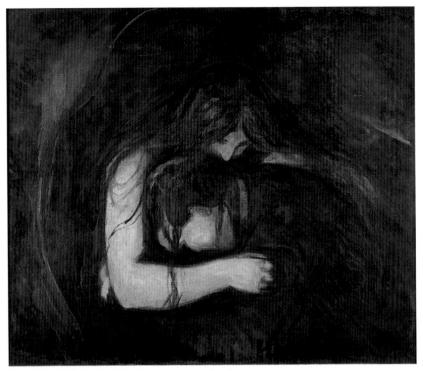

Edvard Munch, *The Vampire*, 1893–94 oil on canvas, 109 x 91 cm Munch Museum, Oslo. © Munch Museum / Munch-Ellingsen Group / ARS 2004

The Vampire, perhaps the second most famous of Munch's paintings, was itself once stolen. Munch feared women and yearned for them; his painting, originally known as *Love and Pain*, was about the anguish that accompanies love, not about literal vampires.

The Sick Child depicts the deathbed of Munch's sister, Sophie. The girl's mother looks on helplessly. At one of his first shows, Munch approached The Sick Child only to find a rowdy crowd gathered before it, "laughing and shouting" in mockery.

Edvard Munch, *The Sick Child*, 1885–86 oil on canvas, 120 × 118.5 cm PHOTO: J. Lathion; © National Gallery, Norway / ARS

RIGHT: Francisco de Goya, Dona Antonia Zarate, c. 1810 oil on canvas, 82 x 103.5 cm © Courtesy of the National Gallery of Ireland

In an undercover sting that reached its climax at an airport in Belgium, Charley Hill recovered two immensely valuable paintings stolen from Russborough House in Dublin. Both paintings were stashed in the trunk of a car, Goya's *Dona Antonia Zarate* rolled up like a cheap poster, Vermeer's *Lady Writing a Letter with Her Maid* concealed inside a plastic trash bag.

Only thirty-five Vermeers exist, and over the years three have been stolen. One, *The Concert*, has been missing since 1990.

Jan Vermeer, Lady Writing a Letter with Her Maid, c. 1670 oil on canvas, 71.1 x 60.5 cm © Courtesy of the National Gallery of Ireland

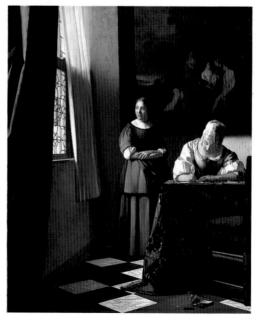

Bournemouth News & Picture Service

In 1995, thieves stole Titian's Rest on the Flight into Egypt, worth perhaps \$10 million, from England's Lord Bath. An ex-hippie, an artist himself, and a self-proclaimed womanizer (portraits of seventy-one of his "wifelets" adorn his home), Lord Bath had inherited the painting from an ancestor who purchased it in 1878. After a seven-year search, Charley Hill recovered the painting. Here Lord Bath returns his Titian to its rightful place in Longleat House.

Longleat House is huge and isolated, with 100 rooms and grounds that stretch across 9,000 acres. Like Britain's other stately homes, it is a sitting duck for thieves. By the time police arrive, the crooks have long since fled.

In 1961 Goya's *Portrait of the Duke of Wellington* disappeared from London's National Gallery, which had purchased it only weeks before. The painting was recovered four years later, but it made a cameo appearance in 1962 in the first James Bond film, *Dr. No*, in the villain's Caribbean hideaway.

Francisco de Goya, *Portrait of the Duke of Wellington*, 1812 oil on wood, 52.4 x 64.3 cm © The National Gallery, London

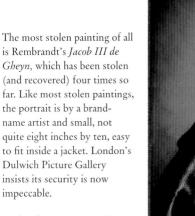

Rembrandt Harmensz. van Rijn, Jacob III de Gheyn, 1632 oil on panel, 24.9 x 29.9 cm © Dulwich Picture Gallery

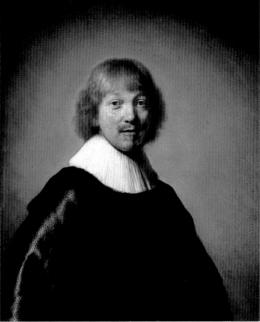

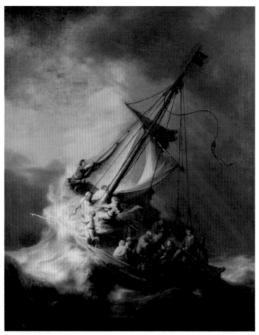

Rembrandt Harmensz. van Rijn, *Storm on the Sea of Galilee*, 1633 oil on canvas, 127 x 160 cm © Isabella Stewart Gardner Museum, Boston, MA / Bridgeman Art Library

On March 17, 1990, two thieves broke into the Isabella Stewart Gardner Museum in Boston and stole \$300 million worth of art. Mrs. Gardner's will stipulated that her museum be kept just as she had arranged it. Below, a visitor looks at the frame that once held Rembrandt's only seascape, *Storm on the Sea of Galilee*. The painting itself is shown left.

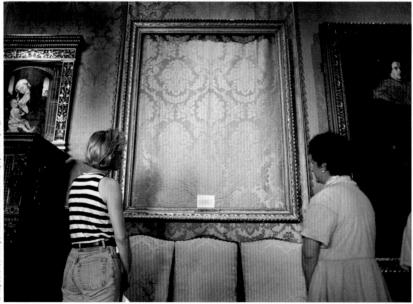

Edouard Manet, *Chez Tortoni*, 1878–80 oil on canvas, 34 x 26 cm © Isabella Stewart Gardner Museum, Boston, MA / Bridgeman Art Library

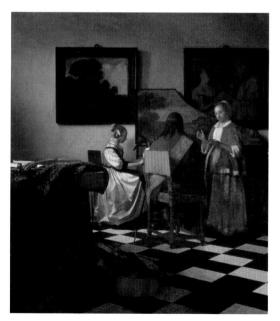

The Gardner theft was the biggest in the history of art. The greatest prizes included Manet's *Chez Tortoni* and Vermeer's *Concert*. The case remains unsolved, and all the paintings are still missing.

Jan Vermeer, *The Concert*, c. 1658–60 oil on canvas, 64.7 x 72.5 cm © Isabella Stewart Gardner Museum, Boston, MA / Bridgeman Art Library

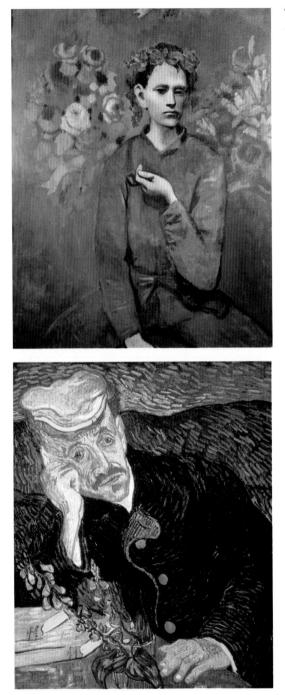

The highest price ever paid for a painting was \$104.1 million for Picasso's *Boy with a Pipe*, at a Sotheby's auction in May 2004. *Boy with a Pipe*, not considered one of Picasso's masterpieces, set a record that eclipsed the previous high, \$82.5 million for van Gogh's *Portrait of Dr. Gachet.* Prices like those make news. The news draws crowds, and not all those in the crowds are solid citizens.

Pablo Picasso, *Boy with a Pipe*, 1905 oil on canvas, 81.3 x 100 cm © Collection of Mr. and Mrs. John Hay Whitney, New York / Bridgeman Art Library / ARS

Vincent van Gogh, *Portrait of Dr. Gachet*, 1890 oil on canvas, 56 x 67 cm © Private Collection / Bridgeman Art Library / ARS him and maybe do a bit of driving, because this was a foreign country and Hill was talking about an awful lot of money. Or so a crook might reason. The Getty would never have approved the business about a bodyguard with a criminal record, Hill knew, so he hadn't told them that part of the story.

Sid was glaringly out of place in a five-star hotel. Hill admitted to himself that he and Walker should have been more careful. Walker obviously wasn't a Norwegian, and, much more important, he looked more like an armed robber than an international businessman.

Still, the close call left Hill closer to exultant than chagrined. He lived for such tightrope-without-a-net moments. "You can't waver," he'd learned in previous undercover ventures. "If you take time to gulp, you're screwed. You've got to be as calm and relaxed and nonchalant and in control as you can be. You don't run through your options. I don't, anyway. I just trust my instincts. I don't have a rational mind, and it's so much easier to trust your instincts than it is to do a calculation. Usually it works out. Sometimes you get it wrong."

This time it worked. Over the course of a few drinks, Johnsen's suspicion of Walker gave way to something almost like camaraderie. The Norwegian leg-breaker recognized in the bad-tempered English crook a brother in arms. They were both professionals; they could work together.

The rooftop bar was more a drinking spot for tourists than for locals, because the prices were as stunning as the view. For Hill, flaunting his credit cards from the Getty, money was no object. Ulving and Johnsen were suitably impressed.

Hill kept the drinks coming and the talk flowing. The conversation dipped and meandered; there was no real agenda except to convince Ulving and Johnsen that they were indeed dealing with the Getty's man. Each of the Norwegians posed a different challenge. Hill figured he had Ulving's measure. The art dealer was unsavory and full of shit, but his self-importance made him vulnerable. Hill would have to watch his step when he talked about art, but he had enormous faith in his "bullshit artspeak mode." And Ulving liked to go on about his helicopter and his hotel and all the rest, but Roberts was the big-spending, free-wheeling Man from the Getty, so Hill figured he had that angle covered, too. Johnsen posed a graver threat. He was a switched-on, alert crook, not much on charm but canny and cunning. The story about Johnsen buying and collecting art was crap, Hill felt certain. When Hill launched into art bullshit, Johnsen didn't have a clue. But he was dangerous anyway. With assholes like him, it wasn't a matter of what they knew. Instinct, not knowledge, was vital. Crooks like Johnsen operated on intuition and experience. Are you the real McCoy or not? Am I dealing with an easy mark?

The worst thing Hill could do was give Johnsen the impression he could take his money *and* keep the painting.

At the bar with Ulving, Johnsen, and Walker, Hill held forth on the strange life and career of James Ensor. He was a Belgian painter, a contemporary of Munch, an odd duck who went in for a kind of Dada-esque surrealism. The Getty owned Ensor's masterpiece, *Christ's Entry into Brussels in 1889*. That huge painting, painted five years earlier than *The Scream*, had thematic and psychological tie-ins with Munch's most acclaimed painting, "and what we have in mind is to show the great icon of expressionism and angst in juxtaposition with the great work of expressionism that relates to it in the Getty's collection."

Hill finished up with a few impassioned words about how important and groundbreaking the proposed exhibition would be. Johnsen seemed to have bought Hill's line, or perhaps he had simply sat through as much art chat as he could take.

"Can we do the deal tomorrow morning?" Johnsen asked.

"Yeah, fine," Hill said. "We can do that." He ignored Walker—Walker was a bodyguard, not a partner, and didn't need to be consulted on arrangements—and directed his attention toward Johnsen and Ulving.

"We'll meet in the hotel restaurant tomorrow, for breakfast," Hill said.

Hill strolled to the elevator and pushed the button for 16. He whistled a few cheery bars of an unidentifiable tune—for good reason, he had never tried to impersonate a musician—and headed to his room to see what the minibar might have in store. The next day's plan, he felt sure, would go off without a hitch. It didn't. 16

Fiasco at the Plaza

MAY 6, 1994

n his way to the rooftop bar, Hill had noticed that the hotel lobby seemed crowded, but he hadn't paid much attention. In the morning he learned his mistake.

While he and Walker had been drinking with Ulving and Johnsen, hundreds of new arrivals had checked in. They had not made it to the pricey top-floor bar, but when Hill walked into the hotel restaurant the next morning, he could barely squeeze through the crowd. Who were all these characters greeting one another like old pals?

Hill would have been less puzzled if he had noticed the small sign near the registration desk: "Welcome to the Scandinavian Narcotics Officers Annual Convention."

The hotel and the restaurant were crawling with plainclothes cops wearing badges that announced their name and rank. There were police and customs officers from Sweden, Norway, Finland, and Denmark, gathered in clusters around every corner and at every table. Every cop in Scandinavia, it looked like, and, along with them, wives, girlfriends, boyfriends, the works. On top of that, the Norwegian police had apparently decided on their own that they needed to protect Hill and Walker, and the entire top-of-the-range surveillance team was there as well.

The timing was terrible. Hill needed Ulving and Johnsen relaxed and

ready to deal. Would they overlook the presence of 200 cops who had popped up in the middle of the first negotiating sessions?

A worse danger still—bad enough that Hill would have to exert all his will to resist the temptation to scan the room for familiar faces—was that one of those cops might be an old friend. Over the years Hill had worked plenty of drug cases and sat through countless meetings with police and detectives from all over Europe. What if some delighted cop came running over to pound his buddy from Scotland Yard on the back?

For the time being, Hill had only Ulving to deal with. Johnsen had announced the night before that he would skip breakfast and join the others later. Hill and Ulving checked out the breakfast buffet. Cops everywhere! Ulving seemed not to mind. Could he really be the honest outsider he claimed to be?

To Hill's dismay, he spotted a high-ranking Swedish police official, a good friend. His name was Christer Fogelberg, and his expertise was in money-laundering scams. Hill had worked similar cases. Fogelberg had even modeled his unit on the corresponding one at Scotland Yard. He would be thrilled to bump into his buddy.

"Shit!" Hill thought. "He's brought the whole entourage." Fogelberg was on the other side of the restaurant, with his wife and his flunkies. "Do you mind if I sit on that side of the table, if we swap round?" Hill asked Ulving. "The sun's in my eyes and I can't see you properly."

Hill scuttled round the table and sat down with his back to Fogelberg. Now he needed to finish breakfast quickly, so that he could be gone before Fogelberg passed by his table.

Oblivious to Hill's suffering, Ulving twittered on, chattering about his business and his views on art. Occasionally he interrupted himself to take a few bites of breakfast. More chat. Now Ulving began contemplating a second trip to the buffet.

Hill, a much larger man than Ulving and normally a big eater, muttered something about getting underway. Finally Ulving finished his meal. Fogelberg still wasn't done. Hill kept his back to Fogelberg and escaped out the restaurant door.

Safely out of sight, Hill made an excuse to Ulving about needing something from his room, and raced away. Then he phoned John Butler, the head of the Art Squad, in his makeshift office in his hotel room. Hill told Butler to get a message to Fogelberg. Butler phoned Stockholm police headquarters, who delivered the message that there was a major undercover operation going on. If Fogelberg recognized anyone, he was to do nothing about it. Hill, who had no idea how long it would take to get the message through, continued to skulk around the hotel.

Hill's only "plan" in case Fogelberg *had* spotted him, he admitted to Butler, was to cross that bridge—to jump off it, really—when he came to it. "I would have come up with *something*. 'You've got the wrong guy,' I don't know, I'd turn on my American accent, I'd think of something. The best plan was to hide, which is what I did."

The escape left Hill almost giddy. He was at least as fond as the next person of telling stories that did him credit, but the stories he liked best were ones where there was nothing to do but duck your head and trust to fate. In Hill's world, a plan that worked was satisfying, but a stroke of undeserved good fortune was thrilling. Hill would have happily taken as his motto Winston Churchill's remark that nothing in life is as exhilarating as being shot at and missed.

Having alerted Butler, Hill hurried back downstairs and met Ulving in the coffee bar. By this time Johnsen had showed up. During the discussions the night before both sides had agreed on a price for *The Scream*'s return: £350,000, the equivalent of \$530,000 or KR 3.5 million. (Why the price had fallen from the £500,000 Ulving had mentioned earlier, Hill never learned.)

Walker had already converted the money from British pounds into Norwegian kroner. The fortune in cash was in the hotel safe near the reception desk, still in Walker's sports bag. Hill feared he might trip up during the money talk, blurting out something about "pounds" that would mark him as English, when, as Chris Roberts, he should have been thinking in dollars. To keep from screwing things up, he steered clear of "pounds" and "dollars" and stuck with "kroner."

Even tiny decisions like that could be crucial. Over the years, Hill had wrestled with the questions that lying brought with it—how to justify it, and when to do it, and how best to get away with it. On his bookshelves at home he had made a place for such tomes as Sissela Bok's *Lying: Moral*

Choice in Public and Private Life, but his own approach leaned more toward the practical than the philosophical. "Remember," he would say, in the earnest tone of a Boy Scout leader teaching his young charges about wilderness survival, "lies are valuable—you don't want to go around squandering them. You want to concentrate them, and you have to be effective with them."

Occasionally Hill would try to explain to non-police friends the gamesmanship at the heart of undercover work. One essential lesson: when you lie, lie big. "The *whole thing* is a lie," Hill would explain. "You're a cop on a cop's salary and you're posing as someone who travels firstclass and has half a million pounds in his suitcase. That's okay. What gets you in trouble is lying about the little things; that's when things get hard to remember and when you trip yourself up.

"If you try to remember too much, then you won't act naturally. You always want to tell the truth as much as you can possibly do. It's easier, there's no conscience involved, there's no blushing—you're just telling the truth, so there's no problem. That's part of it. The other part is that you need to convince the villains that you're a real person with a real life, and that's easier to do if you can talk more or less freely."

So Hill said. His practice contradicted his theory. In real life, as with the Getty plan, Hill rarely went for simple efficiency if he could come up with something elaborate and dangerous instead. Near the end of *The Adventures of Huckleberry Finn*, Tom Sawyer devises a complicated scheme to rescue Jim, the slave who has run away with Huck Finn and been recaptured. Huck had proposed a straightforward solution. "Wouldn't that plan work?" he asks.

"Work? Why, cert'nly it would work,..." Tom says. "But it's too blame' simple; there ain't nothing *to* it. What's the good of a plan that ain't no more trouble than that?"

Then Tom unveiled his own plan. "I see in a minute it was worth fifteen of mine for style," Huck says, "and would make Jim just as free a man as mine would, and maybe get us all killed besides."

Huck at once rejects his own plan in favor of Tom's. Charley Hill would immediately and instinctively have cast the same vote. It was midday on Friday, May 6, and the coffee bar in the Plaza was quiet. Hill's bodyguard, Sid Walker, leaned back in his chair and glared at the world. Walker's main assignment was to look menacing. He was up to the task. Hill's role was to do the talking. They were performing for an audience of two, but they had to get it right. If all went well, the two performances would complement one another—Hill's improvised blather about art and the Getty was a soothing melody line; Walker's nearly silent menace served as an almost subliminal growl, a bass line that reinforced the notion that these were indeed men accustomed to making clandestine deals.

The time was right, Hill judged, to snare Johnsen once and for all. "Sid, you want to show him the money?"

"Yeah, sure."

The etiquette here was more delicate than an outsider might have guessed. "Please" would have been a faux pas. Chris Roberts would use the word "please" for waiters and the like, to show that he was a gentleman, but he had to make sure that no macho crook took him for a wimp. If thugs sensed weakness, they'd move in. Hill was unarmed, in enemy territory. This was no time to play the ingenue.

Walker, too, had to watch himself. His job was to look after Roberts and his money. But he was playing a crook, not a servant. Any kind of "yes, boss" byplay would have been out of place, a jarring intrusion of Jack Benny and Rochester into a world where they didn't belong.

The tiny issue of saying "please" or skipping it hinted at a far larger issue. The challenge for Hill, in playing Chris Roberts, was that he had to send two messages at once, and they contradicted each other. He had to convince the crooks they were dealing with a genuine member of the art establishment and at the same time he had to come across as a man of the world who couldn't be pushed around.

Walker and Johnsen headed off toward the reception desk to look at the money. The scene played out almost wordlessly, punctuated only by a series of barely audible sounds. Footsteps on the gleaming floor, as Walker and Johnsen crossed the lobby. The click of the door to the hotel safe.

Johnsen craned his neck, trying to peek around Walker's broad back.

Walker turned toward Johnsen and held out the bag. A quiet zzziiipp as he opened it. Johnsen gawked.

Three and a half million kroner.

"You want to count it?"

No, said Johnsen, he didn't need to bother counting. The money rustled softly as Walker flicked at a stack of bills with a thick thumb. Walker locked the bag back in the safe.

Johnsen came back to the table unable to hide his excitement. Hill was jubilant. Johnsen had seen the money, and it had gone to his head. "Hooked him!" Hill thought.

Hill and Walker had known all along they had the right bait. The trick was to dangle it gently rather than to risk scaring the crooks away with too much splashing and drama. The image to convey was that this was just one more step in an ongoing business negotiation. No fanfare, no big talk, no urgency.

Hill had learned in earlier deals how fraught this moment was. You had to keep the tone casual: "Do you want to have a look at the money?" But it's not casual, it's *crucial*, because now you've captured their imagination. Now they know that all they've got to do is deliver on their end of the bargain, and all that money will belong to them. Sometimes they count it, sometimes they don't, but that's not the point. The point is for them to know the money is there. Talking about it is one thing. Seeing it is something different.

Johnsen tried to play it cool but couldn't quite carry it off. Ordinarily he left most of the talking to his art dealer pal, Ulving. Today, as always, Ulving was chattering away. But now, revved up by the sight of a bag bursting with cash that was *this close* to belonging to him, Johnsen joined in.

Then he stopped dead, interrupting himself in midsentence. Ulving, oblivious, kept whittering on. Johnsen stood up and walked over to a man sitting at the bar.

Johnsen stood behind the stranger for a moment and then rapped him hard on the back, as if he were knocking on a door. The hollow sounds echoed. "What are you doing with a bullet-proof vest?" Johnsen snarled.

The man shrank into his seat and stammered something incoherent.

The vest was borrowed; someone had asked him to test it; he'd been thinking of buying one. Johnsen cut the floundering short. "You keep staring at us over that newspaper. And you ordered your drink half an hour ago, and your glass is still full." He gestured at the man's untouched beer. "What's your game?"

No reply.

Johnsen stomped back across the room and flung himself into a chair. "The guy's a cop."

"Shit! Now what?" Hill thought.

How to explain away a plainclothes cop doing his (clumsy) best to keep tabs on Johnsen and Ulving? And if the Norwegian police had decided that Scotland Yard needed their help with surveillance, why hadn't they told Hill and Walker what they were up to?

Hill hadn't planned for this, and he had nothing ready. Something popped into his head. "Well, shit," he grumbled, "A few months back they signed the Arab-Israeli peace accords here. They must be worried about some kind of terrorist attack. I guess they've got these guys looking after all the goddamned cops and the other people here for this horseshit conference."

Hill was referring to the Oslo accords, which had been brokered in large part by Norway and signed by Yitzhak Rabin and Yasser Arafat in the fall of 1993. Hill had followed the negotiations closely. Back in London, Hill sometimes sat at his desk with a cup of coffee and a newspaper, and his fellow cops liked to tease the Professor for reading the *Times* when he could have been checking out the topless girl of the day in the tabloids.

Hill's tone, as he griped about the surveillance cops in the hotel, was nearly as important as the message. He had to sound impatient, irritated, bored with the great "discovery" that Johnsen was so excited about. Anything but flustered, even though Hill had grabbed at the business about terrorists the way someone headed over a waterfall would grab at a tree branch over the water.

Johnsen seemed convinced, or at least halfway convinced. Hill was relieved and pleased with himself. The test of an undercover man was his ability to improvise. Before he could savor his escape, Johnsen was fretting again. "I've seen other plainclothes cops around, too."

"Oh, Christ," Hill thought. Still, if the Norwegians were so amateurish that nobody could miss them, maybe Hill could turn that to his advantage. "Well, that's all the proof you need," Hill blustered. "They're obvi-

ously keeping an eye on this bullshit convention."

Hill suggested they move to another hotel and leave the cops behind. Maybe they could put the deal off a week or two. Hill was bluffing—for one thing, the head of the Art Squad had set up his command post in *this* hotel—but Johnsen didn't call him on it.

"I'm leaving for a while," Johnsen said. Off he went. Russborough House Redux

17

here Johnsen had gone, Hill had no idea. Anything was possible. He might have gone off to sulk, or to fetch a rifle so he could take the money that had been waved under his nose. But whether Johnsen was out for vengeance or merely out for a drink, Charley Hill was enjoying himself.

Art crime, Hill likes to say, is "serious farce." Both words are important to him. The art is irreplaceable, which accounts for the seriousness, but fencing with crooks is a game of sorts, too, which is where the farce comes in. But for Hill, "farce" conjures up more than Keystone Kops and crooks falling off ladders. It refers, as well, to a more cosmic contest—the endless, necessary, and futile war of the good guys against the bad.

Hill has fought in that war for years, and happily, but as "an avowed believer in original sin," he takes for granted that the police will never go out of business for lack of work. Hill's good cheer and deep pessimism coexist somehow, and in the cases he likes best, comedy and tragedy wrap around one another as tightly as they do in his own tangled heart.

The years Hill spent chasing muggers down alleyways had done little to engage him. The stakes were too low, the surprises too few, the crimes too simple. Hill didn't fully sort out what was missing until his first world-class case, the hunt for Vermeer's Lady Writing a Letter and the seventeen other paintings stolen from Russborough House by Martin Cahill in 1986.

That once-in-a-lifetime theft was in fact nothing of the sort. Thieves had hit Russborough House in 1974, before Cahill came along. They would return in 2001 and again in 2002, each time making off with masterpieces worth millions. Several paintings, including Vermeer's Lady Writing a Letter, have been stolen more than once, and Gainsborough's Madame Baccelli: Dancer has been stolen three times so far.

Hill once asked an Irish gangster named Martin Foley what he had against Lady Beit, the elderly owner of Russborough House. "It's fookin' nothin' to do with her," came the reply. "It's just fookin' easy." Russborough House is a great, rambling place, Hill notes, "with bars on the window and locks and video cameras and all that shit, but the thieves are in and out—they know what they're going to take—and it's so isolated the cops take fifteen minutes to get there."

"They enjoy doing it," Hill says. "They're violent thieves, and if anyone gets in their way they'll run 'em down." For the crooks, this is sport (though, as is the case with most sports in the modern world, the dream of riches is never far off). The media, too, treat each new attack on Russborough House as light entertainment, a perennial story not far different from Punxsutawney Phil, the groundhog, and his shadow.

If art crime in general is "serious farce," the here-they-go-again thefts at Russborough House are perhaps the ultimate example. Consider the setting, first of all. Russborough House is by repute the grandest house in Ireland. No crime scene could have less in common with the mean streets of a commonplace robbery. Next, the crime itself. Who has Vermeers and Goyas hanging on their walls?

Finally, the victims, who are too remote to win much sympathy. The late Sir Alfred was a nearly silent figure notable mainly for what one obituary called his "Teutonic earnestness." Journalists found Lady Beit equally hard to fathom. In their portrayals, she sounded like Margaret Dumont, the grande dame who played Groucho Marx's foil. In the summer of 2002, Lady Beit took a journalist on a tour of Russborough House. She gestured toward Goya's Portrait of Doña Antonia Zarate (which Hill had recovered with Vermeer's Lady Writing a Letter). "That painting means a great deal to me, for two reasons," Lady Beit explained. "Alfred was standing beneath it when he proposed to me in the house, and then during the Dugdale raid we were tied up beneath it."

The Dugdale raid, in 1974, was the first attack on Russborough House. The thieves in the various raids have been as over-the-top as the victims and Russborough House itself. Rose Dugdale, who organized that first attack, which was by far the most inept of the four robberies, was an English heiress whose trust fund paid her \$200,000 a year. Raised on a 600-acre estate (her parents also owned homes in London and Scotland), Dugdale went to school in Switzerland and then studied economics at Oxford. In her twenties she proclaimed herself a revolutionary, though it was the debutante's life she had seen in her teens that had opened her eyes and turned her stomach. "My coming-out ball was one of those pornographic affairs," she told reporters after her arrest, "which cost about what sixty old-age pensioners receive in six months."

Dugdale's first ventures into crime were marked by ambition and amateurism in roughly equal measures. In June 1973, when she was 32, Dugdale stole a miscellany of paintings, silver, and jewelry from her parents' home and was caught almost at once. The profits, it emerged during the trial, were intended for the IRA. "I think the risk that you will ever again commit burglary or any dishonesty is extremely remote," the judge declared, and then he set the defendant free.

Six months later, Dugdale proved the judge an optimist. In January 1974, while posing as a tourist vacationing in County Donegal in Ireland, Dugdale rented a helicopter for a bit of sight-seeing. She convinced the pilot to help her load an odd cargo, four milk churns. Once the helicopter was airborne, Dugdale hijacked it. The milk churns, she announced, were crammed with explosives. Dugdale's plan was to bomb a nearby police station. As it turned out, almost everyone *but* the police was in grave danger. One milk churn almost blew up inside the helicopter and had to be shoved frantically out the door. It plummeted into a river. Two other churns missed their targets and fell harmlessly into the sea. The last landed in a housing project but failed to go off. Somehow Dugdale escaped arrest. One month after the helicopter caper, on a February evening in 1974, a guard at Kenwood House, a small museum in north London, heard the crash of metal against metal and then the sound of breaking glass. He rushed in and found that someone had smashed through a barred window with a sledgehammer, grabbed Vermeer's *Guitar Player*, and fled. The break-in, the police said, was "an act of primitive violence."

The painting, renowned for its loveliness, depicts a young woman absorbed in her music and caught in midsong; somehow Vermeer contrived to paint the strings of the guitar so that we can virtually see them vibrating. In a corner of the painted scene, deep in shadow, a few stacked-up books sit neglected. The musician and her guitar glow with a honey-colored light.

The frame turned up the day after the theft, damaged, in a bush in Hampstead Heath where the thieves had thrown it. The public and the media responded to the break-in with the usual paradoxical mix of outrage and nonchalance. On the one hand, the stolen work was a priceless masterpiece and recovering it was a national priority. On the other hand, it was only a painting. Television reporters announced the robbery in breathless tones. Tellingly, though, they had to describe the missing picture without showing pictures of it, because the company that held the rights to the color slide had demanded a £10 fee for its use. Both the BBC and ITV, the commercial television channel, decided to save their money.

At this point, the story took an unexpected twist. Newspapers and radio stations began receiving anonymous phone messages. The threecenturies-old painting had apparently been stolen to right a twentiethcentury political grievance. *The Guitar Player* would be destroyed, the caller warned, unless the authorities transferred two IRA activists, sisters named Dolours and Marion Price, from a London prison to an Irish one. The Price sisters had been convicted the previous year of carrying out a string of car bombings in London. Two hundred and thirty people had been injured.

The sisters, who were themselves demanding to be transferred to Ireland and on hunger strike, had been sentenced to life in prison. But the thieves had apparently made their phone calls without informing the Price sisters of their plan. Two weeks after the theft, on March 6, 1974, an envelope arrived at the London *Times*. Inside was a tiny strip of painted canvas, about an inch long and a quarter of an inch wide, and an oddly phrased note, unpunctuated and all in lowercase, typed on a piece of thin blue paper. The strip of canvas had been cut from the back of *The Guitar Player*, the note said, and it went on, "... the price sisters have given no sign of gratitude all we have established is that a capitalist society values its treasures more than humanity therefore we will carry our lunacy to its utmost extent the painting will be burnt on st patricks night with much cavorting about in the true lunatic fashion."

On St. Patrick's Day, Albert Price, the father of the convicted bombers, issued a plea asking the thieves to return the painting. His daughters had studied art, Price said, and they didn't want Vermeer's painting destroyed. "Dolours has seen the painting," her father said, "and she told me that there were few beautiful things left and it would be a sin to destroy it. They appreciate the effort that is being made on their behalf but do not want anything to happen to the painting." St. Patrick's Day passed uneventfully.

One month later, on the evening of April 26, 1974, with *The Guitar Player* still missing, Rose Dugdale approached Russborough House on foot. She rang the bell at the service entrance, and when a servant opened the door, she said that her car had broken down. While Dugdale described her predicament, three gun-wielding men suddenly appeared behind her and pushed their way inside the house. They ordered the servant to lead them to Sir Alfred and Lady Beit, who were sitting in the library listening to music. The gunmen forced the Beits to the floor and tied them up.

Now Dugdale reappeared, telling her three accomplices which paintings to snatch off the wall. She interrupted her orders now and then to shout "Capitalist pigs!" at the Beits. Ten minutes later, the thieves fled with nineteen paintings that represented the gems from one of the greatest private art collections in the world.

A week later, the director of Ireland's National Gallery received an anonymous letter. Part of the message carried an impossible-to-miss echo of the St. Patrick's Day ransom note from the Vermeer theft the month before. The Beit paintings would be destroyed, the letter warned, unless the English authorities transferred the Price sisters to Ireland, along with two fellow prisoners and a \$1.2 million ransom. With the letter, the thieves included three pages torn from Sir Alfred's diary, which had been stolen at the same time as the paintings.

The thieves' plan made little sense-who would try to put pressure on

politicians in London by stealing paintings in Dublin?—but, regardless, the Russborough House paintings were gone. The Irish police organized a nationwide search for the thieves. On the day after the ransom letter was delivered, a policeman checking hotels and rental properties for suspicious characters peeked through the window of a small, isolated cottage near the sea, in Glandore, 200 miles from Dublin. Three oil paintings caught his eye. (These turned out to be Vermeer's *Lady Writing a Letter with her Maid*, Goya's *Portrait of Doña Antonia Zarate*, and Velasquez's *Maid in Kitchen with Christ and Disciples Outside Window*—the best of the 19 stolen works.) Rose Dugdale had rented the cottage two days before the theft. The other paintings were still in the trunk of her car. All were unhurt.

Dugdale was arrested. Only a few days later, the police in London received an anonymous phone tip bringing welcome news. They raced to St. Bartholomew's Church. In the graveyard, leaning against a headstone, inside an old newspaper tied up with a piece of string, they found Vermeer's *Guitar Player*.

Dugdale was never charged with stealing *The Guitar Player*, though the police assume that she was responsible. In June 1974, a month after she was found with the Russborough House paintings, she was put on trial in Dublin. She pleaded "proudly and incorruptibly guilty" and was sentenced to nine years in prison.

Ж

In 1986, Martin Cahill robbed Russborough House. In this second theft, in contrast with the Dugdale one, the Beits were away. Cahill's gang made off with eighteen paintings. In June 2001, the thieves were back. This was the third robbery overall, and the first in daylight. In a stolen Mitsubishi jeep, three thieves roared up the steps to Russborough House, rammed the front doors, and raced inside. Three minutes later they raced out again with Bellotto's *View of Florence* and (for the third time) Gainsborough's *Madame Baccelli*. The thieves sped away in a second stolen car. The two paintings together were worth £2.3 million.

The theft was bold but hardly polished. The thieves poured a can of gasoline over the jeep and tried, unsuccessfully, to set it on fire, and the police found a pair of used gloves inside. During their getaway, the thieves tried to hijack a car at gunpoint (to throw off police pursuit), but the driver refused to hand over his keys.

It happened again in 2002, a fourth attack on the same target, this one at dawn on a September morning. Just four days before, police acting on a tip had found the two paintings that had been stolen from Russborough House the year before. A month before that, they had recovered a Rubens portrait stolen from Russborough House in 1986. The point of the latest theft was presumably to remind the police that, despite their recent successes, it was the crooks who had the upper hand.

This time thieves stole five paintings, worth a total of \$76 million. The two best were by Rubens. His *Portrait of a Dominican Monk* had been stolen before, by Martin Cahill. This latest theft differed only in details from its predecessor of the year before. Rather than crash through the front doors, the thieves drove up to Russborough House from the back. Armed with a makeshift battering ram, they blasted through the steel shutters that blocked a ground-floor window, took what they wanted, and raced off at 100 miles an hour. The lone guard on duty in the sprawling house, a caretaker in his seventies, stood no chance.

"They do it," says Charley Hill, "because they're flipping the bird to the Irish state and the police." So far, nearly all the stolen paintings have come back. All Rose Dugdale's paintings were found with her. All but two of Cahill's haul have turned up. The two paintings stolen in 2001 and the five stolen in 2002 have all been found, by police following up on tips.

But the thieves have the advantage, and they know it. When the mood strikes, they'll hit again.

18

Money Is Honey

f the Russborough House thefts have a moral, it is that the lure of big money is only one of the reasons that thieves steal big-time art. But none of the other reasons—the notoriety, the thrill, the thieves' urge to flaunt their contempt for the patrons and collectors of art—would ever come into play if great paintings did not command stunning prices.

The giant numbers skew everything. "The first thing you have to understand about the art world," Charley Hill likes to say, "is that, with a very few exceptions, including me, everyone's a crook." This is, in part, a joke. In small part.

Hill lives in a black-and-white universe, and he contemptuously dismisses the commonplace view that the world is composed largely of honest, hardworking folk. Whether in politics or history or society at large, he sees a swarm of crooks and con men and cheaters and backstabbers and hypocrites, with, here and there, a hero.

For a man with Hill's preconceptions, art is the perfect field. Revolving around hugely desirable, one-of-a-kind objects whose value is in large measure a matter of opinion, the art world's upper tiers are a natural home for vanity, envy, and greed. Moreover, the art market is a virtually unregulated, anything-goes bazaar. In short, it is a stage for the human comedy in its most rambunctious and delectable form. "I live in a world of bollocks and bullshit," Hill says. His lament would carry more weight if he did not so plainly revel in what he professes to regret. In Hill's jaundiced view, Ulving and Johnsen were merely the latest unsavory characters he'd run across in a field beset by scoundrels and renegades. Many of the top-end players all but acknowledge that no one is quite as high-minded as he seems. They are more likely to quote than to fret about the old joke that the art trade is made up of "shady people peddling bright colors." To protest in indignation would be to proclaim oneself a novice and a rube, close cousin to the playgoer who rushed onstage to wrest a knife from the villain.

"One knows perfectly well that it has been rubbish all the time," remarked Peter Wilson, for more than twenty years the chairman of Sotheby's. "When I go and advise someone to sell their picture because now is the moment to sell it, and they're going to make more money than they'd ever dreamt of, and there's never going to be another moment like this, I know that I'm giving them the wrong advice. I should be telling them to keep their picture, because isn't that what we are telling our buyers—that now is the ideal moment to invest, and that they should all be buying?"

Ж

The rich have always collected art, but the money frenzy that now surrounds great paintings is something new. Even the highest prices from past centuries, when translated into today's dollars, fall far short of modern records. One key reason, the critic and art historian Robert Hughes points out, is that the idea of art as an investment scarcely existed before the twentieth century. "One bought paintings for pleasure, for status, for commemoration, or to cover a hole in the ancestral ceiling," Hughes remarks. "But one did not buy them in the expectation that they would make one richer."

Today that expectation—or, at any rate, that hope—is central. But if art is also business, it is a singularly strange business. Fashion and chance play central roles. A year before his death, van Gogh wrote a letter to his brother thanking him for his latest loan and boldly claiming, "I dare swear to you that my sunflowers are worth 500 francs," which would be perhaps \$500 in today's dollars. No buyer agreed. In 1987, in a frantic auction at Christie's, a bidder acting on behalf of Japan's Yasuda Fire and Marine Insurance purchased van Gogh's *Sunflowers* for \$39.9 million.

Everything can hinge on a name. Rubens's Massacre of the Innocents sold

in 2002 for \$76.7 million, at this writing the fourth highest price ever paid for a painting. For over two centuries, the *Massacre* was thought to be the work not of Rubens but of one of his followers. The family that inherited it in 1923 disliked it so—it depicts infants torn from their weeping mothers and slammed against the ground—that they tried, unsuccessfully, to sell it. Finally they lent it to an Austrian monastery, where it hung for decades in a dim corridor, ignored. Only in 2002, when the eighty-nineyear-old owner tried once again to find a buyer, was the painting properly identified. In the monastery, the painting hung in such darkness that the Sotheby's specialist who attributed it to Rubens had to wield a flashlight.

*

When the simple equations of supply and demand run head-on into the complexities wrought by human psychology, they emerge from the collision bent and twisted. High prices in the art world, for instance, may serve not as a deterrent but a lure. Record-setting prices, one New York dealer explained, work "like a magnet." For buyers, high prices confirm the value of the objects they are chasing. For sellers, high prices draw new objects to market. In the apt words of the late art dealer Harold Sack, "Money is honey."

The result is topsy-turvy bragging, where people boast not about unearthing a bargain but about spending a fortune. One New York art dealer claimed not long ago to know people who wanted to spend \$1 million on a painting and weren't particular about which one. The discovery of this quirk was perhaps the key to the success of the most famous art dealer of all, Joseph Duveen, whose glory days were the early years of the twentieth century. "Duveen's clients preferred to pay huge sums," his biographer observed, "and Duveen made them happy."

Such tackiness is not reserved for rubes. In 1967, when the National Gallery in Washington, D.C., purchased Leonardo da Vinci's portrait of *Ginevra Benci* for \$12 million, the museum's director, John Walker, pointed out that "the cost per square inch of paint... is the greatest in the history of collecting."

For similar reasons, stolen-and-recovered paintings tend to command higher prices after their return than before. What endorsement could be more sincere, after all, than someone's decision that a painting deserved stealing?

Ж

The great boom in art crime came with the skyrocketing art prices of the 1980s and 1990s. In 1961, when the Metropolitan Museum of Art paid \$2.3 million for Rembrandt's Aristotle Contemplating the Bust of Homer, the price set a record that more than doubled the previous high. Time magazine put the painting on its cover, and the story of the "million-dollar Rembrandt" dominated the front page of the next day's New York Times.

Thirty years later, at the peak of the most recent art frenzy, \$1 million would seem like small change. On the evening of May 15, 1990, in an overflowing room buzzing with chatter in half a dozen languages, Christie's auctioneer opened the bidding for van Gogh's *Portrait of Dr. Gachet* at \$20 million! From there, bids increased at \$1 million increments. Five minutes later, the portrait sold for \$82.5 million. Two days after that, Sotheby's auctioned off \$300 million worth of paintings in an hour.

Even the pros seemed awed by the new world that had emerged. "We have moved into a whole new set of prices," Christopher Burge, the president of Christie's in the United States, told the Washington Post. "A \$1 million sale once was thought scandalous and shocking—then it was \$2 million, then \$5 million, then \$40 million. The \$2 million Renoir has become a \$6 million picture. The \$6 million Renoir is now worth \$20 million, and the most important of his paintings would go for a lot more." (In 1868 Renoir traded a portrait for a pair of shoes.)*

An economics writer for the *New York Times* could only shake his head and marvel. "Great Impressionist canvases, worth as much as Rolls-Royces in the 1970s," he wrote in February 1990, "now trade at parity with Boeing 757s."

Through the rest of the 1990s, prices dropped from those record highs.

^{*}He had arranged to paint the cobbler's wife. "Every time I thought the picture was finished and saw myself wearing the shoes," Renoir lamented, "along came the aunt, the daughter, or even the old servant to criticize."

Then, in the spring of 2004, another symbolic barrier fell. In an auction at Sotheby's in New York City, in front of a large and buzzing crowd, an anonymous bidder purchased Picasso's *Boy with a Pipe (The Young Apprentice)* for more than \$100 million. The painting depicts a young boy dressed in blue, wearing a garland of red roses. Picasso painted it at age 24, in 1905. His world-renowned paintings would come later. *Les Demoiselles d'Avignon* dates from 1907, for example, *Girl Before a Mirror* from 1932; *Guernica* from 1937. *Boy with a Pipe*—"a pleasant, minor painting," in the words of one Picasso scholar—is not of that rank.

But unlike Picasso's masterpieces, which belong to museums, *Boy with a Pipe* was available to anyone who could meet the price. The bidding opened at \$55 million and rose, for eight minutes, in \$1 million increments. It passed \$60 million, then \$70 million, then \$75 million. At \$80 million, a new bidder joined in. In the end, the anonymous winner paid \$104.1 million.

News like that draws crowds, and the crowds are not composed entirely of solid citizens.

Dr. No

Whenever a painting with a value like a Boeing 757 vanishes—whenever thieves steal a Rembrandt or a van Gogh or a Vermeer or another "name" painting—the police respond as if they were reading from a script. A beleaguered police chief approaches a bouquet of microphones and sadly delivers the news that yet another masterpiece has been stolen to satisfy the whim of an art-loving recluse. On Millennium Eve, 2000, to cite one of dozens of examples, a thief stole a \$4.8 million Cézanne from Oxford University's Ashmolean Museum and disappeared into the crowd partying outside. "The theory we're going on is that it was stolen to order," the police quickly announced. "We think an art lover from somewhere in Britain or the world probably earmarked the painting for their collection and hired a professional thief to steal it."

The press laps it up. Who are the reclusive art lovers commissioning these thefts? The news accounts seem to have in mind a figure out of a Sherlock Holmes story: Late at night in a castle hideaway, a criminal mastermind—who happens to be an art connoisseur—summons a servant to bring a glass of brandy, give the logs in the fireplace one final poke, and then shut the library doors behind him. Then, finally alone, the reclusive genius strides toward a wall that is empty but for an object about two feet by three feet, concealed by a pair of green velvet curtains like those on a miniature stage. The curtains are closed, as they nearly always are, but now the silent figure in the smoking jacket draws them apart. Then he steps back and gazes contentedly at a painting instantly recognizable all over the world but destined never again to be seen outside this room.

Is the stolen-to-order theory true? Brandy and smoking jackets aside, it certainly *seems* compelling. We know that stolen masterpieces can never find legitimate buyers. We know that masterpieces are stolen regularly nonetheless. We know that many disappear forever.

We know, too, that a person who would spend \$5 million or \$10 million on any painting, stolen or not, is different from you or me. Ardent collectors talk as if they are obsessed, caught in the grip of an urge to acquire that holds them helpless. J. P. Morgan, the financier who reigned over American industry at the dawn of the twentieth century, accumulated treasures on so great a scale and in such variety—*two* Gutenberg bibles, acres of old masters, the last surviving manuscript copy of *Paradise Lost* that the art historian Bernard Berenson compared his collection to "a pawnbroker's shop for Croesus."

According to one biographer of newspaper tycoon William Randolph Hearst, "it was understood everywhere that he could not take a normal view toward art, could not appraise a piece according to cold market value, set a top price and stick to it. When he bid for something, it was seldom with a hard-headed take-it-or-leave-it attitude, but with the idea that he *must* have it. The thought of losing a piece to another was sheer anguish. He was aware of his own weakness, but powerless to correct it."

J. Paul Getty, despite his miserliness, confessed himself "incurably hooked" and "an addict" when it came to art. An entry from his diary echoes the "and this time I mean it" tone of a smoker in the grip of a three-pack-a-day habit. "I think I should stop buying pictures," Getty wrote. "I have enough invested in them. I am also stopping my buying of Greco-Roman marbles and bronzes. I'm through buying French furniture. My mind is set. I am not going to change it."

The next words in Getty's diary are: "The best laid schemes . . ."

And it is not merely that collectors in general are obsessed; art collectors in particular are at more risk than others of losing their bearings and vanishing into the stratosphere. Prices of luxury items like Ferraris and diamond necklaces can reach dizzying heights, but with art almost any price can be justified, because a work of art is an object virtually without peer. Buy a yacht, on the other hand, and someone else can always buy an identical one.

The point is not to deny a family resemblance among, say, van Gogh's sunflowers, but simply to note the difference between that similarity and the near-identity of such assembly-line objects as Ferrari cars. "Imagine how frenzied the world would be," the art critic Robert Hughes has written, "if there were only one copy of each book in the world." The art world *is* that frenzied and strange a place.

When the Getty Museum bid \$50 million for Raphael's *Madonna of the Pinks*, in 2002, the art dealer Richard Feigen hailed the offer as "exactly what the Getty ought to be doing. It's very smart to convert a bunch of pieces of green paper into a masterpiece. The green paper proliferates. The masterpieces evaporate."*

Joseph Duveen, the legendary art dealer, made his fortune with the identical sales pitch. Duveen specialized in selling old masters to new money. Henry Frick, J. P. Morgan, Andrew Mellon, and the other tycoons who dominated the American skyline in the early twentieth century all relied utterly on his guidance. "Art is priceless," Duveen would rhapsodize, as a client reached for his checkbook, "and when you pay for the infinite with the finite, you're getting a bargain."

When items are too rare to go around, economists point out, the mere fact of that rarity may make them desirable. "Scarcity value," the economists call it, and it can kick in even if an object has little else in its favor. A six-year-old taunting her brother by chanting "it's mine and you can't have it" has mastered the principle.

Great art has immense scarcity value (and visual splendor besides). But scarcity and beauty are only part of the lure. It is not simply that there are fewer than three dozen Vermeers and there will never be another. A painting

^{*}The National Gallery in London outbid the Getty and kept Raphael's masterpiece in Britain. The seller, the Duke of Northumberland, pocketed \$65 million (\$40 million of it tax-free). In the 1980s, the painting had been attributed to a follower of Raphael and valued at \$11,000.

has an allure that even other one-of-a-kind creations cannot match, because a person who buys a painting can own it—can possess it exclusively—in a way he could never own a novel, a poem, or a symphony. The difference is that, in an important sense, anyone who picks up a dog-eared, paperback Shakespeare owns something every bit as good as an original Shakespearean manuscript. The glory of Shakespeare lies in the words he conjured up, not in the handwriting in which he set those words down. Shakespeare's penmanship is irrelevant to his art; Rembrandt's way with a brush *is* his art.*

The most expensive words in any language, J. P. Morgan once said, are *unique au monde*—"the only one in the world." For some collectors, the thrill of ownership so outweighs all other considerations that, once they have acquired their treasures and hidden them away, they themselves never look at them again. In seventeenth-century France, for example, one insatiable book collector, Marshall d'Estrées, gathered and immediately stashed away 60,000 volumes, every one of which remained unopened until after his death.

How natural to assume, then, that when a masterpiece vanishes, a reallife Dr. No—a collector as maniacal as Morgan or Hearst or d'Estrées but not as honest—has commissioned the theft. Robert Hiscox, a prominent insurance broker and art collector, believes that most stolen paintings end up on a rich man's wall. "It really is a disease, and you want it almost as much as a heroin addict wants heroin," he says. "And there are certain people who want to *own* it. Museums are just frustrating—you can go and look, but you can't own it. That hunger is not only felt by good, honest, A-1 individuals. It can be felt throughout society, and especially by villains. And why on earth bother to buy it when you can steal it?

"People say, 'But the only point of owning art is to show off,' "Hiscox continues. "That is *absolute paramount rubbish*. There are paintings in my bedroom that no one ever sees, and never will see, and I have no interest in showing my friends or the great British public. I think a villain who's stolen a painting and has, you know, Goya's *Portrait of Wellington* sitting

^{*}Almost everything written in Shakespeare's hand has been lost, with the exception of six signatures (each spelled differently). With Shakespeare out of the running, the record price for a handwritten document currently stands at \$30.8 million, paid by Bill Gates in 1994 for a seventy-two-page manuscript by Leonardo da Vinci. The so-called Codex Leicester is a collection of scientific observations studded with drawings that probe such mysteries as the brightness of the moon and the meandering of rivers.

in his dressing room, would absolutely get a thrill from that. A greater thrill than just owning the Goya, the fact that he'd nicked it."

Even many legitimate buyers of the world's most expensive paintings hide their trophies away forever, off-limits to all eyes but their own. Often the biggest purchases at auctions are cloaked in secrecy; the bidding is done by an agent on behalf of a buyer whose identity is never revealed. That is a modern development. In the Gilded Age, for example, tycoons gloried in flaunting their art collections, much as Donald Trump flaunts his buildings today. If consumption could not be conspicuous, what was the point?

A century before the Gilded Age, Adam Smith made a similar observation as if he were citing a universal truth. "With the greater part of rich people," he wrote, "the chief enjoyment of riches consists in the parade of riches, which in their eye is never so complete as when they appear to possess those decisive marks of opulence which nobody can possess but themselves." But today's tycoons are different, the historian Ben Macintyre observes, and "the ownership and whereabouts of the four most expensive paintings in the world are all unknown."

The four paintings Macintyre had in mind, lost to everyone but their owners, are van Gogh's *Portrait of Dr. Gachet*, which last sold for \$82.5 million; Renoir's *Ball at the Moulin de la Galette*, \$78.1 million; Rubens's *Massacre of the Innocents*, \$76.7 million; and van Gogh's *Portrait of the Artist Without His Beard*, \$71.5 million. Since Macintyre wrote, a new painting, Picasso's *Boy with a Pipe (The Young Apprentice)*, has taken first place at \$104.1 million. Its buyer, too, is anonymous.

Until the early 1990s, the ownership of the two most expensive paintings was known. Then, in two hectic days in May 1990, a Japanese industrialist named Ryoei Saito bought both Gachet and Moulin de la Galette, packed them inside plywood boxes, and hid them away in a climatecontrolled vault near Tokyo. Over the course of the next few years, Saito went bust—or nearly—and was found guilty in a corruption scandal. In 1996 he died of a stroke. Amid the tangle surrounding Saito's financial affairs, no one has yet unraveled the mystery of the whereabouts of his two masterpieces. (Saito had said that he wanted Gachet cremated and buried with him, but he reportedly changed his mind.) If billionaires whose title to their paintings is beyond question see fit to lock their art up where the world will never see it, is it conceivable that a billionaire thief might do the same?

*

Venture a word of any of this to Charley Hill, and—depending on how energetic he happens to be feeling—he will withdraw into a prolonged and angry sulk or explode in a Rumpelstiltskin-style tirade. The whole Dr. No scenario is "Hollywood horseshit," "bollocks," "a complete and unmitigated load of crap." To broach the subject, as Hill sees it, is to proclaim, "I'm an ignoramus and I'm here to waste your time."

Hill's anger is not a simple matter of reflex disbelief. The media's constant invoking of hideaways lined with old masters infuriates him because it invests "scumbags" with glamour. More maddening still, Hill sees the assumption that stolen masterpieces are destined for the secret galleries of untouchable criminals as providing the police with a perfect excuse for giving up on art crime. Why spend time and money in a doomed search for paintings that are locked away forever? It is, after all, only art.

Most of the experts share Hill's scorn of the stolen-to-order claim, but in one crucial way, their opinion is beside the point. Hill and his peers may not believe in the existence of art-loving billionaires willing to pay topdollar for a stolen van Gogh, but what's important is that the thieves do believe it.

And as long as they do, masterpieces will continue to disappear.

20

"This Is Peter Brewgal"

reat paintings will disappear, as well, because when thieves steal great art some of the luster of the masterpieces spills onto the thieves themselves. This gilt by association is almost entirely undeserved, but the notion of the dashing thief is so appealing that it thrives even without any evidence to support it. Art thieves look like Pierce Brosnan or Sean Connery, Hollywood tells us; they are an "elite, artsy SWAT brigade," the *Chicago Tribune* informs its readers, a "highly daring and, let's admit it, cultured coterie of malefactors."

In real life, nearly all art thieves fall into two categories, both of them decidedly nonelegant. Either they are bumblers out of an Elmore Leonard novel or gangsters like Martin Cahill. The gangsters are far more dangerous, but the two categories can bleed into one another as stolen paintings pass from criminal to criminal.

"The commercial dealings can become quite labyrinthine," says Mark Dalrymple, an insurance investigator based in London who specializes in art cases. "It needn't always be a cash purchase. The thief might swap the painting for a shipment of drugs, or for a share in another, bigger deal. Or the thief might *owe* £10,000 and say, 'Take the picture and we'll clear the debt.' "

Dalrymple is a thin man with a world-weary manner and deep bags under his eyes. He peeks out at the world from inside a swirl of cigarette smoke and delivers his judgments in a syrupy drawl that seems to imply that humanity is, for all its foibles, undeniably amusing. "I have great respect for many criminals," he remarks. "They're very clever, very clever indeed, very streetwise in their dealings with their colleagues. They'll buy a mobile phone and throw it away the next day [to foil eavesdroppers]. They can smell your standard undercover cop a mile away.

"But when it comes to these big-time paintings, they smell money and a profit and they get a hard-on, as we say"—Dalrymple raises his eyebrows as if to acknowledge the lapse in taste—"and the streetwise approach goes right out the window.

"These people come up with the most extraordinary ideas," Dalrymple marvels. "They'll think they can sell the painting to a drug baron in South America, or to a friend who's in with some mafioso in Miami. Or they'll think, 'Ah, well, I know some Albanians who like this sort of stuff, and they've got some handguns. Maybe we can do a deal.' Or they might try to ransom the painting back to the original owner. Or keep it for a year and then see if they can collect from the insurance company. Or they may be in it for the reward."

Dalrymple affects a tough guy accent. " 'If they're offering 100,000 quid, I'll tell 'em where it is, and I get the reward, and they get their bleedin' painting back.'

"Even so," Dalrymple continues, "many of them get away with it. Along the line, there *are* people making money. There are always going to be people making money. That's why they do it."

Cops and their allies, like Dalrymple, prefer the bumblers to the pros. They love to swap tales of hapless amateurs, especially if they are meeting colleagues from far-off jurisdictions. Sitting over drinks in crowded bars, the cops play can-you-top-this. They tell true stories like the one about the Los Angeles thief who, in 1998, stole a \$10,000 abstract metal sculpture and ended up selling it to a scrap dealer for \$9.10.

The police tell the stories for laughs, but the laughter is bittersweet because the underlying message is so dismaying. Art theft is such an easy game and the penalties for getting caught are so low, the stories make plain, that the most hopeless sap can play. Take Anthony Daisley, who, one fine December day in 1991, staggered into the Birmingham [England] Museum and Art Gallery almost too drunk to walk. He pulled Henry Wallis's *Death of Chatterton* off the wall, stuck the six-inch-by-ten-inch painting under his arm, and reeled out the door with a £75,000 prize. (The museum had recently spent hundreds of thousands of dollars on electronic security, but the alarms were designed mainly to foil thefts at night, when the building was empty.) Another museum visitor saw the theft and called a guard, but it was too late.

Daisley pulled himself aboard a passing bus and showed his fellow passengers the painting. He had just stolen it, he explained, and now it could be theirs for a mere £200. The thief asked where the bus was headed. "Selly Oak," he was told. That was no place for him, Daisley cried out, because his ex-wife lived there. He stumbled off the bus, taking his painting with him. Five days later, police following up a tip found the stolen painting hidden in a house in Birmingham. A judge let Daisley off with a warning to stay out of trouble for twelve months, and the head of the Birmingham Museum issued him a public invitation to come back and visit the art he so clearly admired.

Charley Hill relishes such stories, partly because they buttress his view that the human race is composed largely of ninnies but mainly because he takes personal offense at the widespread belief that art thieves are masterminds who spend their days plotting elaborate heists. "The thieves who steal works of art," he says, "were usually stealing hubcaps a few years earlier."

Hill's hubcap remark was, in one £2 million case, the literal truth. In 1982 a thief ran out of London's Courtauld Institute Galleries clutching Bruegel's *Christ and the Woman Taken in Adultery* to his chest. (Bruegel produced a great many paintings, but in the nearly four and a half centuries since his death all but forty have been lost.) For the next eight years, the painting passed from thief to thief.

Somehow it fell into the hands of four small-time crooks. Two were failed businessmen who had run into debt; a third stole cars and credit cards; the fourth stole hubcaps.

One of the four had stumbled on the Bruegel, but he'd had no idea that it was special, no inkling at first that here in his hands was the big ticket he and his mates had all been dreaming of. The painting is an odd one, quite unlike Bruegel's famous, sprawling, colorful depictions of everyday life. Christ and the Woman Taken in Adultery is a small, somber work painted in grisaille, entirely in shades of gray. Christ and the other figures look almost like stone carvings. A layman might glance at the dark biblical scene and quickly pass by. "Our great fear during all those years," recalled the director of the Courtauld, "was that whoever had it would get bored of the whole thing and chuck it into a dustbin."

The four crooks rounded up an art expert to tell them whether the painting was worth anything. At this point some of the gang had yet to lay eyes on it. One of the four, a car dealer named Bobby Dee, took his first peek. "I picked it up to look at it and said, 'You got to be joking!' I was worried because I thought these people would think we were idiots. I thought this picture was nothing, just a wind-up."

The art expert arrived. "Then this old bloke came in. He was blabbering on about something. He turned round to look at the picture and then he fainted. I thought, 'Bleeding hell, it must be something proper.'"

Armed with the delightful knowledge that they had landed something big, the gang recruited a front man to do the talking for them. On a Friday afternoon in April 1990, the director of the Courtauld, Dennis Farr, was working at his desk. The phone rang.

"This is Peter Brewgal," the caller said. "I've got something you haven't seen in a long while. I think you'll be interested."

"Brewgal" rhymed with "bugle." The caller's odd name and his south London accent threw Farr for a moment—when Farr tried to mimic the caller later, he sounded like Alistair Cooke impersonating Sylvester Stallone—but then he caught on: Pieter Bruegel.

Mr. Brewgal offered Farr the chance to buy back his own painting. The price was £2 million.

Farr called the Art Squad. They devised an elaborate sting, starring Charley Hill as a rich and loudmouthed boor who wanted to buy himself a "trophy painting." All such subterfuges proved beside the point. Unbeknown to both the Art Squad and the thieves, a second group of cops had been tipped off as to the painting's whereabouts. They raided a house outside London. In a bedroom, they found the Bruegel wrapped in a pillowcase on top of a chest of drawers, and undamaged despite its wanderings. 21

Mona Lisa Smile

o matter how he tries, Charley Hill has never managed to dispel the Dr. No stories. What do you expect? People always prefer glamorous bullshit to mundane truth. They still trundle off to Scotland, for Christ's sake, to look for a sea serpent in Loch Ness.

But a taste for the exotic is not the sole reason that the belief in stolento-order art persists. Another is that people are suspicious of naysayers who are, like Hill, perfectly happy to romanticize the good guys but insistent that crooks are nothing more than violent, grubby men. Hill is, after all, a cop. Maybe thieves come in more varieties than he is willing to concede.

And if Hill has never seen anyone who would qualify as a Dr. No, that's hardly conclusive. A billionaire who collects stolen paintings would be unlikely to invite the neighbors in. Even so, names do surface occasionally. "Idi Amin was one of the biggest collectors of stolen art," according to Allen Gore, onetime head of security at New York's Metropolitan Museum of Art. "He had a French connection and took stuff out of Marseilles. He commissioned people to do it."

Maybe. But no one ever produced any evidence to back Gore's claim. (Masterpieces have occasionally turned up in the homes of South American drug lords, but there is no evidence that they were stolen to order rather than purchased legitimately; the paintings seem to be trophies on a par with the helicopters and hippopotamuses that ornament these private kingdoms.) Even Hill admits that there have been thieves who were also collectors and who stole art they particularly coveted. The problem is deciding what to make of such tales. We know that (a very few) thieves have stolen paintings for themselves. Does it follow that there are collectors who commission others to steal particular paintings on their behalf?

Consider the case of Stéphane Breitwieser, a French waiter who made headlines around the world in the winter of 2003. Breitwieser was arrested for stealing perhaps \$1.4 billion worth of paintings and other art objects for his own pleasure.* Over the course of seven years, he robbed 179 museums in seven countries. He concentrated on small museums, which tended to be poorly guarded, and small objects, which he could tuck inside his coat.

Breitwieser operated in daylight, and his approach could hardly have been simpler. While his girlfriend kept watch or flirted with any guard who happened by, Breitwieser took out his knife, cut a painting from its frame, rolled it up, and walked off with it. The most valuable item in his collection was Lucas Cranach the Elder's *Sybille of Cleves*, valued at \$8 million.

Cranach's painting showed her as a beauty, with red hair to her waist, in an elegant red gown. Sybille had two younger, unmarried sisters, Anne and Amelia. In 1539, in search of wife number four, Henry VIII sent Hans Holbein, his court painter, to paint the sisters' portraits. Henry chose Anne; her portrait now hangs in the Louvre. Holbein may have done his work too well. When Anne arrived in England, Henry was horrified by the true appearance of this "Flanders mare." Only moments before the wedding ceremony, he paused to bemoan his fate. "My lords, if it were not to satisfy the world and my realm, I would not do what I must do this day for any earthly thing." Six months later Henry had the marriage annulled and pensioned Anne off, notably with a castle that had belonged to Anne Bolevn.

^{*}French police estimated Breitwieser's haul at between \$1.4 billion and \$1.9 billion. Jonathan Sazonoff, a television producer and expert on art crime, suggests that a more accurate guess might be in the neighborhood of \$150 million.

Breitwieser stole Cranach's portrait on his twenty-fifth birthday, as a gift to himself. He never tried to sell it or anything else he stole. The artloving thief stored his loot in his mother's apartment. Often, before he brought his paintings to her, he took them to a local shop where the owner admired Breitwieser's latest "purchases" and helped him choose new frames.

Breitwieser was finally caught when a museum guard in Lucerne, Switzerland, saw him trying to steal a bugle. To protect her son after his arrest (or, by some accounts, to keep authorities from revoking her work permit), Breitwieser's mother set out to hide the evidence. She threw 100 objects into a canal and destroyed sixty oil paintings—including the Cranach—by chopping them into tiny pieces and throwing them out with her kitchen garbage, buried under coffee grounds and egg shells.

Ж

What about a low-rent Dr. No? Would the existence of a character who ordered up small-time thefts make it more likely that somewhere in the shadows lurks a full-fledged version?

Listen a minute to Jim Hill (no relation to Charley), one of the most respected art detectives in Britain. A soft-spoken Scot, Jim Hill has spent the last 20 years doggedly chasing stolen art. Most of it is good but not spectacular, perhaps in the \$10,000 range, but his résumé includes such coups as the recovery of a £100,000 grandfather clock.

In a business full of men who love telling stories—and love most of all telling stories where they themselves play the starring role—Jim Hill is that rare character who shuns the spotlight. ("Jim doesn't go in for any kind of self-aggrandizing bullshit," Charley Hill once observed, in a tone of mingled admiration and puzzlement, as if he were describing a cop who drank nothing stronger than ginger ale.) In the old, swashbuckling movies that Charley likes so much, full of cavalry charges and doomed last stands, Jim Hill would be perfectly cast as a soldier in the ranks, true to his mates and steady at his post. He would have only a line or two of dialogue and would manage a tight smile as a medic fished in his shoulder for a bullet. The injury was, he might concede in his gentle burr, "a wee bit of bother." So when Jim Hill *does* venture on a story, no one disputes him. Twice in his career, he says, he has seen a collector with a private gallery of stolen art. "One gentleman had a secret room off a big workshop, and only he had access to it. Over the years he'd received a lot of stolen property—silver, bronzes, paintings—and he put them in glass cases all around the room, and he'd sit there, all alone, with nice, quiet music on, in a lovely armchair, and he would just sit amongst all this property, and enjoy having it in his presence. Never used it, never tried to find a buyer. He was quite a wealthy man, and he just enjoyed being in the company of valuable and lovely items."

Ж

What about *six* Dr. No's, all contemporaries, who were so far from smalltime that each one owned (or so he believed) the world's best-known painting? Early on the morning of August 21, 1911, an Italian carpenter named Vincenzo Perugia crept out of a storage closet in the Louvre where he had hidden overnight. This was a Monday, the day the museum was closed to the public. Perugia had once been employed by the Louvre, and over his clothes he wore one of the floppy, nearly knee-length tunics issued to the hundreds of workmen who maintained the sprawling museum. The outfit rendered Perugia so innocuous as to be nearly invisible. He walked toward the *Mona Lisa* in the Salon Carré and checked to see that no one was nearby. Then he removed the painting from the wall, tucked it beneath his smock, and walked out of the museum.

That much is undisputed fact. The rest of the story, depending on the teller, is an illustration of either the perfect crime or perfect nonsense.

As recounted by Seymour Reit in *The Day They Stole the Mona Lisa*, Perugia was merely a hired hand. The mastermind behind the *Mona Lisa* theft was an Argentinean con man who called himself the Marqués Eduardo de Valfierno. In tandem with a brilliant French forger named Yves Chaudron, the marqués had made a nice living peddling fake old masters to foolish collectors.

In Buenos Aires, the two swindlers had moved beyond the simple selling of fakes and had cooked up an elaborate scheme to sell paintings "off the wall" of the national museum. The marqués, who had bribed a guard to keep away, would lead the dupe to an especially fine painting and ask, in a whisper, if he would like it. He recognized, of course, the marqués would go on, that he was dealing with a savvy businessman who knew a thing or two about how the world worked. And therefore, to make sure there was no funny business—here the marqués drew a handsome pen from his pocket—the customer should take this pen and make some small marks or write some secret cipher on the back of the canvas so that later, when he received his painting, he would know that it was this very one.

One dupe waved the pen aside and instead took out a pocket knife and cut an oddly shaped scrap from the edge of the canvas, in the back, beyond the boundary of the painting proper. When the time came, the man explained, he would check to see if the newly delivered canvas was missing a piece that fit precisely with the one he had just removed. The marqués was struck almost dumb with admiration. Never had he encountered such cunning.

The scam was that Chaudron had already painted his fake before the dupe ever showed up, and Valfierno had mounted the two paintings together, in the same frame. The real one was in front, where visitors to the museum could admire it, and the fake one behind, where gullible strangers could sign (or cut) it.

Out for bigger game, Valfierno and Chaudron had come to Paris. There Chaudron perfected fake *Mona Lisas* while Valfierno cultivated new clients. When he had six suckers with big enough bankrolls and small enough brainpans, Valfierno made his pitch: What would you think of owning the greatest painting in the world? It went without saying, the marqués went on, that no one but you could ever see the masterpiece, but, on the other hand, you would know that you alone possessed what no one else could ever own. So the marqués said, six times, to six customers.

Then Valfierno told Perugia, the carpenter, that it was time for him to do his bit. (The theft itself was so easy because the Louvre in 1911 was focused on vandals, not thieves. The Louvre was heavily guarded during visiting hours and virtually defenseless after hours.) Spooked by an attacker who had slashed an Ingres in 1907, the Louvre had decided to build a glassfronted box to house the *Mona Lisa*. Perugia knew his way around the Louvre because he had been one of the workmen who built the box. News of the theft stunned Paris, and then the world. The headline in *Le Matin* was a single word in giant letters: "*INIMAGINABLE*!" Soon after, Valfierno approached his six clients. Still game?

"Yes" came the answer, six times. Valfierno sold six fakes, each for \$300,000, roughly \$6 million a copy in today's currency. Then, having perpetrated the perfect crime, he vanished. None of the buyers—supposedly six Americans—knew Valfierno's real name. Nor did Perugia. More than that, the marqués had never confided a word to Perugia about the con he had dreamed up. All that Perugia knew was that a well-spoken stranger had hired him to steal the *Mona Lisa*—payment to be made later—and he had done so. But, then, not a word of instruction and not a penny in payment! For two years, Perugia fretted and waited. During all that time, the *Mona Lisa* lay hidden in a box under the stove in Perugia's apartment.

Chaudron, the forger, had good reason to keep quiet. And the buyers could not go to the police without acknowledging that they had tried to purchase stolen goods. Nor did Valfierno have to worry about what would happen if the real *Mona Lisa* ever surfaced. His victims had no idea how to find him, but what if they did somehow track him down? "Now let's just calm down for a minute and think, shall we?" Valfierno could say. "What would you expect the Louvre to do, after they lost their most valuable painting, except to announce that they had marvelous news and they'd found it again? But you and I know who has the real *Mona Lisa*, don't we?"*

Ж

Is the story of the six fakes true? No one knows. By definition, perfect crimes are beyond detection. The source of the story was a journalist named Karl Decker, a flamboyant and much-acclaimed Hearst reporter, who published the tale in the *Saturday Evening Post* in 1932. Decker claimed to have known the marqués, who told him the story on condition that it not be published until after his death.

148

^{*}Despite persistent rumors to the contrary, scholars say that the authenticity of the Louvre's *Mona Lisa* is beyond question. The painting had been studied, photographed, and documented minutely before the theft, and a host of before-and-after comparisons—such as an examination of the tiny cracks in the varnish that covers the painting's surface—establish its identity beyond a doubt.

Half a century later, in 1981, Seymour Reit's book filled in the picture that Decker's magazine article had sketched. Reit was a well-regarded writer, and the *New Yorker*, the *New York Times*, and *Art News*, among others, praised his book. Robert Spiel, a 20-year FBI veteran who specializes in art crime and the author of *Art Theft and Forgery Investigation: The Complete Field Manual*, cited Reit's book in his bibliography and wrote that "if you can read only one true story of art crime, read this."

Decker and Reit died years ago, and neither left behind any hint that he had pulled off a hoax of his own. Even so, Reit's credits are curious enough that a skeptic might raise an eyebrow. Though Reit published such straightforward, well-received works as a history of camouflage in World War II, he also wrote children's books. He was, as well, the creator of Casper the friendly ghost. Donald Sassoon, a historian whose *Becoming Mona Lisa* tells the story of how the painting became an icon, dismisses Reit's story as an urban legend.

In any case, Perugia was arrested in 1913, when he tried to sell the real *Mona Lisa* to a well-known art dealer in Florence. His motive was unclear. (Perhaps he had despaired of ever receiving any money from the marqués.) The dealer contacted the head of the Uffizi, and the two men met Perugia at his shabby hotel in Florence. Perugia rummaged in a homemade wooden trunk, lifted out a bundle wrapped in red cloth, and handed over the *Mona Lisa*. Bowled over, the dealer and the curator stammered something about needing to take the painting to the Uffizi for a closer look. Perugia was to stay in his room and wait. As the two men rushed out the hotel door, the receptionist hollered at them to wait a minute. What was that they were carrying? They hadn't stolen one of the hotel's paintings, had they?

At his trial, Perugia defended himself on patriotic grounds. He had taken the *Mona Lisa* because it offended his Italian pride that France had possession of such a treasure. Perugia's lawyer maintained that no harm had been done—no one had been hurt, and the painting was intact and even betterknown than it had been. The public went along. Perugia was briefly a hero, lauded for his devotion to his native land. The court imposed a sentence of only twelve months, which was reduced to seven on appeal. The Mona Lisa story comes with more than enough holes for a cynic like Charley Hill to dismiss it. But Hill has too much respect for history to ignore one story, this one indisputably true, from roughly the same era as the Mona Lisa theft.

Adam Worth was the greatest thief of Victorian England. He provides the single unimpeachable example we know of a thief who stole a beloved masterpiece and kept it locked away, for his eyes only. More than a century ago, Worth stole the world's most expensive painting and kept it with him, without ever trying to sell it or telling a soul, for twenty-five years.

The story of Worth's obsession, brilliantly told in Ben Macintyre's *Napoleon of Crime*, began in 1876, when an American visitor to London bid a record-setting \$600,000 (in today's dollars) for Gainsborough's portrait of Georgiana, Duchess of Devonshire.

Georgiana, an ancestor of Princess Diana, was sexy and scandalous, by reputation England's greatest beauty. As notorious in eighteenth-century England as Princess Di would be two centuries later, Georgiana was a novelist, a compulsive gambler, the wife of the stunningly wealthy Duke of Devonshire (in a ménage à trois that also included Lady Elizabeth Foster), and mistress to a future prime minister. Georgiana died young, though she outlived her days of glory. "Before you condemn me," she wrote near the end, "remember that at seventeen I was a toast, a beauty and a Duchess."

A century after Georgiana's death, her portrait came up for auction. To judge from the commotion, she might never have been away. Crowds of gawkers clutched their tickets and waited in line at the Thomas Agnew & Sons art gallery on Old Bond Street to glimpse the painting. The Earl of Dudley coveted it, as did Ferdinand de Rothschild. In the end, no one could compete with Junius Spencer Morgan, the American banker, whose winning bid secured the Gainsborough as a gift for his art-loving son, J. P. Morgan. One condition of the sale, which hardly seemed worth mentioning, was that Morgan leave his new acquisition on exhibit a short while before taking it away.

A few weeks later, on a May night in 1876, a small man pried open a window of the Agnew Gallery and climbed inside. He cut Georgiana from her gilt frame, rolled her up, tucked her beneath his coat, and retreated as he had come.

The thief was Adam Worth, an American-born crook of such elegance

and elusiveness that he served Arthur Conan Doyle as the model for Sherlock Holmes's nemesis, Professor Moriarty. Worth had a younger brother, John, who shared his lack of morals but not his savvy. At the time of the theft, John Worth was in Newgate Prison on a forgery charge. Adam's scheme was to work a trade: the painting that all London was hunting in exchange for his brother's freedom.

But the plan skidded off course. John Worth's lawyer proved better than anyone had anticipated. Before Adam Worth had even opened negotiations for his brother's release, John's lawyer had him out on the street on a technicality, a free man.

That left Adam Worth in a most peculiar spot.

For the next quarter century, Worth kept Georgiana with him. Even when he desperately needed money and the police seemed to be closing in and various shady characters came whispering that they had heard rumors about a certain item that perhaps they might help him with, Worth refused to consider a deal. "He turned them all down, preferring to face disgrace, penury, and imprisonment rather than part with the Duchess," Macintyre writes. "The painting became his permanent companion.... When he traveled, she came, too, in his false-bottomed trunk." At home in London, Worth slept with the portrait under his mattress.

In his old age, when Pinkerton detectives finally had him cornered, Worth at last handed his mistress over. Penniless despite a lifetime's illicit income, Worth bartered the Duchess away for a never-disclosed sum one account put it at \$25,000—and a promise of immunity. The painting, then in the United States, was turned over to the son of the art dealer it had been stolen from originally. The rightful owner took custody of the long-missing portrait and set off for home with it, on the steamer *Etruria*, bound from New York to London. Among the passengers was one small man with a sad air, no longer able to acknowledge his beloved but secretly accompanying her on one last voyage nonetheless.

Today, Georgiana, Duchess of Devonshire, is back where she belongs. In 1994, the present Duke of Devonshire bought the portrait and installed it in his ancestral home, Chatsworth. In the grand dining room where Georgiana held court in life, she presides triumphantly once again. 22

Gangsters

n Norway, Charley Hill didn't figure he was dealing with a modern-day Adam Worth. Johnsen and Ulving seemed too small-time. But he did worry about who might be behind them. Criminal gangs have discovered that art is easy pickings, and a trail that started with bumblers could well end with gangsters. Let your guard down and you might get your head blown off.

Violent and ruthless, the professionals have none of the endearing ineptitude of the small-time thieves. Worse still, from the police point of view, the pros may have more complicated motives for stealing than the amateurs do. If a gang steals a painting to send a message of some sort, and not simply to cash in, the odds of recovering it become even smaller.

The involvement of gangsters in art crime dates from the 1960s and took off two decades later, when the art market exploded.* In May 1969, the Italian police announced the formation of the first-ever art squad. The mission of the grandly named Command for the Preservation of Cultural

^{*}It should perhaps be stated explicitly that the amount of art stolen by modern-day gangsters is dwarfed by the amount stolen by the Nazis, gangsters backed by the full might of the state. All armies have looted, but the Nazis made the process organized and efficient. In France alone, according to Hector Feliciano's *The Lost Museum: The Nazi Conspiracy to Steal the World's Greatest Works of Art*, the Nazis seized one-third of all art in private hands. The best account of the Nazi assault on art is Lynn Nicholas's *Rape of Europa*.

Heritage, the government proclaimed, was to safeguard Italy's paintings and sculptures.

Five months later, thieves in Palermo, Sicily, broke into the Church of San Lorenzo, sliced Caravaggio's *Nativity with St. Francis and St. Lawrence* from its frame, and vanished. The church had no alarm system. A priest asleep in a nearby room heard nothing. The enormous painting, roughly six feet by nine feet, was one of the last that Caravaggio completed. (His life, filled with tumult, seems too crowded to have left any time for painting. In a six-year span, in his thirties, Caravaggio was arrested and tried eleven times, on charges ranging up to murder. In 1606 he killed a rival in a quarrel over a game of tennis; he died on the run in 1609 at age thirty-nine.) The *Nativity* had hung in Palermo since 1609. The painting is worth tens of millions, and it has never been seen again.

At once came rumors—endorsed by the police—that the Mafia was behind the theft. Along with the Mafia tales, the headlines screamed the usual rumors of an elusive Dr. No. "Who would take a painting like that?" scoffed General Roberto Conforti, head of the Italian art squad. "What would even the most unscrupulous art collector do with it? It's huge. You couldn't hang it anywhere where it wouldn't be seen. No, what we suspected from the start was that this was a message from the Mafia. They wanted us to understand that they could take whatever they wanted from wherever they wanted in Palermo, and no one—especially not the police could stop them. And we think they held on to it as a symbol."

Finally, a quarter-century after the disappearance of the Caravaggio, word came from the Mafia itself. In November 1996, Italy's former prime minister Giulio Andreotti was on trial for corruption. A Mafia *pentiti*—a supposedly penitent criminal who had agreed to testify against his former colleagues—was on the stand, hidden behind a screen.

Francesco Marino Mannoia was a dangerous man with a harmless appearance. "Mozzarella," he had been nicknamed, in mocking tribute to his bland manner and quiet voice. Mannoia had a storehouse of knowledge that made him a prized witness for the state. Hidden inside an armored car, he had taken police on a tour of Mafia hideouts and heroin-processing facilities in Palermo. He had turned over a thick account book listing payoffs to politicians and other local bigwigs. Mannoia knew, literally, where the bodies were buried and had flown over Palermo in a helicopter with police, pointing out Mafia "graveyards."

It took a month for word of his cooperation with the police to leak. One November evening in 1989, Mannoia's mother, aunt, and sister left their house and settled into the family car. All three women wore black, because they were in mourning for Francesco's brother, a Mafia gunman, who had himself been gunned down by underworld rivals. Mafia lore has it that women are exempt from retaliation. Not so. Hitmen killed the three women and sped off.

Now Mannoia, who was serving 17 years for narcotics trafficking, was on the stand in the Andreotti case. In a trial focused on political scandals at the highest level of government, the theft of a painting two decades before seemed almost incidental. "I've stolen some paintings in my time," Mannoia told the court, in response to a question about his criminal career. "Some modern stuff, and Antonello da Messina. Oh, and remember that Caravaggio that disappeared in Palermo in 1969? That was me, too."

He and his fellow thieves knew nothing about art, Mannoia testified. The Caravaggio was so big that the thieves had folded it to make it easier to carry. "When our buyer saw it," Mannoia said, "he burst into tears and wouldn't take it."

Mannoia may have been lying, for reasons of his own. (The "illustrious figure" who wanted to buy the painting and wept when he saw how it had been damaged, according to Mannoia, was Giulio Andreotti, the former prime minister and the very man on trial for corruption.) Still, no one disputes the central claim that the Mafia was tied up in the theft in some way." "We don't believe that Mannoia was lying," says Conforti, the head of the art squad. "He was telling the truth. Except that, according to our investigations, he was not referring to the Caravaggio but to a similar work that was stolen in a nearby church in the same period."

The lone indisputable point is that Caravaggio's painting, if it still exists, has never reappeared.

154

^{*}The British journalist Peter Watson wrote *The Caravaggio Conspiracy* about the case, in 1984. Watson believes that the painting survived its theft only to be destroyed in an earthquake in 1980.

The involvement of the Mafia and other criminal organizations in art crime means that the risks have grown formidable. Once a respite from "real" crime and an almost cozy world unto itself, art theft now carries all the ugly trappings of organized crime.

"These guys are different," says one British art investigator with 30 years' experience, newly returned from his first trip to the former Soviet bloc. "Your average criminal in England, even some of the nasty ones, if they're stung by another criminal, then, yeah, they'll kill him. But the Serbs and the Albanians will kill his family as well. And his kids, and the dog, and the cat. And then burn the house down."

The twin marks of the new era are more violence and more volume. "In Europe," says Lynne Chaffinch, head of the FBI's art theft program, "criminal gangs are moving just *massive* amounts of art. In Russia, the intelligence people told me they'd identified over forty organized crime groups involved in art theft. At the border, they've caught a whole *train*load of icons and other stolen art."

With the collapse of the Soviet Union and then the opening of borders to the west, eastern Europe became a free-for-all. Thieves who had quickly caught on to the delights of private enterprise scrambled to loot churches and museums. In the Czech Republic, in 1996, Charley Hill helped break up a ring of art thieves run by former secret police officials who had held power in the bad old days. In the end, Hill and his detective colleagues recovered some two dozen old masters, including such hugely valuable works as Lucas Cranach the Elder's *Ill-Matched Lovers*, which had been pulled off the wall of the National Museum in Prague. The venture climaxed in an armed confrontation between a German SWAT team and a band of Czech thieves headed by a gold-toothed killer named Kittler.

In time, old-style gangsters like Kittler or Martin Cahill, the Dublin crime boss, may come to seem quaint. In 1994 in Frankfurt, Germany, for example, thieves stole two Turner paintings on loan from the Tate Gallery in London. The renowned paintings, *Shade and Darkness* and *Light and Colour*, near-abstractions on the theme of the biblical flood, had a joint value in the neighborhood of \$80 million. At some point in the several years the paintings were in limbo, they apparently passed into the control of the Serbian gangster and warlord known as Arkan. The commander of a private army of several thousand men and a pioneer in ethnic cleansing, Arkan was an indicted war criminal.

A century before, art thieves looked like Adam Worth, the dashing Victorian who fell in love with Gainsborough's *Duchess*. By the end of the twentieth century, Worth had given way to the likes of Arkan, who was, in the words of one UN diplomat, "a psychopathic mass murderer."

He met his end in fittingly violent fashion, gunned down with two bodyguards in the Intercontinental Hotel in Belgrade. The fate of the Turners was happier. Just in time for Christmas 2002, the Tate held a joyful news conference to announce that it had recovered both paintings, only slightly damaged.

Crook or Clown?

APRIL-MAY 1994

The Norwegian police didn't know what kind of crooks they were up against. While Charley Hill negotiated with Ulving and Johnsen, the police continued to work their own leads, to little avail. Looked at from one angle, the thieves—whoever they were—seemed professional. They had vanished at once, which showed planning, and then had stayed out of sight, which showed discipline. The police had squeezed their informants hard and come up empty. No booze-fueled bragging, no rumored deals, nothing. Weeks had stretched into months, and still the only clues the police had turned up, most notably the piece of *The Scream*'s frame, had been handed to them.

But viewed from a different angle, the same facts made the thieves look amateurish. True, they had been quick, but they had made climbing a ladder seem a feat on a par with walking on stilts. They had indeed kept silent, but was that silence a ploy designed to increase the pressure on the police or just a sign of befuddlement? Perhaps the thieves, now that they were in possession of their trophy, were in the predicament of the dog in the cartoon who has, to his astonishment, actually caught the car he was chasing. *Now what*?

And what was the moral of the theft's timing? Horning in on the publicity generated by the Olympics was a coup—and a thumb in the eye of the police—but did the thieves' audacity show that they were pros who knew exactly what they were doing? That was the media's theory, based on the idea that the thieves were showing off for their fellow crooks. But maybe the real audience was the great, sensation-loving public. In that case, the theft of *The Scream* was not a mark of professionalism but an amateur's "Hey, look at me" bid for attention.

And uncertainty about the thieves was only the first link in a murky chain. If the thieves who stole *The Scream* in the first place had since bartered or sold it to someone else, then any theories about who had originally done what, and why, were all beside the point.

Once they had sorted through the false leads of the anti-abortion activists and a slew of time-consuming but fruitless tips, the Norwegian police focused on Oslo's small criminal community. In comparison with London or New York, Oslo was cozy and safe—the city's population hovered at around half a million—but serious crime, much of it heroin-related, had encroached even on Norway. At the center of the criminal scene in the 1990s was a group called the Tveita Gang, which was about 200 strong and closely linked with criminals outside Norway. At the center of the gang was a raffish young crook named Pål Enger.

Enger, who was twenty-six when *The Scream* was stolen, had been well-known in Norway since his late teens. He wasn't handsome—he had a big, bent nose and his ears stuck out—but he had a disarming grin and a friendly manner. No one would cast Enger as a movie's romantic lead, but he would do nicely as a charmingly ne'er-do-well best friend. Enger had been a professional soccer player for Valerenga, one of Norway's top teams, and had gone on to become perhaps Norway's best-known criminal. "I was not one of the best [at soccer]," he once told the BBC, "but I was one of the best in the criminal world, and I thought it would be more fun to play on the team where I was best."

In February 1988 Enger and an accomplice stole a Munch painting, *The Vampire*, from the Munch Museum in Oslo. The police launched an all-out investigation. Within a few days they announced they were close to cracking the case. They weren't.

The months dragged on. Growing desperate, the police at one point

even sought help from a psychic. Finally, a break: two men on a train had been spotted carrying *The Vampire*. The police raided their apartment. They spotted the supposed masterpiece at once and groaned in dismay. The painting that an excited tipster had identified as the work of one of the twentieth century's greatest and most tormented artists was nothing of the sort. It was, the police soon learned, a spoof that someone had painted in a couple of hours as a prank, for a bachelor party.

Six months after the theft of *The Vampire*, the police arrested Enger and a second man. He had stolen the painting, Enger said, in the vague hope that "maybe some Arabs would be interested" and he could sell it for a fortune. Enger and his accomplice were convicted and sentenced to four years in prison.

That failed theft hardly seemed the work of a master criminal, but Enger did have at least one genuine skill beyond soccer. He had a gift for publicity, a talent for engaging the police in what amounted to street theater, with the ex-athlete himself in the starring role.

In Enger's glory days, he had featured regularly in newspapers and on television. Now, with his soccer career in the past, it took more ingenuity to gain notice. Enger had developed an array of tricks. One of his favorites was to phone the police anonymously and warn them that Enger was up to something shady: Pål Enger had been seen, Enger would whisper, with what looked to be stolen goods. If the police showed up, Enger would howl that he was being harassed. Then he would report the mistreatment to his lawyer, the lawyer would call in the media, and, if all went well, the ex-con would wake to find his name—and, better, his face—splashed across Norway's newsstands and television screens.

With his conviction for stealing *The Vampire*, Enger was a natural suspect when *The Scream* vanished. He had an alibi for the time of the theft, though, and the police had no evidence against him. Enger thrived on the attention. At the National Gallery, he posed for photographers by the spot where *The Scream* had hung, next to the poster and the handwritten "Stolen" notice that had replaced it. "I didn't steal *The Scream*," he insisted. "I had nothing to do with the theft."

But as the police scanned tapes from the National Gallery's security

cameras, they noticed a familiar figure in the swirling crowd of visitors to the Munch exhibit. Five days before the theft, there was Enger.

Perfectly true, the thief happily agreed, when the police brought him in for questioning. Why shouldn't he visit an exhibit that was the biggest thing to hit Oslo in years? He was, after all, on record as an admirer of Munch.

The cops sighed wearily. Sooner or later, they had learned, Enger was sure to do his best to thrust his way into any case that was likely to draw attention. Like the parents of an incorrigible toddler, the Norwegian police had grown to tolerate what they could not seem to prevent.

Over the years Leif Lier, the detective in charge of the Norwegian end of the *Scream* case, had come to know Enger well. A patient man whose forbearance would be remarkable even if he were not a cop, Lier shrugged off Enger's antics. "Enger was a pain in the neck from time to time," Lier acknowledged, "but he was funny, too."

On April 12, two months after the theft of *The Scream*, Enger's wife gave birth to a baby boy. The proud father placed a notice in *Dagbladet*. The baby had arrived, the birth announcement declared, "With a Scream!"

Prop Trap

MAY 6, 1994

harley Hill had more pressing problems to deal with than Pål Enger's games with the Norwegian police. Hill's primary goal was to retrieve *The Scream*. Everything else, including finding someone to arrest, was less important. That was Hill's approach to all his art cases. The question that truly engaged him was *whereisit*, not *whodunit*. His Art Squad colleagues tended to agree, but many cops did not. Hill's focus on pieces of canvas rather than on criminals, they insisted, amounted to condoning theft. Even a hint of that argument launched Hill into a tirade on "bureaucrats in blue" and police shortsightedness.

Life would be easy if you could recover the painting *and* arrest the thieves. But it didn't usually work like that. Which do you want, Hill would shout, a hubcap thief thrown in prison for six months or a Bruegel back on the wall where the world can admire it?

Just how the art dealer and his arsonist companion had come to be involved with *The Scream* in the first place was something Hill could sort out another day. For now, Hill's job was to get things back on track. His first meetings with Johnsen and Ulving had gone well enough, he figured, and Johnsen had certainly swallowed hard when Walker showed him the money. But what had the Norwegian duo made of the police convention at the hotel and the plainclothes cop in the bulletproof vest? Johnsen had left the Plaza in a hurry, saying he would return in midafternoon, leaving Hill to twiddle his thumbs. Hill hoped the Norwegian crook was busy with his partners, whoever they were, sorting out the logistics of handing over *The Scream*. If the deal was still on, that is. The fiasco with the police convention had certainly spooked Johnsen, and it might have scared him away altogether.

Hill tried to look at things from Johnsen's point of view. On the one hand, the money. On the other, a hotel crawling with cops and a deal put together by two strangers. Who *were* Roberts and Walker?

With time to kill before Johnsen reappeared, Ulving suggested that he show Hill around town. Before they set out, the art dealer gestured to Hill to join him at the back of his Mercedes station wagon. Ulving opened a big box full of prints, including some woodcuts of *The Scream*. Hill couldn't tell if they were genuine, but they looked good. Then the two men headed off for a bit of gallery-hopping. Ulving, in his element, bounced along proudly. He was a "slimeball," Hill thought, cocky as hell and oblivious to the sneers and scowls directed his way by his fellow dealers as he sauntered through Oslo's galleries.

At two o'clock in the afternoon, Ulving and Hill returned to the hotel to see if Johnsen had showed up. They met Walker and settled in at the coffee bar to wait. About 15 minutes later, Johnsen stormed in.

"There's cops all around the building," he snapped, "and police cars parked outside. Two of 'em, at least."

Johnsen was furious, spitting out his words. Hill hadn't known about the Norwegians' plan to keep an eye on things, but he was as soothing and unruffled as Johnsen was indignant. "Let's go up to my room," Hill said. "I've got a bottle of Canadian Club up there, and we can talk."

Hill's room was on the sixteenth floor with a knockout view of the harbor and, what was more interesting to Johnsen, a clear view of the hotel's main entrance. Johnsen and Hill stood together at the window. They looked down, and there was no missing the cops. Hill groaned to himself. The fuckers were in unmarked cars, lounging around in the sun, bored out of their minds and impossible to take for anything but police surveillance officers. Johnsen looked at the cops and then glared at Hill. "What's that about?" he demanded.

Hill decided he'd stick with the same line he'd taken to explain away the cop in the bulletproof vest. If the Norwegian surveillance teams had been skilled—if they'd been well-concealed and Johnsen had managed to spot them anyway—then he would have had some explaining to do. But incompetence like this was a gift. These guys *couldn't* be trying to hide.

"Look at those assholes down there," Hill said. "They can't be looking for us, because nobody could have missed us wandering all over the hotel. They've got to be here to protect the narcotics conference."

Everyone sat down to a drink. Ulving begged off. Hill's opinion of him sank even lower. Johnsen and Hill each took a serious drink, a large Canadian Club, and talked about the merits of rye whiskey compared to scotch or bourbon. Keep it relaxed, Hill told himself. Take it slow.

Hill stood up and walked into the bathroom. In the morning, he had arranged his papers and his traveling kit with all the care of a set dresser on a Broadway play. Setting out a "prop trap" was a kind of silent storytelling. Hill had stacked a few business cards near his bedside lamp: Christopher Charles Roberts, Getty Museum. He had set his plane tickets by the phone, peeking out from a torn envelope; his Getty ID lay nearby, with a photo. On the desk, a few pieces of Getty stationery. Under an ashtray, a couple of crumpled credit card receipts, signed by Christopher Roberts. On top of the receipts, half a dollar or so in change, in American coins.

Hill had taken similar care with his toiletries kit, in case Johnsen (or, much less likely, Ulving) went into the bathroom and looked through his things. Shaving cream, deodorant, toothpaste, all good American brands.

The preparation paid off. As soon as Hill shut the bathroom door behind him, Walker told him later, "Johnsen had a good ferret 'round." Though the crook had waited for Hill to leave the room, he made no attempt to disguise his snooping. For his part, Hill made a point of dawdling in the bathroom, to give Johnsen every opportunity to check him out.

Hill finally reappeared. Johnsen didn't make any reference to the little test he'd conducted, but he seemed more at ease and began to talk again about how to carry out the *Scream* deal. It had to be done that night, he said. Hill and Walker would have to bring the money to a rendezvous. He'd let them know where. Hill balked. "Nope!" he said. "We're not taking the money out of the hotel until I'm assured that the painting *is* the painting and that it's fine. We'll do the deal after that."

They wrangled for a bit. Johnsen left to make a phone call—he didn't want to use the phone in Hill's room—and came back a few minutes later, worried but still hopeful. For Hill, this wary jostling was sport. You had to stay alert and watchful, but there was no way of knowing just what you were watching *for*. In the meantime, you talked, partly to establish a bond, partly to pass the time, but mainly to amuse yourself.

Every case reached a point where the next move was up to the thieves and there was nothing the cops could do to hurry things along. Hill tried to relax and take life as it came. It took work, for though Hill was a brave man, he wasn't a calm one. Off-duty, the moment a conversation lost its hold on him—and that moment was rarely slow in coming—Hill would start jiggling his keys, or twirling his glasses, or scanning the room in search of a book to pick up or a television to turn on or a magazine to skim.

Undercover, Hill's fidgeting vanished. If the bad guys asked a question, you went along, looking to see if you could come up with something new. A drink or two helped. The fog—not knowing the rules of the game, or if there *were* rules, or just who you were dealing with—was part of the undercover challenge. Spinning a story for high stakes was a chance to exercise one's powers. When it worked, it was enjoyable in the same way that it was enjoyable for a sprinter to run or a skier to carve a line through a turn.

Ulving asked Hill about the Getty and about his responsibilities there. Hill made it up as he went along. He hadn't seen any of the new construction at the museum—his only visit had been twenty years before—but when he learned that Ulving hadn't either, he laid it on thick. "When you visit the States, you have to come see us. And make sure you give me a call. If I'm not there, tell them you're a friend of mine, and they'll look after you."

That kind of "lightweight bullshit banter" was Hill's favorite. It kept the tedium at bay and sometimes it even helped move things along.

For Hill, the enemy always lurking in the wings, more formidable than any thief, was boredom. The great virtue of undercover work was that, temporarily at least, it provided a means of vanquishing his old foe. 25

First Time Undercover

By the time *The Scream* was stolen, Charley Hill had been an undercover cop for a dozen years. His very first undercover case, like the great majority of those that followed, had involved a stolen painting. (In most of the nonart cases, including one where he was taken hostage, Hill played a crook who wanted to buy counterfeit money.) The decision to give Hill a chance in an art case was easy. He was well-spoken, he didn't look like a cop, and he had been a soldier and therefore could presumably keep his head. Above all, he was game.

In 1982 Scotland Yard had infiltrated a gang of armed robbers in south London. Somehow the thieves had acquired a painting by the sixteenthcentury Italian Parmigianino, worth a few million pounds. The crooks wanted to unload it, and the cops saw an opportunity. A pair of detectives in the armed robbery squad took a look at Charley Hill and sounded him out about a role he would later make his own. How would he feel about posing as an American art dealer willing to buy a hot painting?

How would he feel? Hill's early days walking a beat hadn't been bad, but that assignment had been followed by a frustrating stint sitting at a desk shuffling papers. Hill had been trapped, like a soldier detailed to filling out endless forms in triplicate. Now someone had set him free. "I felt the way I had when I'd been given a weekend pass from Fort Bragg," Hill recalled. "I saw Bragg Boulevard and Fayetteville, North Carolina, as it was years ago. It all came back. It was like the relief of going home." First stop, clothes. Hill whirled around London, flitting from shop to shop. Subtlety, he had decided, would be a mistake. "I thought I should put myself in the place of the people meeting me and give them what they wanted." That meant something "fancy and flashy, some kind of half-assed cross between a celebrity chef and a Virginia preppy, horsey type." In ordinary life, these were people Hill happily mocked. Now, with an excuse to abandon his English decorum, he combed through suit after suit in search of just the right degree of raffishness. Tie or bowtie? What color socks best set off a pair of spanking new loafers?

When he wasn't shopping, Hill was studying. Parmigianino was a mannerist, he learned, which meant he had better read up on mannerism. Why did Parmigianino distort his subjects' proportions in such odd ways, stretching his madonna's neck so that it could never support her head, depicting fingers longer and thinner than any seen in nature? Parmigianino appears in Vasari's *Lives of the Artists*, Hill found, and he set out to learn the biographical basics as well. Soon he could hold forth on the golden youth, "more like an angel than a man," who at 16 turned out paintings that reduced older artists to awe and envy.

Hill's undercover career began at Heathrow Airport, where he had (supposedly) just landed after a Concorde flight from New York. This was theater on the cheap—Scotland Yard hadn't sprung for a plane ticket, but British Air had churned out the proper paperwork and slapped the appropriate tags on Hill's bags. He'd studied the Concorde menu, too, in case the conversation veered that way. Hill emerged from the arrival area looking dapper and rested, as befit someone whose flight had taken only a few hours.

Waiting to meet him were three people: one of the Parmigianino thieves, the thief's girlfriend, and an East End gangster who knew the American art dealer and could vouch for him. The "gangster" was in fact Sid Walker, and the job marked the first time Hill and Walker had worked together. The meet-and-greet small talk went off well. To Hill's delight, the meeting seemed to be playing out just like a scene from a Hollywood film, complete with a crook and his moll. Life behind a desk didn't come close.

The little group sat down for a get-acquainted drink. Hill, flush with cash, made a point of flashing a wad of greenbacks as he fumbled through his pockets looking for pound notes. The thief seemed to take to Hill, but his girlfriend held back. Hill and Walker chatted away like old friends. The thief made a passing reference to someone who had lost his nerve. Hill jumped in. "You mean," he said, "his arsehole went sixpence half a crown."

The phrase was not an idiom but a kind of compressed joke. A sixpence is roughly the size of a dime and a half crown is close to a silver dollar. Hill had heard the expression a few days before, and it had stuck in his mind. "I just blurted it out," he said later, "because this was my first undercover job and I was in tough-guy-talk mode. And as soon as it was out of my mouth, I realized, My God, an American would *never* say anything like that. He wouldn't say 'arsehole,' he wouldn't talk about crowns and sixpence. Jesus!

"And so I immediately said, 'That's what you'd say over here, isn't it?' to cover my tracks, as if I'd been joking. And they all laughed. The one who laughed the most, of course, so everyone would join in, was Sid. But he hadn't laughed when I came out with that."

Walker already had a towering reputation in Scotland Yard. Hill's narrow escape from self-inflicted disaster impressed him. Maybe the new kid had the makings of an undercover cop.

Hill ordered another round of drinks. Then the party swept off downtown, to Grosvenor House, the hotel on Park Lane, to drop Hill at his room. The room was real, unlike the plane flight, but this stop was entirely for show. Guests at Grosvenor House had money to spare. If Hill stayed here, he was a player.

After dark, Walker swung by the hotel in a long blue Mercedes. The two cops ate dinner and Walker took Hill through various scenarios he might encounter when he met with the thieves again. Then they set off to a midnight rendezvous with the thieves on the eastern outskirts of London. After an hour's wait at Falconwood train station in Kent, the crook from the airport showed up.

He and Hill drove off. Walker stayed behind. After endless twists and detours intended to throw off any surveillance and disorient Hill, they reached a large pseudo-Tudor house. Inside they met a new man. A standard feature of life undercover was that characters came and went without explanation, and detectives had to depend on their intuition and experience to guess who was who. Hill put the new man's age at about sixty. He looked like an extra from *The Godfather*, and he seemed to be in charge. Out came a bottle of Rémy Martin, and with it, a stream of questions directed at Hill. Who was he?

Hill made it up as he went along, though he told the truth when he could. No one mentioned art; this was about Hill, not the nature of Raphael's influence on Parmigianino. Hill found that stories about Vietnam went over well. This was a double bonus because it was rich territory and also safely outside the experience of a pair of English crooks.

Hill told the story of the first time he had come under serious fire. He had been in Vietnam about two weeks, in remote country in the central highlands. Hill was in the lead platoon making its way up a steep hill. "And then all this shit came flying down at us from the North Vietnamese—intense fire from AK-47s. About half the men in my squad were hit straight away. I hit the ground because I'd never experienced that in my life before. Whatever training you've done, nothing actually prepares you for that moment. You think, 'Shit, I'm going to *die* here!'

"Well, they stopped firing, and we started firing back. The worst thing was that our guys below us started firing up through us, and they were coming up short with their grenade launchers, dropping these things right on us. And then, at just that moment, I saw one of our machine gunners was firing, but neither his assistant gunner nor his ammo bearer was anywhere near him. Except that the sergeant was nearby and cowering behind a boulder. I thought, 'Oh fuck, what the hell is he doing?'

"I crawled over and grabbed the ammo belt, which was flying around, and Sterger—he was the machine gunner—and I moved forward quite some distance, to cover the whole front of the line. So we were above the point where the guys in my squad were being shellacked by the guys down below. It was chaos. We had to stop at one point because my glasses fell off. I said, 'Shit! Wait!,' and I put them back on, the sweat pouring down my brow, and off we went again. I was just popping the bullets in, and we were really laying down a hell of a blaze of fire.

"The M-79 grenade launcher rounds were dropping on us, plus the bullets flying up from down below toward the Vietnamese, and there was an artillery battery that must have been five miles away, and their rounds were dropping short. It was an *awful* thing. And then, just to make the nightmare worse, in flew some old F-100s—I don't know if they were U.S. Air Force or the Vietnamese Air Force—dropping napalm, and they took out the whole tree line in front of us. *Kaboomph!*

"The napalm was exploding, and everything was red with flame and black with smoke, and we were so close we could feel the air being sucked from our lungs. The Dust Offs [medevac helicopters] were just flying around up high, but the ordinary helicopters came down and picked up the wounded. Eventually our lieutenant colonel pitched up in his Huey with the battalion sergeant major. But they didn't land; they hovered up there and kicked a few boxes of ammunition out the door and disappeared off.

"Sterger certainly should have got a medal, but he got no commendation whatsoever. And the lieutenant colonel, who never got his hands dirty, ended up getting a Silver Star."

Ж

It was a story that touched on several of Hill's favorite themes—the bravery of the troops (not least himself) in contrast with the incompetence of their leaders; the danger of being shot in the back by one's own side; the eternal truth that, when honors are doled out, virtue is ignored and cowardice rewarded. The crooks liked it, too. Hill is no thief, far from it, but his antiauthority streak runs deep, and the thieves saw in him some kind of cracked-mirror version of themselves.

With everyone in a convivial mood, the older of the two crooks pulled out the stolen painting. It was about twenty-four inches by thirty inches. Hill took it in his hands. "It certainly looked like a Parmigianino," he said later, "but when I turned it over, I realized that the stretcher"—the wooden frame on which the canvas is stretched—"didn't look old enough. It obviously wasn't medieval. And when I looked more closely at the canvas, I could see that the craquelure, the pattern of hairline cracks on the surface of the painting, wasn't right, either.

"So now I was on the horns of a dilemma."

The thieves weren't trying to peddle a fake; if Hill was right, they had *stolen* a fake that they (and the owner) had believed was genuine. Hill, who had yet to say anything about the painting, fortified himself with more cognac. The two thieves looked on, amused rather than alarmed, as Hill once again scanned the painting front and back.

"We've got a problem here," Hill said. "This might not be by Parmigianino; it may just be in his style. Because if you look closely..." and then he launched into "a stream of bullshit" on wormholes in the wood and patterns in the cracking.

The thieves were indignant. Their painting was a *fake*?! But though they didn't believe Hill, at least he had put an end to any suspicion that he was a cop. The aim of detective work is to bring down criminals. Any genuine undercover cop, the thieves assumed, would have glanced at the painting, cheered his good fortune, and slapped on the handcuffs.

By now it was four in the morning. Hill told the thieves he didn't want their painting. They drove him back to meet Walker at the train station. Walker, who had spent a long, cold night waiting in a parking lot, noted without enthusiasm that Hill had booze on his breath. Part of the job, Hill explained, and besides, it was not beer but cognac and good cognac at that. Walker didn't seem much mollified.

Hill had far more distressing news to impart. "I think the thing's a fake," he said.

"Shit! Are you serious?"

Walker and Hill sped back to headquarters and reported the night's doings. Their superiors, convinced that the painting was real and that they were on the brink of catching two criminals they had long been pursuing, ordered a raid on the house Hill had visited.

The next day Walker collected Hill at Grosvenor House. The police had grabbed the Parmigianino and brought it to the auctioneers at Christie's. The painting, the experts decreed, was a Victorian copy in the manner of Parmigianino. It was worth not £3 million but, on a good day, £3,000.

For an art historian or a restorer, recognizing the painting as a fake might have been a routine day's work. But they would have had expertise on their side and all the time they wanted. Hill, armed only with nerve and a good eye, was an amateur who had to make a snap judgment while a pair of crooks glowered at him.

It came out eventually that the thieves had stolen the painting twenty-

five years before and put it away. For a quarter of a century, they had looked on it as a retirement fund worth millions.

"Well, everyone was bitterly disappointed," Hill recalled, "because they were so desperate to put these guys away for something big. But my reputation soared; it made me. From then on, I was the Yard's art 'expert.' And Sid suddenly realized that I could do the job. He said, in that growl of his"—here Hill put on a tough guy accent—" 'Chollie, the thing I like about choo is, you got charisma.' "

Charisma wasn't quite the right word—nerve or flair would have been closer. But the point was that Charley had won Sid's endorsement. Years later, he still glowed at the memory. "I was flattered by that. No fucker had ever said anything like that to me before. Sid was a really hard-nosed cop, whom I'd heard a lot about but never met, the foremost of all police undercover officers. And from that moment, I became one of his protégés." 26

The Trick of It

ill, who had spent a lifetime in dissatisfied flight from career to career, found a home in undercover work. Art jobs in particular were a perfect match, one of the few vocations in the world that called for someone who would be equally glad to study the brushstrokes in a 300-year-old painting or to kick down a robber's door.

For Hill, the pattern never varied. Talent and brains would lift him up, and restlessness and rebelliousness would send him tumbling back down. He had nearly managed to flunk out of college, despite his taste for books. In the army, he no sooner earned a promotion than he picked a fight with an officer who busted him back to private. At Scotland Yard, nearly every higher-up was a "complete dunce who talked through his ass." On the ladder of career success, Hill broke every rung.

Hill saw the pattern himself, but he took it as proof of integrity rather than of self-destructiveness. "Pissing people off is what I've done best in life," he has said more than once, and his tone when he says so is boastful rather than wistful. He is, after all, a lone wolf, not a creature made to work in harness. "I was a real 'fuck the army' kind of guy, but I enjoyed fighting, and the people I was with enjoyed having me with them," Hill says defiantly. "I was a good fighter but not a good soldier, and later on I was a good thief-taker but not a good police officer."

Undercover work, with its emphasis on making it up as you went along and on working in small teams rather than in large groups, set him free. Suddenly the very traits that had set Hill apart and made him an odd fit in the police—the chafing at authority, the posh accent, the tendency to drip polysyllables, the arcane interests, the "outsiderness" in general all turned to his advantage. The starting point in undercover work was the ability to go unrecognized. Hill was the last person anyone would identify as a cop.

"English detectives all look alike," says Mark Dalrymple, the insurance investigator. "They're always in suits—always the same inexpensive suits. Very plain ties, with a neat knot. Short hair, neatly cut. Polished shoes." Dalrymple puts down his wineglass and swings his eyes around the crowded pub where he is holding forth, in search of a live example. "The minute they come in the room, every villain in a place like this knows who they are. *Nobody* ever makes Charley Hill."

It is not because he is a man of a thousand disguises. Hill's range is narrow. One of his undercover colleagues once worked his way inside a neo-Nazi gang and thwarted its plan to firebomb a synagogue. Hill could no more pass for a skinhead than could John Cleese. (Hill is typecast partly because his acting skills go only so far. But vanity comes into play as well. Hill brushes aside certain roles as not for him. He is a leading man. If all that's wanted is a brute, plenty of others can fill the bill.)

"Most police operations are for drugs or arms," says Dick Ellis, the Art Squad detective who specialized in putting together undercover teams, "and those tend to work out quite nicely. Those deals are done on a villain-to-villain basis, and we have some very well-trained, very astute police officers we can insert into those scenarios. But they could never, *ever* pose as anything other than a villain."

The man who brought down the neo-Nazi gang, for instance, was a highly regarded detective named Rocky, who looks like a bigger, tougher Charles Bronson. In police circles, he was renowned for such feats as throwing a desk at a sergeant (and, more surprisingly, getting away with it). Rocky's partner was supposedly the only person who could handle him. Charley Hill, a friend of both men, referred to them as "the monster and his manager."

"Have you met Rocky?" asks Dick Ellis. "You aren't going to get Rocky posing as a representative of the Getty." Ellis is so struck by the image that he wheezes with laughter, as if he has a slow leak. "Rocky does not come across as a well-educated, aesthetic, well-to-do person," he goes on. "Rocky is your rough-and-tumble black market dealer, and he's *very* good at it. But when you come up against something unusual, you need someone else."

You need, in fact, Charley Hill.

Nearly always, Hill plays a swaggering American or Canadian with a loud mouth and a thick wallet. His characters are invariably light on scruples and, when it seems the best way to tempt a crook into the open, sometimes low on brainpower as well.

Despite Hill's years in the United States, posing as a North American is trickier than it sounds. Getting the accent right is the first requirement, and the easiest. Capturing the melody of American speech, as opposed to the sound of individual words, is slightly more of a challenge. The pitch of an American's voice tends to fall at the end of sentences; an Englishman's voice falls less steeply, or even rises, almost as if he were asking a question. Hill must remember, too, not to cap his sentences with the rote questions—"He's not really up to the job, is he?"—that the English use to soften their judgments.

Speed bumps pop up everywhere. Hill needs to purge his speech of countless English words and idioms beyond the familiar "lift" for "elevator" and "underground" for "subway." The hardest to remember are words where the difference in pronunciation seems idiosyncratic, like the American "CONtroversy" and the English "conTROversy."

A few differences are specific to art. Americans pronounce "van Gogh" like "van go," for instance, while the English choke out something closer to the guttural Dutch original, as if the speaker has a fishbone caught in his throat.

The greatest danger hides in expressions that are more verbal reflexes than products of conscious thought. Say "cheers" rather than "thank you" to a waiter who has brought a drink, and you have blown your cover. In similar fashion, habits deeper than thought—like the proper way to deploy a knife and fork—pose grave risks. Unlike the English, Americans at the dinner table set their knife down between bites and switch the fork to their right hand. When he plays Americans, Hill sometimes feigns arguments during meals so he will have an excuse to jab the air angrily and, perhaps, draw attention to his fork-wielding right hand.

The problem is not that the differences between England and the United States are so vast. They aren't. The problem, which is familiar to every tourist in London who has looked left instead of right and stepped blindly into traffic, is that the consequences of a moment's carelessness can be disastrous.

For undercover cops, the need to be on guard is constant. Thieves and gangsters confronted with a stranger immediately begin trying to size him up. The process is not subtle. In contrast with ordinary encounters, where etiquette forbids challenging a new acquaintance with belligerent questions, crooks encountering someone new probe him openly and aggressively.

"People are always testing you to find out if you're a cop or a taxman or if you're who you say you are," Hill says. "Are you a wrong 'un or the right guy to deal with? They ask about your background, what you did before this. It could be anything. In my case, maybe some question about art or a painting."

It is not a game for the timid, which is, for Hill, a great part of the appeal. Whether out of courage or foolhardiness or a never-outgrown faith in his own invulnerability, Hill feels most alive when most in danger. Even under fire in Vietnam, he insists, he was never scared but at most "concerned." This smacks of Daniel Boone's remark that he was never lost in the wilderness though he was once "confused" for three days, but the larger point holds: Hill places a high value on physical courage, believes that he is at his best under pressure, and delights in putting himself in harm's way.

When it comes to undercover work, those are essential traits. If Hill were handed a script and told to read it, his performance would be no better than that of many others. A great many actors, after all, can switch with ease between American roles and English ones. Throw away the script, though, and then raise the stakes, and Hill would come into his own.

For it is the setting rather than the acting per se that sets the undercover craft apart. Acting is easy if the greatest danger is that someone in the audience will walk out or a stagehand will miss a cue. But try it when the penalty for flubbing a line is a shotgun to the head. "All undercover work comes down to mental ingenuity," Hill says. "It's a matter of quickwittedness, imagination, the capacity to lie on the hop." *Beverly Hills Cop* was a silly movie, Hill remarks, but in its emphasis on talk rather than gear, it came closer to conveying the realities of undercover work than any of the legion of earnest, grim cop films. "You've got to have something to say, all the time, that's sharp and plausible and says "This guy can't be a cop." The villains don't necessarily have to like you, but they have to accept you and feel they can trust you."

An arsenal of high-tech gizmos like James Bond's is beside the point. "You survive by your wits," Hill insists. "Hardware will only let you down." The bare-bones approach, it should be noted, applies only to things, not words. When it comes to the stories he spins, Hill begins with the simplest of premises and then tacks on as many unlikely and over-the-top embellishments as pop into his head.

Characteristically, Hill takes his "the less gear the better" view to an extreme. Guns are out, first of all. He never carries a weapon, even when he knows he will be dealing with killers. Out, too, are any kind of hidden recording devices and any disguises beyond some new clothing. No beards or mustaches. No contact lenses or new eyeglasses or changes of hairstyle. No bullet-proof vests. The gallant knight will ride into battle bareback and unarmed.

Even Hill's false identities are willfully, almost perversely, thin. His tycoons and wheeler-dealers start out as cardboard cutouts, stereotypes cobbled together from old movies and corny television shows like *Dallas*. In the Czech Republic job in 1996 that involved a gang of ex-secret police turned criminals, for instance, Hill created a ludicrously unlikely role for himself.

He had decided to play a sleazy Canadian and had it in his head, for no very good reason, that the ideal outfit would be "a tam-o'-shanter hat, a really garish orange-colored blazer, and yellow trousers. I tried to look like a complete Canadian asshole. I told them I was going to sell all these wonderful medieval objects and paintings stolen from various churches to people who owned yachts in the Bahamas.

"You'd have to be some kind of eastern bloc jackass to believe the crap I was coming out with," Hill gasps, red-faced with laughter. "But they loved it; they went for it." Nervy though he is, Hill chooses outlandish roles not to spice up the game but because he thinks he knows what crooks expect an art sleazeball to look like. "You have to feed the art crook arseholes' fantasies," Hill says. "You have to be what they want you to be." Their notions are almost guaranteed to be wildly off, since they are based on guesswork and stereotype, but that's fine with Hill.

His job is to hit the notes that signify authenticity to his crook audiences. If a posh accent or a plush hotel room spells credibility, so be it. In the world of natural history, scientists have spent years exploring such triggers. When birds bring food to their nests, for example, they meet a host of gaping beaks pointed at the sky. If scientists take away a hungry chick and substitute even the crudest replica of an open beak, the hardworking parents will labor mightily to feed *it*. Charley Hill is the least scientific of men, but the performances that he calls his "amateur theatrics" are essentially experiments to find the triggers that cajole crooks into responding the way he wants them to.

Mark Dalrymple, the insurance investigator, is a far less impetuous man than Charley Hill. But even though he shakes his head at Hill's lack of prudence, Dalrymple is quick to acknowledge the detective's undercover skills. "Charley Hill," Dalrymple says, "has more brains and more balls than the rest of the police combined."

Hill's aversion to any gear beyond the most basic is partly a personal quirk and partly a matter of experience. "Brits don't do guns," Hill will say, if he is pressed, but that is patently insincere. If he happened to *favor* going armed, he would just as happily chalk his preference up to his American heritage. More to the point, Hill's anti-gun bias is a legacy of his time in Vietnam. When guns are around, things go wrong, and not just for the person at the wrong end of the barrel. "Going unarmed doesn't put me in extra danger," Hill insists. "It puts me in *less* danger, because carrying a gun gives you a false sense of security."

Guns foster a "shoot first, think later" approach that can only mean trouble. In Vietnam, Hill himself had nearly killed one of his own men by accident. "He was a little guy, named Peewee. He was Hispanic but he looked almost Vietnamese. He was one of those assholes who liked to put his helmet on the wrong way around, like wearing your baseball cap backward." One morning Hill spotted something in a clump of elephant grass. "Suddenly this head popped up, and the helmet was the wrong shape. I stopped just short of blasting him full in the chest. He must have been fifteen yards away, no more than that. 'Oh, fuck,' I thought. 'Jesus! Peewee!' I nearly blew him away, and all he'd been doing was having a crap in the bushes."

Hill's dislike of guns also reflects hostility toward technology in general. He can manage a cell phone or send an e-mail, but that is as far as he goes. The function of mechanical contrivances is to betray their user at the worst possible moment.

In the Czech case that featured a crew of ex-secret police turned art thieves, Hill had no choice but to trust his life to gadgetry. The good guys—the German counterparts of the FBI—had given him a briefcase rigged up so that when Hill pressed a button it sent out an electronic "come quick" signal. In a parking garage beneath a hotel in Wurzburg, Germany, Hill met with the Czech gangsters and perused the stolen paintings they proposed to sell him. The Germans were poised to race in when they got Hill's signal. Hill pressed the button. Nothing happened. Maybe the problem had to do with being underground, or perhaps there was a mechanical failure. He tried again. Still nothing.

For half an hour, Hill studied and restudied the paintings, playing for time and rambling on about Lucas Cranach and Veronese and Reni as best he could, to an audience made up of cops gone bad, at least one of them a killer. When he could manage to do it inconspicuously, he tried again to send the help signal. Nothing. Finally the Germans acted on their own, bursting in brandishing Dirty Harry handguns and arresting everyone. Hill and the Czech gang leader ended up sprawled next to one another face-down on the concrete floor. A cop bent low to handcuff Hill's arms behind his back and whispered into his ear, "Goot verk!"

180

Charley Hill, on the grounds of Blenheim Palace. The pose was a subtle homage to one of Hill's favorite paintings, Gilbert Stuart's *The Skater*. A man of action with a connoisseur's eye, Hill liked to think of himself as spiritual kin to Stuart's skating scholar.

Gilbert Stuart, *The Skater*, 1782 oil on canvas, 147.4 x 245.5 cm © National Gallery of Art, Washington DC, USA / Bridgeman Art Library

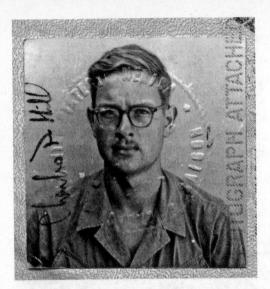

LEFT: Hill's passport photo, taken in 1969 in Saigon.

BELOW. A memorial service for the eleven men of Bravo Company's Lima Platoon, killed in an ambush on Easter Monday, 1969.

OPPOSITE. BOITIOM. Hill is proud of his dual ancestry, "log cabin on one side and knight of the realm on the other." His mother grew up in a glamorous English household where the likes of George Bernard Shaw and H. G. Wells were frequent visitors. His father's family hailed from the American west. Here several of Hill's relatives (the boy who would become his grandfather is sixth from the left) pose in front of the family homestead in Oklahoma in the 1890s.

Zita Hill, Charley's mother. An elegant, high-spirited woman, Zita trained as a ballerina but joined Bluebell Kelly's troupe of high-kicking dancers for a European tour just before the outbreak of World War II.

Landon Hill, Charley's father, in Air Force uniform.

In Charley Hill's first case as an undercover detective, two crooks tried to sell him a painting by the 16th-century Italian Parmigianino. The painter's most famous work, often called the *Madonna of the Long Neck* because of its exaggerated proportions, is at left. Hill examined the crooks' painting and told them he thought their prize was a fake.

Christ and the Woman Taken in Adultery was stolen from London's Courtauld Institute of Art Gallery by a thief who tucked it under his arm and ran out the door. The painting, by Bruegel, was valued at £2 million. The painting eventually made its way to a gang of small-time thieves, who showed it to an expert to find out if it had any value. The expert took a look and fainted.

Francesco Mazzola Parmigianino, *Madonna of the Long* Neck, 1534–40 oil on panel, 135 × 219 cm © Galleria degli Uffizi, Florence, Italy / Bridgeman Art Library

Pieter Bruegel the Elder, *Christ and the Woman Taken in Adultery*, 1565 oil on panel, 34.4 x 24.1 cm © The Samuel Courtauld Trust, Courtauld Institute of Art Gallery, London

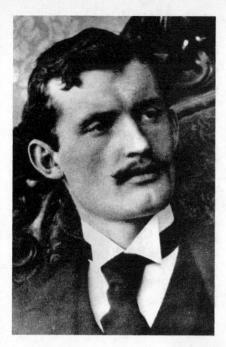

Munch painted his self-portrait in 1895, two years after *The Scream.* A more tormented man would be hard to imagine. "Disease, insanity, and death were the angels which attended my cradle," he once wrote, and they chased poor Munch throughout his long life.

Edvard Munch, *Self-Portrait with Cigarette*, 1895 oil on canvas, 85.5 x 110.5 cm PHOTO: J. Lathion; © National Gallery, Norway / ARS

Photograph of Edvard Munch c.1892 © Munch Museum, Oslo

Edvard Munch, *Spring Evening on Karl Johan Street*, 1892 oil on canvas, 121 x 84.5 cm © Courtesy of the Bergen Art Museum / ARS

Munch painted this melancholy street scene, Spring Evening on Karl Johan Street, in 1892, a year before The Scream. The skull-like heads and staring eyes would reappear in The Scream.

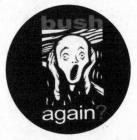

ABOVE. *The Scream* has served as the basis for countless spoofs and cartoons. Munch, a tormented and melancholy man, had hoped that audiences would "understand the holiness" of his images.

LEFT. Munch may have seen this Incan mummy at the Palais du Trocadéro (now the Musée de l'Homme) in Paris. Some art historians believe it helped inspire *The Scream*'s central figure.

RIGHT. The National Gallery, in Oslo. *The Scream* had been moved from its customary location in the museum to the second floor, so that it would be more convenient for tourists. Not only was the painting moved closer to ground level, but it was hung in a room with easy access from the street and within a few feet of a window. This photo was snapped moments after *The Scream* vanished. Note the billowing curtains, as the wind blows through the broken window, and the police tape.

BELOW. *The Scream* was stolen on the opening day of the Winter Olympics in 1994. With the world's attention focused on Norway, the *Scream* thieves stole the international spotlight as well as a \$72million painting.

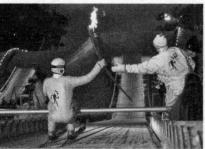

Pål Enger was an ex-soccer star turned crook and a publicity hound. Enger, who had been convicted in 1988 for stealing Munch's Vampire, was a natural suspect when The Scream vanished. He had an alibi. though, and enjoyed teasing the police. Here he poses next to the spot where The Scream had hung; in the place of the \$72million masterpiece is a poster from the museum's gift shop, hanging above a label reading "Stolen."

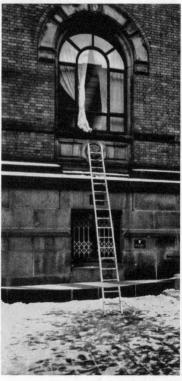

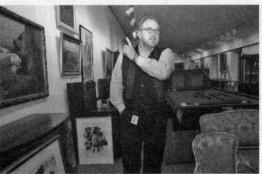

An art dealer named Einar-Tore Ulving found himself mixed up in *The Scream* case when an ex-convict client told him he had underworld contacts who could arrange for the return of Munch's masterpiece.

The first break in the case following a tip from an anonymous caller, authorities found a piece of *The Scream*'s ornate frame. The National Gallery's ID numbers proved that the frame was the real thing.

C Dagbladet / All Over Press / Retna Ltd.

Leif Lier, the Norwegian detective in charge of *The Scream* case.

John Butler headed up the three-man team that Scotland Yard sent to Norway to find *The Scream*.

Charley Hill's business card, for his role as wheeler-dealer Chris Roberts, "The Man from the Getty."

IIM 17985 Pacific Coast Highway Malibu, CA 90 Mailing Address: P.O. Box 2112 Santa Mo 310 459-7611 0407-2112

C Dagbladet / All Over Press / Retna Ltd.

Adam Worth, the renowned Victorian thief, provided the model for Sherlock Holmes's nemesis, Professor Moriarty. Worth stole one of the most famous paintings of his day, Gainsborough's *Portrait of Georgiana*, and kept it with him, secretly, for twenty-five years. Worth is the only undisputed example of a thief who stole a masterpiece and clung to it not for profit but for his own delectation.

Thomas Gainsborough, Georgiana, Duchess of Devonshire, 1787 oil on canvas, 74 x 102 cm © The Devonshire Collection, Chatsworth. Reproduced by permission of the Chatsworth Settlement Trustees.

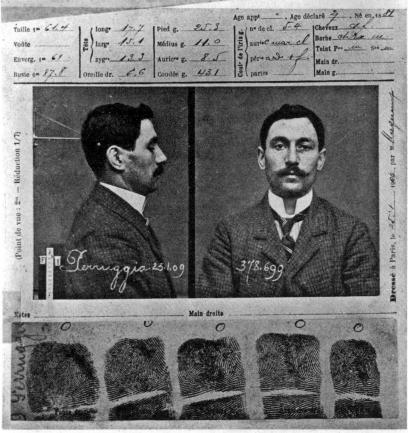

On a Monday morning in August, 1911, a day when the Louvre was closed to the public, a carpenter named Vincenzo Perugia sneaked out of a closet where he had hidden overnight. He hurried to the *Mona Lisa*, took the painting off the wall, tucked it inside his coat, and walked out the door. Two years later, when he tried to sell the world-famous work, he was arrested. (Police misspelled his name in this mug shot.)

Perugia was arrested in Florence. Though convicted, he was sentenced to only twelve months, reduced on appeal to seven. Perugia, an Italian, argued successfully that he had been motivated by patriotism, not greed, and wanted only to see the *Mona Lisa* in its homeland. Here officials at the Uffizi examine the painting before returning it to France.

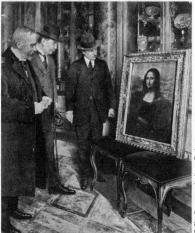

C The Bettmann Archive, Corbi

© The Newcastle Journal

C PA Photos Limited

David and Mary Duddin. A majorleague fence, or seller of stolen goods, Duddin was dubbed "Mr. Big" by an English judge. Duddin once tried to sell a stolen Rembrandt. He wasn't much impressed by the painting. "I wouldn't hang it on me wall." he scoffed.

Kempton Bunton, who was Mary Duddin's uncle, was in the art line himself. In 1961 he stole Goya's Portrait of the Duke of Wellington from London's National Gallery. (See photo insert p. 5.)

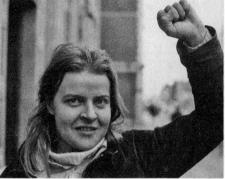

ABOVE Rose Dugdale, an ex-debutante turned political radical, stole a Vermeer, a Goya, a Velasquez, and sixteen other paintings from Russborough House, a stately home outside Dublin. The theft was inept and all the paintings were quickly recovered. At her trial in 1974, Dugdale proclaimed herself "proudly and incorruptibly guilty." She was sentenced to nine years in prison.

LEFT. In 1986, a Dublin gangster named Martin Cahill robbed Russborough House yet again, pulling off what was then the biggest art theft ever. "The General," as Cahill was known, was a vicious thug—he once took hammer and nails to the hands of a gang member he suspected of betrayal—who had a strange sense of showmanship. Here Cahill is led to jail; the gangster, who made a fetish of hiding his face, nonetheless flaunts a pair of boxer shorts and a Mickey Mouse T-shirt. Art thieves have attacked Russborough House four times so far.

RIGHT Niall Mulvihill, a Cahill associate. Charley Hill, who recovered the two most valuable paintings stolen by Martin Cahill, negotiated their return with Mulvihill. (See photo insert p. 3.) In 2003 Mulvihill was shot to death by a gunman in Dublin.

C PA Photos Limited

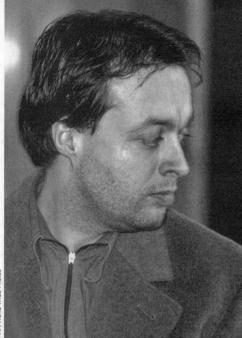

One of the very few thieves who stole art for his own collection, Stéphane Breitwieser was a French waiter arrested in the winter of 2003 for stealing perhaps \$1.4 billion worth of paintings and other objects. When the police closed in, his mother sliced many of the paintings in tiny pieces and threw them away in the trash and tossed others into a canal near her home. Here police search the partly drained canal.

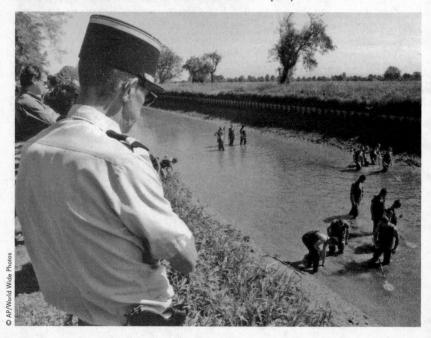

C AP/World Wide Photos

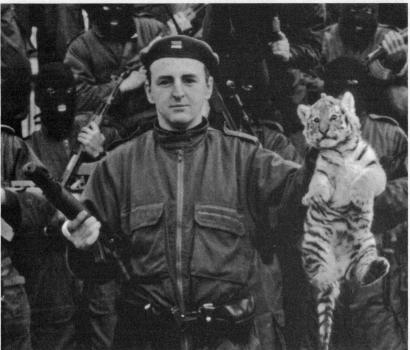

Arkan, a Serbian gangster and accused war criminal, was reportedly involved in the theft of two Turners, worth a total of \$80 million, stolen in 1994 while on exhibit in Frankfurt, Germany. Above, on a tank captured by his "Tigers" unit, he poses with a tiger cub. Art thieves were once dashing figures like Adam Worth. Today the swashbucklers have been shoved aside by brutes like Martin Cahill and Arkan.

Whenever a world-famous painting disappears, police speculate that some master criminal, a real-life Thomas Crown, has ordered the painting for his private collection. Outside of Hollywood, Charley Hill insists, there are only wannabe Thomas Crowns like Stéphane Breitwieser, never outsize figures on a Hollywood scale. One villain who supposedly assembled a collection of paintings stolen to order was the Ugandan dictator Idi Amin.

C AP/World Wide Photos

The Isabella Stewart Gardner Museum in Boston was the site of the largest art theft ever—eleven paintings and drawings worth \$300 million. The photo above shows the museum courtyard. The robbery, still unsolved, is the holy grail of art crime. The FBI reward in the case is \$5 million. Ten years after the theft, the FBI admitted that "we haven't got a clue," and, after another four years, the agency remains stymied. 27

Front-Row Seat

Indercover work is not a spectator sport. Almost always, the only eyewitnesses are the participants themselves, and both cops and robbers have biases that distort their view. Dennis Farr, who was director of the Courtauld when thieves stole its £2 million Bruegel—this was the "Peter Brewgal" affair—is one of the rare laymen who have seen an undercover operation.

Farr is a tall, thin man with elegant manners. He looks like a fluttery type, a bird-watcher perhaps, the sort of scholar who would go pale at the sight of a typo. As the Bruegel case played out, though, it fell to Farr to string crooks along on the phone (while Art Squad detectives at his elbow listened in and scribbled him instructions). He found he had a flair for the task. "One discovers one has a bit of a thespian bent," he acknowledges shyly.

Charley Hill and Dennis Farr hit it off at once. Hill put on his best manners at their first meeting, deferring to "Dr. Farr" and chatting away about the Courtauld collection and art in general. Bruegel was one of Hill's favorites. He grew animated when he discussed how Bruegel had painted the shaft of light that descends from the left and illuminates *Christ and the Woman Taken in Adultery*, the stolen painting. Farr took up the theme, and both men went on to a happy discussion of similar uses of light in Rembrandt and Vermeer.

Farr is no snob, and he had been taken with the other Art Squad detectives,

too, but Hill intrigued him. "As soon as I met him," Farr recalls, "I saw there was a maverick quality in Charles Hill. I said to myself, 'He's either going to end up commissioner of the metropolitan police, or he'll quit the force alto-gether.' "

The second time they met, Farr found Hill considerably changed. The plan was to rendezvous with the crooks, and Hill was in character. "I was a loudmouthed 'Hey there, you old son of a bitch' kind of guy," Hill recalls. For this role, the point was *not* to come across as an art connoisseur but as someone so smug and ignorant that he was ripe for the plucking. "I wasn't arty, but I was a trophy art type, some J. Ralston Ridgeway type from Dallas, Texas. Those guys are legion. They're the ones who buy fakes and spend big bucks on overpriced paintings. They're extremely wealthy chumps who see art as a way to establish their bona fides in society. So that was me, some asshole who's got more money than sense."

The meeting with the crooks was set for the Savoy, a grand old hotel on the Strand, overlooking the Thames. Ideally, the thieves would produce the painting, Hill would hand over a ransom, and a gang of cops would burst from hiding to make the arrests.

Farr was thrilled with his insider's peek at all the planning and deception. Hill and Farr walked into Hill's hotel room—a large and handsome suite, with a river view—and Hill started yelling almost at once. He'd been in a foul mood all day. Hill was a big-picture thinker, not a detail man, he liked to say, but sometimes details did catch his eye. The police had showed up earlier in the day with the ransom money, £100,000 in £20 notes, stuffed in "a crappy police cardboard kind of thing." Any crook would immediately start wondering what kind of high-roller he was dealing with. Hill insisted the police buy him a proper leather bag. Hill had won that battle, but his superiors had been horrified at the cost of a leather case intended as a one-time prop.

Now, in the suite, he saw at once that the carpet had been tamped down by the cops in the surveillance team. Size 12 footprints were everywhere, because the cops had been stuffing wires down every crevice they could find. "It looks like the Serengeti after the gnus have gone thundering past," Hill complained to Farr.

Hill called for the cops. "Get somebody in here to get rid of these

fucking footprints," he shouted. "Those guys are going to come in here and see that, and then we're all fucked!"

Once the telltale footprints had been vacuumed away, Hill relaxed. He picked up the phone and ordered a bottle of champagne and a tray of smoked salmon sandwiches. Farr scanned the room to decide which sofa would be the best to hide behind, if anyone started shooting. ("Now, dear," his wife had told him that morning, "don't come home perforated.") In the meantime, he rehearsed his assigned line time after time. "This is what we're after," Farr was to shout, and on that signal the cops in the next room would rush in.

Hill asked Farr if he had ever seen £100,000 in cash.

"No, let's have a look."

Hill unlatched his new case, which burst open, spilling money everywhere. The maid knocked on the door, with the smoked salmon. "And Charles Hill and I were sitting on this bloody briefcase," Farr says, "trying to squash it flat."

Ж

"The whole thing was marvelous," Farr bubbles. "Hill was totally convincing. He dressed elegantly, not flashily, but he *exuded* money, shall we say. He just had this presence. You've met Charles Hill? So you know he's a big, broad-shouldered chap, and he just . . . well, when he chooses, he can throw his weight about."

Bullies like the one Hill was playing were new in Farr's experience. He himself was fond of expressions seldom heard outside a boy's adventure magazine of the type popular three-quarters of a century ago—his stories are full of "blighters" and "frightful chaps" and even "four-flushing swine"—and he watched Hill's performance goggle-eyed.

Years later, he could still recite many of the exotically ugly phrases Hill had thrown around so casually. "I remember, he leaned over and tapped the case with the marked bills and said. "This money will stick to 'em like dog shit,' " Farr says gleefully. The line holds such appeal that he tries it a second time, like a mischievous schoolboy reading aloud a smutty scribble on the wall.

"Charles Hill knew just how to play a big, swaggering, loudmouthed

American, if I may say that, saving your grace," Farr says. " 'I can't waste my time with this, I'm off to Europe tomorrow, I've got business all over the world, I can't be dealing with little twits like you.' "

Farr frets that his cultured accent drains this "good, coarse stuff" of virtually all its menace, but he replays his favorite lines nonetheless. "I've had it about up to here with your horseshit," he growls, mimicking Hill.

Though Farr didn't know it, that seemingly offhand line was far from casual. The key was the word "horseshit." It is an Americanism, first of all, and reinforced Hill's American persona. In the taxonomy of nonsense, "bullshit" is universal, but "horseshit" is unique to America. Second, the r sound emphasized Hill's American accent and reminded him to keep hammering those r's.

At the Savoy, Hill abused the thieves for the better part of an hour and then threw them out, even though he had yet to see the stolen Bruegel. Dick Ellis was hidden in a hotel room next door, eavesdropping as the tape recorders whirred.

Even Ellis and his fellow cops, as experienced with scenes like this as Farr was new to them, feared Hill had overdone it. "We were saying, 'Charley, steady down. We're gonna lose these guys.'"

"He said, 'Don't worry, they'll be back,' " Ellis recalled.

"And he was absolutely right. They came back. They came back, they got arrested, and they got convicted."

184

28

A Crook's Tale

ill's confidence in his ability to read crooks is a product of endless hours listening to their tales. Many are hard to draw out. Not David Duddin. A flamboyant, 300-pound crook who once tried to sell a stolen Rembrandt, Duddin recounts past misdeeds with the relish of a retired athlete recalling the first time he heard a delirious crowd shout his name.

The world that Hill navigates is replete with treacherous but useful characters like Duddin. Hill and Duddin go back several years; they met when Hill visited Duddin in prison, after the Rembrandt deal had gone bad. Hill hadn't been involved in catching Duddin, but he hoped to cultivate him as a source.

Duddin lies with gusto and without scruple, for the sheer style of it. Convivial and self-absorbed, he talks freely about crime and crooks, with only the most perfunctory nods toward conventional morality. It's all a bit of a lark. Where's the harm?

One of his favorite roles is tour guide to the underworld. "I'll let you make up your own mind how criminally minded you think I am," he begins. "I don't particularly think I am criminally minded, but having said that, I've been found guilty of six counts of handling stolen goods, so that's me criminal record."

This seeming confession is in fact closer to a boastful dig in the ribs, an invitation to share in the joke. "Who are you going to believe," the tone implies, "me or some judge?" In Duddin's world, the fundamentals of morality—tell the truth, keep your promises, pay your debts, and so on—are not rules to live by but a credo for suckers. To earn your living by the sweat of your brow is to proclaim yourself a sap.

Duddin is no sap. Straight society is something to plunder, not to join. He explains matter-of-factly, for example, that although art is always easy to steal, stealing from Britain's grand and stately homes (like Russborough House) is easiest of all. The homes are colossally expensive to keep up, and many of the owners have decided that their only chance of survival is to open up to ticket-buying visitors. "Picture your own house," Duddin says. "Would you take several thousand people around it, and then think it was secure? You wouldn't, would you?

"I've spoken with people—and bear in mind that where I've been, I've been with some of the heavier criminals in the country—and they say, 'If somebody's going to show you something and tell you it's worth millions, well, then, you're going to take it.'

"It's natural. It's normal. It's redistribution of wealth." This last grand phrase is a mocking joke, and Duddin rolls the words around his mouth voluptuously, savoring the syllables.

Massive and slow-moving, with arms like hams, Duddin is a great Buddha of a man, albeit a Buddha who favors such touches as gold Rolexes and bright red jackets and gleaming red shoes to match. His criminal ambition was as outsized as the man himself. At his peak, Duddin drove a Rolls-Royce ("a Roller") and gave his wife a BMW as a Christmas present. The judge who sent him away for selling the Rembrandt and a host of other stolen treasures said Duddin was the biggest handler of stolen goods in England and dubbed him "Mr. Big."

In his early days, Duddin ran a jewelry business. The illegal buying and selling took place in a back room. Duddin presided from behind a large, nearly bare desk. Neatly arrayed atop the desk were a scale and an eyepiece, a Kellogg's Cornflakes box stuffed with cash, and a shotgun. No one ever mentioned the shotgun, which faced outward, but it did seem to cut down on haggling over the prices Duddin offered his clients for their wares.

He has lived all his life in Newcastle, in the north of England, and he

speaks with the thick local accent. "I was blind out of me skull," he says, fondly recalling one monumental bender, and, to American ears, the stretched-out vowels give his speech the wavery sound of a tape played on a malfunctioning machine: "I was blaind oot of me skool."

Duddin's wife, Mary, is always by his side. She is tiny, though she teeters on colossal high heels, and she has bright red hair and a tiny voice, too, pitched in a high squeak. Mary looks as if she has just wandered in from a rehearsal of *Guys and Dolls*, but she is shrewder than her husband, and far too shrewd to acknowledge that she knows it. As Duddin talks, Mary plays the role of the attorney who whispers a helpful word into her client's ear while he covers the microphone and turns away from his senatorial prosecutors.

Mary's family, too, is in the art line. In 1961, in one of the notorious art thefts in recent history, someone stole Goya's *Portrait of the Duke of Wellington* from the National Gallery in London. The theft generated enormous publicity because the museum had purchased the painting only weeks before, after a great kerfuffle. The painting had been in private hands and had sold at auction to an American oilman for £140,000. Furious at the prospect of losing a famous painting of a national hero to a foreign buyer, Parliament and a private foundation came up with £140,000 of their own. The American gave in, the painting stayed home, and the National Gallery put it on exhibit. Eighteen days later, it vanished.

In 1962, with the portrait still missing, the first James Bond movie opened. This was *Dr. No*, and the plot, such as it was, had to do with a villain who hatched evil schemes at a secret lair in the Caribbean. Dr. No took Bond on a house tour, which led past a portrait mounted on an easel. Lest anyone miss the joke, Bond did a double-take and the camera moved in for a close-up of the *Duke of Wellington*.

The real portrait finally turned up in 1965, unharmed but without its frame, lying amid a jumble of forgotten suitcases in the lost-luggage office of the train station in Birmingham. Six weeks later, the thief turned himself in, apparently convinced that the world would want to hear his story and that no one would punish a person for stealing something that was back where it belonged. The self-proclaimed thief was an unemployed taxi driver named Kempton Bunton, a Newcastle man who looked a bit like Alfred Hitchcock.

Bunton, a clumsy, eccentric man in his sixties, was Mary's uncle. "Only an uncle by marriage," she clarifies, "me auntie's husband. Well, I don't know how he got the painting home, but he put it in his cupboard in the bedroom. And Auntie made a joke the night he turned himself in. 'I've been sleeping with the Duke of Wellington for four years,' she said, 'and I've never even known.'"

At his trial, Bunton explained that he had stolen the painting as a political protest. He had no interest in commercial gain; his sole aim was to remedy a gross injustice. The government charged everyone who owned a television set a yearly fee, which went to support the BBC. Not even the elderly were exempt. Bunton was beside himself. What kind of government charged its citizens to watch television and then lavished £140,000 on a bloody *painting*?

Both judge and jury seemed to find Bunton endearing, and they apparently had doubts about whether he really was agile enough to have taken the Goya from the museum by climbing out a window in a men's bathroom, as he claimed. The jury performed a contortionist's trick of its own. Bunton was not guilty of stealing the painting, they found, but he was guilty of stealing the frame. The judge imposed a sentence of three months.

Mary does not believe that her uncle stole the portrait. His two sons did, she says, and then he horned in on their glory. (The family, she says, was "all a bit nuts"—"*a bit noots.*") It is a convincing if not ringing defense: her uncle was too fat to steal, not too honest.

Duddin's world and the conventional one are not self-contained. They meet occasionally, as the lion's world sometimes meets the antelope's. But in ordinary times the two worlds *are* isolated from one another, and Duddin betrays surprise when it becomes clear that yet another commonplace feature of his life is strange to an outsider. Mundane questions—How big a bag does it take to hold £20,000 in small bills? How long would it take to count?—throw him off-stride for a moment, as if an earnest visitor had asked him to explain how to make a sandwich or dial a phone. A broader question that seems absolutely fundamental to a layman— Why steal a masterpiece?—leaves him frustrated and befuddled. Art is worth stealing because it's valuable; what valuable *means* is "worth stealing."

Speaking slowly and emphatically, Duddin strives to make matters clear. "If it's very easy to take," he says, "it doesn't matter if you've got a buyer for it or not. If it's *difficult* to take, you're going to make sure there's a market for it, because you've got to put extra work into it."

But what do you do with it?

Driven to distraction, Duddin resorts almost to baby talk. He has been sipping his drink, but this calls for a pause and a deeper swallow. "Mr. Burglar, all right, goes and steals a painting that he's got no market for. If he's a professional burglar, then he deals with people regular. Someone who regularly steals antiques, we'll say, will have an antique dealer that he deals with. So he goes to that antique dealer and says, 'I know this isn't your kind of meat, but I've got this'—Duddin lowers his voice to a stage whisper—'and it's worth a fortune. All I want is twenty grand on something that's worth two million.'"

Here Duddin interrupts himself to add an explanatory note. "All they want is enough money to live on for the next six months, what they call 'working money.' Enough money to go and look at other things and do something that's easier sold."

"I didn't realize 'til I went to prison," Duddin says, with feigned coyness, "that people that burgle houses for a living consider they've got a purpose in life. They consider it their job. It's a job of work, isn't it? No different than a doctor going to hospital every day."

It is not just work but hard work. "It costs money to burgle houses," Duddin says wearily. "You've got to go and look around, you've got to set it all up, you've got to have transport. It's like a building contractor, isn't it?"

Duddin is as disdainful as Hill of the notion that reclusive tycoons commission thieves to steal for them. "Do you honestly think there are people who have millions of pounds, and art collections worth millions, who would risk going to prison for a painting?" he scoffs. "Are you addled? Would *you*, if you had that sort of money? It doesn't make sense, does it?

"Freedom's not worth much if you've got nothing," he says. "If you're sleeping rough under a tree and thinking somebody's going to put you in a cell instead, well, that might even be an improvement. But when you've got a lot, your freedom's worth a lot more, isn't it? If you're living in palatial surroundings and eating lobster and drinking champagne, you don't want to go to prison, do you?"

Now Duddin turns his attention from the thief who steals a painting to the middleman he sells it to. "A dealer will lend Mr. Burglar £20,000, £50,000, whatever the figure might be, according to the article. It's no different from a bank, is it, when you think of it? Even though he hasn't got a use for it, he's got security for his money, hasn't he? He might have something worth several million"—Duddin's voice rises in incredulity— "so it's good security, isn't it?"

Wearying of logistics, Duddin raises his sights and turns briefly to philosophy. "Let's say you've got one prize possession, a painting. If someone stole that painting from you, you've lost the majority of your possessions. But if someone stole a Rembrandt from the Earl of Pembroke"—as someone did in fact steal the Rembrandt that Duddin tried to fence—"he's probably got several hundred times that left. So why should it be so important? And that's the ethics of it."

Duddin shifts ponderously in his chair and leans back, pleased with the case he's made. "You understand the difference? You haven't stolen *all* of somebody's wealth, even though you've stolen a great deal *more* wealth. You don't break into an old lady's house and take her pension book when that's all she's got."

The theory of relativity, criminal version.

29

"Can I Interest You in a Rembrandt?"

harley Hill has dutifully absorbed endless such tales of "life as I see it." Old acquaintances though he and Duddin are, neither man would believe for a minute that the other is his friend. Instead, the two are rivals in a complicated contest. The game is a free-form quest for information and advantage, and each man takes for granted that he has the other's measure. With Duddin, Hill plays up his academic side and downplays his menace. For his part, the blustery old crook assumes without question that, as a man of the world, he is miles ahead of a scholar like Hill. He lards his stories with such remarks as, "Here's another thing that I explained to Charley."

Mary Duddin shares her husband's disdain. "Do you know what we call Charley?" she asks, giggling as if she is being naughty. "Rumpole of the Bailey."

As proud a man as Hill is, he knows better than to defend his record to the likes of Duddin. If crooks take him too lightly, so much the better. Over the years Hill has learned three key lessons from David Duddin. They are not the lessons Duddin meant to impart.

Lesson One: Everything starts with a brand-name. If a painting is to have value to a thief, the artist had better be instantly and universally recognizable.

With rare exceptions, anyone more recent than Picasso is strictly for amateurs. Lesson Two: Thieves steal now and ask questions later. No one is as optimistic as a thief. *Something will turn up.* Lesson Three: Dollars trump everything. An enormously valuable painting is worth stealing by reason of its price tag alone. (Lesson 3 is the hardest for outsiders to grasp. By that reasoning, the baffled but honest citizen objects, the crown jewels would be worth stealing. A thief would agree, in a heartbeat. If the crown jewels were as easy to grab as an old master, they'd be gone tomorrow. In New York City, in the past decade, for example, thieves have stolen Stradivarius violins—far too famous ever to resell—on three occasions.)

For Charley Hill, who has considerable interest in psychology and next to none in logic, what matters is how thieves think, not whether their views hold together. He sums up the thief's worldview with characteristic impatience. "The big-picture thefts are all motivated by bragging and stupidity. The crooks just move the things around until some sap gets landed with them, like the last guy with a chain letter. The paintings will always have great intrinsic value, so the saps will always dream on."

Ж

The Rembrandt story is a case in point. Duddin tells it as a sadly comic tale. Theft is the backdrop, but in Duddin's eyes the story is less a crime saga than a charming tale of a rogue who took a chance. It didn't pan out, but nobody was hurt and everyone had a good time. All a bit of fun, and of no deeper significance than a story about an ordinary Joe who somehow ran into a supermodel and, what the hell, asked her out.

The Rembrandt, by some accounts a portrait of the artist's mother, was stolen in 1994 from Wilton House, a palatial home not far from Stonehenge, where it had hung since 1685. Wilton House and Rembrandt's portrait belong to the seventeenth Earl of Pembroke; the first earl was a friend of Henry VIII who had the good fortune, when Henry confiscated the church's property for his own uses, to be given a delectable tract of land and the abbey that stood on it.

As with so many stately homes in Britain, the very factors that make Wilton House remarkable—the size of the house, the immensity of the grounds, the distance from the nearest neighbors—make it a sitting duck for thieves. The Rembrandt vanished on November 5, Guy Fawkes Day, traditionally celebrated with fireworks and bonfires. The thieves made good use of the distractions. "What I was told," Duddin says, "is that it happened while the Earl of Pembroke and everyone else was at the bonfire. But the earl's daughter went back to the house, and I've been told categorically that she walked straight past one of the burglars. He saw her, but she never saw him."

The painting was insured for £400,000. Estimates of the amount it would bring at auction range up to £4 million, but the work is unsigned and may be merely School of Rembrandt. It depicts an old woman in a brown dress, sitting down, reading a book that lies open on her lap. Most of the painting is dark, though the book itself glows with light. "No one was more gifted [than Rembrandt] at turning old women into great art," one historian remarks, but Duddin doesn't go along. *The Granny*, as he refers to it, isn't much. Duddin casts a proprietary eye around his own large house and says, "*I* certainly wouldn't have it on me wall."

Duddin has decided that the story is best told over a meal. He is not a picky eater ("after prison, everything is delicious"), and he orchestrates a trip into town, where he sweeps into a Chinese restaurant, commandeers a table, and orders a pitcher of beer and a plate of spare ribs to tide him over while he studies the menu.

"It began with someone I'd known for quite a while," Duddin says. "How long was it, Mary, that we'd known Martin?" Martin was a mysterious character who entered Duddin's life around 1990 and, for half a dozen years, brought him antique silver and antique clocks. "When he first came to me," Duddin says, "he appeared to be a pukka businessman, dressed in a suit and tie, and the goods he was selling were properly presented, if you know what I mean. It wasn't in a bag with 'swag' marked on it."

Even so, something was off. "To be perfectly fair and honest"—Duddin drops the phrase into sentence after sentence with cheerful insincerity, like a magician saying "nothing up my sleeve"—"having dealt with him for a while, I began to have me suspicions. But what do you do, if you've dealt with somebody for several years and now suddenly you think he may not be straight? Do you take everything you've bought off him and try to give it to the police? Of course you don't. I'd have lost a fortune, wouldn't I? "In the meantime," Duddin goes on, "a diamond merchant that I used to deal with on a regular basis said to me one day, 'Dave, do you know anybody who wants a Rembrandt?' Literally like that.

"And I said, 'Don't be daft. I don't know anything about Rembrandt,' and just left it at that."

Soon after, Martin turned up again. "Well, when Martin came to see me, it wasn't unusual for me to belittle what he was bringing us, if you know what I mean. It's just a means of getting it cheaper. So you rubbish it. He tells you something is wonderful, you tell him it isn't, so it's half the price, isn't it? Nothing wrong in that.

"Anyhow, on this particular account, I was rubbishing what he'd brought, and his response was, 'Do you ever get anything magnificent yourself?'

"And I said, 'Well, there's a Rembrandt, you know."

"And he said, 'Honestly, a Rembrandt?"

"I said, 'Yeah.' "

Duddin had walked into a police sting. Martin was a crook who had gotten himself in trouble; the police had offered to go easy on him in return for his cooperation. On Martin's next visit, he offered to put Duddin in touch with a drug dealer who wanted the Rembrandt. (The story was that the dealer and his cronies had lined up an American buyer.)

Duddin doesn't bother trying to cast himself as an innocent dragged into a dark alley where he would never have ventured on his own. "Now, if you like, knowing it was a Rembrandt, it couldn't *not* be stolen," he acknowledges cheerfully. "Not many people wander around with one under their arm, if you know what I mean."

But *be* hadn't dreamed up the theft or had anything to do with it. He was just a businessman, perhaps a little more enterprising than most, doing nothing more than greasing the wheels of commerce. "All I wanted was what I would call 'a drink' out of it—that would have been five hundred or a thousand quid for putting the different parties together."

Having fallen into a hole, Duddin began digging it deeper. Word came from the drug dealer and his partners that, before they did the deal, they needed assurance that Duddin was as big a player as he claimed. "They suggested I get some decent quality things and they'd buy them," Duddin says. "But they had to be cheap—that is, they had to be stolen."

Duddin started working the phones. "I contacted people that I know in the trade. And I'm not talking about burglars or robbers or anything like that, I'm talking about bona fide people in the antiques trade, some of them with very, very nice, high-quality premises. I told them that I've got a buyer who's interested in anything that's good quality and cheap. And they all knew what I meant by that. They all understood what 'It's got to be cheap' means. It's bloody straightforward, isn't it?"

The loot came rolling in. "There was a collection of pins that had been stolen in Cheshire, worth about £60,000," says Duddin, "and a gold box that had been stolen from a local museum, worth about £20,000, and a collection of ivory from a private house, and three silver honeypots stolen from Floors Castle that were made by Paul Storr, who's recognized as one of the finest silversmiths this country's ever had, and a walking stick made from the sword that killed Captain Cook."

Duddin puts down the spare rib he is holding in his surprisingly dainty hands. "You can imagine the pressure I was under, negotiating it all," he says, as if even now he might collapse under the burden. Cyril Ritchard, playing Captain Hook, never delivered his lines with more gusto. And, he hints darkly, someone wanted to make sure there was no backing out. "In the middle of it all," Duddin moans, "I got two phone calls threatening to shoot me missus and me little dog if I didn't do the Rembrandt."

Duddin gathers himself. "Now it's fair to say that the judge entirely disregarded that. He didn't believe a word of it. He didn't believe I felt threatened at all." Duddin's speech has grown slow and sad, as if he were dismayed by the cynicism of some people.

In the end, the police trap worked perfectly. While Duddin counted the £106,000 the "drug dealers" had paid him (they had negotiated a price of £70,000 for the Rembrandt, with £3000 to Duddin for his pains), the police swarmed in. "I had bags full of stuff," Duddin recalls, "ivory and swords and whatever else, and then a van pulled in the drive to collect it and about ten policemen piled out. There were people on the roof of the garage, which is

195

where me office is, there were people jumping over fences, and God knows where."

He looks fondly at Mary. "You were back at the house, then, Mary, weren't you?"

Mary, for once given a turn in the spotlight, gleefully fills in the picture. "I'd helped you to count the money, and I came back here and sat on the sofa, doing a crossword. And I looked out, and there were all these horrible men in the back garden, so I rushed to the front door, and there was this man there with a video camera and this horrible, scruffy, dirty woman, and she said, 'Mrs. Duddin, you're under arrest.' "

Mary was released after two days. "I remember at the end," she says, "the diamond dealer, Robert—it was Robert who told us about the Rembrandt in the first place—he turned to me and he said, 'I *thought* it was too easy."

Cackling with laughter, Duddin and Mary signal to the waiter for another drink. For Duddin, the story had only one sad element, though admittedly it was the most important one. Duddin ended up before a judge who, for unfathomable reasons, decided to make an example of him and sentenced him to nine years in prison. (He was released after four and a half.)

Even today, his time served, Duddin is indignant. His beef is not with the conviction but with his sentence. This is a game played with rules, and the judge violated the code out of spite. 30

Traffic Stop

MAY 6, 1994

harley Hill had run out of patience. He had spent the early afternoon visiting galleries around Oslo with Einar-Tore Ulving, a man he had disliked from the moment they met. The point of the excursion, Hill hoped, was to kill time while Ulving's colleague, Tor Johnsen, plotted strategy with the thieves who held *The Scream*. A few hours in Ulving's company hadn't done anything to improve Hill's mood.

Then Ulving had wandered off, too, leaving Hill alone and more restless than ever. The phone finally rang. It was Ulving. Could they meet at Fornebu, the old airport south of the city?

Hill found Walker, and the two men briefed John Butler, in his command post, and set off for Fornebu. The two cops waited an hour, and then an hour and a half. Not a thing stirring. Afternoon gave way to evening. At last, Ulving turned up, ashen-faced and trembling. "The traffic police stopped me," he said, "and they searched my car."

Walker and Hill avoided looking at one another, but their hearts sank. What a thing to do!

The police had pulled Ulving over, they told him, for a random safety inspection. Did he have one of the triangular warning signs you put out on the road in case of an accident? It sounded farfetched, and, more unsettling still, the police seemed to be marking time, or perhaps waiting for instructions. Johnsen was in the car, too, and he was badly upset.

After fifteen minutes, Ulving had asked the policemen if they would be done soon.

"Yes, everything seems to be in order. But tell me, aren't you an art dealer?"

Ulving said he was. The police asked if they could check his car. For forty-five minutes they searched but found nothing. They flipped through the box of art prints in the back of Ulving's Mercedes, but somehow they missed the woodcuts of *The Scream*.

When the police finally finished, Johnsen told Ulving to go on to meet Hill and Walker without him. The way the Norwegian cops kept turning up had to be more than just coincidence.

Now Hill and Walker had a shaken Ulving to calm down. Hill guessed at what had happened—when he and Walker had told John Butler about the planned rendezvous at the old airport, the Norwegian police who were with Butler in his improvised headquarters had notified *their* bosses. They had immediately leapt to the conclusion that Ulving was headed toward Hill and Walker to show them *The Scream*. Following orders, the local cops had pulled Ulving over. When they failed to find the missing painting, they had sent him on his way.

Hill hid his exasperation with his Norwegian colleagues and tried to convince Ulving to laugh the whole thing off. The Getty wanted *The Scream*; it had no interest in running around the countryside playing cops and robbers.

"Well, it's not your lucky day," Hill told Ulving, "but it's nothing whatever to do with us. First of all, I'd never be stupid enough to get involved with the police. And, second, it's not my style of doing business."

It wasn't much of an argument, but apparently it didn't have to be. Ulving wanted reassurance that Hill and Walker weren't in cahoots with the cops, and Hill batted the suggestion away with convincing indignation.

Then, mission not accomplished, everyone headed irritably back to the hotel. (Hill and Walker could only guess what the airport meeting had been *intended* to accomplish.) Ulving went off to meet up with Johnsen, and Hill and Walker settled in for yet another debriefing with John Butler. "Whatever you do," Hill asked Butler, "can you call off the surveillance? They're really causing us problems. I'm going to run out of excuses soon, to explain away that we're nothing to do with all this."

Butler, every bit as frustrated as Hill and Walker but not as free to act on his own, promised he'd do what he could. But there were limits. "It's not our operation, it's a Norwegian police operation," Butler said. "They can do what they want. We're just helping them."

Hill retreated to his room, waiting for the phone to ring. The afternoon's false start hadn't dispelled his confidence. Johnsen had ogled the cash in Walker's bag. He'd be back.

Hill flopped down on his bed, fully dressed except for his shoes, staring at the ceiling. It was nearly midnight. The phone rang. Ulving.

"We're downstairs. We need you to meet us."

"Why can't it wait 'til morning?"

"It's got to be done now."

"Go fuck yourself! I'll talk to you in the morning." Hill slammed down the phone.

Hill's anger was fake. Crooks always made unreasonable demands. Assholes act like assholes. Do it their way, they'd say, or they'd burn the painting or cut it into pieces. And they might. The first thing was to persuade them not to act on their threats. Then, once they were done with that crap, you imposed your personality on them. You're the guy who's going to provide them with the money they want.

In negotiating with crooks, Hill had found that belligerence was key. Accommodation was always a mistake. "The minute you start agreeing with people, you're finished," Hill once observed, "because you can't be credible then. That's the way life works. Life is built around creative tension."

It is difficult to know if Hill was talking about life in general or life in one dark corner of the world. He may not know himself. "Thieves and gangsters all hate each other, they screw each other, they betray each other," he insists. "That's the world they live in. And if you suddenly appear in it and agree to everything they say and do everything they want, then you're just not credible. If you act agreeable, it's not a sign you're close to a deal. It's a sign they should push harder. They'll take you for some complete asshole." Hill sat on his bed, certain his phone would ring again in a minute or two. He didn't phone Butler because he wanted to keep the line free. The phone rang.

"I'm serious," Ulving said. "We need to get this done now."

"I've talked to you and Johnsen all day, off and on," Hill said. "What more can anyone say?"

"No. It's something else."

"Okay. Do you want to meet in the coffee bar? But it may be closed by now."

"No, no, not there. Outside, in the car."

"Listen, I'm in bed," Hill said. "The light's out. Just give me a minute to throw some water on my face and get dressed. I'll be down in ten minutes."

Hill phoned Butler, waking him up. "They're downstairs," he said.

"Don't go down there!"

"I've got to. Don't worry, I won't go anywhere with them. I'll just go down dressed as I am now"—Hill was in tan chinos and a blue buttondown shirt, wearing loafers but no socks—"and if they want to drive me somewhere, I'll say, 'I don't have my coat or my socks, I'm not going outdoors.' "

"All right, but you can't leave the hotel."

"Okay."

"And that includes going outside the hotel to sit in the car."

"Fine."

Hill went downstairs and walked outside. There it was, Ulving's Mercedes, with Ulving and Johnsen inside. Hill climbed in the back.

31

A Stranger

MIDNIGHT, MAY 6, 1994

ill climbed in the back seat of Ulving's Mercedes, but he made a point of leaving his door open. "I'm happy to listen to what you've got to say," he announced, "but I'm not going anywhere with you." Ulving was in the driver's seat, with Johnsen next to him. Hill sat behind Johnsen, half in the car and half out, with his right foot on the ground. Johnsen was in a foul mood, cursing Ulving and the Norwegian cops and life in general. Evidently he had been going on for a while. Ulving slumped meekly in his seat.

Johnsen gestured toward a black van parked nearby, its windows dark and its roof festooned with antennas. "I checked it out," he snarled. "It's police surveillance."

"Did you speak to 'em?" asked Hill. The Norwegians again, trying to help.

"No, there's nobody in it. I rocked it back and forth, just to be sure. But I know it's a surveillance van."

"Then where the hell are they?" Hill asked. "Where're the goddamned cops?"

Johnsen pointed to a club next to the hotel. Blaring music poured into the night. The police were making a night of it.

Hill tried to calm Johnsen down. Flattery was usually a good bet. "The

cops must be watching you because they know you're a jailbird." At least for a moment, Johnsen quit his bitching. "Ah, vanity," Hill told himself. In any case, better for Johnsen to think that the cops were keeping an eye on him than to think they were in league with Roberts and Walker.

Suddenly someone yanked open the back door across from Hill. The stranger slid into the car and directed an angry stare at Hill, who braced for trouble. Something about the newcomer's eyes was wrong, almost crazy. He was a big, physically imposing man, dressed entirely in black, with a cap pulled low on his forehead and a scarf and gloves. For Hill's benefit he spoke in English. Hill couldn't place the accent. Where was this hoppedup fuckhead from? France?

Johnsen seemed to know the new man, but Ulving didn't. "We've got to go meet a friend of mine," the stranger said. He gestured toward Hill. "You'll be able to see the painting."

Then he gave Ulving, in the driver's seat, a shove. "Now!"

"Horseshit!" Hill said. "It can wait 'til morning. I'm not going anywhere now."

The newcomer turned toward Hill. "Why is that door open? Close it." "I'm not closing the door."

The stranger again. "Close it!"

"Listen, if one of you guys pulls out a .38 and points it at me, I want to cause you some problems. If you're going to get me, you're going to have to be quick."

It was a standoff, but the crooks seemed to like the tough-guy talk. The stranger was a thug and Johnsen was a bully, and Hill had responded in a way they understood. Rash though he could be, Hill had been serious about not going anywhere. A drive in the dark to a destination he didn't know, on his own, in a foreign country—he'd have to be nuts. Hill looked at the black-clad, bug-eyed crook trying to cajole him into this dubious excursion, and an image of the wolf and Little Red Riding Hood flashed into his mind. Who's for a walk in the woods?

"I'm not going to sit here forever," Hill said. "It's cold, and I've got no socks on." Johnsen and the stranger craned around for a look. This was Norway, in winter. The tension ratcheted down a notch.

"I'll be happy to travel anywhere you want me to in the morning," Hill said.

Ulving chimed in. "Let's do it now."

The others ignored him. Hill turned to Johnsen. "If you want to keep an eye on me, why don't you stay in the hotel overnight? Let's book you a room."

Hill and Johnsen headed toward the hotel. Ulving stayed behind with the stranger with the manic eyes. Hill stepped up to the reception desk. "Do you have a room?" This could have been trouble. With hundreds of narcotics officers gathered for a convention, the hotel might be full. Hill hadn't made a backup plan.

"Yes, Mr. Roberts, of course."

Hill handed over his Getty credit card and signed for Johnsen's room without asking the rate. Johnsen watched closely, noting the clerk's obsequiousness and registering all the little flourishes that marked Hill as a man of the world. Hill was, Johnsen would say later, "a very elegant gentleman, a little too elegant, in my opinion, to be a police officer."

With Johnsen safely assigned to a room well away from his own, Hill hurried off to Butler's room, to brief him. Butler was irritated that Hill had gone out of the hotel, but Hill brushed the scolding aside. It was his ass on the line; he'd make his own calls.

But there was a problem with the next day's plans. Ulving and Johnsen and the stranger had said something about driving out of the city.

"You say you're going south with these guys?" Butler asked.

"Yeah."

The Scotland Yard detectives had permission to wander around Oslo as they pleased, but for reasons Hill didn't quite follow, they had been warned to steer clear of the area south of the city.

"John, for fuck's sake, what are you talking about?" Hill shouted. "Are we going to get this painting back or not? What is this police bureaucracy territorial-imperative jurisdictional-hassle shit? I mean, stop it!"

"No. You can't do it."

"John, if we don't do it this way, there's no chance we can keep our credibility with these assholes."

"Fuck it, you're not going! There are procedural problems, and you can't do it."

For the first time, Sid Walker joined the argument. "Well, John," he said quietly, "Charley's got a point."

Outvoted two to one, Butler gave in. The three men made a plan, or at least agreed to proceed without a real plan. They did take steps to safeguard the fortune in kroner that Walker had flashed under Johnsen's nose. At dawn, Walker would take his bagful of cash out of the Plaza, book a room at the Grand Hotel, and lock the money in a safe there.

Beyond that, they would have to wing it. Come morning, Hill and Walker would go off with Johnsen to wherever it was the Norwegians had been so eager to get to the previous midnight.

34

On the Road

EARLY MORNING, MAY 7, 1994

ill and Walker left Butler and headed off to their own rooms. It was late—Hill hadn't gone out to Ulving's car until midnight and they would be underway early the next morning. (Walker, who had to switch hotels, would be on the move even earlier than Hill.) But they had time to grab a few hours' sleep. For Einar-Tore Ulving, on the other hand, the night of May 6, 1994, would prove the longest of his life.

The art dealer's ordeal began at midnight, when the stranger slipped into his car. Even with Johnsen and Hill out of the car and in the hotel, the newcomer stayed in the back seat, his eyes fixed on Ulving at the wheel. In the dark, with his cap pulled low over his eyes and his scarf pulled high over his chin, he was a large and looming shape. Afraid to speak or to turn around, Ulving sat cowering and waiting for instructions. His unwelcome guest never gave his name. The art dealer thought of him simply as "the man with the cap."

Finally the stranger broke the silence. "Drive," he said, directing Ulving through the near-empty streets of a wintry Oslo night. "Right." "Left." "Through the tunnel."

Ulving obeyed. The route led out of the city, but Ulving had no idea of their destination. Soon they were on a quiet road. The houses were dark, the street deserted. No streetlights, no traffic, no pedestrians. "Stop!" Ulving pulled over. "Wait here." The stranger walked to a pay phone. A minute or two later, he returned and gestured to Ulving to roll down his window. "Drive south on the E-18," he said, "and someone will phone you."

Then he vanished into the gloom.

Ulving found his way to the motorway. He knew the E-18. He drove along, expecting his cell phone to ring at any moment. It didn't. For an hour and fifty minutes he sped along the motorway in silence. The E-18 south from Oslo, as it happened, led toward the town of Tønsberg, where Ulving lived. He decided to drive home.

By now it was well past two in the morning. Ulving entered his darkened house. At once the phone rang. Unnervingly, the call came not on Ulving's cell phone, as he had been expecting, but on his home phone. *How did they know where I was?* The stranger again, with more instructions. "Get back on the E-18 and go to the By the Way."

Ulving knew the name—the By the Way was a restaurant on the expressway only five or ten minutes from his house. He sped over. The restaurant was long since closed, and the parking lot was empty. Ulving pulled his car to the edge of the lot and parked by a low stone wall. Then he sat in the dark and waited.

Suddenly the stranger materialized in front of Ulving's car.

"Get out!"

Ulving stood in the deserted parking lot. The man in the cap stared at him, silently, for a minute or two. "Open the back!"

The stranger moved a short distance away. Another man took shape in the darkness, on the far side of the stone wall. He carried a neatly folded blanket with something wrapped inside. He handed the blanket to the stranger and disappeared again. The stranger placed the blanket and its contents in the back of Ulving's station wagon.

"That's the picture."

Ulving gathered his nerve. "I don't want it in my car."

"Well, it's in your car."

"Where are we going to take it?"

"To your house."

"We can't. My kids and my wife are there. But I've got a summerhouse in Åsgårdstrand. It's empty now. We can take it there." The man in the cap went along with the new plan. Åsgårdstrand was only a few miles away. He and Ulving drove off and hid their package in Ulving's summer house.

Ulving, exhausted, pleaded with the stranger. Couldn't he go home and take a shower and change his clothes?

Yes, he could. This was unexpected good news, the first conciliatory remark the stranger had made. Ulving drove home eagerly and entered his dark house. To his dismay, the man in the cap barged into the house behind him. Ulving walked into the bathroom and climbed into the shower. His "guest" shoved the bathroom door open, then stood a yard from the shower, watching.

It was nearly five in the morning. Ulving's wife, Hanne, woken by the commotion, hurried to investigate. Her husband was in the shower, a hulking stranger nearly at his side, glowering.

"What's going on?"

Where to start? "It's okay. Everything's all right," Ulving said. "Go back to sleep."

"Hands Up!"

The Norwegian cops, in the meantime, had their own trouble sleeping. "The thing keeping me up at night," said Leif Lier, the Norwegian detective, "was worrying that the undercover agents would be hurt or killed, because we didn't know who the criminals were."

Charley Hill had more regard for Lier than he did for most cops, but he didn't share Lier's concern. Though Hill was the least laid-back of men, his own well-being was not a subject that engaged him. Let someone venture a foolish opinion on, say, the French Revolution, and Hill would scowl and leap to correct the record. If the conversation turned to his own safety, he would drift off.

Before 1994, Hill's closest call had come in a counterfeit money case. In autumn 1988, Hill was undercover as a crooked American businessman named Charles Gray. He had heard rumors about someone looking to sell serious quantities of counterfeit hundred-dollar bills. Hill, as Gray, put out word that he might be interested. Soon a shady used-car dealer outside London made an approach. The dealer handed over a few of the counterfeit hundreds.

Hill took them to a friend at the U.S. embassy, a Secret Service man with a plum posting in London. Hill's friend oohed and ahhed. Franklin's portrait, the shading—these bills were superb. The Secret Service had picked up whispers about a giant shipment of counterfeit money coming into Britain from Italy. These were thieves worth going after. Scotland Yard agreed. Anything to help their American colleagues. Charles Gray met with the car dealer contact to work out a deal. A bit of haggling and then a handshake—Gray would pay £60,000 for a cool \$1 million in phony but virtually undetectable hundred-dollar bills.

Hill booked a ground-floor room at a Holiday Inn near Heathrow Airport for the handover. Though he liked to freelance, this job was not to be an improvised solo act. The Counterfeit Currency Squad was in charge, and the Regional Crime Squad was on hand, too. Hill's hotel room was bugged, to obtain evidence for an eventual trial, and a surveillance team was in place. The Counterfeit Squad gave Hill a briefcase with £60,000 in cash.

Hill met the car dealer at the Holiday Inn. The counterfeit hundreds, the man said, were in a valise in his car, in the parking lot. Hill and the dealer walked to the car, and Hill picked up the case with the phony bills. Immediately, he knew there was trouble. A million bucks in hundreds should have weighed about twenty pounds. This case was far too light.

Hill played along. Carrying the valise with the counterfeit bills, he walked back inside and turned down the hotel corridor to his room, where he had left his briefcase and its £60,000. The car dealer was by his side. Suddenly two men in stocking masks leapt out.

One robber jammed a sawed-off shotgun into Hill's back. The two masked men hustled Hill and the car dealer down the hall and into Hill's room. Shoving Hill toward the middle of the room, one robber forced him face-down on the bed. He pressed the shotgun hard into the back of Hill's neck, below his right ear, and yanked his arms behind his back. Zzzzpppff! Duct tape. For criminals, tape was more convenient than handcuffs or rope. First the hands, then the ankles. In moments Hill was trussed and helpless.

With his face mashed into the bedspread, Hill found that his glasses reflected glimpses of the room behind him. He occupied himself by trying to memorize his captors' clothing, in case he ever had a chance to testify in court.

The robbers tied up the car dealer, too, but—though Hill had no way of knowing this—not as tightly. The robbers and the car dealer were in cahoots, it would turn out later, and they had cooked up a simple scheme: the robbers would flee with their £60,000 profit and with the counterfeit money, too, to use another day. The car dealer would eventually work himself free and would then free Gray. The duped buyer would slink away—he could hardly go to the police to tell them he'd been robbed and the thieves would live happily ever after.

The police plan had gone ludicrously wrong. When Hill had left the hotel to pick up the counterfeit money in the parking lot, a team of cops had tailed him. When Hill returned to the hotel, the backup team found that they had locked themselves out of the fire escape door.

In the meantime, the surveillance cops holed up in the hotel room next to Hill's were preparing their recording gear. They had no idea that Hill had been mugged in the hallway. When the scene finally shifted to Hill's room, they found themselves eavesdropping on a robbery. Convinced that Hill was about to be killed, they called in the troops. In came the nearest armed police, with machine guns, from nearby Heathrow. In came a police helicopter, hovering low over the hotel, rotor blades whooping through the air, strobe lights flashing.

The cops who were already on the scene, unarmed and reduced to play-acting, did their best. One cop standing in the parking lot outside Hill's room smashed his hand through the window (slicing himself badly) and shouted "Armed police!" Other cops followed his lead, shoving their hands through the broken window and into the curtains, pretending to have guns. Down the hallway thundered two more cops shouting "Armed police!" though they were only pointing the antennas of their radios.

The crooks might have shot Hill or fired at the cops. Instead, they fled. Out the door and down the hall they ran, cops in pursuit. Moments later, they were tackled and arrested.

The crooked car dealer hadn't managed to make a break. Too slow in freeing himself, he was still wrapped up in duct tape when the police crashed in. The police untied Hill and handcuffed the crook. Hill fixed himself a drink at the minibar. He raised his glass to his former partner in crime. "You don't mind if I don't offer you one?"

Hill relished such cinematic moments. What could be better than an adrenaline-pumping adventure that featured large helpings of danger, stupidity, and bravery and then wrapped itself up in a happy ending and a wisecrack from the hero? Somewhere in the back of Charley Hill's attic of a mind, *Casablanca* is always on the bill and Hill himself is Bogey.

212

Hill turned over the £60,000 pounds and the counterfeit money to the police and made his way out of the hotel. A crowd had gathered. Tourists gawked in the lobby, trying to sort out what had happened. The waiters and chefs from the restaurant craned their heads to look. Hill threaded his way through the crowd to the reception desk.

"I'd like to book out. I didn't like my room."

"Oh, I'm sorry. What was the matter?"

"It was too noisy."

Ж

By the time Hill had finished with a police debriefing and driven home, it was three in the morning. At five-thirty, the doorbell rang. It was Sid Walker. He and Hill had an informant to meet, in connection with the paintings stolen from Russborough House in Dublin.

"They're talking about the counterfeit deal on the radio," Sid said. "Well done." Walker had absorbed the details of the story from the radio announcers' breathless reports, but his own style was as understated as theirs was shrill. By his standards, his few words were close to a hymn of praise.

"Well, I'm a bit knackered now."

Hill's wife, Caro, had been roused by the doorbell and the sound of her husband talking to someone. Hill hadn't woken her when he'd come in the night before. She stumbled downstairs and greeted Walker, an old friend.

"How'd it go?" she asked.

Sid chimed in. "Oh, it went very well. It's on the news."

Caro noticed the angry red scrape just above Charley's collar. "What's that on your neck?"

Sid stepped closer to see for himself. "It looks like the mark of a doublebarreled shotgun," he said deadpan, as if he were doing his earnest best to be helpful.

The Thrill of the Hunt

n the years that followed, Hill made the shotgun story sound like a glorious prank. He and Walker teasing poor Caro might as well have been two boys on a playground chasing a pretty girl with a frog.

But when it came to the safety of works of art, Hill could hardly have been more serious. "I'm no artist, and I'm not even Kenneth Clark or Robert Hughes or anyone like that," he once remarked, in a rare philosophical mood, "but I do have a compulsion to recover these pictures, and I enjoy doing it."

To create beauty was rare and lofty work, but to safeguard cultural treasures was no paltry thing. "You're just trying to keep these things in the world," Hill went on. "It's simply a matter of keeping them safe and protected and in the right places, where people can enjoy them."

Hill was always reluctant to talk about "art and truth and beauty and all the rest of it," presumably for fear of sounding like one of the "hoitytoity art-world pompous assholes" he so disliked. But, grudgingly, he did admit to a sense of mission. "It's the story of Noah and the rainbow and all that, but you're a steward not just to the animals two by two but to *everything* worthwhile in life. I left seminary school after two years, and sometimes I still think of myself as a failed priest. I suppose that makes me a self-righteous son of a bitch"—having veered dangerously near introspection, Hill scurried back to safer ground—"but this is a way of fulfilling that vocation." If the would-be priest could not save souls for all eternity, at least he could do his best to save some of mankind's greatest creations for the next few centuries.

As always, though, Hill's motives were mixed. Some of his zeal for recovering stolen paintings spoke more to adrenaline hunger than to spirituality.

Art theft was a "kudos crime," Hill liked to say, which was to say that thrills and glory beckoned thieves every bit as temptingly as did daydreams of riches. Hill was quick to concede that the flip side of a kudos crime was a kudos chase. If stealing was a thrill, so was hunting down the thieves. "It's a big thing, recovering an important painting," Hill said, after one of his early recoveries, "and obviously I get a buzz out of it."

Some thieves talked openly, almost sensually, about the thrill of taking what belonged to others. Peter Scott was an English cat burglar, a tabloid favorite, and yet another of Hill's adversaries. From Scott's first crime to his last, the risk of getting caught had only made the game more alluring.

Scott did more than his share of mundane thieving, but his favorite cases involved glamorous victims. In a decades-long career in which he claimed to have stolen loot worth £30 million, Scott robbed Lauren Bacall, Shirley MacLaine, Vivien Leigh, and countless others. Most notoriously, he made off with a diamond necklace that belonged to Sophia Loren, who had been in Britain filming *The Millionairess*. In Scott's heyday, London newspapers trumpeted the exploits of "The Human Fly." (And he still ended up broke.)

In 1998, Scott came out of retirement and tried to fence a $\pounds650,000$ Picasso portrait called *Tête de Femme*, stolen at gunpoint by a bank robber who was disappointed that the media never seemed to deem his crimes newsworthy. This time they did. Scott, who had hoped that his part of the deal would earn him $\pounds75,000$, ended up instead (at age 67) sentenced to three and a half years in prison.

Scott had succumbed to the thrill, "more potent than any woman," of trying to outwit the clumsy and rule-bound authorities. "As a husband I was a failure and as a lover indifferent," he acknowledged in his autobiography, "because my real passion was to be out on the roof, or creeping through the country, or making a little tunnel through a wall. I'd found this private . . . world which yielded a sexual, antisocial excitement unobtainable by other means."

Charley Hill thought Scott was a *poseur* and a blowhard, but he shared Scott's disdain for authority and his taste for the grand gesture. For Hill, when it came to art, and to life in general, high stakes were the only ones worth playing for. In college, he had rowed crew but quit when it became plain that he would never be great. "Unless you can gear yourself up for the Olympics or a national championship," he asked, as if the answer were self-evident, "what's the point of being a rower?"

Art crime was the same. "When I'm talking to villains," Hill said, "the bigger they are, the more interesting it becomes. And the paintings I want to get back are the masterpieces of the western European canon."

The outsized ambition was characteristic. But so was a sense of mocking self-awareness. The cynical gaze that Hill directed at the rest of the world could turn inward as well. "I feel as if I'm some kind of St. George," he admitted happily. "The thieves are the dragon, and these wonderful paintings are the damsel about to be eaten.

"It's all bullshit, of course, but it's necessary bullshit. You've got to have some sort of self-esteem in this life, and that's mine."

The Plan

MORNING, MAY 7, 1994

hile Ulving spent a terrifying night obeying the cryptic commands of the man with the cap, Hill snored contentedly behind the thick walls of his room at the Plaza. At six in the morning, his phone rang. "This is Johnsen. I'm in the lobby. It's time."

Hill phoned Walker, and the two cops met Johnsen downstairs. "Let's go for a drive," Johnsen said. The little party set out in Hill's rented car. Walker took the wheel, with Hill at his side. Johnsen sat behind Hill, twisted halfway around so that he could look out the back window.

Johnsen gave directions, though he wouldn't reveal their destination. A rendezvous somewhere, Hill and Walker figured, presumably with Ulving and the bug-eyed stranger.

"Just make sure we're not followed," Johnsen told Walker. He cast a nervous glance out the side window and then corkscrewed himself around again, to resume his vigil out the back.

Walker quickly convinced himself there was no one on his tail—for once, they'd shed the Norwegians—but he hammed things up for Johnsen's benefit. He came to a traffic circle and made a point of going around an extra time; he pulled off the highway as if he had engine trouble and let traffic pass by; he whipped across the road in a tire-squealing U-turn and briefly headed back in the direction they had come. Hill enjoyed the show from his front-row seat. About thirty-five miles south of Oslo, they reached the town of Drammen. Johnsen pointed to a restaurant alongside the highway. Walker pulled in.

"Park next to that Mercedes."

Hill, Walker, and Johnsen walked into the small, tidy café. It was quiet and almost empty at this early hour on a frigid Saturday morning. A few patrons sipped their coffee and tried to shake off their sleepiness. Ulving sat waiting at a table with the stranger. He'd never given his name, and Hill thought of him as Psycho.

Ulving, cringing and bleary-eyed, looked like the bigger man's captive. The three newcomers joined Ulving and Psycho. Ulving barely spoke. Psycho, on the other hand, started in on business at once. It was time to work out the exchange; he had a plan. Walker would bring the money to a particular address. If the money was all there and there was no funny business, Hill or Walker would get a phone call relaying the painting's whereabouts.

"You'll have to do better than that," Walker growled. Why would he hand over the money for nothing and then trust the crooks to keep their side of the bargain?

Psycho countered with another plan that was just as flawed.

"That's bullshit! Forget it!" Walker snapped. Logistics were his domain. The mood at the crowded table was sullen and tense. Neither side trusted the other; each needed what the other had. Ulving cowered, Psy-

cho blustered, Walker snarled. Psycho repeated his first, no-hope plan.

"Screw that! Find another way." This time it was Hill.

A tour bus pulled into the parking lot. Suddenly the café was jammed with new arrivals jostling one another as they looked for seats and menus and shuffled off to the bathrooms. Ulving took advantage of the commotion to jump to his feet. "This is all too much. I don't know what I'm involved in here. I have to leave."

Psycho grabbed Ulving by the arm. "Sit down!" he growled, and he shoved Ulving back into his seat.

Ulving fell silent. Psycho leaned across the table and glared at Walker and Hill. "If we don't get this done, I'm going to eat the painting, shit it out, and send it to the minister of culture."

Johnsen chimed in with a plan. Just as bad as the others. Finally, Walker cut through the impasse. "Why don't we do it this way?" he said. "I'll drive back to the hotel with you two"—he gestured toward Johnsen and Psycho—"and Chris will go with you"—Walker glanced at Hill and then at Ulving—"and look at the picture. If everything's okay, Chris will ring me, and I'll give you the money. Then Chris can come back with the picture in a taxi."

It was a simple plan but it offered something to everyone. Johnsen and Psycho jumped at it. They knew that Walker had charge of the money; where he went, they wanted to be. Poor Ulving liked the idea, too, since it set him free from Johnsen and the stranger. Hill welcomed any plan that would get him to *The Scream*.

Walker would be on his own with two large, dangerous men, but he'd be back in the vicinity of John Butler and his police command post. In addition, by heading off with Johnsen and Psycho, Walker had separated them from the painting. If Hill couldn't find it, or decided he'd been shown a fake... well, the plan didn't cover that.

Still, Hill liked it. For a start, the scheme got him out of the goddamned restaurant. And Sid was a big boy. He could take care of himself.

In agreement at last, all five men headed to the parking lot. Psycho strode ahead, several steps in front of the others, as if he were in charge. That was a showoff's mistake, and Hill registered it at once. What an arrogant asshole. Hill and Walker took the chance to hang back and exchange a few clandestine words. Walker kept his voice low and relied on the rumble of traffic on the highway to muffle his words even further.

"Get hold of Butler straight away and tell him what's happening," he whispered.

"I'll do it as soon as I can."

At the cars, the men split into two groups. Walker, Johnsen, and Psycho piled into Hill's rented car and headed north, back to Oslo. Hill and Ulving settled into Ulving's Mercedes sports coupe—Ulving had left his station wagon at home—and started south. Precisely where Ulving was taking him, Hill didn't know.

The trail ended, he presumed, wherever the thieves had hidden *The Scream.* But even that was a guess, or a hope. All that Hill knew for certain was that he was headed into the unknown, without backup, at risk once again that someone would jam a shotgun into his neck. 36

"Down Those Stairs"

MIDDAY, MAY 7, 1994

Iving set off, veering all over the road. His speed wasn't a problem. Hill was a fast and aggressive driver himself. But even in ordinary circumstances he hated riding in a car that someone else was driving, and Ulving seemed manic, swerving back and forth and talking without letup. Hill began to fear that before he ever had a chance to set eyes on *The Scream*, Ulving would skid into a ditch or smash head-on into another car.

"What the hell's wrong with you?" Hill barked.

Hill disliked Ulving and his tone held more than a hint of menace, but Ulving replied as if the question were genuinely a request for information. He was exhausted, he said. He'd been up all night with the man with the cap. He jabbered on about how scared he'd been, how threatening the stranger was, how frightened his wife had been to see a huge and silent intruder trailing her husband through their house.

Hill laughed. The poor son of a bitch. He took Ulving for a crook, like his companions, but what a sorry excuse for a villain.

"What's your point?" Hill demanded.

Ulving tried to bring his story back to *The Scream*. The deserted road, the man who emerged from the shadows with the painting wrapped in a blanket, the decision to hide it in Ulving's summerhouse.

Hill felt a jolt of adrenaline. He did his best to force himself to let Ulving tell his story in his own way, but the reference to still another person handling the painting grabbed his attention.

"How many other people did you see?"

"Just him. Just the one man."

"Wherever we're going," Hill said, "what's going to happen when we get there? Are a bunch of gorillas going to jump on top of me and hold me at gunpoint until the other guys get their money?"

"No, no, no. That won't happen. Nothing like that. There's no danger. Only two people in the world know where the painting is, me and the man with the cap."

"Right. Sure."

A moment's silence. Ulving concentrated on his driving and Hill pondered end-game scenarios. It'd be a fine balls-up if the bodyguard was safe in Oslo and the art cop was a hostage in East Nowhere, Norway.

"I won't believe you until I see for myself," Hill said. "If you think you're going to get the money by holding me for ransom, you've got the wrong idea."

"No, no, I promise you," Ulving said. "There won't be anything like that. It's just going to be you and me."

Hill half-believed him. In any case, Ulving was such a twit that he'd be a liability to anyone he was in league with. If somebody leapt out at Hill, Ulving would panic before anything terrible happened.

But Hill kept fretting. "Stop the car," he ordered. He scanned the road anxiously for a tail. After a few minutes, he gestured for Ulving to pull back onto the road.

"I'm not worried about *you*," Hill told Ulving. "I'm worried about how many goons turn up when we get there." But only a few miles later he again told Ulving to pull over. Again he surveyed the traffic.

They reached the town of Åsgårdstrand, where Ulving had his summerhouse. Munch had lived and painted in a summerhouse in this tiny village on a fjord, and Hill took the opportunity to talk about art for a few minutes. Munch had done a series of paintings that showed three girls on a pier, he said. Didn't those paintings depict Åsgårdstrand?

Ulving perked up. Yes, that was Åsgårdstrand. And the white building in the background of those paintings was the hotel in town. It was still there, and that very hotel was the one Ulving owned a part-interest in. Ulving's summerhouse, the hotel, and Munch's summerhouse were all within a few hundred yards of one another.

Ulving drove to a small house and parked in front of the garage. His cottage was attractive and well-sited, perched above a glittering fjord and nestled in a stand of birch trees. Hill looked around appreciatively. White flowers grew all around. They looked almost like snowdrops. "Are these some sort of Scandinavian edelweiss?" Hill asked.

It was early May. Spring comes late to Norway, and Ulving's house was still shut up. "You're sure it's safe to go in?" Hill asked yet again.

"It's definitely safe," Ulving said, and he pushed the front door open.

The glint of glass struck both men before they had a chance to step inside.

"What's that?" Hill asked.

A large mirror lay smashed on the floor of the entrance hall. Shards of broken glass poked out of the frame. Smaller pieces had been flung farther away when the mirror crashed to the ground.

Hill turned to Ulving. "Was that there when you were here last night?" "No."

"How'd it get there, then?"

"I don't know. The house is closed until summer."

Hill considered a moment, then stepped inside. The house was dark and cold, the furniture swaddled in bedsheets.

With Ulving trailing behind, Hill stepped silently to the nearest door and shoved it open. Nobody inside. Next room. That one was empty, too. In a few minutes, Hill had surveyed the small house.

"Where is it?" Hill asked. No chit-chat about flowers now.

"Through here."

Ulving led the way back to the kitchen. The floor was wood, bare except for a small rug. Ulving flipped the rug aside and revealed a trapdoor. The art dealer took a step back out of Hill's way.

"After you," Ulving said.

Hill laughed. "I'm not going down there. What do you expect me to do, spend the next three months locked in your cellar?"

"That's fine. I'll go myself."

Ulving clambered down the steps into his basement, into the dark. A

moment's fumbling and he found the light switch. More commotion near the stairs, then darkness again as Ulving flipped the switch off. He came back up the stairs carrying a blue bedsheet wrapped around something square. Hill heard a clinking sound.

Ulving handed Hill the blue sheet and replaced the trapdoor. Hill looked down at his hands. About a yard apart. That made sense. He raised his hands an inch or two. Hardly any weight at all. Good.

The two men walked into the dining room. The table was draped in a white bedsheet. Hill set the blue package down in the center of the white table. Ulving reached into his pocket and handed over two small pieces of engraved brass. Hill read one: *Edvard Munch*, 1893 and then the other: *Skrik*, Norwegian for "scream." Taken from the frame, Hill figured.

Hill turned back toward the dining room table. Ulving stood at his shoulder. Hill held the blue-wrapped package with his left hand and began to lift the sheet away with his right. Eager as he was, he worked carefully and gently. Even so, it took only a few seconds.

Horror-struck, Hill gawked at the sheet of cardboard before him. The problem wasn't the cardboard—Hill knew that Munch had painted his masterpiece on cardboard and not on canvas—but the image. Everyone knew *The Scream*.

This wasn't it.

Crude as *The Scream* was, this was vastly cruder. Hill saw *The Scream*'s famous central figure outlined in charcoal, a hint of railing in the foreground, a smudge of sky along the top. "What is this goddamned drawing?" Hill muttered. He stared at the cardboard a moment. Then, holding it by the sides, he slowly flipped it over.

Aha! The Scream, in its full glory.

None of the reading Hill had done had said a word about a false start on the back of the cardboard. Munch had evidently started working, disliked what he had done, and started again on the other side. Compared with its world-famous sibling, the abandoned *Scream* is upside-down. Munch had no doubt rotated the cardboard in 1893 just as Hill did a century later.

Hill started to breathe again. Jesus! Why hadn't anybody written about that? Hill held the painting up and scanned it, savoring the kind of opportunity that he knew only came along a few times in a lifetime. No frame, no glass, no hovering guards, no crowds, nothing between you and a few square feet of sublime achievement.

A year before, Hill had stood in an Antwerp parking lot, alongside a gangster, and briefly held Vermeer's *Lady Writing a Letter* in his hands. "Whenever you hold a genuine masterpiece," Hill had said afterward, "you see immediately that it's a stunning picture. It *tells* you it's a stunning picture. The quality just jumps out at you."

In ordinary circumstances, Hill would have guffawed at anyone who talked like that—he liked tales of frauds and forgeries and he cackled with malicious laughter when he told stories of "some pompous asshole whose prized possession turned out to be a ghastly fake churned out in a downmarket bedsit"—but face-to-face with a masterpiece, he was not cynical enough to deny the thrill he felt.

Hill knew immediately that the painting before him, in this closed-up cottage 70 miles south of Oslo, was the genuine article. Even so, he forced himself to scan it slowly. He paid particular attention to the bottom right side of the painting. At the end of one long night a century before, Munch had blown out a candle and splashed wax onto his painting.

The drips, white verging on blue-gray, were unmistakable. The most prominent one was toward the bottom right corner, close to the screamer's left elbow. Another, slightly less conspicuous, was a little higher and a few inches further to the right, across the top of the railing. Hill checked and then checked again. 37

The End of the Trail

AFTERNOON, MAY 7, 1994

or a moment, Hill indulged himself. Concentrating on *The Scream*, he let Ulving drift out of his thoughts. The blue chalk was brighter in real life than in any of the reproductions, and so delicate that a cough could blow away lines that Munch had laid down a hundred years before. Close up, the green arcs next to the screamer's head held the eye as forcefully as the famous orange bands across the sky. Tiny patches of raw cardboard peeked through the face.

Now Hill focused again. He turned to the art dealer, who had never been more than a few steps away, and addressed him with his customary brusqueness.

"Right, great. So what are we going to do now?"

"Well, there's the hotel here in Åsgårdstrand," Ulving said. "We could go there."

"Okay. Sounds good. Let's do it."

"I can't drive you back to Oslo. I'm just not fit to do it."

"I don't want you to. I've got the painting now. The last thing I need is for you to land us upside-down in a ditch."

Hill picked up *The Scream* and wrapped it back up in the blue sheet. He followed Ulving outside and leaned over the passenger seat of Ulving's sporty Mercedes, trying to set the priceless painting in the back of the little two-seater. Wrestling the bulky square of cardboard over the front seat headrest, Hill heard a dismaying thump. "Shit! I've dented the fucker on the goddamned headrest."

He glared at Ulving. "Drive."

Ulving drove to the hotel, only a few minutes away. "We can get a day room."

"Fine. Do it."

Ulving and Hill walked into the hotel, leaving *The Scream* unattended in the car. Hill, who was breathtakingly careless whenever he was not overtly paranoid, hardly gave it a thought. Who steals cars in Norway?

Hill had yet to phone Butler. He spotted a pay phone near the front desk. *The Scream*'s brass nameplates jingled in his pocket as he strode across the lobby.

"I'm just going to phone Sid," Hill told Ulving, although it was John Butler and not Sid Walker that he planned to call. Hill couldn't have phoned Walker if he had wanted to, since he had neglected to write down his number.

Ulving tagged along. That wouldn't do. Hill turned to Ulving. Fuck off! That was English, not American. Hill changed idiom and spoke aloud. "I need to talk to Sid. Go screw yourself!"

"Oh, excuse me," Ulving said, retreating.

"John, it's Chris."

"Charley, where the hell are you?"

Butler was a good man in a crisis, but his voice was a near-whisper that betraved his tension.

Hill whispered, too, to foil Ulving. "I've got the picture. We're at the Åsgårdstrand Hotel. We just booked into room 525. I'll be there. No one else, just me and the painting. Send the cavalry.

"Now listen," Hill went on. "The important thing is, Sid is back at the Grand, with the two villains, Johnsen and the other guy."

"Shit! Okay."

"I'll ring you again as soon as I get to my room."

Hill walked back toward Ulving. "Okay," he said. "Everything's fine. Sid'll give them the money."

"What should we do with the painting?" Ulving asked.

"Let's go look at the room."

The room was on the second floor. Hill asked Ulving if there was a set of stairs in back. Ulving showed him the fire escape. Hill wedged the door open with a fire extinguisher.

"Get the car and pull it around," Hill ordered. "I'll wait for you here." Even for Hill, this was a colossal—and pointless—risk. He didn't see it that way. Utterly confident that he knew his man, Hill figured it was impossible that Ulving would race off with his \$70 million prize. The only danger Hill could see was that, in the course of driving from the front to the back of the small hotel, Ulving would find a way to crash his car.

Ulving pulled into view. Hill, still mortified that he had thumped *The Scream* on the headrest, lifted the painting from the car in slow motion. Then he dismissed Ulving.

"Okay, I'll get a taxi back. Drive home safely."

Ulving, trembling with a night's accumulated tension, sped away.

Hill carried *The Scream* up the fire escape and into his room. He placed the painting, still wrapped in its blue sheet, on the bed. Then he locked the door, chained it, and shoved a chest of drawers in front of it. He scanned the small room. What else could he do to protect himself in case someone tried to snatch the painting? Hill looked out the window. Ten feet to the ground. If someone managed to get in, maybe Hill could grab the painting and make it out the window. Worth a try. He opened the window wide.

Hill ran through the brief roster of people who knew where he was. Ulving. Would he send someone to do what he would never dare do himself? Probably not. The receptionist? She had seen Hill but not the painting. She shouldn't be a problem. The mystery man who had handed the painting to Ulving?

"Fuck it! No one's going to take the painting," Hill said aloud. He unwrapped *The Scream* and propped it up on the bed, against the pillow. To his relief, he saw that the smack on the headrest hadn't made a dent. He stepped back for a better look, then sat in a chair and stretched contentedly. Sprawled at full length, Hill put his hands behind his head and contemplated the painting he had studied in so many books. Munch had hated the idea that one of his paintings could disappear "like a scrap of paper into some private home where only a handful of people will see it." It was good to think that his greatest painting had been saved from a far darker fate.

Hill wasn't especially motivated by money. He couldn't have stayed a cop for twenty years if he had been. But, still, \$70 million! Even more disorienting was to think that the piece of decorated cardboard on his bed had been copied and photographed and parodied and admired thousands and thousands of times.

Hill despised talk of Dr. No and his secret lair, but for several minutes he basked in the luxury of this private viewing. Not many people had ever had a chance to see a masterpiece in a setting like this. "Jesus!" he thought. "We've done it."

Itching to share his triumph, Hill phoned his contact at the Getty to give him the good news and thank him for his help. What time was it in California? Midnight? Anyway, nobody home. Hill left a cheery message. It was only eleven in the morning in Norway, but it was time to celebrate. On a small table in the room, the hotel had provided a bottle of wine. Hill poured himself a drink. Vile! He found a small bottle of Scotch in the minibar. Much better. Drink in hand, he spent another minute with *The Scream*.

Back to the world. When the good guys came to fetch him, Hill didn't want them accidentally hurting the painting. He wrapped it up again, laid it flat on the bed, and set the brass nameplates next to it.

Then he phoned Butler. When they had spoken just minutes before, Butler had whispered. Now he shouted down the line.

"Where's Sid? Charley, I can't find Sid."

Hill was as alarmed as Butler. "Oh, Christ," he said. "Something's happened. They've had an accident, something gone's wrong."

It didn't make sense. When Sid and Charley had driven away from the restaurant earlier in the morning, in separate cars, Sid had the shorter drive. He should have made it back to his room at the Grand Hotel long ago. Worse than that, Sid had headed straight back to Oslo. Hill and Ulving had made a longer drive and after that they had chased around forever to get the goddamned picture.

Where was Sid?

The answer emerged soon enough. Unbeknown to Butler and Charley, Sid was back at the Grand, in his room with Johnsen and Psycho. The Norwegian police team watching the hotel, whose job was to keep a sharp eye out for Walker and to contact Butler the instant they saw him, had managed to miss him.

Which meant that Walker was alone in a hotel room with two highstrung, violent criminals, and no one had the slightest idea where he was.

The three men did their best to pass the time. Psycho, whose real name was Grytdal, seemed to have taken a liking to Walker. He tried to strike up a conversation. The next day was his twenty-seventh birthday. Maybe someday he would travel to England and he and Walker could meet up. Maybe they could go fishing?

Walker played along, but everyone was preoccupied and the conversation kept sputtering out. Time dragged on, and the crooks grew jumpier. Walker rummaged in the minibar for something they could drink. Any minute now, the Norwegians knew, Hill should call Walker to say that he had *The Scream* and it was time to hand over the money. When was that goddamned phone going to ring?

Instead of a ring, they heard a knock on the door. Sid went to see who it could be. Two men in street clothes, chatting nonchalantly. One carried a bulging sports bag that Walker recognized at once—*his* bag, with the money! In his other hand, the man held a steaming cup of takeout coffee with a roll balanced precariously on top. His companion stood clutching a hamburger and a Coke.

The Norwegian cops, one more time. Somehow signals had gotten crossed yet again. The Norwegians had expected to find Walker alone in his room. Their plan—which had never been communicated to Walker was that eventually the crooks would show up, Walker would produce the money, and a team of cops from the next room would swarm in and arrest the bad guys.

The two cops walked into the room. Johnsen jumped to his feet to see what the commotion was about. Grytdal lay sprawled across the bed. The cops looked at Grytdal and at Johnsen—they knew Walker, but not these two—and saw at once what they had walked into. "Police!" one of them shouted.

Grytdal leaped up from the bed and tackled the cop nearer to him. The bag with the money fell to the ground. Coffee splashed across the carpet. The second cop jumped in, fists flailing. Grytdal struggled to his feet and threw a bearhug around the cop he had tackled. The other, larger cop pounded Grytdal from behind. Grytdal, in a fury, seemed not to notice the blows falling on his back and head. Grytdal and the cop fell to the ground again and rolled across the carpet, neither man willing to let go. The bigger cop stuck close to the tumbling bodies. He looked like a referee in a wrestling match, but he was hoping for a chance to deliver a good, hard kick to Grytdal's head or ribs. The bag with the money lay unattended on the floor.

Walker and Johnsen had yet to join in. Dodging bodies, Walker grabbed Johnsen's leather jacket and flung it to him. "Let's run!"

The two men dashed out the door and down the hotel corridor. Johnsen spotted the emergency exit door that led to the stairs. Down he raced. Walker lumbered after him. Younger and faster than Walker, Johnsen soon left the detective alone in the hotel stairwell.

That wasn't ideal, but it wasn't the worst thing in the world. Walker hadn't had time to devise a polished plan—only a minute or so had elapsed between the Norwegians' knock on the door and the moment when the room became a cyclone of punching, kicking bodies—but fleeing the room wasn't a bad idea. Walker hadn't expected the Norwegians to drop by for a visit, but he did know that the cops had the hotel surrounded. If Johnsen did run, the cops ringed around the hotel should catch him.

The alternative—staying in the room and joining the free-for-all didn't have much appeal. True, the cops would outnumber the bad guys three to two, but Grytdal's mania seemed to even the score. Walker was a rough customer himself, but he knew that Johnsen was younger and, more important, a kick-boxing champion. Better to run Johnsen out the door and into a trap than to barge into the melee.

Except that the police watching the hotel missed Johnsen as he ran out. With Johnsen gone, Walker raced back to his room. By the time he arrived the Norwegians had managed to handcuff Grytdal and radio for backup. Cops flooded into the hotel. They arrested Grytdal and dragged him off to police headquarters and took custody of the bag with the cash. Johnsen, on the loose, took a moment to think things through. The police, he knew, were after him already. His fellow thieves would be after him, too. In many a police sting, one thief is allowed to slip away. For the police, the rationale is cold-hearted but straightforward. The thief's cronies would likely pin the blame for the arrests and the failed operation on the lone escapee, figuring that he had sold out his mates. Better to have the bad guys think they knew why things had gone wrong than to have them nosing around for an explanation. It wasn't quite fair, the cops might concede, but, then, life isn't fair.

Less than an hour after he fled the Grand, Johnsen picked up a phone and called Leif Lier, the Norwegian detective. The two were old acquaintances, and Lier had a reputation for fairness.

I need to come in, Johnsen said. Lier thought that seemed like a good idea. Johnsen summoned a taxi and rolled up to police headquarters in style. He had warned Lier that he didn't have money to pay the fare, but Lier had told him not to worry. This one would be on him.

At the Åsgårdstrand hotel, someone rapped loudly on the door to Charley Hill's room.

"Yeah?" Hill called.

Back came a shouted name and a word that sounded to Hill like "Politi!" Presumably the Norwegian for "police."

"Okay." Hill shoved the chest of drawers away from the door and opened it a few inches, though he left the chain on. He saw two men in street clothes, one of them tall and somber-looking, the other smaller, with curly hair. They held ID cards out toward Hill.

Cops, or a pretty good imitation. Hill opened the door. "Hi, I'm Chris Roberts."

One of the newcomers looked at the square parcel in the blue sheet lying on top of the bedspread. "Is that it?"

"Yeah."

Hill unwrapped *The Scream* one more time. The cops stared. Then Hill rewrapped the painting and handed it to one of the cops. He handed the brass plates to the other. The three men headed downstairs.

Hill told the Norwegian cops to give him a minute. The hotel was

perched on a fjord, and a pier stood nearby. Hill remembered Munch's painting of three girls on a pier, and he strolled out to the pier's end as a small sign of respect for the artist whose work had led him to this out-of-the-way town.

One of the cops kept a discreet watch. What was this crazy Brit up to now? Hill didn't notice. He looked out across the water for a minute and punched a fist into the air in triumph. Then he broke into a celebratory jig. The Norwegian cop looked on—alone, at the end of the pier, a 200pound bear of a man shuffled his way through a tentative and earthbound dance.

That was mundane reality. On the movie screen that plays so often in Charley Hill's mind, the picture was different. There, his mission accomplished, the dashing detective leapt high into the air and spun halfway around in a joyful arc.

Epilogue

n Norway, the National Gallery put together a triumphant press conference. *The Scream* was the star, and photographers pressed close for pictures. A hugely relieved Knut Berg, the museum's director, posed for photo after photo with his recovered masterpiece. Leif Plahter, the art restorer, beamed happily at the painting he knew so well. The Norwegian detective Leif Lier hailed his British colleagues. "We would never have got the picture back," he said, "if it had not been for Scotland Yard." John Butler made a few gracious remarks about the benefits of international police cooperation. Only Charley Hill and Sid Walker, phantoms whose visit to Norway was a state secret, missed the party.

Back in England, the press celebrated. "Yard's Artful Dodgers Find *The Scream*," the *Daily Mail* crowed, and in their own, more sedate way, the "quality" papers cheered, too. Scotland Yard stood on the sidelines and pouted. Butler's television appearance in Norway had been replayed in Britain, and the police brass gave Butler a drubbing for his troubles. What was he doing flouncing around on television? What did that bloody painting have to do with police work? What did Norway have to do with London? Two years passed before the trial began. In the meantime, Johnsen did his best to insure that Ulving, at least, would not forget him. The ex-con turned up at Ulving's hotel one day, drunk and angry, with a snarling pit bull on a thick leash. He demanded that the clerk tell Ulving that a friend of his had come to see him, and then he took a room, kicked a few holes in the wall, and collapsed in a stupor on the bed. Months later, he was back, this time at Ulving's summer cottage. Ulving was outdoors, sunbathing. Johnsen suddenly materialized, from a neighbor's yard. He had traded in the pit bull for a rottweiler. "What are you going to say in court?" he demanded.

By the time of the trial, the state had long since fit the pieces of the story together. The plot had been the brainstorm of Pål Enger, the soccer player turned crook, who had planned the theft in the confident hope that a buyer would turn up.

At the trial, Enger was charged with theft, and Grytdal and Johnsen with handling stolen property. A fourth man, William Aasheim, who had been only eighteen years old at the time of the break-in, was charged with theft, too. According to the prosecution, Aasheim and Enger were the two men with a ladder who had set the whole story in motion on a February morning in 1994. Enger and Grytdal, it emerged, were old colleagues. The two had done time in prison together for stealing Munch's Vampire.

Ulving, who had not been charged, saw to his relief that the prosecution case seemed strong even without him. For fear of retaliation, he did his best to keep his testimony vague and innocuous.

The trial began in Oslo, but Norwegian law forbade anonymous testimony. That seemed to rule out Hill and Walker. The two undercover detectives worked in a violent world; forcing them to reveal their true identities in open court would have left them (and their families) sitting ducks for any crook with a gun and a grievance. In a compromise, the Norwegian court agreed to move part of the trial to London. There Hill and Walker gave their testimony from behind a screen, as "Chris Roberts" and "Sid Walker."

In January 1996, the judge read out his verdict. Guilty! Guilty! Guilty! Guilty! Enger, the ringleader, was sentenced to six years, three months; Grytdal, to four years, nine months; Aasheim, to three years, nine months; and Johnsen, to two years, eight months.

The four began serving their time but appealed their convictions. Conclusive as the evidence had been, a Norwegian appeals court ruled in favor of three of the four convicted thieves. All but Enger were set free. The court reasoned that, because Hill and Walker had entered Norway using false identities, their testimony about what they had seen there was inadmissible.

Hill, never much impressed by the law's majesty (and always more concerned with paintings than with crooks), shrugged it off. With his customary refusal to allow mere logic to hem him in, he squeezed two contradictory responses into a single sentence and then dismissed the whole subject from his mind. "My personal view is that it's complete bullshit," he said, "but it's the Norwegian system and you've got to respect it."

Enger is still in Norway, still proclaiming his innocence. (He managed to get his name in the papers not long ago, this time by buying, rather than stealing, a \$3,000 Munch lithograph at an auction.) Grytdal is reportedly a pimp in Oslo, and Johnsen has died of a heroin overdose. In February 2004, Aasheim was murdered on the streets of Oslo.

Ulving, the art dealer, came out of the story triumphant and officially vindicated. Charley Hill, unswayed, consoles himself with the bittersweet knowledge that, once again, the system worked as poorly as he expected it would. Hill refuses to believe that Ulving was an innocent caught in a mess not of his making. Ulving, Hill speculates, "wanted to run with the hare and hunt with the hounds." He wanted, that is, to have it both ways. If the money from the artnapping had come through, he would have taken his share of the proceeds. If the crooks' plan fell apart, he would present himself as a patriot who had strived mightily to help his country recover one of its treasures.

The Norwegian authorities don't see it Hill's way. "I don't think Ulving was involved with the criminals," says Leif Lier, the detective. "He was *used* by the criminals." The police had arrested Ulving on the day they recovered *The Scream*, but they released him later the same day. For that arrest, Ulving won a judgment of about \$5,000 against the state.

*

Today, Charley Hill is working as zealously as ever to find stolen paintings. Still a detective, he is out of the undercover game. He is on his own now, a detective-for-hire free to operate without layers of bosses to second-guess him. Characteristically, Hill paints the catch-as-catch-can life of a freelancer in the brightest of colors. "I'm a hunter-gatherer now," he exults, "and my family and I eat what I kill."

Some days the eating is better than others. Though Hill is not the only detective working full-time on recovering stolen art, he may be the only one who focuses almost exclusively on *great* art. Given Hill's nature, the decision not to hedge his bets was inevitable. The coups, when Hill can pull them off, are colossal. In the summer of 2002, for example, he recovered Titian's *Rest on the Flight into Egypt*, which had been missing for seven years. The painting, worth something in the neighborhood of \$10 million, had been stolen from the Marquess of Bath, a seventy-one-year-old exhippie and flower child, the author of a six-volume (so far) autobiography titled *Strictly Private*, and the owner of a 100-room estate that has been in his family for four centuries and sits amid grounds that cover 9,000 acres.

The ponytailed, bearded Lord Bath is an exotic creature who favors velvet jackets, dangling jewelry, and the company of striking women. He has had seventy-one "wifelets" to date, by his count, and keeps a portrait of each one on display in Longleat House. (Several of the flesh-and-blood women live in cottages dotted around the sprawling grounds.) "To some extent," Lord Bath boasts, "I pioneered polygamy in this country."

Lord Bath's insurance company announced that it would pay a £100,000 reward for the Titian's return. Every swindler and nutcase in Britain phoned in tips. For seven lean years, Charley Hill chased leads. Eventually he pieced together a trail that led from one Irish Traveler clan to another and then to a dicey sports promoter whom someone in the second gang had had the bad judgment to shoot. Titian's exquisite painting, which depicts Mary holding the infant Jesus while Joseph looks on approvingly, was apparently handed over in an attempt to smooth things over. (Hill likes to imagine the scene around the victim's hospital bed: "Sorry about the bullet. How about a picture of Joseph, Mary, and Jesus for all you've been through?") The promoter eventually decided he could do without this particular get-well card and shipped the Titian off to a gang somewhere south of London. In the summer of 2002, Hill met an informant who claimed he knew where it had washed up. The story seemed to check out, though the thieves themselves were long gone, and Hill and his contact worked out a tentative deal.

On a hot August afternoon, Hill and the informant set out together.

"So off they went," recalled Tim Moore, the manager of Longleat House, who had been working with Hill, "and I thought, 'Unless poor old Charles Hill is going to end up with a knife in his back or in a sack in the Thames, maybe we're on to something.""

Hill drove. The informant gave directions. Eventually they pulled up to a bus stop. "There it is," said the informant. "The bag at the old man's feet."

Hill grabbed the bag, a shabby, blue-and-white plastic thing with a cardboard-wrapped package inside. He climbed back in his car, made a U-turn, and double-parked. He tore off a piece of the cardboard. Joseph's head, Titian's brushwork. Bingo!

For his efforts, Hill earned £50,000, half the reward money. The other half went to the informant. And how did Lord Bath feel about the recovery? "I felt several million pounds richer."

Ж

Hill's decision to leave the police force was not a matter of walking away from a thriving enterprise. Police interest in art crime, never intense (except in Italy), is nowadays tepid at best. Undercover operations, in particular, take so much planning and involve so many people that they gobble up time and money in great chunks. The sting involving *The Scream* was not quite the grand finale of the undercover era in art crime, though it was close. That melancholy title will likely rest with a sting in Madrid in June 2002, in which Spanish police and the FBI recovered \$50 million worth of paintings that had been stolen from the home of a billionaire named Esther Koplowitz.

Now that he is off the police force, Hill's acting days are over. His job these days is to work his underworld contacts in search of news about stolen paintings and then to negotiate their return. He knows who works which territory, which gangs steal paintings themselves and which hire local thieves to do the breaking-in, which gangs go for ladders and which prefer "ram raids" in which a driver crashes a car through locked doors.

His competition have gone about things in a different way. The bestknown are not individuals but small companies. One is called Trace; a competitor is Art Loss Register. Both work roughly on the model of matchmaking services. At the heart of each company's business is a vast, computer-searchable list of stolen paintings and furniture and the like, compiled from police reports and insurance claims. That list is compared, automatically, against the art and antiques on offer at countless auctions and art fairs and galleries. (Trace employs armies of typists on the Isle of Wight, where wages are low, to feed the computer listing after listing from an endless array of art catalogs and brochures.) When the computer red-flags a suspect item for sale, the companies step in to investigate. To find work better calculated to drive Charley Hill mad would take a long search.

The companies have different business models, but, in theory at least, they can make money in several ways: by charging a fee for listing stolen property in their database, by collecting a finder's fee if they make a recovery, by charging art dealers for access to their records (dealers are required to exercise "due diligence" to make sure they are not selling stolen goods).

It hasn't paid off yet. Trace is the pet project of an English billionaire and art collector, who can afford to swallow the considerable losses he has racked up. Art Loss Register says that its own losses will soon come to an end.

Both companies are small, but they are mega-corporations in comparison with the one-man band that is Charley Hill. (When he first left the police, Hill went into business with a partner, another ex-detective. The venture fared as poorly as anyone but Hill would have expected. The only relic of that short-lived era is a sign that Hill brought home and mounted on his bathroom door, identifying "The Charles Hill Partnership Meeting Room.")

Hill figures that the freedom to set his own priorities is worth the financial risk he is running. Let someone else chase after silverware and stolen clocks. But the flip side of independence is isolation. Crooks are naturally not pleased to have Hill on their tail, and the cops are only marginally cheerier. The police see Hill as trying to show them up, and, in truth, that is not a role that would cause him many sleepless nights. "The police had seven years to get the Titian back. And the simple fact is, they didn't get it back. Nor did the insurers through their various means. And I went out and cultivated people and got it back."

This is treacherous territory, pocked with ethical traps, as Hill is quick to acknowledge. Hill's underworld sources expect to be paid for their help. (The money comes from insurance companies or from the robbery victims.) The problem is getting those payments in the right hands or, more to the point, keeping them out of the wrong ones. Paying a reward to a source who has heard a rumor is one thing; paying a ransom to a criminal to buy back property he himself stole is another.

The police pay informants as a matter of course. The FBI's Ten Most Wanted list, for example, dangles rewards on the order of \$1 million (and, in the case of Osama Bin Laden, \$25 million). But in the case of stolen property, tradition held that money was paid only if arrests were made. Many police officials believe that rule should apply to stolen art. Do that, Hill insists, and stolen paintings will never be seen again. The police may talk about integrity, he says, but their real credo is indifference.

Hill's view, which is that in today's world freelancers will have to do what the police cannot trouble to do, has won him slews of enemies. Who is he to authorize rewards? More important, how can Hill know if his "informant"—whose own hands are supposedly clean—was in truth one of the thieves who stole the painting in the first place or, almost as bad, a fence who bought it from the thieves?

Despite his swashbuckling ways, Hill steps carefully here. He consulted Sir John Smith, the University of Nottingham law professor who was Britain's leading authority on the laws governing stolen property, and he has the great man's imprimatur. The two key principles, as spelled out by Smith, are that Hill must act on behalf of the owner of the stolen painting—he cannot go running around the country on his own authority—and he can't interfere with the police—he cannot make a deal where a crook hands over a painting in return for a Get Out of Jail Free card.

The black-and-white moralist has landed in a world of grays, but Hill lives with that contradiction as happily as with all the others. Far from waiting for a go-ahead signal from the police, he has his eye fixed, at any one time, on half a dozen major cases. At Christmas 2003, for example, he was looking for Jean-Baptiste Oudry's *White Duck*, stolen from Lord Cholmondeley and worth £5 million, and Leonardo's *Madonna of the Yarnwinder*, worth perhaps £50 million, and Cellini's gold and ebony saltcellar, worth \$57 million, and a variety of treasures in Belgrade and Sicily.

Always lurking in the background-often shoving its way into the foreground-are the \$300 million worth of paintings stolen from the

Gardner Museum. Hill has pondered the theft since the news broke, on March 18, 1990. He believes he knows who took the paintings, and why, and what they did with them. Most important, he believes Vermeer's Concert, Rembrandt's Storm on the Sea of Galilee, Manet's Chez Tortoni, and the others, are still intact and unhurt.

In search of the Gardner paintings, Hill has spent endless hours cultivating contacts and chasing leads and pursuing men who very much do not want to be pursued. He is up against formidable competition; the advertised reward for finding the Gardner paintings (put up by Sotheby's, Christie's, and Chubb Insurance) is \$5 million.

The FBI is by far the most prominent player in the hunt. The bureau has already followed up 2,000 leads in the Gardner case, it says, and has sent agents to Japan, South America, Mexico, and Europe. To no avail. At the ten-year mark, the FBI supervisor in charge of the case acknowledged that "we haven't got a clue." Today, another three years on, the picture is just as grim. "All logical leads have been followed through to conclusion," the FBI admits, through clenched teeth, "with no positive investigative results."

For a proud loner like Hill, no triumph could be sweeter than outwitting scores of rule-following, memo-writing FBI agents, all dutifully following "logical leads." In the end, it may not happen. Hill's efforts could all end in fiasco. It's happened before.

But, then again, it might work. Hill has thought it through a thousand times. First a proper drink and a long, private look at the pictures. Then it will be a matter of picking up the phone and calling the director of the Gardner.

"It's Charley Hill," he'll say. The tone will be light, casual, all in a day's work. "I believe I've found some things you've been missing."

AFTERWORD

SEPTEMBER, 2004

A month after I'd sent the manuscript of this book to my publisher, I sat in a Manhattan taxi stuck in traffic. It was a Sunday afternoon in August, and an idyllic day if not for the blaring of horns and the dentist-drill whine of the music on the taxi radio. "It's 2:00. This hour's top story. In Norway, thieves have stolen one of the world's best-known paintings, *The Scream*. Experts say the painting could be worth as much as \$100 million. Police say they have no suspects."

I sat back stunned, but I should have known better. The story hadn't ended when I turned in my manuscript. Art and art thieves aren't history; they're headlines.

Ж

"Count no man happy before he dies," the ancient Greeks said, by which they meant that even the most successful life can fall apart in a moment. The same insight holds for great paintings. When it comes to stolen art, no case is ever truly closed.

On Sunday morning, August 22, 2004, the Munch Museum in Oslo was crowded with visitors. August is tourist season, and the museum had been bustling since it opened at 10 A.M. The collection is devoted entirely to Munch; when the painter died, in 1944 at age 80, he willed his art to the city of Oslo. The museum, nowhere near as large or as imposing as the nearby National Gallery, seems almost to invite its patrons into Munch's cluttered studio. Many visitors pause at Munch's austere single bed and its frayed blanket, on exhibit along with the paintings, drawings, and prints.

Sooner or later, and in most cases sooner, everyone who enters the Munch Museum ends up standing before *The Scream*. This is not the same painting that Charley Hill recovered in 1994, but an equally valuable near-twin. Munch painted four versions of *The Scream* in all—he returned obsessively to the themes that haunted him—and the two at Norway's National Gallery and the Munch Museum are the ones familiar around the world.

At 11:10 on that Sunday morning, two armed men in black ski masks and gloves burst into the museum. One burglar pointed his pistol at the head of an unarmed guard and shouted, in Norwegian, for the guard and the terrified tourists to "Lie down!" In the meantime, his partner strode over to Munch's *Madonna*, a famous and hugely valuable work in its own right, pulled out a pair of wire cutters, and cut it from the wall. "It looked like he was crazy," one eyewitness reported. "He was banging it against the wall. Then he got it off the wall, and he was banging it on the floor." Then he grabbed *The Scream*.

The two thieves ran outside, each clasping a priceless painting. As they neared the getaway car, a black Audi station wagon, a third man threw open its back door. The thieves flung the masterpieces inside, and the three men sped off.

The nearest police station is only half a mile from the museum, and when the thieves cut the paintings from the wall they triggered an alarm connected to the station. The police arrived within minutes. Still, it was too late.

By one o'clock in the afternoon, police had found the getaway car, abandoned, and battered bits of the paintings' frames. In the case of *The Scream* especially, this further evidence of rough handling was bad news. Munch painted his *Madonna*, an eerie, erotic depiction of a bare-breasted, black-haired woman, in oil on canvas, which makes it relatively robust; but the newly stolen *Scream*, like the version stolen in 1994, is painted on a piece of cardboard, so it could easily be bent or creased.

On the day after the theft, the director of the Munch Museum held an anguished press conference to plead with the thieves. "Whatever they do," said Gunnar Sorensen, speaking from a position in front of the blank spot on the wall where *The Scream* had hung, "they should take care of the pictures as well as they can."

That was apparently more than the Munch Museum itself had done. According to indignant accounts in the Norwegian press, four months before the theft the museum had withdrawn from the Norwegian Industry's Security Board. The board, under the auspices of Norway's Justice Department, advises its members on issues of crime and security. Its membership includes Norway's most prominent institutions, including banks, oil companies, the Museum for Contemporary Art, and the National Gallery. A month before it withdrew from the Security Board, the Munch Museum had been given KR500,000, roughly \$70,000, to beef up security. It had not spent the money.

Like the National Gallery's *Scream*, the Munch Museum's stolen paintings were not insured for theft. "They are irreplaceable works of art," said the head of the agency that insures assets belonging to the city of Oslo, "and it makes no sense to insure them against theft."

That is debatable; at the least, an insurance company faced with the possibility of a \$50 million or \$100 million payout might strive mightily to turn up the heat on the crooks. As it is, the police have found themselves chasing down random leads and praying the thieves will contact them. The obvious suspect, Pål Enger, who had been convicted twice before of stealing paintings by Munch, proclaimed his innocence. "Weapons are not my style," Enger maintained. "I have always used the methods of a gentleman."

Frustrated and forlorn, the authorities scarcely try to hide their floundering. "We're working with the tips we've got from the public," one police official told an interviewer two weeks after the theft. "So far we haven't tied ourselves to any main theory."

Ж

Charley Hill, whose boiling point is barely above room temperature, rages whenever he contemplates these latest examples of official ineptitude. Even stolid Leif Lier, the Norwegian detective who worked with Hill in 1994, cannot hide his indignation. "Hasn't the city of Oslo learned anything about security in ten years?" he demands. "I am shocked that once again it was so easy." In the best of scenarios, the thieves will realize they cannot sell their paintings and will drop them somewhere where they will be quickly found. Failing that, the robbers may surface with ransom demands. Or, since *The Scream* and *Madonna* will surely retain their value for many decades to come, perhaps the silence will drag on. In the case of the Gardner Museum paintings, for example, the silence now spans fourteen years.

An impasse like that is unlikely. Thieves do not steal paintings in order to stash them in a warehouse. But schemes fall apart and deals dissolve. Yesterday's trophy can become today's white elephant. Sometimes a seeming lack of activity means not that a painting has been destroyed or stored away but that it has become a trade item in the criminal underworld, like Metsu's Woman Reading a Letter, stolen in Dublin in 1986 and recovered in Istanbul in 1990 in the hands of a thief trying to barter it for a shipment of heroin.

In the short run, the case is in the Norwegians' hands. In all art robberies, the local police have first crack at sorting things out. But if months go by without progress and all the obvious leads unravel, Charley Hill's phone will ring again.

In the meantime, when two weeks had gone by without a word about the whereabouts of its two most valuable paintings, officials from the Munch Museum contacted the press. "We are closed and will be closed for three weeks," museum officials announced, "to install alarms, among other things."

NOTES

This is a work of nonfiction. If readers find themselves eavesdropping on someone's thoughts— "It's perfect," Hill thought. "I'll be the Man from the Getty"—or privy to an interior monologue—These guys *couldn't* be trying to hide—the material came from an interview.

The great bulk of *The Scream* narrative comes from my interviews with the principal players, notably Charley Hill. In addition, I am grateful to the producers of a BBC-4 TV documentary called *The Scream* for providing me the unedited transcripts of their interviews. I also made use of a memoir by Jens Kristian Thune, who was chairman of the board of Norway's National Gallery when *The Scream* was stolen. I am grateful to Eileen Fredriksen for translating Thune's account, *Med et skrik*, into English.

Since this book is in great part an oral history, I have chosen to keep the notes compact. In particular, readers seeking further details of the various thefts mentioned in passing would do well to begin by consulting the extensive archives at http://www.museum-security.org.

Chapter 1: Break-in

The account of *The Scream* theft in Chapters 1 to 5 is based on interviews with Charley Hill, Dick Ellis, Leif Lier, and Ludvig Nessa; Thune's book; news reports (particularly those in the Norwegian newspaper *Dagbladet*); the BBC-4 documentary cited above; and a second BBC documentary on *The Scream* case, entitled "The Theft of the Century," produced by Keith Alexander in 1996.

The minister of culture who found it "hard to imagine that such evil things" as the theft of *The Scream* could take place was Asa Kleveland. She was interviewed in "The Theft of the Century."

Chapter 2: Easy Pickings

The figures on stolen art in the Museum of the Missing come from the database of the Art Loss Register and were current as of May 2003.

Steven Keller remarked that many museum guards "couldn't get jobs flipping burgers." See "Busted," Art & Auction, March 2004. The Louvre's security shortcomings were detailed in a report by the French national audit office, the Cour des Comptes, in February 2002.

Chapter 6: The Rescue Artist

Jon Dooley, CEO of Invaluable Ltd., likened Charley Hill to "a man fishing with a rod." Dooley was quoted in an article headlined "Lost and Found" in the *Financial Times*, September 27, 2002.

Charley Hill's remark that statistics on art crime are "completely made up" appeared in Anthony Haden-Guest's "Catch Me If You Can," *Art Review*, March 2003.

Michael Kelly was quoted in an article by Robert Vare. See "True to His Words," Atlantic, April 2004.

Chapter 7: Screenwriters

The best account of the frenzy in the art world in the late 1980s is Cynthia Saltzman's Portrait of Dr. Gachet: The Story of a Van Gogh Masterpiece, Money, Politics, Collectors, Greed, and Loss (New York: Viking Penguin, 1998).

Chapter 9: The General

The indispensable work on Cahill and the basis for all later accounts of his career, including this one, is Paul Williams's *The General* (Dublin: O'Brien Press, 1995). Cahill's career was dramatized in a film also called *The General*, directed by John Boorman.

James Donovan told of surviving a car bomb in the London Sunday Mirror, August 8, 1999.

In his book *Jan Vermeer* (New York: Barnes and Noble, 1962), Lawrence Gowing remarked that "everything of Vermeer is in the Beit *Letter.*"

The information about Vermeer's widow selling *Lady Writing a Letter* to settle a debt with her baker—and the information that the debt, 617 florins, corresponded to roughly \$80—was provided by the research staff at the National Gallery of Ireland.

The brief sketch of Vermeer's life is based on Anthony Bailey's Vermeer (New York: Henry Holt, 2001) and Norbert Schneider's Vermeer: The Complete Paintings (Cologne: Taschen, 2000). Robert Hughes noted that Vermeer left no written accounts of his life or his art; see "Shadows and Light," *Time*, May 7, 2001. Bailey discussed the identity of Vermeer's models on pp. 115–116.

Paul Johnson remarked on Vermeer's long fall from favor; see Art: A New History (New York: HarperCollins, 2003, p. 379).

Thoré paid 500 francs, roughly \$2,000 in today's money, for Young Woman Standing at a Virginal. He paid roughly \$16,000 in today's dollars for Woman with a Pearl Necklace and roughly \$8,000 for Young Woman Seated at a Virginal. See Frances Suzman Jowell, "Vermeer and Thoré-Burger: Recoveries of Reputation" in Gaskell and Jonker, eds., Studies in the History of Art, vol. 55 (Washington: National Gallery of Art, 1998, pp. 35–58). The conversions from nineteenth-century prices to present-day dollars were provided by the Musée de la Monnaie de Paris.

Laura Cumming made the point that, in the days before museums and mass reproductions, artists might disappear from view; see her fine essay, "Only Here for the Vermeer," in the *Observer*, May 27, 2001.

Sir Alfred Beit's remark that "no amount of money" could compensate him for the loss of his paintings appeared in the *New York Times* on May 1, 1974, in an article headlined "Insurance Was Low on 19 Works of Art Stolen in Ireland."

Paul Williams discussed Martin Cahill's belief that he could sell stolen paintings to unscrupulous art collectors for "millions, countless millions" on a British television documentary called "The Fine Art of Crime" (Fulcrum Productions, 1998).

Chapter 11: Encounter in Antwerp

Rebecca West called the once-fashionable novelist Michael Arlen "every other inch a gentleman," according to Victoria Glendinning's biography of West. (The comment is sometimes attributed to Alexander Woollcott.)

Chapter 12: Munch

My account of Munch's life and *The Scream* is based on J. P. Hodin's *Edvard Munch* (London: Thames & Hudson, 1972), Poul Erik Tøjner's *Munch in His Own Words* (New York: Prestel, 2003), Reinhold Heller's *The Scream* (New York: Viking, 1973), Mara-Helen Wood's *Edvard Munch: The Frieze of Life* (London: National Gallery Publications, 1992), Monica Bohm-Duchen's *The Private Life of a Masterpiece* (Berkeley: University of California Press, 2001), and Stanley Steinberg and Joseph Weiss's "The Art of Edvard Munch and Its Function in his Mental Life," *Psychoanalytic Quarterly*, vol. 23, no. 3, 1954. The psychoanalytic speculation in Steinberg and Weiss is far-fetched ("the swirling red landscape may represent Munch's dying mother"), but the compilation of biographical facts is useful.

My remark comparing Freud and Munch is a variant on an observation by Christopher Hume, who called Munch "the great liberator of the tormented Self" and wrote that "if Freud was its cartographer, Munch was the illustrator." See "Munch Kitsch Makes a Fearful Image Safe," *Toronto Star*, March 1, 1997.

Simon Winchester's superb *Krakatoa* (New York: HarperCollins, 2003) is by far the best account of the volcano's eruption and its ramifications (including the story of the Poughkeepsie firemen, as well as countless others). The link with *The Scream* is perhaps the only Krakatoa connection that eluded Winchester.

Chapter 17: Russborough House Redux

The best account of Rose Dugdale's career, and the theft of the Kenwood Vermeer in particular, was written by Luke Jennings. See "Every Picture Tells a Story," *London Evening Standard*, December 28, 1999.

Chapter 18: Money Is Honey

Peter Wilson's remark on ethics and auctions appeared in Robert Lacey, Sotheby's: Bidding for Class (Boston: Little, Brown, 1998, p. 183).

NOTES

The observation that the prices of art in the past do not match today's prices and the Robert Hughes quotation beginning "one bought paintings for pleasure" come from a fascinating, two-part article by Robert Hughes. See "Art and Money," *New Art Examiner*, October 1984 and November 1984.

Harold Sack's remark that "money is honey" appeared in "Rewriting Auction Records," *New York Times*, January 25, 1990. The art dealer who observed that some buyers wanted to spend \$1 million was Arnold Glimcher. See Calvin Tomkins, "Irises," *The New Yorker*, April 4, 1988.

S. N. Behrman noted in his brilliantly witty *Duveen* (New York: Random House, 1951, p. 293) that Joseph Duveen's clients "preferred to pay huge sums."

John Walker was quoted on "the cost per square inch" of *Ginevra Benci*; see William Grampp, *Pricing the Priceless* (New York: Basic Books, 1989, p. 25).

Christopher Burge was quoted on "a whole new set of prices" in "The Specter of the Billion Dollar Show," Washington Post, June 9, 1988.

The story about Renoir trading a painting for a pair of shoes appears in Ambroise Vollard, *Renoir: An Intimate Record* (New York: Dover, 1990, p. 50). Vollard was an art dealer and collector who wrote biographies of Renoir, Cézanne, and Degas. Renoir's *Portrait of Ambroise Vollard* is at the Courtauld in London.

The New York Times writer who compared the prices of Impressionist paintings to those of Boeing 757s was Peter Passell. See "Vincent Van Gogh, Meet Adam Smith," New York Times, February 4, 1990.

Pepe Karmel called *Boy with a Pipe* "a pleasant, minor painting," and said he was "stunned" that it "could command a price appropriate to a real masterpiece by Picasso. This just shows how much the marketplace is divorced from the true values of art." See "A Record Picasso and the Hype Price of Status Objects," *Washington Post*, May 7, 2004.

Chapter 19: Dr. No

Bernard Berenson's remark about "a pawnbroker's shop for Croesus" comes from Philipp Blom, *To Have and to Hold: An Intimate History of Collectors and Collecting* (Woodstock, N.Y.: Overlook Press, 2003, p. 127).

The Hearst anecdote is from W. A. Swanberg, Citizen Hearst (New York: Scribners, 1961, p. 465).

J. Paul Getty's diary entry is from Werner Muensterberger, Collecting: An Unruly Passion (Princeton: Princeton University Press, 1994, p. 142).

Robert Hughes discussed "how frenzied the world would be if there were only one copy of each book in the world" in "Sold!" *Time*, November 27, 1989.

Richard Feigen commented that "masterpieces evaporate" in "Getty Closing in on Acquiring Last Raphael in Private Hands," by Christopher Reynolds, Los Angeles Times, October 31, 2002.

The argument that "art was priceless" was S. N. Behrman's formulation of Duveen's sales pitch. See Duveen, p. 292.

For a fuller discussion of "the complex interplay between art and ownership," including insights on the distinction between works of art that belong to everybody versus those that one person can own, see "When Thieves Steal Art, They Steal from All of Us" by Sid Smith, *Chicago Tribune*, December 22, 2002. Robert Hiscox talked about art thieves on a BBC radio program called "Stealing Beauty," broadcast on July 8, 2001.

The anecdote about Marshall d'Estrées is from Pierre Cabanne, *Great Collectors* (New York: Farrar, Straus, 1961, p. ix). This classic account of collectors and their obsessiveness is so comprehensive that it threatens to become an example of the mania that it explores.

The specific examples Adam Smith had in mind were gold, silver, and diamonds, whose "principal merit... arises from their beauty" rather than their utility; the same could surely be said of art. Colin Platt quotes the passage from Smith and draws on it for the title of his excellent history of art and art buying, *Marks of Opulence* (London: HarperCollins, 2004). Smith's remarks are from *Wealth of Nations*, Vol. 1, Chapter 11.

Macintyre's remark appears in a stimulating essay called "For Your Eyes Only: The Art of the Obsessive," *Times* (London), July 13, 2002.

Chapter 20: "This Is Peter Brewgal"

The *Chicago Tribune* characterized art thieves as a "cultured coterie of malefactors"; see "When Thieves Steal Art, They Steal from All of Us," December 22, 2002.

The first and by far the best account of the Courtauld theft was "The Case of the Stolen 'Christ'" by Henry Porter, in the *Evening Standard Magazine*, October 1991. The direct quotations in the account in the text are from Porter's article and from my interviews with Dennis Farr.

Chapter 21: Mona Lisa Smile

Allen Gore's claim that Idi Amin collected stolen art appeared in Judith Hennessee's "Why Great Art Always Will Be Stolen (and Seldom Found)," *Connoisseur*, July 1990.

The best biography of Georgiana is Amanda Foreman's Georgiana: Duchess of Devonshire (New York: Random House, 1999).

Chapter 23: Crook or Clown?

Enger joked that he was better at crime than at soccer in an interview that appeared in Keith Alexander's BBC documentary "The Theft of the Century."

Chapter 31: A Stranger

Johnsen remarked that Charley Hill looked "too elegant" to be a policeman in an interview in the BBC documentary "The Theft of the Century."

Chapter 34: The Thrill of the Hunt

Peter Scott described the "sexual, antisocial excitement" of crime in his memoir Gentleman Thief: Recollections of a Cat Burglar (London: HarperCollins, 1995, p. 4).

ACKNOWLEDGMENTS

The cops and robbers who specialize in art crime are few in number and wary of strangers. My guide to their ranks was Charley Hill. In a life marked by unlikely choices, Hill's decision to take an outsider behind the scenes ranks as one of the most surprising. The most important access Hill provided was to his own thoughts. I pestered him with questions in long interviews in London, New York, and Washington, D.C.; in short stints on the Staten Island ferry, a double-decker bus in London, and at the Vietnam Memorial in Washington; and in endless e-mails. For his patience in putting up with so intrusive a visitor, and for his forbearance in agreeing from the start that he would have no say in whatever I eventually wrote, I'm deeply grateful.

Ж

I had wanted to write about thieves who steal art and the detectives who chase them since 1990, when two crooks snatched \$300 million of art from the Gardner Museum in Boston, my hometown. Two of my good friends, Reed Hundt and Bill Young, helped me turn that vague hope into a specific plan. At every stage of the process, from the earliest outline through draft after draft, Bill and Reed served as unpaid but overworked advisers.

No writer can have better colleagues than grown children who are writers themselves. My two formidably talented sons, Sam and Ben, labored mightily to round their father's prose into shape.

Michele Missner, a researcher who is herself a precious find, cheerfully unraveled countless mysteries both large and small. Katerina Barry, an artist and a computer savant, took time from her own projects to gather and arrange pictures from around the globe. Pat Barry, a writer and historian with an encyclopedic knowledge of English (as opposed to American) slang and usage, labored valiantly to help me dodge the pitfalls that bedevil an innocent abroad.

Rafe Sagalyn, my agent and my friend, shepherded this project along from the beginning. Hugh Van Dusen is as superlative an editor as his reputation would imply, and that is high praise indeed.

For Lynn, for bottomless reserves of inspiration, insight, and encouragement, my fervent and inadequate gratitude. INDEX

Aasheim, William, 234 Action New Life, Norway, 22 The Adventures of Huckleberry Finn (Twain), 116 Amin, Idi, 143 Andreotti, Giulio, 153, 154 Anti-abortion group, suspected involvement of, in theft of The Scream, 21-24 Anxiety (Munch), 80 Arafat, Yasser, 119 Aristotle Contemplating the Bust of Homer (Rembrandt), 131 Arkan, Serbian gangster, 156 Art determining authenticity of Munch's, 87-88, 223 - 24forgeries, 146-49, 171-73 high prices in, 129-32 insurance on, 27-29, 63 as investment, 129-30

stolen (see Art crime; Stolen art) Art collectors hidden identity of, 137-38 Japanese, 48, 129, 137 motivations of, 134-36 speculation about art thefts commissioned by, 72, 133-34, 138 thieves as, 144-45, 150-51 Art crime, 11-16. See also Art thieves and crooks; Stolen art amateurs and bunglers involved in, 139, 140-42 appeal of, to thieves, 16 gangsters involved in, 139, 152 - 56high prices of art linked to, 131-32, 139-40 C. Hill on, as "farce," 121 as "kudos" crime, 215 laws on, 25

Art crime (cont.) as opportunism, 15-16 recovery rate in, 1, 13-14 simple techniques of, 14-15 speculation on art collectors willing to commission, 72, 133-34, 138, 143, 145-49, 189 statistics on extent of, 11-12 violence associated with, 57-58, 123, 124, 154, 155 Art Loss Register art recovery company, 237 Art market, 128-32 high prices in, 129-32 investment aspect of, 129 - 30for stolen-and-recovered paintings, 130-31 unregulated nature of, 128 - 29Art News (U.S. magazine), 149 Art Squad (Scotland Yard), 24 campaign by, for permission to recover The Scream, 46 - 47sting set up by, and recovery of Munch's The Scream, 48-49, 78-88. See also The Scream (Munch), 1994 theft and recovery of work of, and problems facing, 25 - 33

Art Theft and Forgery Investigations: The Complete Field Manual (Spiel), 149 Art thieves and crooks, 139, 140 - 42amateurs and bunglers as, 139, 140 - 42S. Breitwieser, 144-45 M. Cahill as, 56-60, 63-64, 67, 68, 70, 77, 122, 126, 127 categories of, 139 as collectors, 144-45, 150 - 51A. Daisley as, 140-41 D. Duddin, 185-96 R. Dugdale as, 123-26 efficiency of, 14-15 P. Enger as, 160-62, 234 - 35financial issues and, 131-32, 139 - 40gangsters as, 139, 152-56 motives of, 29-32 as opportunists, 15 V. Perugia as, 146-49 P. Scott as, 215-16 A. Worth as, 150-51 Ashmolean Museum, Oxford, Great Britain, 13, 133 The Astronomer (Vermeer), 12n

Bailey, Anthony, 62 Ball at the Moulin de la Galette (Renoir), 48, 137 Bath, Marquess of, 236 Beit, Alfred, Sir, 59, 60, 63, 122, 125. See also Russborough House, Ireland, art thefts from Beit, Clementine Freeman-Mitford, Lady, 59, 63, 122-23, 125 Belgium, recovery of Vermeer painting in, 69, 70-77 Bellotto, Bernardo, 126 View of Florence, 126-27 Berenson, Bernard, 134 Berg, Knut, director, Norway's National Gallery, 8-9, 18, 93, 233 Berman, Charley (C. Hill alias), 65,68 Berntsen, Geir, 7 Birmingham Museum and Art Gallery, England, 140-41 Bishop, Tom (FBI pseudonym), 68 Bok, Sissela, 115-16 Bouquet of Peonies (Manet), 13 Boy with a Pipe (The Young Apprentice) (Picasso), 132, 137 Breitwieser, Stéphane, art thefts perpetrated by, 144-45

Bruegel the Elder, Pieter, 104 theft of Christ and the Woman Taken in Adultery by, 141-42, 181-84 Brueghel the Younger, Pieter, 104 Buccleuch, Duke of, 29 Bunton, Kempton, 188 Burge, Christopher, 131 Butler, John (head of Art Squad), 29, 32, 233 campaign by, for permission to recover The Scream. 46 - 47role in sting to recover The Scream, 51-53, 109, 114-15, 197, 198-99, 205 - 6By the Deathbed (Munch), 80

Cahill, Martin "The General," 1986 theft of Vermeer painting and other artwork by, 56–60, 63–64, 67, 68, 70, 77, 122, 126, 127 Caravaggio (Michelangelo Merisida), 153–54 Nativity with St. Francis and St. Lawrence, 153 The Caravaggio Conspiracy

(Watson), 154n

Cellini, Benvenuto, 12, 239 Cézanne, Paul, 13, 133 Chaffinch, Lynne, 155 Chaudron, Yves, 146-48 Le Chemin de Sèvres (Corot), 16 Chevalier, Tracy, 60 Chez Tortoni (Manet), 14, 240 Cholmondeley, Lord, 239 Christ and the Woman Taken in Adultery (Bruegel), 104 theft and recovery of, 141 - 42Christie's auction house, 131 Christ's Entry into Brussels in 1889 (Ensor), 82, 112 Church of San Lorenzo, Palermo, Italy, 153 Codex Leicester, 136n Command for the Preservation of Cultural Heritage, Italy, 152 - 53Concerned Criminals, 59 The Concert (Vermeer), 12, 14, 62,240 Conforti, Roberto, 153 Corot, Jean Baptiste Camille, Le Chemin de Sèvres, 16 Counterfeit Currency Squad, Great Britain, 211 Counterfeit money case, Charley Hill's undercover work on, 210-13

Courtauld Institute Galleries, London, theft of Bruegel's *Christ and the Woman Taken in Adultery* from, 141–42, 181–84 Coyle, Tommy, 65–67 Cranach the Elder, Lucas, 155 *Ill-Matched Lovers*, 155 theft of *Sybille of Cleves* by, 144–45 Czech Republic, 155, 178

Dagbladet (Norwegian newspaper), 17, 95-96, 162 Daisley, Anthony, theft of Wallis's Death of Chatterton by, 140-41 Dalrymple, Mark, 139-40, 175, 179 The Day They Stole the Mona Lisa (Reit), 146 Death of Chatterton (Wallis), 141 Death Struggle (Munch), 80 Decker, Karl, 148-49 Degas, Edgar, 14 Les Demoiselles d'Avignon (Picasso), 132 Despair (Munch), 80, 86

Diamonds, stolen, 67, 70 Dr. No, imagined wealthy art collector willing to commission art thefts, 72, 133-34, 136, 138, 143, 145 - 49Doescher, Russell, 85n Donovan, James, 57-58 Doyle, Arthur Conan, 151 Drugs, smuggling and selling illicit, 30, 31, 70 Duddin, David, 185-96 on lessons applied to art crime, 191-92 on market for stolen art. 189 - 90on stolen Rembrandt. 192 - 96Duddin, Mary, 187, 188, 191, 196 Dugdale, Rose, art thefts committed by, 123-26 Dürer, Albrecht, 78 Duveen, Joseph, 135

Elizabeth II, Queen of England, 60 Ellis, Dick (Art Squad detective), 26, 175–76 on Art Squad stings to recover art, 47, 48 work on sting to recover The Scream, 52–53, 91, 107–8 Enger, Pål, 243 art thefts perpetrated by, 160–62 theft of The Scream and role of, 234, 235 Ensor, James, Christ's Entry into Brussels in 1889, 82, 112 d'Estrées, Marshall, 136 Europol, 32 Expressionism, 112

Farr, Dennis, 142 on observing Charley Hill working undercover, 181 - 84Federal Bureau of Investigation (FBI), U.S., 239, 240 Feigen, Richard, 135 Feliciano, Hector, 152n Fitzgerald, F. Scott, 105 Fogelberg, Christer, 114-15 Foley, Martin, 122 Foster, Elizabeth, 150 Francis I, King of France, 12n Freud, Sigmund, 81 Frick, Henry, 135 The Frieze of Life (Munch), 86

Gainsborough, Thomas, 150 Madam Baccelli:Dancer (Gainsborough), 69, 122, 126 Gangsters involved in art crime, 139, 152-56 Gardner, Isabella Stewart, 28 Gardner Museum, Boston, USA, 14-15, 28, 240, 244 Gates, Bill, 136n Gauguin, Paul, 18 Georgiana, Duke of Devonshire, 150-51 Getty, J. Paul, 50, 134 Getty Museum, California, 50-51, 135 Charley Hill's cover as representative of, 51-54, 107, 111, 166 Girl Before a Mirror (Picasso), 132 Girl Reading a Letter at an Open Window (Vermeer), 61 Girl with a Pearl Earring (Vermeer), 61 Girl with a Red Hat (Vermeer), 61 Gombrich, E. H., 60 A Good Story (Walle), 8 Goya, Francisco de, 18, 63, 77, 79, 136-37, 187 Portrait of Dona Antonia Zarate, 76, 123, 126

Portrait of the Duke of Wellington, 136–37, 187–88 Grey, Charles, 210 Grytdal ("Psycho"), role in theft of *The Scream*, 203–5, 217–19, 229–31, 234, 235 Guardi, Francesco, 64, 77 Guernica (Picasso), 132 *The Guitar Player* (Vermeer), 12, theft of, 124–26 Gutenberg Bibles, 134

Harwood, Billy, 47-48, 91-92 Hatred (Munch), 82 Hawkwood, John, Sir, 37 Head of a Girl (Vermeer), 62 Hearst, William Randolph, 134 Henry VIII, King of England, 144, 192 Hill, Charley, 1, 34-42 anti-gun bias of, 179-80 close calls while doing undercover work, 210-13 on corrupt cops, 104 departure from police to become detective-for-hire. 235 - 40family of, 35, 38-40

D. Farr on observing Hill working undercover, 181 - 84investigation of Parmigianino artwork by, 167-73 as London police officer, 45 his love of art, 41-42, 45 mission and motives of. 214 - 16personality and character of, 36-38, 45-46, 71, 92, 99, 104-6, 175, 176 his philosophical approach to lying, 115-16 on police attitudes toward art crime, 26 "prop traps" used by, 163 - 66recovery of Vermeer painting by, 65-77 relationship of, with crooks and informants, 101-4, 185 - 96Scream recovery sting and role of, 32-33, 53-55, 78-88, 91-92, 107-12, 163-66, 197-200, 203-9, 217 - 32on speculation about art collectors who commission art thefts, 138 spoken-language accent of, 23-25, 176

undercover role as Getty Museum representative, 51-54, 107, 111, 166 undercover work of, prior to Scream sting, 35, 65-77, 142, 167-84, 210 - 13uses of American and British mannerisms and vernacular language by, 54-55, 176-77, 184 Vietnam military service, 40-41, 106, 170-71 wife Caro, 104-5, 213 Hill, Jim, 145-46 Hill, Landon (Charley Hill's father) 38, 39, 40 Hiscox, Robert, 136 Hitler, Adolf, 12n Holbein, Hans, 144 Hopper, Edward, 80 Hughes, Robert, 129, 135 Hultgreen, Gunnar, 95-96

Ill-Matched Lovers (Cranach), 155 Ingres, Jean-Auguste-Dominique, 147 Insurance on art, 27–29, 63 Interpol, 11, 32 Irises (van Gogh), 48 Irish Republican Army (IRA), 123, 124 Italy, 25 extent of art theft in, 11–12 gangsters involved in art crimes in, 152–54

Japan, 25 Japanese art buyers, 48, 129, 137 Johnsen, Tor, role in theft and sting to recover The Scream, 94, 95, 98-99 first meeting with Charley Hill, 107, 109-12 C. Hill's "prop trap" left for, 163 - 66meetings with Hill, Ulving, and "Psycho" Grytdal, 203-5, 217-19, 229-31 money exchange and, 117-18 Plaza Hotel meetings with E. Ulving and C. Hill, 113-20 trial for theft of The Scream and death of, 234, 235 Johnson, Paul, 61

Keller, Steven, 15 Kelly, Richard, 68 Kenwood House, London, art theft at, 124 *King and Queen* (Moore), 103 Kittler, Czech thief, 155 Knudsen, Børre, 22–23 Koplowitz, Esther, 237 Krakatoa volcanic eruption, 84–85 Kunsthistorisches Museum, Vienna, Austria, 12

Lacemaker (Vermeer), 62 Lady Playing a Guitar (Vermeer), 60 Lady Writing a Letter with her Maid (Vermeer), 12, 126, 246n theft and recovery of, 59-60, 63-77, 122 Larsen, Tulla, 82 Lefevre Gallery, London, 31 Leonardo da Vinci, 136n Madonna of the Rocks, 78 Madonna of the Yarnwinder, 12, 13, 29, 239 Lier, Leif, 23, 94, 162, 210, 231, 235, 243 Light and Colour (Turner), 155 Lives of the Artists (Vasari), 168 The Lost Museum: The Nazi Conspiracy to Steal the

World's Greatest Works of Art (Feliciano), 152n Louvre, Paris, France, 16 Lying, C. Hill's approach to undercover work and, 115–16 Lying: Moral Choice in Public and Private Life (Bok), 115–16

McGarrick, Gerry, 68, 69 Macintyre, Ben, 137, 150 Madam Baccelli:Dancer (Gainsborough), 69, 122, 126 Madonna (Munch), 242, 244 Madonna of the Pinks (Raphael), 135 Madonna of the Rocks (Leonardo da Vinci), 78 Madonna of the Yarnwinder (Leonardo da Vinci), 12, 13, 29, 239 Mafia, possible involvement in art crimes, 153, 154 Manet, Edouard, 14, 240 Bouquet of Peonies, 13 Chez Tortoni, 14, 240 Mannoia, Francesco Marino, 153 - 54Man Writing a Letter (Metsu), 77

Massacre of the Innocents (Rubens), 129-30, 137 Mellon, Andrew, 135 Messina, Antonello da, 154 Metropolitan Museum of Art, New York City, 131, 143 Metsu, Gabriel, 69, 77, 244 Man Writing a Letter, 77 Woman Reading a Letter (Metsu), 69, 244 Mona Lisa (Leonardo da Vinci), forgeries and claimed theft of, 146-49 Moore, Henry, King and Queen (Moore), 103 Morgan, J. P., 134, 135, 136, 150 Morgan, Junius Spencer, 150 Mulvihill, Niall, 72-77 Munch, Edvard, 1, 6 Anxiety by, 80 By the Deathbed by, 80 Death Struggle by, 80 Despair by, 80, 86 Frieze of Life by, 86 Hatred by, 82 C. Hill's study of, 78-79, 82, 87 - 88life and work of, 79-82, 83 - 87Madonna by, 242, 244 Portrait of the Painter Jensen-Hjell by, 83

Munch, Edvard (cont.) The Scream (see The Scream, Munch, theft of) The Sick Child by, 80, 83 Study for a Portrait (Munch), 19 The Vampire by, 18–19, 160–61, 234 Munch Museum, Oslo, Norway, art thefts from, 18–19, 160, 241–43 Museum for Contemporary Art, Norway, 243 Museum of the Missing (missing artwork), 13

Napoleon of Crime (Macintyre), 150 National Fine Arts Museum, Paraguay, 13 National Gallery, Great Britain, 15, 27, 135n National Gallery, Oslo, Norway, 243 art thefts from, 18, 19 press conference announcing return of *The Scream*, 233 security mistakes of, 9, 11 theft of *The Scream* from. See *The Scream* (Munch), 1994 theft of National Gallery of Ireland, 60 National Gallery of Modern Art, Rome, Italy, 13 Nativity with St. Francis and St. Lawrence (Caravaggio), 153 Nazis, art thefts perpetrated by, 12n, 152nNessa, Ludvig, 22-23 New Yorker (U.S. magazine), 149 New York Times (U.S. newspaper), 131, 149 Nicholas, Lynn, 152n Norway, criminal gangs in, 160 - 62Norwegian police investigation of The Scream theft, 19-20, 32, 94, 159-62, 198-99, 203-4, 210, 229-31 presence of, at Plaza Hotel where C. Hill and thieves met, 113-15, 118-20, 164 - 65E. Ulving stopped by traffic police, 197-98

Olson, Don, 85*n* Olson, Marilyn, 85*n* Olympic Winter Games (1994), Norway, 7–8, 18, 159 Organized crime involved in art thefts, 152–56 Oslo Accords, 119 Oudry, Jean-Baptiste, 239 *White Duck*, 239

Parmigianino, C. Hill's investigation of thefts of works by, 167-73 Paradise Lost (John Milton), 134 Pembroke, Earl of, 192, 193 Perugia, Vincenzo, art theft perpetrated by, 146-49 Picasso, Pablo, 31, 215 Boy with a Pipe (The Young Apprentice), 132, 137 Les Demoiselles d'Avignon, 132 Girl Before a Mirror, 132 Tête de Femme (Picasso), 215 Plahter, Lief, 96, 233 Poe, Edgar Allan, 46 Police. See also Art Squad (Scotland Yard); Norwegian police disdainful attitude of, toward art crimes, 26-27, 29, 237 C. Hill on corrupt, 104

Portrait of a Dominican Monk (Rubens), 69, 127 Portrait of Dr. Gachet (van Gogh), 48, 131, 137 Portrait of Dona Antonia Zarate (Goya), 76, 123, 126 Portrait of the Artist Without His Beard (van Gogh), 137 Portrait of the Duke of Wellington (Goya), 136-37, 187 - 88Portrait of the Painter Jensen-Hjell (Munch), 83 Price, Albert, 125 Price, Dolours, 124, 125 Price, Marion, 124, 125 Priests, anti-abortion, suspected in art theft, 22-24 The Procuress (Vermeer), 61 Prop trap, Charley Hill's undercover, 163-66

Rabin, Yitzhak, 119 Raging Hormones (Walle), 8 Rape of Europa (book by Nicholas) 152n Rape of Europa (painting by Titian), 14 Raphael (Sanzio), Madonna of the Pinks (Raphael), 135 Regional Crime Squad, Great Britain, 211 Reit, Seymour, 146-49 Rembrandt van Ryn, 14, 18, 31, 78, 131, 240 D. Duddin on stolen painting by, 192-96 Sacrifice of Isaac, 78 Storm on the Sea of Galilee, 240 Renoir, Pierre Auguste, 131 Ball at the Moulin de la Galette, 48, 137 Rest on the Flight into Egypt (Titian), 236-37 Reynolds, Joshua, 64 Roberts, Christopher Charles (Hill alias), 53-54, 71, 72, 78, 91, 107, 117. See also Hill, Charley Rocky, undercover detective, 175 - 76Rubens, Peter Paul, 63, 69, 127 Massacre of the Innocents, 129-30, 137 Portrait of a Dominican Monk, 69, 127 Russborough House, Ireland, art thefts from, 59-60, 63-69, 77, 121-27, 186 M. Cahill's theft and recovery of Lady Writing a Letter

with her Maid from, 59–60, 63–77, 122 Dugdale raid and theft at, 123–26 thefts between 1986 and 2002, 126–27 Russell, Tom, 102–4

Sack, Harold, 130 Sacrifice of Isaac (Rembrandt), 78 Saito, Ryoei, 137 Sargent, John Singer, 28 Sassoon, Donald, 149 Sazonoff, Jonathan, 144n Scotland Yard detectives, 24. See also Art Squad (Scotland Yard) Scott, Peter, burglar, 215 - 16The Scream (Munch), 80, 82 delicate condition of, 22 determining authenticity of, 87-88, 223-24 first exhibition of, 84 Krakatoa eruption and, 84 - 85in popular culture, 85 - 86Spring Evening on Karl Johan Street by, 81

266

Still Life by, 82 theft of one of four versions of, in 2004, 241-44 The Scream (Munch), 1994 theft and recovery of, 5-10, 17-20, 237 Art Squad and C. Hill prepare sting to recover, 32-33, 48-49, 53-55, 78 - 88frame of, 95-96, 97 C. Hill as undercover agent in, and interactions with thieves, 107-12, 163-66, 197-200, 203-9, 217-27 luring thieves of, from hiding, 91 - 106Norwegian police investigation of, 19-20, 32, 94, 159-62, 198-99, 203-4, 210, 229-31 public reaction to, 20, 21 return of, to National Gallery, 233 - 34role of T. Johnsen in (see Johnsen, Tor) role of National Gallery's J.K. Thune in recovery, 93–94, 107 role of E. Ulving in (see Ulving, Einar-Tore) security problems leading to, 9,11

suspicions about P. Enger as thief of The Scream, 161 - 62taunting card left by thieves, 8,17 thieves' fee for return of The Scream, 115 timing of theft, coinciding with Olympics, 7-8, 17, 159 tips to police about, 21-24, 91-92, 95-96 S. Walker as undercover agent in, 108-11, 117-18, 165, 205, 217-19, 229-31 Security mistakes and art theft, 9, 11, 15 Serious and Organised Crime Unit (Scotland Yard), 26. See also Art Squad (Scotland Yard) Shade and Darkness (Turner), 155 Shakespeare, William, 136 The Sick Child (Munch), 80, 83 The Silent Scream (anti-abortion film), 23 Skater (Portrait of William Grant) (Stuart), 78 Smith, Adam, 137 Smith, John, 239 Sorensen, Gunnar, 242-43 Spiel, Robert, 149

Spring Evening on Karl Johan Street (Munch), 81 Still Life (Munch), 82 Stolen art financial aspects of, 139-40 insurance and, 27-29, 63 organized crime and, 152-56 ransom for, 32, 50 recovery rate, 1, 13-14 rewards offered for, 21-22 speculation about thefts commissioned by art collectors, 72, 133-34, 143, 145-49, 189 Storm on the Sea of Galilee (Rembrandt), 240 Storr, Paul, 195 Strictly Private (Marquess of Bath), 236 Stuart, Gilbert, Skater (Portrait of William Grant), 78 Study for a Portrait (Munch), 19 Sunflowers (van Gogh), 129 Sybille of Cleves (Cranach), 144 - 45

Tate Gallery, London, 27, 155–56 Tate Modern Museum, London, 15

Tête de Femme (Picasso), 215 Thieves. See Art thieves and crooks Thoré, Théophile, 61, 246n Thune, Jens Kristian, direction, Norway's National Gallery, 93 - 94Titian (Tiziano Vecellio) Rape of Europa, 14 Rest on the Flight into Egypt, 236 - 37Trace art recovery company, 237, 238 Trump, Donald, 137 Turner, Frederick Jackson Light and Colour, 155 Shade and Darkness, 155 Turow, Scott, 99 Tveita Gang, Norway, 160-62

Ulving, Einar-Tore, role in theft/recovery of *The Scream*, 94–95, 97–99 C. Hills "prop trap" left for, 163–66 C. Hill's suspicions of, 98–99 first meetings with C. Hill, 107–12 leads C. Hill to *The Scream*, 220–26

meetings with T. Johnsen, C. Hill and "Psycho," 203-5, 217-19 painting hidden in summerhouse of, 207-9 Plaza hotel meetings with T. Johnsen and C. Hill, 113 - 20stopped by traffic police, 197 - 98trial for theft of The Scream and, 234, 235 United States poor security at art museums in. 15 theft insurance in, 27

Valfierno, Eduardo de, 146–48 The Vampire (Munch), 18–19 theft of, 160–61, 234 van Gogh, Vincent, 13, 48, 129 Irises, 48 Portrait of Dr. Gachet, 48, 131, 137 Portrait of the Artist Without His Beard, 137 Sunflowers, 129 Van Ruysdael, Salomon, 64 Velázquez, Diego, 63 Verdens Gang (Norwegian newspaper), 10 Vermeer, Johannes, 12 The Astronomer, 12n The Concert, 12, 14, 62, 240 Girl Reading a Letter at an Open Window, 61 Girl with a Pearl Earring, 61 Girl with a Red Hat, 61 The Guitar Player 12, 124 - 26Head of a Girl, 62 Lacemaker, 62 Lady Playing a Guitar, 60 Lady Writing a Letter with her Maid, 12, 59-60, 63-77, 122, 126, 246n life and art of, 60-63 The Procuress, 61 Woman with a Pearl Necklace. 62 Young Woman Seated at a Virginal, 62 Young Woman Standing at a Virginal, 62 Vestier, Antoine, 77 View of Florence (Bellotto), 126 - 27Violence associated with art crimes, 57-58, 123, 124, 154, 155

Walker, Sid role in sting to recover The Scream, 108-11, 117-18, 165, 205, 217-19, 229 - 31undercover investigations by, 168, 169, 213 Walle, Marit, 8 Wallis, Henry, 140-41 Death of Chatterton, 141 Watson, Peter, The Caravaggio Conspiracy (Watson), 154nWhite Duck (Oudry), 239 Widdrington Hill, Zita (Charley Hill's mother), 38-39 Williams, Paul, 67 Wilson, Peter, 129

Wilton House, England, Rembrandt painting stolen from, 192
Woman Reading a Letter (Metsu), 69, 244
Woman with a Pearl Necklace (Vermeer), 62
Worth, Adam, art thefts perpetrated by, 150–51

Yasuda Fire and Marine Insurance Company, 129 Young Woman Seated at a Virginal (Vermeer), 62 Young Woman Standing at a Virginal (Vermeer), 62

270

About the author

2 Meet Edward Dolnick

About the book

- 5 Meeting Mr. Hill
- 9 Travails with Charley: Edward Dolnick on Frequently Asked Questions

Read on

- 13 Author's Picks: Best Heist Films, Best Art Crime Books
- 16 Have You Read? More by Edward Dolnick

Insights, Interviews & More ...

About the author

Meet Edward Dolnick

EDWARD DOLNICK was born in 1952. "I grew up in a little town called Marblehead, on the ocean about twenty miles north of Boston," he says. "The town was once home to fishermen and sailors. In the Revolutionary War these sailors turned soldiers had been notorious for their rowdy ways. One group of Marblehead fishermen started a snowball fight that grew into a riot, and it took George Washington himself to break it up. But by my day the small town was just another suburb. Dads wore suits

and commuted to work; moms cooked dinner. Somehow I missed most of that. I was a dreamy kid fond of tales of derring-do, preferably in exotic and watery settings."

Dolnick's earliest memory of reading and then rereading a book concerns what he dubs "a kind of poor man's Treasure Island." That book, lim Davis, traces the adventures of "a boy who runs off to sea with a gang of thieves and raiders," says Dolnick."The tale of smugglers and secret hideaways was perfect for a ten-year-old. Better yet, it actually belonged to my big sister. She had been assigned the book in school and rejected it immediately ('Pirates!'). This was a hard to beat twofer-an adventure

yarn that had been officially deemed suitable only for older readers."

As a teenager Dolnick fell lastingly under the spell of *Moby-Dick*. "The strange and tangled language ('a whale ship was my Yale College and my Harvard') and the subversive message were meat and drink for a suburban dreamer marooned in the twentieth century," he says. "My parents had chosen not to give my sister or me a middle name so that we could eventually pick our own. Now I was ready. Enthralled, and sixteen, I chose: Ishmael."

A former chief science writer at the Boston Globe, Dolnick has written for the Atlantic Monthly, the New York Times Magazine, the Washington Post, and many other publications. He is the author of Down the Great Unknown: John Wesley Powell's 1869 Journey of Discovery and Tragedy Through the Grand Canyon.

Asked to share an anecdote about his days as a cub reporter, Dolnick very quickly unpacks the following: "On my very first day as a reporter they announced that year's Nobel Prize winners. I was working in Boston, and by coincidence one of the winners for medicine happened to be in town giving a lecture. A veteran reporter knocked out a long, complicated story explaining the great man's breakthrough. My job, I learned with dismay, was to write a ministory providing a glimpse of the winner's human side. I squeaked out a question about hobbies. Then I retreated to my desk with a nugget of information—our man liked skiing-and labored over my prose. Hours passed. "His hobbies, which include skiing ... "Delete. "Skiing, the pastime that ... "Delete. Shifts ended; reporters came and went; editors glowered. Hours after deadline I handed over my opus in all its two-sentence glory."

Asked to describe his writing habits, he opens the curtains on a scene of questionable charm. "I write at home," he says, "in a cluttered office lined floor to ceiling with file drawers, each bearing a scrawled label ► 66 'My parents had chosen not to give my sister or me a middle name so that we could eventually pick our own. Now I was ready. Enthralled, and sixteen, I chose: Ishmael.'

Meet Edward Dolnick (continued)

('most expensive paintings,' recent thefts') and bursting with clippings and articles. Closer at hand, concentric stacks of paper encircle my chair. The tallest piles, which contain the most consulted references, form the inner circle. A slightly lower ring is next, followed by another one or two rings in descending order. Lined up precariously near my computer keyboard sit half a dozen cups of tea, fetched and then forgotten at about half-hour intervals throughout the day.

"This sanctum," he continues, "is offlimits to all visitors with the exceptions of two colossal 125-pound dogs named Blue and Lily. The pure white and immensely friendly Great Pyrenees dogs spend most of their days stretched out like bearskin rugs. At random intervals—when the FedEx man knocks on the door, when a squirrel dares to venture into view, or when an interview subject finally returns my call—they spring to life in a frenzy of barking, toppling stacks of carefully arranged papers in their glee."

Dolnick has two grown sons and lives with his wife near Washington, D.C.

Meeting Mr. Hill

THE FIRST DETECTIVE I EVER MET outside a book was Charley Hill. I didn't have any idea what to expect, but I didn't expect much. Nor did Charley, as he made clear at once. He didn't have a lot of time, he said, by way of introduction. How long did this "goddamned blind date" figure to take?

We'd met as a favor to a mutual friend. When Charley was sixteen, nearly forty years before, he'd shown up at a Washington, D.C., high school limping and battered from a rock climbing accident in the Rockies. One of his classmates, starstruck by the exotic new kid, had befriended him. Four decades later they were still the best of friends, though one had become a cop and the other a top-tier, toppriced lawyer.

The lawyer and I were neighbors in Washington. He knew my books and that I'd just finished one. Now he had an idea for me.

I muttered something noncommital. Every writer hears a dozen story ideas a week. Casual acquaintances will grab you at the grocery store. "You should write something about my wife's brother. Guy's a genius." I needed something better, stranger, and more engaging than that.

"Cut it out," my friend said. "This is for real."

Within a few months Charley Hill happened to be passing through Washington. He's lived in London for decades now but keeps up with American friends with whom he goes back as far as grade school. We met in the borrowed home of one of these old pals. Charley arrived empty-handed; I came weighed down with books I'd written, magazine articles, and even a yellowed newspaper clipping or two. I'd never ► About the book

66 I'd never written about art. Charley, curiously, seemed to find that not offputting, but appealing.

When thieves struck the Gardner in 1990...I knew at once that I wanted to write about it.

Meeting Mr. Hill (continued)

written about art. Charley, curiously, seemed to find that not off-putting, but appealing.

He only explained his reasoning a year or two later. First of all, a lack of art credentials was no drawback. The art world was full of crooks and creeps. If anybody was going to get it right it would be an outsider. My first book, a critique of Freud called Madness on the Couch, was on psychology. Charley read it delightedly; what better preparation could a writer have for a venture into a world of selfdelusion and colossal egos? Down the Great Unknown, my next book and an account of the first expedition through the Grand Canyon, suited him even better. The hero of that true tale was a one-armed Civil War veteran named John Wesley Powell, a vain, brave explorer who succeeded in an adventure he had no business even considering. Hill, a swashbuckler himself, found a soul mate.

Art was less of a stretch for me than it sounded. Though I'd never written about art, I had grown up in an art-saturated home. In my parents' house near Boston no objects were as important as paintings; no people were as revered as artists. My mother, an art school graduate and a talented painter and sculptor, was seldom without a brush or a chisel in her hand. I'd been dragged through countless museums as a kid; maybe a little had sunk in. Many of those excursions had ended up at one of the most alluring of all such institutions: Boston's Isabella Stewart Gardner Museum.

When thieves struck the Gardner in 1990 a serene little gem of a museum suddenly became the site of the biggest art theft ever— I knew at once that I wanted to write about it.

The problem was that the books I like best tell a story. Many fine books are essentially long essays, but I wanted something with a beginning, middle, and end. The Gardner story had a superb beginning—a knock on the museum door in the middle of the night, thieves disguised as policemen, a Rembrandt, a Vermeer, and other treasures snatched from the Gardner's walls—but then . . . nothing.

How do you tell a story that ends almost as soon as it begins? Stymied by the Gardner story, I put art crime on a back burner and turned to other things.

About a decade would pass before I met Charley Hill. It quickly became clear that the story of *The Scream* had several of the elements I needed—a world-famous painting, first of all. Nobody would care much about a hunt for a painting they had never heard of. Second, the *Scream* saga began with a bold break-in, moved on to a satisfying tangle of loose ends and false leads, and ended with a confrontation in an empty house. If that wouldn't do as beginning, middle, and end, then nothing would.

That left one obstacle, but it was a daunting one. The first editor I ever met had explained to me years before that for every writer considering a new book one question was key. The magic question: "Who do we root for?"

Every story needs a character at its core, and the richer and more complicated, the better. When I met with Charley, my mission was to sort out whether he had enough meat on his bones to carry a book. We sized each other up warily. We weren't much alike, but that wasn't a problem. I didn't need a new friend, and Charley took for granted from long experience that almost no one was much like him. He told war stories about old cases and I asked rude questions—Who doesn't like you? Whom can I call who'll tell me you're a bag of wind?

Challenged, Charley relaxed a bit. "Who can't stand me?" He pondered the question and rattled off a list of names. The war ►

Challenged, Charley relaxed a bit. 'Who can't stand me?' He pondered the question and rattled off a list of names.

Meeting Mr. Hill (continued)

stories hadn't really engaged him; he'd told them clearly but without animation. (I would learn to recognize these rote performances. In Charley's grumpy view, the world is full of ignoramuses and he has better things to do than explain the ABCs to them.)

But thinking about old friends and enemies, or friends turned enemies and vice versa, cheered Charley up. I liked that orneriness. I began to think that maybe this gruff, scholarly cop would prove a satisfactorily complex character. I cheered up too.

Travails with Charley Edward Dolnick on Frequently Asked Questions

THE FUN IN WORKING on *The Rescue Artist* was that art crime brought such different worlds into collision. Those collisions didn't stop after the book had been published. I gave a talk about the book at Harvard's Sackler Museum. As I made my way out afterward, weaving past the professors and art curators in their academic tweeds, someone whispered or growled—at me, "Give my best to Chollie."

I looked around. A hulking figure grinned down at me like an Easter Island statue come to life. "Who are you?" I asked.

"I'm Rocky."

Rocky was one of Charley Hill's Art Squad colleagues, a legendary wild man and a much admired, much feared undercover cop. He tended to play crooks, convincingly. We'd never met. Rocky's fellow cops loved telling stories about him, but even in mid-anecdote they'd hesitate and peer around the room as if making sure that the man himself would not appear and grab them in a headlock. The odds that anyone at the Sackler mistook Rocky for an art historian were pretty low.

When I give talks about *The Rescue Artist*, surprises like Rocky's visit are rare. I do know I can count on being asked several questions.

What was it like working with Charley Hill?

It wasn't dull. "Your other books," Charley said at our first meeting, "are about dead people. I guess it's harder when you write about people who are still alive." Good point. To write a book about someone you don't know is to **b** 66 A hulking figure grinned down at me like an Easter Island statue come to life. 'Who are you?' I asked. **99**

66 To write a book about someone you don't know is to take a long journey with a stranger in a small and overheated car.

Travails with Charley (continued)

take a long journey with a stranger in a small and overheated car.

By and large Charley was a good traveling companion. But I got on his nerves when I kept circling back to material we'd already covered a dozen times in search of ever more detail. "Was it your car or a rented car? What were you wearing? But was the suit old or one you'd bought for that role? I thought you said you were wearing a bow tie?"

Charley has a terrific memory. But the incessant questioning, like a mosquito's whine, drove him wild. He wanted to make sure I saw the big picture—it's not like Hollywood—and I kept nattering on about bow ties.

If we were together and I'd kept after him too long, Charley would retreat into glowering silence. This wasn't good. We were based on opposite sides of the Atlantic, and when one of us had crossed the ocean, we had no time to waste. During the long stretches between visits we communicated almost exclusively by e-mail. I never knew what to expect. Charley might vanish for weeks at a time, or he might respond with half a sentence to a question I had hoped would keep us busy for a month.

Q: Tell me about your first art case. A: A complete and utter cock-up.

On the other hand, he was more than capable of delivering long, detailed, out-ofthe-blue answers to questions I'd given up on months before. The unpredictability of the whole process could drive you mad. Charley and I were slumped in his living room one evening, worn out and half-watching the news, when a story about problems in the London underground came on. The reporter did her stand-up near a station entrance. "That's around the corner from where Grant-McVicar did the Picasso job," Charley muttered. The name of the crook, the very fact that there had been a Picasso stolen in downtown London, and Charley's intimate knowledge of all the players in the case were all news to me. "Charley, when there are stories like this lying around, *big* stories, you've got to let me know!" "Right. Yeah. Do you see where the damned remote has got to?"

Did Charley edit what you wrote?

No. Almost the first thing I did in my initial conversation with Charley was lay out ground rules. We were not coauthors; I'd write the book and give it to him to read before it was published as a courtesy. At that point he'd be free to make all the comments he wantedfactual, stylistic, grammatical. I promised I'd listen carefully to his suggestions, especially if he thought I'd made a factual error, but I didn't promise to do more than listen. I emphasized there was always the risk that as I got deeply into the reporting I'd decide he was bad news, in which case I'd go ahead and write that. Finally, we agreed in that first conversation that Charley would have no share in money made from the book.

We never quarreled over any of those rules. When the time came, Charley read the book and marked it up. He resisted the impulse to suggest changes in things he found merely irritating; the few revisions he fought for had mostly to do with keeping secret identities secret or with softening criticisms he had directed at various rivals.

What did Charley think of the book?

He liked it, generally, although he didn't like the way I'd characterized him—he felt I'd exaggerated the risks he ran and underplayed his love of art. His mother thought there ► **66** 'Charley, when there are stories like this lying around, *big* stories, you've got to let me know!' 'Right. Yeah. Do you see where the damned remote has got to?'**9**

Travails with Charley (continued)

was too much swearing. Despite his complaints about the book, its mere existence was a kick—not everyone has a book written about him. Charley handed out copies to the postman and the babysitter and the woman who cuts his hair. Characteristically, and to the utter dismay of business-minded friends who fret over his financial stability, he neglected to pass along copies to the art collecting lords and ladies of his acquaintance or to anyone else in a position to hire him.

I admired tremendously the way Charley responded to reading about himself. It's seldom fun to see oneself through someone else's eyes, but beyond a snarl or two Charley barely lobbied for changes in how he was portrayed. On the contrary. We got together late one night after I'd spent the day talking with some of his nonadmirers at Scotland Yard. Charley asked what I'd been up to. I told him where I'd been. He laughed.

"Well, Ed," he said, "as Cromwell said to Peter Lely, 'Paint it warts and all.' " Both the thought itself and the footnote to the littleremembered Lely were pure Charley Hill.

What's next?

The next book deals with art crime again, but this time with art forgery rather than art theft. The book tells a true story, with a cast ranging from Johannes Vermeer to Hermann Goering. The story begins in Holland in the 1600s, skips ahead to the French Riviera in the 1930s and Occupied Holland in the 1940s, and culminates in a trial for treason in a Dutch courtroom lined with forged—or are they authentic?—Vermeers.

66 [Charley's] mother thought there was too much swearing

in the book. **9**

Author's Picks Best Heist Films, Best Art Crime Books

The Three Best Heist Films

THE THOMAS CROWN AFFAIR (1999)

Everything about it is wrong—thieves don't act like Pierce Brosnan, insurance agents don't look like Rene Russo, and museums don't seal themselves off like automated fortresses. But it's fun.

If you ever meet an art cop or an art crook and the conversation begins to flag, mention this movie. Then stand back. The good guys detest it because it glamorizes the thieves, but the baddies hate it too. Their problem with the film is wounded vanity—tuxedo-clad, art-loving Pierce Brosnan strikes them as a bit effete. Read on

66 If you ever meet an art cop or an art crook and the conversation begins to flag, mention [*The Thomas Crown Affair.*]

THE GENERAL (1998)

This brilliant, grim film tells the story of Martin Cahill, the Dublin gangster who pulled off what was at the time the biggest art theft ever. Cahill's criminal career was so hectic that director John Boorman makes quick work of the art heist, but this portrayal of the brutal Cahill shows what a real art thief is like.

One brief scene is an inside joke. The reallife Cahill once broke into Boorman's house and stole a gold record the director had been awarded for the score of *Deliverance*. In the course of a burglary in *The General*, Cahill grabs a gold LP from the wall and then throws it away in disgust when he realizes that it isn't real gold.

Author's Picks (continued)

DR. NO (1962)

Well, "best" is pushing it. The first James Bond movie is hard to sit through. But it's worth seeing for two historic reasons: first, a young Sean Connery; second, Dr. No's stolen Goya, which helped plant in every crook's mind the fantasy that if he steals a masterpiece a crooked tycoon will surely want it.

Goya's portrait of Wellington is now back in the National Gallery in London, where it belongs. The austere label next to the painting omits any mention of the screen credit.

Sean Connery's more recent heist movie, *Entrapment*, is less painful though no more plausible.

The Three Best Art Crime Books

THE NAPOLEON OF CRIME: THE LIFE AND TIMES OF ADAM WORTH, MASTER THIEF by Ben Macintyre

This nonfiction account of one of the greatest Victorian criminals provides a gorgeous picture of a time when art thieves were truly glamorous. Or at least Adam Worth was. Charley Hill, a stickler for historical accuracy, always felt compelled to interrupt his diatribes about the thuggishness of art thieves to hail the elegant Mr. Worth as the lone counterexample.

THE DAY THEY STOLE THE MONA LISA by Seymour Reit

On an August day in 1911 a workman named Vincenzo Perugia walked out of the Louvre with the world's most famous painting tucked inside his coat. Reit crafts an elaborate story around that simple starting point. The reader

66 [*The Napoleon of Crime*] provides a gorgeous picture of a time when art thieves were truly glamorous. **99** will gulp it down with a delight marred only slightly by a single nagging question—is this a true story or a legend?

THE RAPHAEL AFFAIR by Iain Pears

An art historian by training and the author of that acclaimed doorstop of a book *An Instance of the Fingerpost*, Pears has also written half a dozen less earnest novels that he calls "art history mysteries." This may be the best.

Several years ago, after a career spent dreaming up art crimes, Pears nearly walked into a real one. On New Year's Eve 1999 he and a houseful of guests had gathered to ring in the new millennium. Shortly before midnight the baby began to howl. Pears dutifully grabbed baby and stroller and ventured outdoors in the hope that a change of scene would prove soothing. At that moment a thief broke into Oxford's Ashmolean Museum—only a few blocks from where Pears stood rocking the baby—and ran off into the night with a \$4.8 million Cézanne.

Don't miss the next book by your favorite author. Sign up now for AuthorTracker by visiting www.AuthorTracker.com.

Have You Read? More by Edward Dolnick

DOWN THE GREAT UNKNOWN: JOHN WESLEY POWELL'S 1869 JOURNEY OF DISCOVERY AND TRAGEDY THROUGH THE GRAND CANYON

On May 24, 1869 a one-armed Civil War veteran named John Wesley Powell and a ragtag band of nine mountain men embarked on the last great quest of the American West. No one had ever explored the fabled Grand Canyon, to adventurers of that era a region almost as mysterious as Atlantis-and as perilous. The ten men set out from Green River Station, Wyoming Territory, down the Colorado in four wooden rowboats. Ninetynine days later, six half-starved wretches came ashore near Callville, Arizona. Drawing on rarely examined diaries and journals, Down the Great Unknown is the first book to tell the full, dramatic story of the Powell expedition.

"Down the Great Unknown is both good history and a successful adventure yarn." —Harper's

"Written with authority and zeal, this rich narrative is popular history at its best." —*Kirkus Reviews* (starred review)